TO BE SEEN.
QUEER LIVES
1900−1950

TO BE SEEN.
QUEER LIVES 1900–1950

Herausgegeben von
Karolina Kühn und Mirjam Zadoff

Edited by
Karolina Kühn and Mirjam Zadoff

HIRMER

NS-Dokumentationszentrum
München

INHALT

10 GRUSSWORT VON CLAUDIA ROTH,
STAATSMINISTERIN FÜR KULTUR UND MEDIEN

14 EINFÜHRUNG VON KAROLINA KÜHN UND MIRJAM ZADOFF

28 SELBSTERMÄCHTIGUNG

 32 Karl Heinrich Ulrichs – ein Pionier der Homosexuellenemanzipation

 34 August Fleischmann – Aufklärung über die Freundlingsliebe in München

 36 Anita Augspurg – unangepasst leben, Frauen eine Stimme geben

 38 Claire Waldoff – „Berliner Schnauze" aus Gelsenkirchen

 42 Gerda von Zobeltitz – die eigene Identität leben gegen alle Widerstände

44 Künstler*innen: Philipp Gufler, Maximiliane Baumgartner, Zackary Drucker & Marval Rex

60 Michaela Dudley: Weimar 2.0: Reflexionen zwischen Regenbogen und „Rosa Winkel"

72 BEGEGNEN, BEWEGEN – BANDEN BILDEN

 76 Organisationen

 96 Treffpunkte

 104 Zeitschriften und informelle Netzwerke

110 Künstler*innen: Nicholas Grafia, Lena Rosa Händle, Zoltán Lesi & Ricardo Portilho

126 Gürsoy Doğtaş: Mishimas Röhm-Affäre. Eine Materialsammlung

136 Sander L. Gilman: Queere Körperhaltung: Die Ambiguität des Andersseins erkennen

150 WISSEN, DIAGNOSE, KONTROLLE

 154 Frühe Sexualwissenschaft

 162 Das Institut für Sexualwissenschaft und seine Patient*innen

 184 Charlotte Wolff – Sexualwissenschaft im Exil

190 Künstler*innen: Jonathan Penca, Henrik Olesen

198 Ulrike Klöppel: Die „Intersexualitätslehre" in der Weimarer Republik. Zur verschränkten
Geschichte von Sexualitäts- und Geschlechternormen

212 Dagmar Herzog: Schwul, jüdisch, „unzüchtig": Der Sexualreformer Magnus Hirschfeld
als Hassfigur der Nazis

224 KÖRPER FÜHLEN, BILDER SEHEN

 228 Neue Körperbilder

 240 Liebende

 250 Queere Literatur

 262 Die Bühne als Ort der Utopien

278 Künstler*innen: Karol Radziszewski, Wolfgang Tillmans, Pauline Boudry/Renate Lorenz

288 Cara Schweitzer: Künstler*innenporträts und Geschlechteridentität zu Beginn des
20. Jahrhunderts

304 Ben Miller: Die „Klarwelt" verwerfen: Wie Elisàr von Kupffer die queere Geschichte
verkompliziert

318 LEBEN IN DER DIKTATUR

 322 Homosexualität in NS-Verbänden und beim Militär

 328 Angepasst überleben

 336 Verfolgung und Haft

 354 Exil und Widerstand

366 Künstler*innen: Katharina Aigner, Mikołaj Sobczak

372 Sébastien Tremblay: Der Rosa Winkel: Vielschichtige Symbolik und Erinnerung
in der Schwulenbewegung beiderseits des Atlantiks

386 EPILOG

CONTENTS

11 FOREWORD BY CLAUDIA ROTH, MINISTER OF STATE FOR CULTURE AND THE MEDIA

15 INTRODUCTION BY KAROLINA KÜHN AND MIRJAM ZADOFF

28 SELF-EMPOWERMENT

- **32** Karl Heinrich Ulrichs – A Pioneer of Homosexual Emancipation
- **34** August Fleischmann – Account of the Love between *Freundlinge* in Munich
- **36** Anita Augspurg – Living Unconventionally, Giving Women a Voice
- **38** Claire Waldoff – "Berlin Slang" from Gelsenkirchen
- **42** Gerda von Zobeltitz – Living Out Your Identity against All Opposition

44 Artists: Philipp Gufler, Maximiliane Baumgartner, Zackary Drucker & Marval Rex

61 Michaela Dudley: Weimar 2.0: Reflections between the Rainbow and the "Pink Triangle"

72 MEETING, MOVING – FORGING BONDS

- **76** Organizations
- **96** Meeting Places
- **104** Magazines and Informal Networks

110 Artists: Nicholas Grafia, Lena Rosa Händle, Zoltán Lesi & Ricardo Portilho

127 Gürsoy Doğtaş: Mishima's Röhm Affair: A Material Collection

137 Sander L. Gilman: Queer Posture: Seeing the Ambiguity of Difference

150 KNOWLEDGE, DIAGNOSIS, CONTROL

- **154** Early Sexology
- **163** The Institute for Sexology and Its Patients
- **184** Charlotte Wolff – Sexology in Exile

190 Artists: Jonathan Penca, Henrik Olesen

199 Ulrike Klöppel: The "Theory of Intersexuality" in the Weimar Republic: On the Entangled History of Sexual and Gender Norms

213 Dagmar Herzog: Gay, Jewish, "Obscene": Magnus Hirschfeld as a Sexual Reformer and Target of Nazi Hate

224 FEELING BODIES, SEEING IMAGES

- **228** New Images of the Body
- **240** Lovers
- **250** Queer Literature
- **262** The Stage as Site of Utopias

278 Artists: Karol Radziszewski, Wolfgang Tillmans, Pauline Boudry/Renate Lorenz

289 Cara Schweitzer: Portraits of Artists and Gender Identity at the Beginning of the Twentieth Century

305 Ben Miller: Rejecting the "Klarwelt": How Elisàr von Kupffer Complicates Queer History

318 LIFE UNDER DICTATORSHIP

- **322** Homosexuality in Nazi Organizations and in the Military
- **328** Adapting to Survive
- **336** Persecution and Imprisonment
- **354** Exile and Resistance

366 Artists: Katharina Aigner, Mikołaj Sobczak

373 Sébastien Tremblay: The Pink Triangle: Multilayered Symbolism and Memory in the Queer Atlantic

387 EPILOGUE

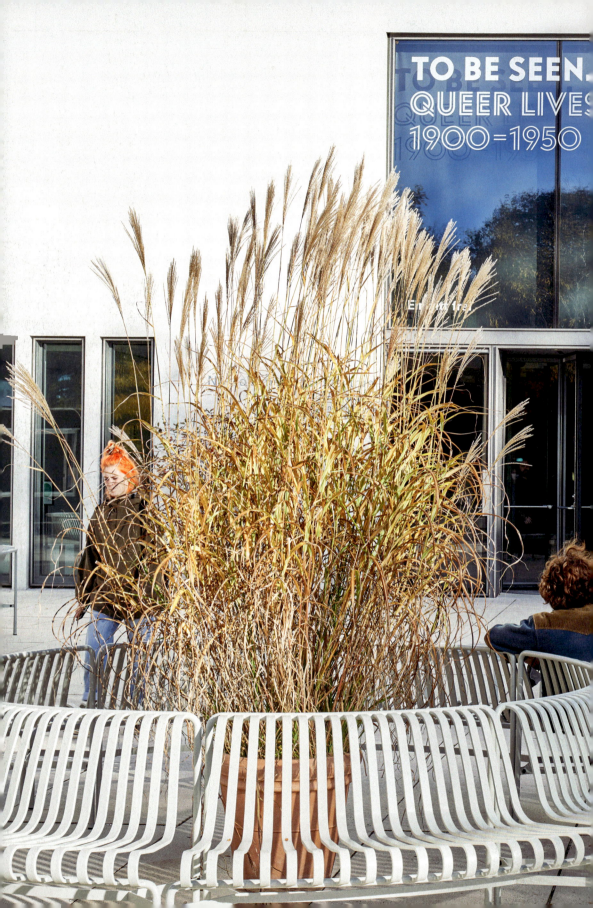

GRUßWORT

Es ist mir eine große Freude und eine besondere Ehre, die Schirmfrauschaft über die Ausstellung *TO BE SEEN. queer lives 1900–1950* zu übernehmen. Sie zeigt, mit wie viel Mut und Fantasie queere Menschen in dieser Zeit für ihre Rechte gekämpft und versucht haben, ihr Leben zu leben. Aber sie macht auch deutlich, welches Unrecht diese Frauen und Männer in der ersten Hälfte des 20. Jahrhunderts und ganz besonders in der Nazi-Zeit erleiden mussten.

Was selbstverständlich sein sollte, war es nie – und ist es allen erkennbaren Fortschritten zum Trotz leider auch heute noch nicht: Das Recht eines jeden Menschen auf Selbstbestimmung, auf die Freiheit zu sein, wer wir sind, zu lieben, wen wir lieben, anerkannt, respektiert und mit gleichen Rechten ausgestattet.

Dafür kämpfen queere Menschen, und dabei ging es nie um Nebensächlichkeiten. Es ging immer um demokratische Rechte für alle, die in diesem Land leben, unabhängig davon, wen sie lieben. Es ging um die Einlösung eines Menschenrechts, um Gleichberechtigung.

Artikel 1 des Grundgesetzes erklärt: „Die Würde des Menschen ist unantastbar." Er stellt diese Würde unter den Schutz des Staates. Und dieses Versprechen gilt für alle, Mann oder Frau, trans-, hetero-, homo- oder bisexuell, unabhängig von der Hautfarbe, Religion und Herkunft. Es gilt für jeden Menschen – ohne Kategorie, ohne Wenn und Aber.

Ich verneige mich vor allen, die im Kampf für ihre Rechte als LGBTIQ* gekämpft haben, verfolgt oder gar ermordet wurden – vor allem in der Nazi-Zeit, als Queer-Feindlichkeit Teil der menschenverachtenden Staatsideologie war und alle Fortschritte, die in den Jahren davor erkämpft worden waren, wieder zunichtegemacht wurden. Bis zu 10.000 homosexuelle Männer wurden zwischen 1933 und 1945 in Konzentrationslager verschleppt. Tausende von ihnen überlebten den NS-Terror nicht.

Aber auch mit dem Ende des NS-Regimes hörte die Verfolgung queerer Menschen nicht auf. Der widerwärtige Paragraf 175 wurde vor gerade einmal 28 Jahren aus dem Strafgesetzbuch verbannt. Trotz großer Fortschritte wie der „Ehe für alle" nimmt heute die Gewalt gegen LGBTIQ* und ihre Einrichtungen wieder zu. Der rechte Rand, erzkonservative und reaktionär christliche Kreise machen Stimmung gegen die menschliche Vielfalt.

Leider sind Vorurteile und Ressentiments auch in Deutschland kein Phänomen, das sich nur ganz rechts außen zeigt; es durchzieht die gesamte Gesellschaft, mal deutlicher, mal subtiler. Und viele Menschen trauen sich immer noch nicht, sie selbst zu sein und sich zu outen. Auch deshalb ist diese Ausstellung so wichtig.

Es gibt noch so viel Emanzipation zu erstreiten, noch so viele Räume zu schaffen – im Kleinen wie im Großen. Für alle Demokratinnen und Demokraten heißt das: Gesicht zeigen, Stimme erheben, Verantwortung übernehmen. Gemeinsam und solidarisch stehen wir ein gegen Hass, Diskriminierung und

FOREWORD

It is a great pleasure and a special honor for me to serve as the patron of the exhibition *TO BE SEEN. queer lives 1900–1950*. This exhibition shows how much courage, determination, and imagination queer people of the early twentieth century brought to their struggle for basic rights and to simply live their lives. But it also makes clear what grave injustices these people suffered throughout this period and especially under Nazi rule.

The rights that should have been self-evident never were – and despite all the visible progress that has been made, that remains the case today. Recognition and respect for the right of every person to self-determination, to the freedom to be who we are and to love whom we love, to be endowed with the same rights as others: that is what queer people have struggled for and continue to struggle for, and these have never been trivial matters. What has always been at stake are democratic rights for everyone who lives in this country, regardless of whom they love. This is a matter of asserting a human right; it is about fundamental equality.

Article 1 of Germany's constitution, known as the Basic Law, states: "Human dignity shall be inviolable." It places this dignity under the protection of the state. And this promise is for all people, regardless of their gender, or of whether they are cis or trans, or heterosexual, homosexual or bisexual, regardless of their skin color, their religion, or their background. This applies to every human being – unconditionally.

I offer my deepest and most heartfelt respect to all those who suffered persecution or lost their lives in the struggle for their rights as LGBTIQ+ people – especially in the Nazi era, when hostility to queer people was part of a broader official ideology of contempt for humanity and when all the progress that had been made in the previous years was erased. Up to 10,000 gay men were deported to concentration camps between 1933 and 1945. Thousands of them did not survive the horrors of the Nazi regime.

But even after the end of Nazi rule, the persecution of queer people continued. It was only twenty-eight years ago that the abhorrent Paragraph 175 which criminalized homosexuality was removed from the German criminal code. Despite major milestones such as marriage equality, violence against LGBTIQ+ people and institutions is today on the rise again. The far right, ultra-conservatives, and Christianist reactionaries are agitating against human diversity.

Unfortunately, in Germany prejudices and resentments are not limited to the far right; they permeate our whole society, sometimes taking a more blatant form and sometimes a more subtle form. And many people still do not dare to be themselves or to come out of the closet. That is one of the reasons this exhibition is so important.

Ressentiments, für ein vielfältiges und gerechtes Miteinander. Mit Begeisterung und Mut, mit Liebe statt Hass.

Wir wollen, dass wahr wird, wovon Rio Reiser sang:

"*Ich will ich sein, anders kann ich nicht sein.*
Ich will leben, wie ich leben will.
Und will lieben, wen ich lieben will.
Ich will ich sein."

CLAUDIA ROTH MdB
Staatsministerin für Kultur und Medien

We have so much emancipation yet to gain, so many spaces still to be created – on both a small and a large scale. For all who are committed to democracy, this means that we need to show our faces, raise our voices and assume responsibility. In a spirit of solidarity, we stand together against hatred, discrimination, and resentment and for a just and diverse society. With courage and vigor, with love, not hate.

We want what the German musician Rio Reiser sang of to become a reality:

"Ich will ich sein, anders kann ich nicht sein.
Ich will leben, wie ich leben will.
Und will lieben, wen ich lieben will.
Ich will ich sein."

I want to be me, I can't be anything else.
I want to live how I want to live.
I want to love who I want to love.
I want to be me.

CLAUDIA ROTH
Member of the German Bundestag
Minister of State for Culture and the Media

KAROLINA KÜHN, MIRJAM ZADOFF

EINFÜHRUNG

„Wir erzählen unsere Geschichten, um zu wissen, wer wir sind, und um uns gegenseitig zu versichern, dass wir nicht allein sind."
Masha Gessen, Schriftsteller*in und Aktivist*in, 2013[1]

Die Wahrnehmung unserer Gegenwart ist eng daran geknüpft, wie Vergangenheit erinnert und gedeutet wird. Wie wir erinnern, hängt zugleich auch von unseren gegenwärtigen Bedürfnissen und Möglichkeiten ab. Mit *TO BE SEEN. queer lives 1900–1950* wollen wir den Blick für die Vielfalt queerer Lebenswelten im frühen 20. Jahrhundert öffnen und die Teilhabe queerer Menschen und Communitys an gesellschaftlichen Entwicklungen sichtbar machen.[2] Damit erinnern wir an vergessene Vielfalt und antworten zugleich auch auf gegenwärtige Diskussionen und Veränderungen.

„Sind wir Frauen der Emanzipation homosexuell – nun dann lasse man uns doch! Dann sind wir es doch mit gutem Recht. Wen geht's an? Doch nur die, die es sind." Johanna Elberskirchen, Schriftstellerin, 1904[3]

Die Ausstellung zeigt, wie Geschlechterrollen in Deutschland ab 1900 allmählich aufbrachen und Emanzipationsbestrebungen von Frauen, Schwulen, Lesben und trans* Personen in Gesellschaft, Wissenschaft und Kultur zum Ausdruck kamen. Die sogenannte Erste Welle der Homosexuellenbewegung wurde mit der nationalsozialistischen Machtübernahme 1933 gewaltsam unterbrochen.[4] Nach 1945 sorgten Kontinuitäten – das verschärfte Strafrecht und eine reaktionäre Geschlechterordnung – dafür, dass die Geschichte queeren Lebens nicht erzählt und Selbstzeugnisse nicht archiviert wurden. Eine Rehabilitierung der Opfer unterblieb.

Nach jahrzehntelangen Kämpfen um Selbstbehauptung und Sichtbarkeit im öffentlichen Raum haben LGBTIQ* die Lebensgeschichten ihrer Vorgänger*innen seit den 1980er Jahren eigenhändig ans Licht gebracht. Sie suchten nach Zeugnissen der eigenen Geschichte, gründeten selbstorganisierte Archive und kämpften für eine Erinnerung an die NS-Verfolgung. Sie begannen, das ihnen aufgezwungene Schweigen zu brechen und queere Geschichte auf eigene Weise aufzuarbeiten. Erst seit einiger Zeit haben auch öffentliche Museen und Archive damit angefangen, ihre Bestände zu „queeren" und die Geschichte von LGBTIQ* auszustellen.[5]

Heute haben in Deutschland queere Menschen und Anliegen mehr Raum: 2017 wurde die „Ehe für alle" eingeführt, und seit 2018 können Menschen im Geburtenregister den Eintrag „divers" auswählen. Mit Sven Lehmann hat die Bundesregierung ihren ersten Beauftragten für „die Akzeptanz sexueller und geschlechtlicher Vielfalt". 2021 wurde das Gesetz zum „Schutz von Kindern mit

KAROLINA KÜHN, MIRJAM ZADOFF

INTRODUCTION

"We tell our stories to know who we are and to tell each other that we are not alone." Masha Gessen, writer and activist, 2013[1]

The perception of our present is intimately linked with how the past is remembered and interpreted. At the same time, the ways in which we remember depend on our current needs and options. In *TO BE SEEN. queer lives 1900–1950* we want to broaden perspectives on the diversity of queer lives and experience in the early twentieth century and make visible how queer individuals and communities have participated in social developments.[2] In this way we commemorate a forgotten diversity and also respond to contemporary discussions and changes.

"Are we women of emancipation homosexual? Then let us be! It's with good reason that we're this way. And whose business is it? Only those of us who are this way." Johanna Elberskirchen, writer, 1904[3]

The exhibition documents how gender roles in Germany gradually began to change around 1900 and how aspirations for the emancipation of women, gays, lesbians, and trans+ people were manifested in society, science, and culture. The so-called first wave of the homosexual movement was violently cut short by the Nazi takeover in 1933.[4] After 1945, ongoing repression – such as the more severe criminal law and a reactionary gender order – ensured that the history of queer life remained untold and participants' testimonies were not archived. There was no rehabilitation of the victims.

Since the 1980s, after decades of fighting for self-affirmation and visibility in the public sphere, LGBTIQ+ people have single-handedly brought the stories of their predecessors to light. They searched for personal testimonies, founded self-organized archives, and fought for preserving the memory of Nazi persecution. In their own way they began to break the silence imposed on them and to work through queer history. Only recently have public museums and archives begun to "queer" their collections and to exhibit LGBTIQ+ history.[5]

Today, queer people and concerns have gained more space and attention in Germany: same-sex marriage was introduced in 2017, and since 2018 people can select "diverse" as their gender designation in official records. Sven Lehmann has been named the German government's first commissioner for "the acceptance of sexual and gender diversity." In 2021, a law for the "protection of children with variants of sex development" was passed, aimed to protect intersex children from unnecessary treatments. At present, a Self-

Varianten der Geschlechtsentwicklung" verabschiedet, das inter* Kinder vor unnötigen Behandlungen an den Geschlechtsmerkmalen schützen soll. Derzeit wird das Selbstbestimmungsgesetz für trans*, inter* und nicht-binäre Menschen auf den Weg gebracht, und auch eine Reform im Familienrecht ist geplant, das lesbischen Ehepaaren in Bezug auf Kinder die gleichen Rechte zugesteht wie heterosexuellen.[6] Öffentlichkeitswirksame Coming-outs machen die Vielfalt queeren Lebens in Deutschland sichtbar.[7] Und nach jahrelangem Einsatz von Aktivist*innen und Wissenschaftler*innen wird der Bundestag 2023 am Holocaust-Gedenktag erstmals Menschen gedenken, die aufgrund ihrer sexuellen und geschlechtlichen Identität verfolgt und ermordet wurden.

Zugleich erfahren LGBTIQ* auf der ganzen Welt weiterhin politisch motivierte Gewalt, wobei die Dunkelziffer vielen Hilfsorganisationen zufolge oft sehr hoch ist.[8] Transfeindlichkeit ist unter Rechten und Rechtsextremen zu finden, aber auch bei christlichen Fundamentalist*innen oder radikalen trans* exkludierenden Feminist*innen. Teilweise gehen diese unterschiedlichen Gruppierungen sogar Allianzen ein.[9] Geschlechtsidentitäten jenseits der heterosexuellen Norm werden nicht zuletzt gern als vorübergehende „Mode" stigmatisiert. Dabei ist die Vielfalt von Geschlecht und Begehren so alt wie die Menschheit selbst. Die Vorstellung von zwei Geschlechtern hingegen, die über eine „natürliche" Hierarchie miteinander verbunden sind, ist in vielen Kulturen relativ jung und war oft das Ergebnis kolonialer Machtverhältnisse oder religiöser Ideologien.[10]

Ein Blick in die Geschichte des 19. und 20. Jahrhunderts zeigt, wie eng die Diskriminierung und Verfolgung von Menschen, die sich nicht einer vorgegebenen Geschlechternorm unterordnen, mit rechten und faschistischen Ideologien verknüpft sind. Feminismus, Gender Studies oder Queerness werden als Bedrohung traditioneller Männlichkeitsvorstellungen propagiert, die Nation als ein Ausdruck einer ausschließlich männlichen Welt gesehen. Mit *TO BE SEEN* möchten wir dazu einladen, marginalisierten historischen Emanzipationsbewegungen und Lebensgeschichten zu begegnen, Leerstellen im Umgang mit dieser Geschichte aufzuspüren und Bezüge zur Gegenwart herzustellen.

> *„Wenn wir Momente in der Geschichte beleuchten, in denen trans Menschen Erfolge feierten, treten wir damit meiner Meinung nach dem Missverständnis entgegen, trans Menschen seien ein neues Phänomen."*
> Zackary Drucker, Künstlerin und Producerin, 2015[11]

Sichtbarkeit ist jedoch kein Wert per se. Zahlreiche Queer-Theoretiker*innen, Autor*innen und Aktivist*innen haben darauf hingewiesen, dass gerade die visuelle Repräsentation nicht für alle Menschen mit Freiheit und Selbstbestimmung verbunden ist – dass hingegen Sichtbarkeit sogar zur Falle werden kann.[12] Diese Ambivalenz gilt auch für die Ausstellung, die als solche ja immer auch die Gefahr eines Zur-Schau-Stellens oder voyeuristischen Vorführens mit sich bringt.

Determination Act for trans+, intersex, and non-binary people is being prepared, while a reform in family law is planned that will grant lesbian married couples the same rights as heterosexual ones with regard to children.[6] Prominent coming-outs have made the diversity of queer life in Germany visible.[7] On Holocaust Memorial Day in 2023, following years of effort by activists and scholars, the Bundestag will for the first time commemorate people who were persecuted and murdered by the Nazi regime due to their sexual and gender identity.

At the same time, LGBTIQ+ people around the world continue to experience politically motivated violence, with the number of unreported cases often extremely high, according to many aid organizations.[8] Transphobia can be found among conservatives and right-wing extremists, but also among Christian fundamentalists or radical trans-exclusionary feminists. Sometimes these dissimilar groups have even forged alliances.[9] Gender identities outside the heterosexual norm are often stigmatized as a passing "fashion." Yet the diversity of gender and desire is as old as humanity itself. The notion of two genders, on the other hand, related to one another by a "natural" hierarchy, is relatively recent in many cultures and was often the result of colonial power relations or religious ideologies.[10]

A glance at nineteenth- and twentieth-century history shows how directly the discrimination and persecution of people who do not submit to a predetermined gender norm are linked to right-wing and fascist ideologies. Feminism, gender studies, or queerness are denigrated as a threat to traditional ideas of masculinity, and the nation is seen as an expression of an exclusively male world. *TO BE SEEN* invites viewers to encounter marginalized historical emancipation movements and life stories, discover gaps in dealing with this history, and establish connections with the present.

> *"I think that by illuminating moments in history when trans people have flourished, we're offsetting the misconception that trans people are new."* Zackary Drucker, artist and producer, 2015[11]

Visibility, however, is not a value per se. Numerous queer theorists, authors, and activists have pointed out that visual representation does not mean freedom and self-determination for all people – and visibility can even turn into a trap.[12] This ambivalence also concerns our exhibition, which as such always entails the risk of becoming a mere display or voyeuristic presentation.

What can be shown, what traces can still be discovered? Much has disappeared or was deliberately never documented, written down, or visually recorded. Only a few personal accounts have been preserved; the everyday life of queer people is hardly known. The surviving testimony from the nineteenth and twentieth centuries, on the other hand, was often recorded in the context of oppression and persecution. Existing documents from police and

Was kann gezeigt werden, welche Spuren sind noch auffindbar? Vieles ist verschollen oder wurde absichtlich nicht dokumentiert, aufgeschrieben oder abgebildet. Nur vereinzelte Selbstzeugnisse wurden aufbewahrt, das Alltagsleben queerer Menschen ist kaum überliefert. Die erhaltenen Zeugnisse aus dem 19. und 20. Jahrhundert sind dagegen häufig im Kontext von Unterdrückung und Verfolgung entstanden. Überlieferungen von Polizei- und Justizbehörden, von Medizin und Wissenschaft verengen den Blick auf den Moment der Verfolgung. Neben den Dokumenten zur Verfolgung schwuler und bisexueller Männer aufgrund des Paragrafen 175 existieren außerdem nur wenige Zeugnisse über lesbische, trans* oder inter* Biografien. Wie also lässt sich queere Geschichte in einer Ausstellung erzählen, ohne dass die Narrative einer Gesellschaft wiederholt werden, in der Heterosexualität als Norm gilt? Die Geschichte von LGBTIQ* ist mehr als eine Geschichte von Verfolgung und Ausgrenzung, sie erzählt auch und gerade von mutigen, selbstbestimmten Lebensentwürfen.

> *„Als Urninge sollen und müssen wir auftreten. Nur dann erobern wir uns*
> *in der menschlichen Gesellschaft Boden unter den Füßen, sonst niemals."*
> Karl Heinrich Ulrichs alias Numa Numantius, Jurist, 1865[13]

Zum einen haben wir uns dafür entschieden zu dokumentieren, was war, bevor das NS-Regime es zerstörte. So zeigen die beiden ersten Ausstellungskapitel, wie einzelne Menschen oder auch Bewegungen widerständige Sichtbarkeiten entwickelten und damit vorhandene Gesellschaftsstrukturen infrage stellten. Um die Jahrhundertwende und in der Weimarer Zeit erzielten Homosexuelle sowie vereinzelt auch trans* Personen in ihrem Kampf für gleiche Rechte und Akzeptanz erste Erfolge: Sie organisierten sich und traten selbstbewusst für die wissenschaftliche und rechtliche Anerkennung ihrer Geschlechtsidentität und sexuellen Orientierung ein. Sie trafen sich in eigenen Bars und Vereinen, gründeten Zeitschriften und prägten neue Begriffe, um ihre Identitäten zu beschreiben: Urning, lesbisch, Freundin, Bubi, homosexuell. Auch die Weiterentwicklung queerer Selbstbezeichnungen ist keine Erfindung der letzten Jahre. Dokumente zu prägnanten Beispielen queerer Selbstermächtigung ebenso wie zu subkulturellen Verbindungen machen historische Erscheinungen der Solidarität, des Verbundenseins und Bandenbildens sichtbar. Die Perspektiven queerer Protagonist*innen, ihre Ideen und Visionen stehen in der Ausstellung im Mittelpunkt, um auf diese Weise nicht nur die in offiziellen Akten dokumentierte Verfolgungsgeschichte zu reproduzieren.

> *„Ich finde, trans Menschen verdienen es, nicht nur im Licht unseres Traumas*
> *gesehen zu werden, sondern auch in dem unseres Glücks."*
> Angelica Ross, Schauspielerin, 2022[14]

Zudem erzählt *TO BE SEEN* nicht nur von Vorreiter*innen, sondern auch von politischen Widersprüchen und schwierigen Ahnen: seien es die homoerotischen

judicial authorities, from medicine and science, restrict our view to the moment of persecution. Alongside the evidence of the persecution of gay and bisexual men due to Paragraph 175, only a few remnants of lesbian, trans+, or intersex biographies exist. So how can queer history be told in an exhibition without repeating the narratives of a society where heterosexuality is considered the norm? The history of LGBTIQ+ is more than a story of persecution and exclusion, it also and especially speaks of courageous, self-determined lives.

> *"We should and must appear as* Urninge *[homosexual men]. Only then can we gain ground in human society, otherwise never."*
> Karl Heinrich Ulrichs, alias Numa Numantius, lawyer, 1865[13]

To begin with, we have chosen to document what existed before the Nazi regime destroyed it. The first two sections of the exhibition narrate how individuals or even movements developed resilient visibilities, questioning existing social structures. At the turn of the century and during the Weimar era, homosexuals – and, in some cases, trans+ people – achieved their first successes in their struggle for equal rights and acceptance: they organized themselves and asserted their right to scientific and legal recognition of their gender identity and sexual orientation. They met in their own bars and clubs, founded magazines, and coined new terms to describe their identities: *Urning*, lesbian, female friend, *Bubi* (lad), homosexual. The evolution of queer self-descriptions is likewise not an invention of recent years. Documents on salient examples of queer self-empowerment and subcultural links uncover historical phenomena of solidarity, connectedness, and grouping together. In order not to simply replicate the history of persecution documented in official files, the exhibition focuses on the perspectives of queer protagonists, on their ideas and visions.

> *"I think trans people deserve to be seen not only in our trauma but in our joy."* Angelica Ross, actress, 2022[14]

TO BE SEEN not only presents pioneers, but also political contradictions and problematic predecessors: be it the homoerotic notions of male associations, which can also be found among gay activists of the Weimar Republic, or queer perpetrators such as the lesbian concentration camp guard or the gay SA commander. Sexology, which began to flourish at the turn of the century, not only created visibility for a variety of new body images, but at the same time led to pathologization and facilitated state control. In addition to the most influential positions, we also display documents and testimonies of individual "patients" that illustrate their own scope of action.

The National Socialist dictatorship initiated a period of open persecution against parts of the queer community. Magnus Hirschfeld and other Jewish

Männerbundsvorstellungen, die sich auch unter schwulen Aktivisten der Weimarer Republik finden lassen, oder queere Täter*innen wie die lesbische KZ-Aufseherin oder der schwule SA-Chef. Auch die Sexualwissenschaft, die ab der Jahrhundertwende eine erste Blüte erlebte, brachte nicht nur Sichtbarkeit für eine Vielfalt neuer Körperbilder, sondern führte zugleich zu einer Pathologisierung und erleichterte die staatliche Kontrolle. Wir zeigen neben den einflussreichsten Positionen auch Dokumente und Selbstzeugnisse einzelner „Patient*innen", die deren eigene Handlungsspielräume ans Licht bringen.

Mit der nationalsozialistischen Diktatur begann für Teile der queeren Communitys eine Zeit der offenen Verfolgung. Magnus Hirschfeld und weitere jüdische Sexualwissenschaftler*innen flohen noch vor der Machtübernahme oder kurz darauf ins Exil, seine Bücher wurden im Mai 1933 verbrannt. Im Herbst 1934 fanden die ersten Razzien gegen homosexuelle Männer statt. Bis 1945 wurden über 57.000 von ihnen durch die NS-Justiz verurteilt und zwischen 6.000 und 10.000 in Konzentrationslager verschleppt. Lesbische Frauen waren in weit geringerem Ausmaß betroffen, aber gerade in Verbindung mit anderen Verfolgungsgründen waren auch sie zusehends gefährdet. Solidarität und Netzwerke erlangten nun existenzielle Bedeutung für alle Betroffenen.

Und schließlich präsentiert *TO BE SEEN* eine Auswahl künstlerischer Werke. In der Kunst und der Literatur der ersten Hälfte des 20. Jahrhunderts entwickelten sich vielfältige Vorstellungen queerer Körperlichkeit. Auch Bühnen wurden zu Möglichkeitsräumen der Befreiung von herrschenden Geschlechterzuschreibungen sowie zum Raum für soziale Aushandlungsprozesse. Vieles von dem, was wir heute als queer wahrnehmen, fand sich bereits in den künstlerischen Utopien der Zwischenkriegszeit.

> *„Queerness bedeutet im Wesentlichen, das Hier und Jetzt zurückzuweisen und darauf zu beharren, dass eine andere Welt möglich ist und verwirklicht werden kann."*
> José Esteban Muñoz, Theaterwissenschaftler und Queer-Theoretiker, 2009[15]

Erweitert wird der historische Blick durch Positionen zeitgenössischer Künstler*innen, die als Teil der Ausstellung, aber auch als Intervention auf allen Geschossen des NS-Dokumentationszentrums zu sehen sind. In bestehenden und eigens für die Ausstellung entwickelten Arbeiten werden marginalisierte Lebensentwürfe künstlerisch in den Blick genommen, historische Narrative hinterfragt und durch neue Perspektiven erweitert. Die Künstler*innen widmen sich der Untersuchung biografischer, thematischer und ästhetischer Leerstellen und setzen sich mit den Vermächtnissen queerer Geschichte vor dem und im Nationalsozialismus auseinander. Dabei werden immer wieder Fragen nach dem historischen Kanon und seiner Autor*innenschaft gestellt, wie auch nach Erweiterungen und Veränderungen. Die künstlerischen Arbeiten verweisen zudem auf Kontinuitäten der Ausgrenzung und Stigmatisierung über die Zäsur des Jahres 1945 hinaus,

sexologists fled into exile before the Nazi seizure of power or shortly there-after; Hirschfeld's books were burned in May 1933. The first raids against homosexual men took place in the fall of 1934. By 1945, over 57,000 of them had been convicted by Nazi courts and between 6,000 and 10,000 were deported to concentration camps. Lesbian women were affected to a much lesser extent, but they too were increasingly endangered, especially in con-nection with other motives for persecution. Solidarity and networks now acquired existential significance for all those affected.

Finally, *TO BE SEEN* presents a selection of artistic works. The art and literature of the first half of the twentieth century generated a variety of ideas of queer corporeality. The stage also became a potential space of liberation from dominant gender ascriptions, as well as a site for processes of social negotiation. Much of what we perceive as queer today can already be found in the artistic utopias of the interwar period.

> *"Queerness is essentially about the rejection of a here and now and an insistence on potentiality or concrete possibility for another world."*
> José Esteban Muñoz, theater scholar and queer theorist, 2009[15]

The historical view is augmented through the works of contemporary artists, which can be experienced as part of the exhibition, but also as interventions on all the floors of the Munich Documentation Center for the History of National Socialism. Their works, whether preexisting or specially created for this exhibition, examine marginalized lives artistically, question historical narratives, and expand these through new perspectives. The artists scrutinize the biographical, thematic, and aesthetic voids, engaging with the legacies of queer history before, during, and after the Nazi period. Questions about the historical canon and its authorship are continuously raised, as well as questions about the canon's expansion and transformation. The artworks, moreover, unmask how exclusion and stigmatization continued beyond the watershed year of 1945, and how they persist in some cases to this day, positioning the historical experience within the context of current issues. In their works the artists explore how and whether a narrative, a debate, can exist beyond individual and collective traumas.

In this sense, the catalog endeavors to open up an interdisciplinary dialogue. In addition to documenting the exhibition through selected objects and artworks, it features essays that expand and supplement the themes of the exhibition's sections. We are especially grateful to the authors and artists, whose texts and artworks can be regarded as contributions to this discussion – and not least to all the visitors and readers, who take part in this conversation with their interest and their stories.

teilweise bis heute, und setzen die historische Erfahrung in den Kontext aktueller Fragen. In ihren Arbeiten loten die Künstler*innen aus, wie und ob es eine Erzählung, ein Gespräch jenseits von individuellen wie kollektiven Traumata geben kann.

In diesem Sinn soll auch der Begleitband einen interdisziplinären Dialog öffnen. Neben einer Dokumentation der Ausstellung anhand ausgewählter Exponate und Kunstwerke finden sich Essays, die die Themen der Ausstellungskapitel erweitern und ergänzen. Unser besonderer Dank gilt den Autor*innen und den Künstler*innen, deren Texte und Arbeiten ebenfalls als Beitrag zu diesem Gespräch verstanden werden können – und nicht zuletzt allen Besucher*innen und Leser*innen, die sich mit ihrem Interesse und ihren Geschichten an diesem Gespräch beteiligen.

1 Masha Gessen, My life as an out gay person in Russia, in: The Guardian, 15.11.2013, URL: https://www.theguardian.com/world/2013/nov/15/life-as-out-gay-russia [gelesen am 16.8.2022], übers. von Birgit Lamerz-Beckschäfer.

2 Wir begreifen „queer" als Sammelbegriff für eine Vielfalt sexueller und geschlechtlicher Identitäten; vor allem, aber nicht nur LGBTIQ* – also lesbische, schwule, bisexuelle, trans* sowie inter* Personen. Darüber wird „Queering" als die Praxis verstanden, einen kritischen Blick auf jene Weltanschauung zu werfen, die Heterosexualität als soziale Norm begreift. Somit wird eine starre binäre Geschlechterteilung in Mann und Frau und die damit verbundenen Rollenbilder hinterfragt. Historische Selbstbezeichnungen werden dort verwendet, wo sie sich durch Quellen nachweisen lassen; abwertende Begriffe, falls möglich, nicht reproduziert.

3 Johanna Elberskirchen, Revolution und Erlösung des Weibes: Was hat der Mann aus Weib, Kind und sich gemacht? Eine Abrechnung mit dem Mann – Ein Wegweiser in die Zukunft! 2. Aufl. Leipzig 1904, S. 9.

4 Vgl. z.B. Insa Eschebach (Hg.), Homophobie und Devianz. Weibliche und männliche Homosexualität im Nationalsozialismus, Berlin 2012; Michael Schwartz, Homosexuelle im Nationalsozialismus. Neue Forschungsperspektiven zu Lebenssituationen von lesbischen, schwulen, bi-, trans- und intersexuellen Menschen 1933 bis 1945, München 2014; Johanna Ostowska, Joanna Talewiez-Kwiatkowska und Lutz van Dijk (Hg.), Erinnern in Auschwitz: auch an sexuelle Minderheiten, Berlin 2020.
Die erste Ausstellung in einem öffentlichen Museum zum Thema war 1984 *Eldorado: Geschichte, Alltag und Kultur homosexueller Frauen und Männer in Berlin von 1850–1950*. Sie wurde von einer Gruppe Homosexueller angeregt, im Berlin-Museum gezeigt und legte den Grundstein für die Gründung des Schwulen Museums in Berlin.

5 Ein aktuelles Beispiel ist der Sammlungsaufruf des Münchner Stadtmuseums in Kooperation mit dem Stadtarchiv München und dem Forum Queeres Archiv München e.V., über den unter dem Motto „München sucht seine LGBTI* Geschichte" queere Objekte als Teil der Stadtgeschichte gesammelt und bewahrt werden sollen, eine Arbeit, die das Forum Queeres Archiv München e.V. bereits seit 1999 verfolgt; vgl. URL: https://www.muenchner-stadtmuseum.de/sammlungen/forschungsprojekte/muenchen-sucht-seine-lgbti-geschichte [gelesen am 16.8.2022]. Siehe auch Maria Bühner, Rebekka Rinner, Teresa Tammer und Katja Töpfer (Hg.), Sexualitäten sammeln. Ansprüche und Widersprüche im Museum, Köln 2021. Zu verschiedenen spezifisch Queeren Museen siehe URL: https://www.nytimes.com/2022/08/04/arts/design/lgbt-museums-queer-britain.html [gelesen am 4.8.2022].

6 Zum Selbstbestimmungsrecht siehe URL: https://www.bmfsfj.de/bmfsfj/aktuelles/alle-meldungen/eckpunkte-fuer-das-selbstbestimmungsgesetz-vorgestellt-199378 [gelesen am 16.8.2022]. Zum „Gesetz zum Schutz von Kindern mit Varianten der Geschlechtsentwicklung" siehe URL:https://www.bmj.de/SharedDocs/Gesetzgebungsverfahren/DE/Verbot_OP_Geschlechtsaenderung_Kind.html [gelesen am 16.8.2022]. Zur Reform des Abstammungsrechts siehe URL: https://www.lsvd.de/de/ct/2506-Reform-im-Abstammungsrecht-Regenbogenfamilien-endlich-rechtlich-absichern [gelesen am 16.8.2022].

1 Masha Gessen, "My life as an out gay person in Russia," *The Guardian* (November 15, 2013), https://www.theguardian.com/world/2013/nov/15/life-as-out-gay-russia (accessed August 16, 2022).

2 We understand "queer" as a collective term for a variety of sexual and gender identities, especially but not only LGBTIQ+, that is lesbian, gay, bisexual, trans+, and intersex people. Beyond that, "queering" is understood here as the practice of taking a critical look at the worldview that understands heterosexuality as a social norm, questioning a rigid binary gender division into man and woman and the resulting role models. Historical endonyms (that is, self-designations) are used where they can be proven by sources; pejorative terms, if possible, are not repeated.

3 Johanna Elberskirchen, *Revolution und Erlösung des Weibes: Was hat der Mann aus Weib, Kind und sich gemacht? Eine Abrechnung mit dem Mann – Ein Wegweiser in die Zukunft!* 2nd ed. (Leipzig: 1904), 9.

4 See for example Insa Eschebach, ed., *Homophobie und Devianz. Weibliche und männliche Homosexualität im Nationalsozialismus* (Berlin: 2012); Michael Schwartz, *Homosexuelle im Nationalsozialismus. Neue Forschungsperspektiven zu Lebenssituationen von lesbischen, schwulen, bi-, trans- und intersexuellen Menschen 1933 bis 1945* (Munich: 2014); Johanna Ostowska, Joanna Talewiez-Kwiatkowska, and Lutz van Dijk, eds., *Erinnern in Auschwitz: auch an sexuelle Minderheiten* (Berlin: 2020).
The first exhibition on the topic in a public museum took place in 1984: *Eldorado: Geschichte, Alltag und Kultur homosexueller Frauen und Männer in Berlin von 1850–1950* (Eldorado: History, Everyday Life, and Culture of Homosexual Women and Men in Berlin from 1850 to 1950). It was initiated by a group of homosexuals, shown at the Berlin Museum, and became the cornerstone for the founding of the Schwules Museum in Berlin.

5 A current example is the "München sucht seine LGBTI* Geschichte" (Munich Searches for Its LGBTI+ History) appeal put out by the Münchner Stadtmuseum, in cooperation with the Stadtarchiv München and the Forum Queeres Archiv München e.V. The project seeks to collect and preserve queer objects as part of the city's history, a task that the Forum Queeres Archiv München e.V. has pursued since 1999. See https://www.muenchner-stadtmuseum.de/sammlungen/forschungsprojekte/muenchen-sucht-seine-lgbti-geschichtegelesen (accessed August 16, 2022). See also Maria Bühner, Rebekka Rinner, Teresa Tammer, and Katja Töpfer, eds., *Sexualitäten sammeln. Ansprüche und Widersprüche im Museum* (Böhlau: 2021). On various, specifically queer museums, see https://www.nytimes.com/2022/08/04/arts/design/lgbt-museums-queer-britain.html (accessed August 4, 2022).

6 On the "Selbstbestimmungsrecht" (Self-Determination Act), see https://www.bmfsfj.de/bmfsfj/aktuelles/alle-meldungen/eckpunkte-fuer-das-selbstbestimmungsgesetz-vorgestellt-199378 (accessed August 8, 2022). On the "Gesetz zum Schutz von Kindern mit Varianten der Geschlechtsentwicklung" (protection of children with variants of sex development) see https://www.bmj.de/SharedDocs/Gesetzgebungsverfahren/DE/Verbot_OP_Geschlechtsaenderung_Kind.html (accessed August 16, 2022). On the reform of the family law, see https://www.lsvd.de/de/ct/2506-Reform-im-Abstammungsrecht-Regenbogenfamilien-endlich-rechtlich-absichern (accessed August 16, 2022).

7 As in the "Manifest #ActOut," in which 185 actors and actresses revealed their sexual and gender identities in 2021. Or "#OutInChurch," a hashtag under which 100 employees of the Catholic Church outed themselves as lesbian, gay, bi, trans+, intersex, and queer.

8 Compare the study conducted by the European Union Agency for Fundamental Rights in 2020, which covered the twenty-seven member countries of the EU as well as the United Kingdom, Serbia, and Macedonia, https://fra.europa.eu/de/news/2020/umfrage-unter-lgbti-personen-europa-dominiert-die-hoffnung-oder-die-angst (accessed August 22, 2022); the number of cases of politically motivated cases in Germany in 2021 indicate criminal acts against queer people (section sexual orientation/identity) have increased by more than 50 percent in comparison to the previous year, https://www.bka.de/SharedDocs/Downloads/DE/UnsereAufgaben/Deliktsbereiche/PMK/2021 PMKFallzahlen.pdf (accessed September 1, 2022); on this, see also the Lesben- und Schwulenverband in Deutschland, http://www.lsvd.de/de/ct/2445-Homophobe-Gewalt (accessed August 4, 2022).

9 Information on the current German context, see https://www.spiegel.de/kultur/geschlechter-identitaet-warum-die-transfeindliche-debatte-einfach-nicht-verstummt-a-83f1a47f-e800-46bf-b5ed-252afb213310; on the United States context, see https://xtramagazine.com/power/far-right-feminist-fascist-220810 (accessed August 18, 2022).

10 Historically, a number of cultures and cultural traditions around the world have incorporated a third gender. These include the *hijra* on the Indian subcontinent, the *two-spirits* among the First Peoples of North America, the *fa'afafine* in Samoa, and the *muxe* in Mexico. Descriptions of a third

7 So etwa das Manifest #ActOut, in dem 185 Schauspieler*innen 2021 ihre sexuelle und Geschlechts-identität offengelegt haben. Oder #OutInChurch, ein Hashtag, unter dem sich dieses Jahr 100 Mitarbeiten-de der Katholischen Kirche öffentlich als lesbisch, schwul, bi, trans*, inter* und queer outeten.

8 Vgl. die 2020 durchgeführte Studie der European Union Agency for Fundamental Rights, die 27 Mitgliedstaaten der EU sowie das Vereinigte Königreich, Serbien und Nordmazedonien umfasst, URL: https://fra.europa.eu/de/news/2020/umfrage-unter-lgbti-personen-europa-dominiert-die-hoffnung-oder-die-angst [gelesen am 28.6.2022]; Die bundesweiten Fallzahlen in Deutschland im Jahr 2021 zu politisch motivierter Kriminalität zeigen, dass die Straftaten gegen queere Menschen (Bereich Sexuelle Orientie-rung/Identität) um mehr als 50 Prozent gegenüber dem Vorjahr zugenommen haben. URL: https://www.bka.de/SharedDocs/Downloads/DE/UnsereAufgaben/Deliktsbereiche/PMK/2021PMKFallzahlen.pdf [gelesen am 1.9.2022], vgl. hierzu auch der Lesben- und Schwulenverband in Deutschland, URL: www.lsvd.de/de/ct/2445-Homophobe-Gewalt [gelesen am 4.8.2022].

9 Informationen zum aktuellen deutschen Kontext, siehe zum Beispiel URL: https://www.spiegel.de/kultur/geschlechter-identitaet-warum-die-transfeindliche-debatte-einfach-nicht-verstummt-a-83f1a47f-e800-46bf-b5ed-252afb213310, zum US-amerikanischen Kontext siehe zum Beispiel URL: https://xtramagazine.com/power/far-right-feminist-fascist-220810 [gelesen am 18.8.2022].

10 Globalhistorisch gibt es eine Vielzahl von Kulturen und kulturellen Überlieferungen, in denen ein drittes Geschlecht vorkommt. Dazu gehören die Hijra auf dem indischen Subkontinent, die Two-spirits bei den Native Americans, die Fa'afafine in Samoa, die Muxe in Mexiko. Auch in der griechischen und römischen Antike existieren Beschreibungen eines dritten Geschlechts, beispielsweise in Platons Symposion oder in Ovids Metamorphosen.

11 Zackary Drucker im Interview, 2015, siehe URL: https://www.refinery29.com/en-us/2015/12/99223/transgender-rights-transparent-tv-show [gelesen am 18.8.2022], übers. von Birgit Lamerz-Beckschäfer.

12 Vgl. Peggy Phelan, Unmarked: The Politics of Performance, London/New York 1993; Johanna Schaffner, (Un)formen der Sichtbarkeit, in: FKW // Zeitschrift für Geschlechterforschung und visuelle Kultur. Kunst, Sichtbarkeit, Queer Theory, 2008/45, S. 60–71; Reina Gossett, Eric A. Stanley und Johanna Burton (Hg.), Trap Door: Trans Cultural Production and the Politics of Visibility (Critical Anthologies in Art and Culture), Cambridge 2017.

13 Karl Heinrich Ulrichs alias Numa Numantius, Vindicta. Kampf für Freiheit von Verfolgung, Leipzig 1865, S. 25.

14 Angelica Ross im Interview, 2022, siehe URL: https://www.designscene.net/2022/06/angelica-ross-talks-equality-and-lgbtqia-visibility-for-dscene.html [gelesen am 18.8.2022], übers. von Birgit Lamerz-Beckschäfer.

15 José Esteban Muñoz, Cruising Utopia. The Then and There of Queer Futurity, New York 2009, S.1, übers. von Birgit Lamerz-Beckschäfer.

gender also appear in Greek and Roman antiquity, for example in Plato's *The Symposium* or Ovid's *Metamorphoses*.

11 Interview with Zackary Drucker, 2015; see https://www.refinery29.com/en-us/2015/12/99223/transgender-rights-transparent-tv-show (accessed August 18, 2022).

12 See Peggy Phelan, *Unmarked: The Politics of Performance* (London and New York: 1993); Johanna Schaffner, "(Un)formen der Sichtbarkeit," *FKW // Zeitschrift für Geschlechterforschung und visuelle Kultur. Kunst, Sichtbarkeit, Queer Theory* 45 (2008), pp. 60–71; Reina Gossett, Eric A. Stanley, and Johanna Burton, eds., *Trap Door: Trans Cultural Production and the Politics of Visibility*, Critical Anthologies in Art and Culture (Cambridge: 2017).

13 Karl Heinrich Ulrichs, alias Numa Numantius, *Vindicta. Kampf für Freiheit von Verfolgung* (Leipzig: 1865), 25.

14 Interview with Angelica Ross, 2022, siehe URL: https://www.designscene.net/2022/06/angelica-ross-talks-equality-and-lgbtqia-visibility-for-dscene.html (accessed on August 18, 2022).

15 José Esteban Muñoz, *Cruising Utopia: The Then and There of Queer Futurity* (New York: 2009), 1.

TO BE S

QUEER L

1900–19

EN.

IVES

50

SELBST-
ERMÄCHTI-
GUNG

SELF=
EMPOWER=
MENT

Im Deutschen Kaiserreich werden Politik, Wirtschaft und Gesellschaft von Männern bestimmt. Die über Jahrhunderte von Staat und Kirche festgeschriebene Geschlechterordnung ist strikt zweigeteilt: Männern und Frauen sind eindeutige Rollen zugewiesen, innerhalb derer sie sich zu bewegen haben. Menschen, die diesen Rollenbildern nicht entsprechen und geschlechtliche und sexuelle Identitäten jenseits der normierten Ordnung leben, werden ausgegrenzt. Sie gelten als sittenlos, verbrecherisch oder krank. Nach Paragraf 175 des Strafgesetzbuchs des Deutschen Reichs von 1871 sind sexuelle Handlungen zwischen Männern verboten und werden mit Gefängnis bestraft. In Österreich ist auch Sex zwischen Frauen strafbar.

Doch es gibt Einzelne, die gegen die herrschende Geschlechterordnung aufbegehren und für eine offenere Gesellschaft eintreten. Sie wenden sich gegen die Ächtung von Homosexualität und Transgeschlechtlichkeit, setzen sich für eine Änderung des Strafrechts ein und engagieren sich selbstbewusst für die Anerkennung ihrer Lebensweisen. Neue Allianzen und Selbstbilder entstehen. Viele dieser Vorreiter*innen zahlen einen hohen Preis für ihr Aufbegehren: Sie verlieren ihren Arbeitsplatz, ihre Familie oder Freundschaften und werden gesellschaftlich isoliert.

In the German Empire, politics, the economy, and society were dominated by men. The gender order, which was maintained over centuries by state and church, was strictly divided into two parts: men and women were assigned clear roles within which they must operate. People who did not conform to these role models and lived gender and sexual identities outside the normative order were ostracized. They were considered immoral, criminal, or ill. According to Paragraph 175 of the Imperial Criminal Code of 1871, sexual acts between men were forbidden and punishable by imprisonment. In Austria, sex between women was also punishable.

But there were individuals who rebelled against the prevailing gender order and fought for a more open society. They opposed the outlawing of homosexuality and transsexuality, advocated a change in criminal law, and assertively engaged in the recognition of their identities. New alliances and self-images emerged. Many of these pioneers paid a high price for their rebellion: they lost their jobs, their families, and their friendships, and were socially isolated.

„QUEERNESS EXISTIERT FÜR UNS ALS IDEAL, DAS WIR AUS DER VERGANGENHEIT GEWINNEN UND NUTZEN, UM DARAUS EINE ZUKUNFT ZU ERTRÄUMEN."

José Esteban Muñoz, 2009
Theaterwissenschaftler und Queer-Theoretiker

"QUEERNESS EXISTS FOR US AS AN IDEALITY THAT CAN BE DISTILLED FROM THE PAST AND USED TO IMAGINE A FUTURE."

José Esteban Muñoz, 2009
Theater Scholar and Queer Theorist

Karl Heinrich Ulrichs – ein Pionier der Homosexuellenemanzipation

Der Jurist Karl Heinrich Ulrichs (1825–1895) ist ein Vorkämpfer für die sexuelle Selbstbestimmung. In zahlreichen Schriften wendet er sich gegen die Kriminalisierung von Homosexualität. Seine Theorie des Urningthums deutet gleichgeschlechtliches Begehren als natürliches und somit auch gottgewolltes Phänomen. Für die erste, um 1900 entstehende Homosexuellenbewegung ist er ein wichtiger Impulsgeber.

Karl Heinrich Ulrichs – A Pioneer of Homosexual Emancipation

The jurist Karl Heinrich Ulrichs (1825–1895) was a champion of sexual self-determination. He opposed the criminalization of homosexuality in numerous writings. His theory of *Urningthum* (gayness) interpreted same-sex desire as a natural and thus also God-willed phenomenon. He was an important pioneer for the first homosexual rights movement that emerged around 1900.

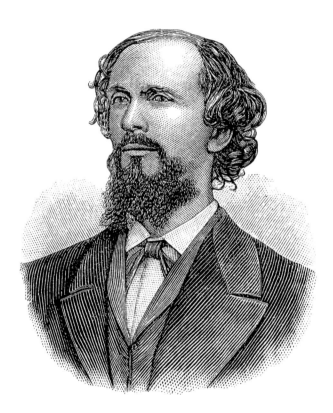

Karl Heinrich Ulrichs, Grafik nach einer verschollenen Porträtfotografie, abgedruckt in: *Jahrbuch für sexuelle Zwischenstufen*, 1899 | **Karl Heinrich Ulrichs**, drawing after a lost photograph, reproduced in *Jahrbuch für sexuelle Zwischenstufen*, 1899

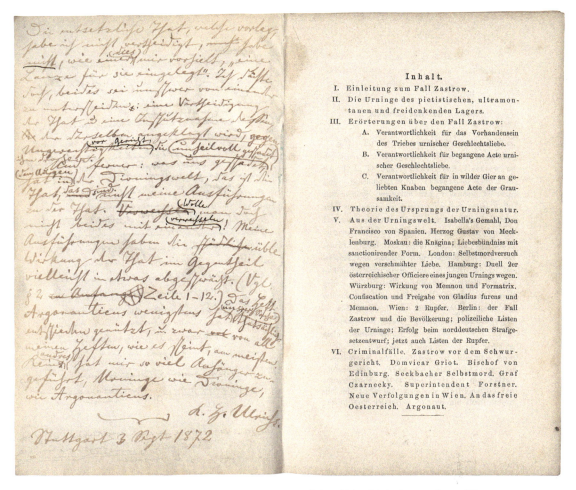

Karl Heinrich Ulrichs, *Forschungen über das Räthsel der mannmännlichen Liebe*, Bd. 9: *Argonauticus*, 1869, persönliches Exemplar von Karl Heinrich Ulrichs mit handschriftlichen Notizen des Autors | **Karl Heinrich Ulrichs,** *Research on the Riddle of Male–Male Love*, vol. 9: *Argonauticus*, 1869, personal copy of Karl Heinrich Ulrichs with handwritten notes by the author

Als „Urning" und „Urninde" bezeichnet Karl Heinrich Ulrichs gleichgeschlechtlich Liebende, noch bevor der Begriff der Homosexualität eingeführt ist. Abgeleitet von der griechischen Mythologie ist auch seine Wortschöpfung „Dioning", die für Heterosexuelle steht. 1870 bringt Ulrichs mit *Uranus* die weltweit erste Homosexuellenzeitschrift heraus. Mangels ausreichender Nachfrage wird sie nach der ersten Ausgabe eingestellt.

Urning (gay man) and *Urninde* (lesbian) is how Karl Heinrich Ulrichs called same-sex lovers, before the term homosexuality had been established. His neologism *Dioning*, likewise derived from ancient Greek mythology, referred to heterosexuals. In 1870 Ulrichs brought out *Uranus*, the first ever homosexual magazine. Due to a lack of demand, it closed down after one issue.

August Fleischmann – Aufklärung über die Freundlingsliebe in München

August Fleischmann (1859–1931) wird zum Kämpfer für die Rechte Homosexueller, nachdem er 1899 selbst wegen eines Verstoßes gegen Paragraf 175 zu einer Gefängnisstrafe verurteilt worden ist. Im Münchner Eigenverlag veröffentlicht und vertreibt er eine Reihe von populären Aufklärungsbroschüren über männliche Homosexualität und die damit verbundene Erpressungsgefahr. Auf der Suche nach einer positiven Selbstbezeichnung für homosexuelle Männer prägt er den Begriff „Freundling".

August Fleischmann – Account of the Love between *Freundlinge* in Munich

August Fleischmann (1859–1931) became an advocate for the rights of homosexuals after he was sentenced to prison in 1899 for violating Paragraph 175. From his own publishing company in Munich, he created and distributed a series of popular information brochures on male homosexuality and the associated danger of blackmail. In his search for a positive endonym for homosexual men, he coined the term *Freundling*.

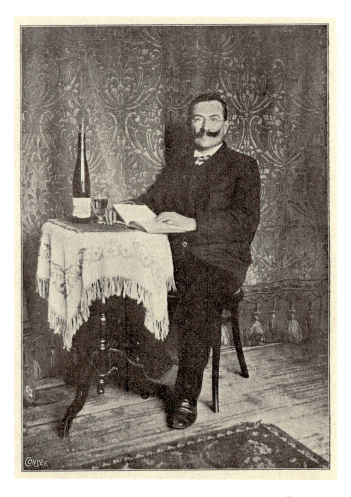

August Fleischmann, um 1902, aus: August Fleischmann, *Die Überbevölkerungsfrage und das Dritte Geschlecht*, München 1902 | **August Fleischmann**, ca. 1902, from August Fleischmann, *Overpopulation and the Third Sex*, Munich, 1902

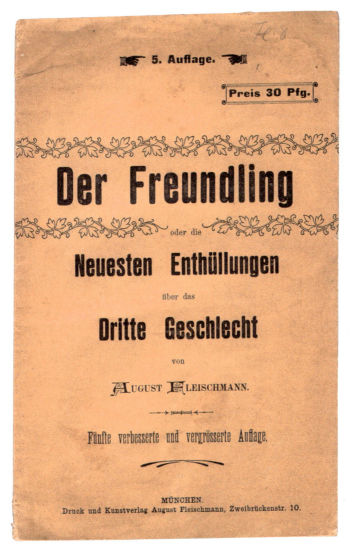

Der Freundling oder die Neuesten Enthüllungen über das Dritte Geschlecht, hg. von August Fleischmann, 1902 | *The Freundling or the Latest Revelations about the Third Sex*, ed. August Fleischmann, 1902

Fleischmanns Zeitschrift *Der Seelenforscher. Monats-Schrift für volksthümliche Seelenkunde* – später *Der Freundling* genannt – richtet sich an eine nichtakademische Leserschaft und ermöglicht homosexuellen Männern einen Austausch per Kontaktanzeige. Sie ist eine der ersten periodisch erscheinenden Homosexuellenzeitschriften. Mit einer Auflage von wenigen hundert Exemplaren ist ihre Reichweite allerdings eher gering. 1904 wird sie eingestellt.

Fleischmann's journal *Der Seelenforscher. Monats-Schrift für volksthümliche Seelenkunde* – later known as *Der Freundling* – was aimed at a non-academic readership and enabled homosexual men to exchange information via lonely hearts ads. It was one of the first homosexual magazines to appear regularly. With a print run of a few hundred copies, however, its impact was limited. It was discontinued in 1904.

SELF-EMPOWERMENT 35

Anita Augspurg – unangepasst leben, Frauen eine Stimme geben

Anita Augspurg – Living Unconventionally, Giving Women a Voice

Anita Augspurg (1857–1943) ist Frauenrechtlerin und die erste promovierte Juristin Deutschlands. Mit ihrer Lebensgefährtin Sophia Goudstikker eröffnet sie 1887 das Fotostudio Atelier Elvira in München, das zum Treffpunkt emanzipierter Frauen wird. Als Aktivistin kämpft sie für das Frauenstimmrecht, das 1918 eingeführt wird.

Anita Augspurg (1857–1943) was a women's rights activist and the first woman to earn a doctorate in jurisprudence in Germany. With her partner Sophia Goudstikker she opened the photo studio Atelier Elvira in Munich, which became a meeting point for emancipated women. As an activist she fought for women's suffrage, which was introduced in 1918.

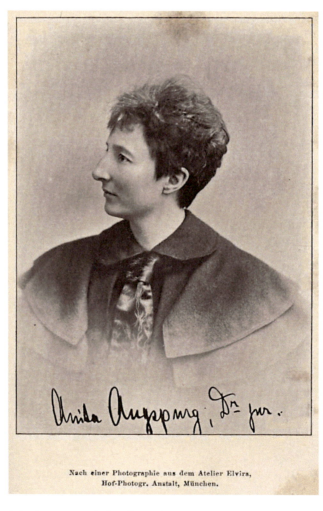

Anita Augspurg, nach einer Fotografie aus dem Atelier Elvira, München, aus: *Jahrbuch für die deutsche Frauenwelt*, 1899 | Anita Augspurg, from a photograph by the Atelier Elvira, Munich, from *Yearbook of German Womankind*, 1899

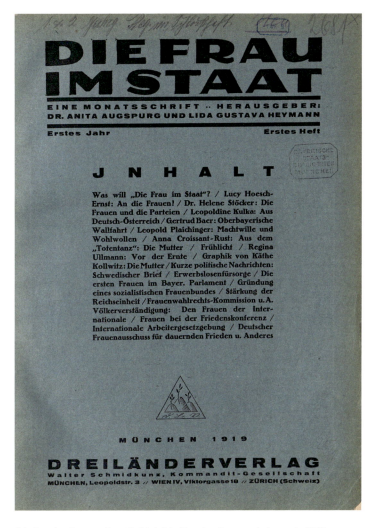

Die Frau im Staat, 1. Jg., 1919/1 | *Die Frau im Staat*, vol. 1, no. 1, 1919

Nach der Revolution von 1918 gehört Anita Augspurg dem Provisorischen Nationalrat in Bayern an und kandidiert – vergeblich – für den Bayerischen Landtag. Gemeinsam mit ihrer langjährigen Lebensgefährtin Lida Gustava Heymann setzt sie sich für eine aktive Mitwirkung von Frauen in Politik und Gesellschaft ein. 1919 gründen sie die Monatsschrift *Die Frau im Staat*, in der sie für frauenpolitische Belange, dauerhaften Frieden und Völkerverständigung eintreten.

After the revolution of 1918 Anita Augspurg was a member of the Provisional National Council in Bavaria and ran – unsuccessfully – for the Bavarian parliament. Together with her longtime companion Lida Gustava Heymann, she advocated the active participation of women in politics and society. In 1919, they founded the monthly paper *Die Frau im Staat* (The Woman in the State), in which they promoted women's political concerns, lasting peace, and international understanding.

SELF-EMPOWERMENT 37

Claire Waldoff – „Berliner Schnauze" aus Gelsenkirchen

Claire Waldoff – "Berlin Slang" from Gelsenkirchen

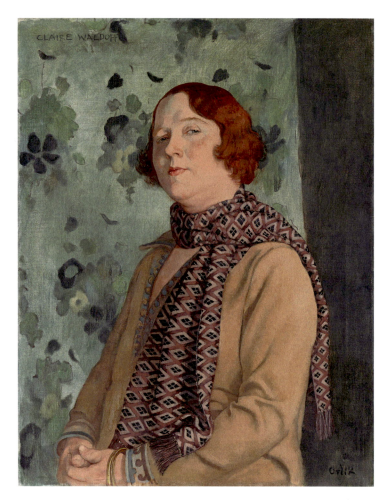

Emil Orlik, *Porträt von Claire Waldoff*, Öl auf Leinwand, 1930 | Emil Orlik, *Portrait of Claire Waldoff*, oil on canvas, 1930

Die Chansonnière und Kabarettistin Claire Waldoff (1884–1957), geboren als Clara Wortmann in Gelsenkirchen, ist eine zentrale Persönlichkeit der Berliner Kulturszene der 1920er Jahre. Ihre Lieder sind deutschlandweit bekannt. Sie lebt offen mit ihrer Partnerin Olga (Olly) von Roeder zusammen und prägt die lesbische Szene der Stadt. In dem für sie geschriebenen Schlager *Hannelore* besingt sie eine neue weibliche Freiheit jenseits gesellschaftlicher Konventionen. In seinem Porträt gelingt es Emil Orlik, Waldoffs selbstbewussten, frechen Blick einzufangen, der ihre Lebenseinstellung und Arbeit charakterisiert. Der Maler, der Mitglied der Wiener und Berliner Secession ist, ist bekannt für seine Porträts und zählt zu den einflussreichsten Grafikern des frühen 20. Jahrhunderts.

The chanteuse and cabaret artist Claire Waldoff (1884–1957), born Clara Wortmann in Gelsenkirchen, was a central figure in the Berlin cultural scene of the 1920s. Her songs were known throughout Germany. She lived openly with her partner Olga (Olly) von Roeder and left her mark on the city's lesbian scene. In the song "Hannelore," written for her, she sang about a new female freedom beyond social conventions. In his portrait Emil Orlik succeeds in capturing Waldoff's self-confidant, brash gaze, which characterized her attitude to life and her work. The painter, a member of the Vienna Secession and Berlin Secession, is known for his portraits and is regarded as one of the most influential graphic artists of the early twentieth century.

„Hannelore trägt ein Smokingkleid
Und einen Bindeschlips
Trägt ein Monokel jederzeit
Am Band von Seidenrips
Sie boxt, sie foxt, sie golft, sie steppt
Und unter uns gesagt: Sie neppt!
Besonders so im Mai
Es hat mir einer anvertraut
Sie hat'n Bräutjam und 'ne Braut –
Doch dies bloß nebenbei."

Strophe aus dem Claire Waldoff-Schlager *Hannelore* von 1928
Text: Willy Hagen
Musik: Horst Platen

Claire Waldoff (links) und Olga (Olly) von Roeder in ihrem Haus, Bayerisch Gmain um 1950 | **Claire Waldoff (left) and Olga (Olly) von Roeder in their house, Bayerisch Gmain, ca. 1950**

"Hannelore wears a tuxedo
And a tie
Wears a monocle at all times
On a silk ribbon
She boxes, she foxtrots, she golfs,
she tap dances
And between you and me, she teases!
Especially in May
Someone told me
She's got a groom and a bride –
But that's just by the way."

Verse from the Claire Waldoff song "Hannelore" from 1928
Text: Willy Hagen
Music: Horst Platen

SELF-EMPOWERMENT 39

Claire Waldoff, *Mein letzter Wille*, Bayerisch Gmain 25.1.1945 | Claire Waldoff, "My Last Will and Testament," Bayerisch Gmain, January 25, 1945

Mein letzter Wille.

Hierdurch setze ich zur alleinigen Erbin ein meine Freundin Frau Claire Wortmann gen. Claire Waldoff Bayr. Gmain (Ob. Bayern) Weissbach Hausl 85. und schliesse alle gesetzlichen Erben aus.

Sollte die Erbin vor mir gestorben sein oder mit mir sterben, so setze ich als alleinige Erbin Frau Gertrud von Weyrauth geb. von Roeder, in Hohenwiesen bei Lenggries. Haus Weyrauth, ein.

Bayr-Gmain am 25. Jan 1945

Freiin Olga von Roeder —

Olga (Olly) von Roeder, *Mein letzter Wille*, Bayerisch Gmain 25.1.1945 | Olga (Olly) von Roeder, "My Last Will and Testament," Bayerisch Gmain, January 25, 1945

Gerda von Zobeltitz – die eigene Identität leben gegen alle Widerstände

Gerda von Zobeltitz (1891–1963) wird bei Geburt das männliche Geschlecht zugewiesen, fühlt sich aber schon früh als Frau. Aufgrund eines medizinischen Gutachtens des Sexualforschers Magnus Hirschfeld erhält sie 1913 als eine der ersten trans* Personen überhaupt einen behördlichen Ausweis, der ihre Identität als Frau verbrieft. Dieser sogenannte Transvestitenschein bewahrt sie vor der Verhaftung wegen „Erregung öffentlichen Ärgernisses", wenn sie sich öffentlich als Frau zeigt. In den 1920er Jahren tritt sie als Tänzerin in Berliner Szenelokalen auf. Daneben verdient sie ihren Lebensunterhalt als Damenschneiderin.

Gerda von Zobeltitz – Living Out Your Identity against All Opposition

Gerda von Zobeltitz (1891–1963) was assigned the male sex at birth, although she felt very early she was a woman. In 1913, on the basis of a medical report by the sexologist Magnus Hirschfeld, she received an identity card certifying her identity as a woman, making her one of the first trans+ people ever to have their actual gender officially recognized. This so-called "Transvestite Certificate" saved her from arrest for "causing a public nuisance" when she publicly appeared as a woman. In the 1920s she performed as a dancer in Berlin bars. She also earned her living as a dressmaker.

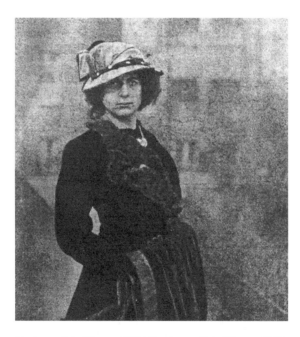

Gerda von Zobeltitz, um 1913 | Gerda von Zobeltitz, ca. 1913

Am 5. Juli 1930 macht eine Gruppe des queeren Verbands „Bund für Menschenrecht", unter ihnen auch Gerda von Zobeltitz, einen Schiffsausflug auf dem Zeuthener See im Süden Berlins. Sie kehrt in Rauchfangswerder ein – im selben Lokal wie eine Berliner Polizeieinheit mit ihren Frauen. Die alkoholisierten Polizeibeamten beleidigen die Neuankömmlinge und versuchen sie zu vertreiben. Statt zu fliehen, leisten diese Widerstand und kämpfen selbstbewusst für ihre Rechte – es kommt zu einer Massenschlägerei.

On July 5, 1930, members of the queer association Bund für Menschenrecht (Alliance for Human Rights), including Gerda von Zobeltitz, went on a boat trip on the Zeuthener See in southern Berlin. In the Rauchfangswerder neighborhood, they entered a pub where a Berlin police unit was sitting with their wives. The inebriated police officers insulted the newcomers and tried to drive them away. Instead of fleeing, they resisted and fought confidently for their rights. A major brawl ensued.

„Du Dussel – siehste denn nicht, dass ich heute Gerda bin?"

Kolportierte Aussage von Gerda von Zobeltitz, nach 1945

"You numbskull – don't you see that today I'm Gerda?"

Attributed to Gerda von Zobeltitz, after 1945

Einladung zur Dampferfahrt (oben), *Die Freundin*, 6. Jg, 1930/26 | Invitation to the steamboat trip (top), *Die Freundin*, vol. 6, no. 26, 1930

SELF-EMPOWERMENT 43

PHILIPP GUFLER

Philipp Gufler (*1989, Deutschland) erforscht Fragen queerer Bildwelten und stellt die westliche Geschichtsschreibung infrage, in der Heterosexualität und ein binäres Geschlechtersystem die soziale Norm darstellen. In seiner künstlerischen Praxis verwendet er verschiedene Medien, darunter Siebdruck auf Stoffe oder Spiegel, Künstlerbücher, Performances und Videoinstallationen, zudem ist er Mitglied im selbstorganisierten Forum Queeres Archiv München.

In seinen Quilts, einer fortlaufenden Serie von Siebdrucken, nimmt Gufler Bezug auf queere Künstler*innen, Wissenschaftler*innen und Orte queeren Lebens, die in schriftlich festgehaltenen Erinnerungen und im Geschichtskanon nicht oder kaum Platz finden. Die Serie wird damit zu einem alternativen Archiv, das über die Technik des *quiltings* eine Form der generationsübergreifenden Erinnerung schafft. In dieser Technik werden die hinterlassenen Textilien verstorbener Menschen neu zusammengefügt und kontextualisiert. Die feine Materialität der Stoffe steht dabei in direktem Gegensatz zu den oft schweren, steinernen Monumenten westlicher Geschichtsschreibung. Indem auch Philipp Gufler verschiedene historische Relikte neu kombiniert, entsteht eine Vielfalt an persönlichen und familiären Erinnerungsformen unterschiedlicher Herkunft. Die Auswahl der Stoffe in den Arbeiten ist dabei ebenso wichtig wie die Wahl der Motive und die damit verbundenen Geschichten, die erzählt werden.

Philipp Gufler (b. 1989, Germany) explores matters of queer imagery, questioning the Western historiography, in which heterosexuality and a binary gender system define the social norm. In his artistic practice he uses various media, including screen-printing on fabrics or mirrors, artist books, performances, and video installations. He is also a member of the self-organized Forum Queeres Archiv München.

In his quilts, an ongoing series of silkscreen prints, Gufler references queer artists, scholars, and places of queer life that have found little or no place in written accounts and the historical canon. The series thus becomes an alternative archive that generates a form of intergenerational memory through the technique of quilting, in which the textiles left behind by deceased people are reassembled, resituating them in a new context. The fine materiality of the fabrics stands in direct contrast to the often massive, solid stone monuments of Western historiography. By reusing a variety of historical relics, he creates diverse personal and ancestral forms of memory of different origins. The choice of materials in the works is just as important as the choice of motifs and the associated stories that are told.

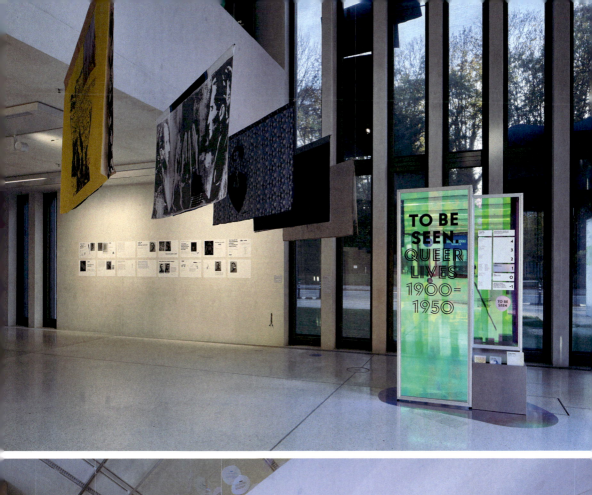
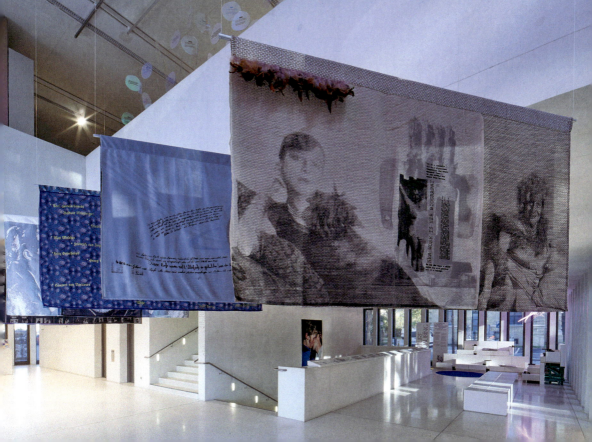

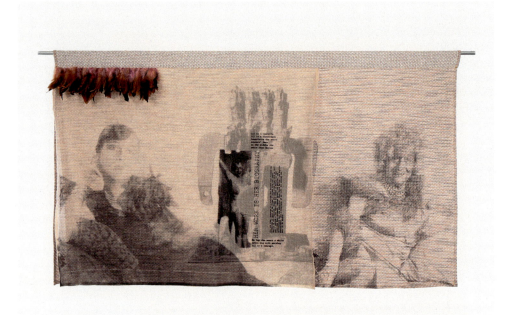

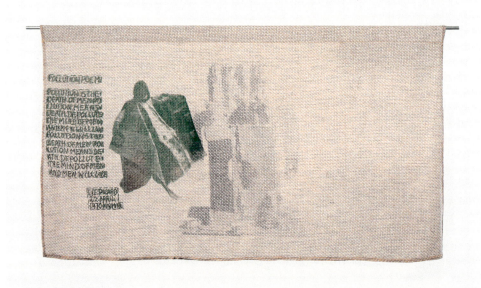

Quilt #50 (Lil Picard), 2022
Siebdruck auf Stoff, Federn | Silkscreen on fabric, feathers
Courtesy the artist and Galerie BQ

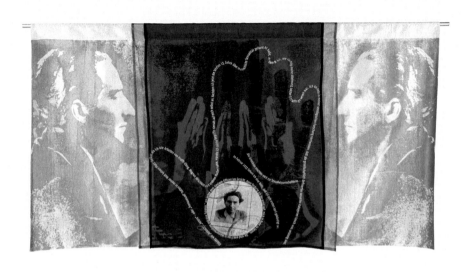

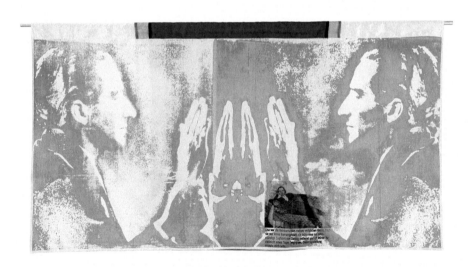

Quilt #47 (Charlotte Wolff), 2022
Siebdruck auf Stoff | Silkscreen on fabric
Courtesy the artist and Galerie Françoise Heitsch

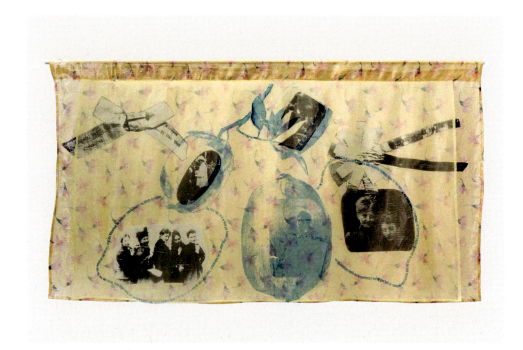

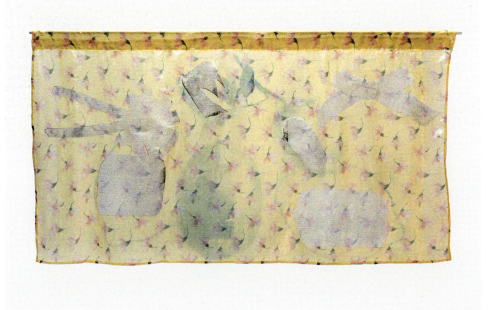

Quilt #43 (Sophia Goudstikker), 2021
Siebdruck auf Stoff | Silkscreen on fabric
Courtesy the artist and Galerie Françoise Heitsch

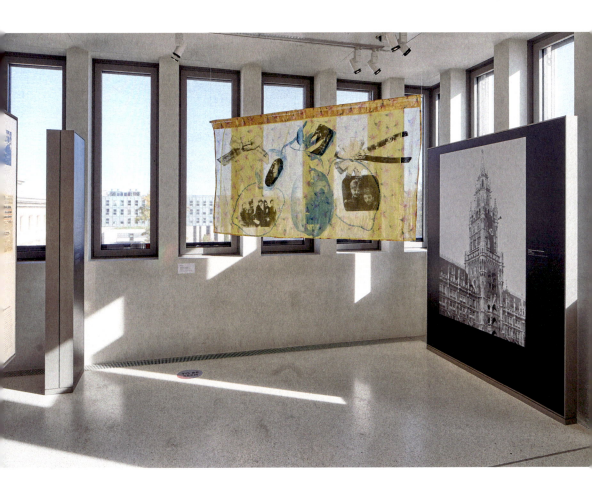

MAXIMILIANE BAUMGARTNER

Maximiliane Baumgartner (*1986, Deutschland) verschränkt in ihrer Arbeit künstlerische und pädagogische Konzepte. Sie interessiert sich für den Einsatz von Malerei als erweitertes soziales Handlungsfeld. Im Sinne einer modularen Malerei, die frei an Räume und Architekturen andocken kann, zeigt sie ihre Arbeiten nicht nur im Ausstellungsraum, sondern auch an Fassaden oder in kunstpädagogischen Zusammenhängen.

Die Arbeit *You look at us – we look at you* an der Fassade des NS-Dokumentationszentrums verweist auf die Frauenrechtsaktivistinnen und Lebensgefährtinnen Anita Augspurg (1857–1943) und Lida Gustava Heymann (1868–1943). Durch widerständige Handlungen auf juristischer Ebene prangerten sie die gesellschaftlichen und sozialen Einschränkungen von Frauen an und traten für deren Rechte ein. Als aktive Antifaschistinnen kämpften sie bereits in den 1920er Jahren gegen den in der Gesellschaft und Politik aufstrebenden Nationalsozialismus, 1923 forderten sie die Ausweisung Hitlers.

Augspurg ist in der Malerei von Baumgartner auf einer Leiter positioniert, eine erhöhte Position, die sie sich eigenständig erarbeitet hat. Baumgartner verweist in ihrer Arbeit damit auf Fragen von Solidarität und Handlungsspielräumen, um Ausgrenzungserfahrungen aufgrund von Gender, Sexualität oder auch Armut zu thematisieren. Indem die Malereien auf das Wirken von Frauenrechtlerinnen im öffentlichen Raum aufmerksam machen, setzt die Künstlerin diesen gleichsam ein Denkmal in der städtischen Erinnerung.

Maximiliane Baumgartner (b. 1986, Germany) interweaves artistic and pedagogical concepts in her work. She is interested in the use of painting as an expanded social field of action. Baumgartner shows her work not only in exhibition spaces, but also on façades or in art educational contexts, as a modular painting that can freely occupy spaces and architectures.

The work *You look at us – we look at you* on the façade of the Munich Documentation Center for the History of National Socialism refers to the women's rights activists and life partners Anita Augspurg (1857–1943) and Lida Gustava Heymann (1868–1943). They denounced the social and societal restrictions on women and fought for their rights through legal action. As active anti-fascists, they were opposed to the National Socialism emerging in society and politics as early as the 1920s; in 1923 they demanded Hitler's expulsion.

Augspurg is placed on a ladder in Baumgartner's painting, an elevated position that she has achieved on her own. In her work, Baumgartner alludes to questions of solidarity and scope of action in order to address experiences of exclusion based on gender, sexuality, or even poverty. By using a public space to draw attention to the work of women's rights activists, the artist creates a monument to them in the city's memory.

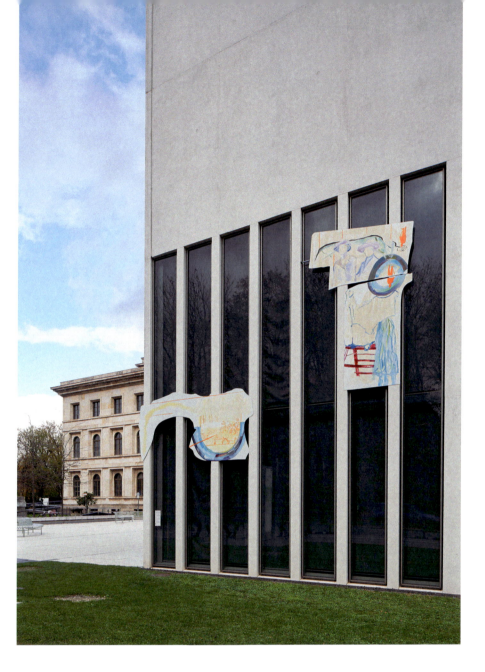

Façade
You look at us – we look at you: Rubbing against the architecture of the executive gaze
(based on a paper by Anita Augspurg, *Mißgriffe der Polizei | Abuses by the Police*, 1902), 2021
Lack auf Alu Dibond, zweiteilig | Paint on aluminum Dibond, two parts

You look at us – we look at you: On spaces you opened (based on a reportage drawing of the International Congress of Women, Berlin 1896), 2021
Lack auf Alu Dibond | Paint on aluminum Dibond

Courtesy the artist and Galerie Max Mayer

*Lückentexte und Geistergitter. Die Presse über Sophia Goudstikker, Vorsitzende der Rechtsschutzstelle für Frauen und die erste, autodidaktische, bei den Münchner Gerichten zugelassene Verteidigerin, und ihre Lebensgefährtin Ika Freudenberg, langjährige Vorsitzende des Vereins für Fraueninteressen, die sich intensiv für die Rechte von Arbeiter*innen einsetzte* | *Gap Texts and Ghost Grids: The Press on Sophia Goudstikker, Chairwoman of the Legal Defense Office for Women and the First Self-Taught Defense Lawyer Admitted to the Munich Courts, and Her Partner Ika Freudenberg, Longtime Chairwoman of the Association for Women's Interests, Who Campaigned Intensively for the Rights of Workers*, 2022
Lack auf Alu Dibond, zweiteilig | Paint on aluminum Dibond, two parts

Auf Fassaden schauen oder Die vierte Wand der dritten Pädagogin III | *Looking at the Façade or The Fourth Wall of the Third Female Pedagogue III*, 2021
Lack auf Holz (Displaystruktur aus Holz) | Paint on wood (wooden display structure)

o.T., *aus dem Fußnotenapparat (Banner)* | *Untitled, from the Footnotes* (Banner), 2022
Digitaldruck auf Papier, Grafik: Ibrahim Oeztas | Digital print on paper, graphic design: Ibrahim Oeztas
Courtesy the artist and Galerie Max Mayer

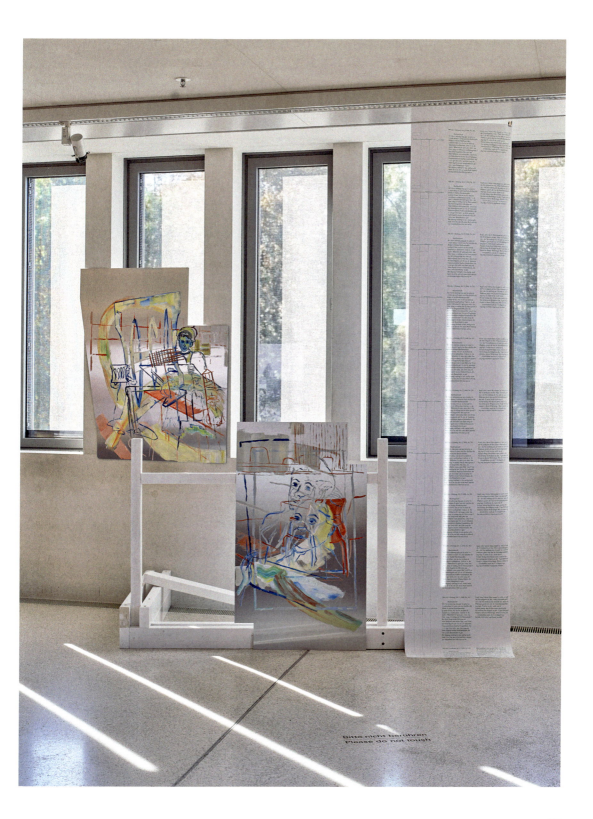

Neben den Malereien spielen die von der Decke hängenden Papierbanner eine wichtige Rolle. Im Sinne einer künstlerischen Praxis dienen sie der Aktivierung der Arbeit, ähnlich einem bewusst geführten zwischenmenschlichen Gespräch, das die Bilder entsprechend kontextualisiert. Basierend auf den künstlerischen Recherchen Baumgartners zur Rechtsschutzstelle Sophia Goudstikkers und Anita Augspurgs in München, die sie als Teil ihres gemeinsam geführten Hof-Ateliers Elvira betrieben, bezieht sich der Text auf den Aufsatz „Die Fotografie als Lebensberuf für Frauen". Hier spricht Anita Augspurg bereits 1889 von „künstlerischen Forschern" sowie der Bedeutung und den Zusammenhängen von Spekulation, Forschung und Experiment. Im Sinne einer Anleitung zur Selbstermächtigung für Fotografinnen, verweist Augspurg auf ein aktives strategisches Handeln, das Frauen Unabhängigkeit ermöglicht und gleichzeitig einen künstlerischen Ansatz erlaubt, ohne jemals eine Verleugnung von queerfeministischer Lebensweise darzustellen und dient damit als noch heute gültiges und zeitgenössisches Vorbild, das aktuell verhandelte Diskurse innerhalb der Kunst und Wissenschaft frühzeitig vorwegnimmt.

In addition to the paintings, the paper banners hanging from the ceiling play an important role. In the sense of an artistic practice, they serve to activate the work, similar to a consciously conducted interpersonal conversation that contextualizes the images. Based on Baumgartner's artistic research on Sophia Goudstikker's and Anita Augspurg's legal protection agency in Munich, which they operated as part of their jointly run Hof-Atelier Elvira, the text refers to the essay "Die Fotografie als Lebensberuf für Frauen" (Photography as a Life Profession for Women). Here, as early as 1889, Anita Augspurg speaks of "artistic researchers" and the importance and interrelationships of speculation, research, and experimentation. In the sense of a guide to self-empowerment for women photographers, Augspurg refers to an active strategic action that allows women to be independent and at the same time permits an artistic approach without ever compromising a queer-feminist way of life, and thus serves as a model that is still valid today, anticipating current discourses in the arts and sciences.

Mü chn r Zeitung, 04.12.1908, Nr. 283

,', Rechtsanwalt'
M t Verw nderung mag gar m ncher in v rschi denen il ustrie ten Zeit chriften die Bilder w blicher Rechtsanwälte g sehen h ben, wie sie im Au land da manchero ts auftauchen. Und nu is da auch i München Er ignis gew rden. Am Don rstag vo mittag trat im Sitzu gssaal 5 des Schö fengerichts Mü chen am Mari hilfplatz zum ersten Mal eine D me als Verteidigerin auf. Es wa di bekannte Frauenrechtlerin Sophia Goudstikker, die v r ei iger Zeit scho um Zula sung als Verte digerin zweier Arbeiterfrauen, die von e nem Bauarbeiter w gen Bel idigung verklagt w ren, nachg sucht hatte. In ei fac em sch arzen Refo mkleid, ein barettähnliches Hüt hen auf de

Kopf, eine l derne A
die Ve teidigerin an
sie i die Ver andlur
Plädoyer, gesch ckt
ang legt. E zielte si
Freispr chung ihrer
Ver rteilung des Klä
Grund er obener Wi
. Goudstikker auc
Jug ndg nrichtshof z

55

ZACKARY DRUCKER & MARVAL REX

Zackary Druckers (*1983, USA) künstlerische Praxis bewegt sich zwischen den Themenfeldern Gender, Sexualität und Sichtbarkeit. Als Produzentin und Regisseurin *(Transparent, The Lady and the Dale)* setzt sie sich mit der Geschichte von trans* Personen und deren Kampf gegen Unterdrückung auseinander.

Zackary Druckers Collagen im Assemblage-Stil sind auf halbtransparente Flaggen gedruckt. Die trans* Künstlerin arbeitet hier kollektiv mit ihrem Partner Marval Rex (*1992, USA) zusammen und kombiniert in ihrer Arbeit Bilder der Weimarer Republik, Abbildungen von trans* Personen aus Zeitschriften und Material aus dem Archiv ihrer jüdischen Familie, die zu Beginn des 20. Jahrhunderts aus Europa nach New York emigrierte. Die Arbeiten verweisen auf die nicht sichtbaren Netzwerke von trans* Geschichten, die sich über Zeiten, Generationen und topografische Grenzen hinweg spannen. Die Verbindung der eigenen Familiengeschichte mit Symbolen und Elementen der trans* Historie, die sich in den halbtransparenten Fahnen vielfach überlagern, erzeugt eine unerschöpfliche Kombinationsmöglichkeit an Bildzusammenhängen und damit einen neuen Blick auf Diversität und Vielfalt.

Zackary Drucker's (b. 1983, USA) artistic practice navigates between the thematic fields of gender, sexuality, and visibility. As producer and director (*Transparent, The Lady and the Dale*), she explores the history of trans+ people and their struggle against oppression.

Zackary Drucker's assemblage-style collages are printed on semi-transparent flags. The trans+ artist works here in collaboration with her partner Marval Rex (b. 1992, USA), combining images of the Weimar Republic, images of trans+ people from magazines, and material from the archives of her Jewish family, who emigrated from Europe to New York in the early twentieth century. The works reference the invisible network of trans+ histories that span time, generations, and topographical boundaries. The connection of personal family history with symbols and elements of trans+ history, which often overlap in the semi-transparent flags, generate the possibility of inexhaustible combinations of pictorial contexts and thus a new perspective on diversity and variety.

A Study in Disappearing (M-OM), 2022

A Study in Disappearing (XX, A Woman?), 2022

A Study in Disappearing (Fear, Strike, Kill, Rhythm), 2022

A Study in Disappearing (Safe Sex Forever), 2022

A Study in Disappearing (Totally Willing, Totally Giving), 2022

A Study in Disappearing (Keep the Thought Forever), 2022

Digitaldruck auf Seidenorganza | Digital print on silk organza
Courtesy Zackary Drucker & Marval Rex

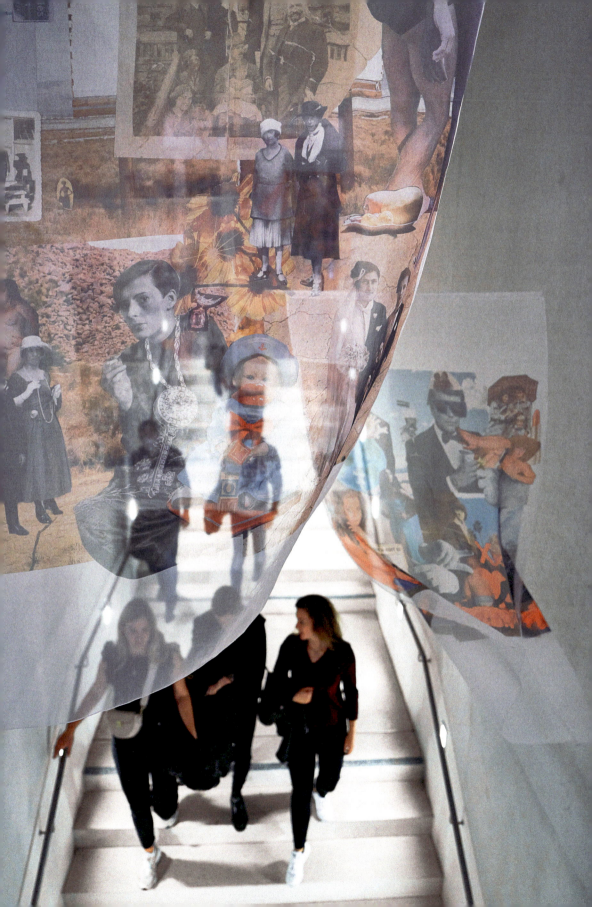

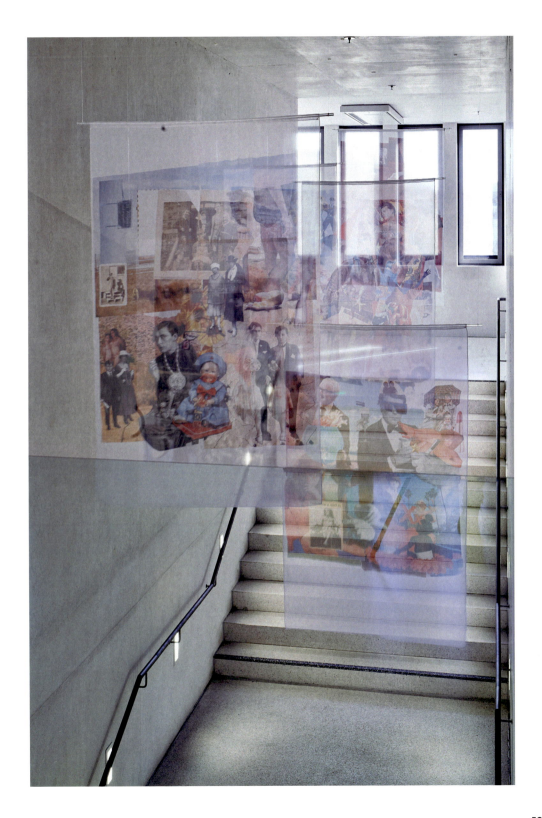

MICHAELA DUDLEY

WEIMAR 2.0: REFLEXIONEN ZWISCHEN REGENBOGEN UND „ROSA WINKEL"

„Die Entmenschlichung fängt mit dem Wort an, die Emanzipierung aber auch",[1] so ermahne ich seit Jahren – in Interviews, in Kabarettstücken, in Kolumnen, in Vorträgen, in Workshops. Der geflügelte Spruch, der meiner Feder entstammt, ruft dabei Bilder eines phönixartigen Aufstieges ins Gedächtnis. Eines Aufstieges aus der Asche, wohl bemerkt. Gewagt, aber gewollt. Mit dem Leitsatz bin ich also darauf bedacht, nicht lediglich eine Lamentation zu artikulieren, sondern auch gleichsam zur Liberation aufzurufen. Das Zitat fungiert als Maxime meines neuen Essaybands zum Thema Rassismus,[2] es eignet sich jedoch ebenfalls als Appell gegen andere Formen der Ausgrenzung und Vernichtung. Dazu zählt eindeutig die systematische, jahrhundertelange Verfolgung der LGBTIQ*-Community.

TO BE SEEN. queer lives 1900–1950 widmet sich dieser Thematik mit dem Fokus auf der facettenreichen und folgenschweren deutschen Verstrickung. Die Ausstellung des NS-Dokumentationszentrums München sprengt dabei den Rahmen, und zwar mit einer diversen Auswahl an Kunstwerken und Exponaten, die Licht ins Dunkel einer entsetzlich finsteren Geschichte bringen. Um die Sichtbarkeit geht es. Die Protagonist*innen von damals, aufgrund ihrer sexuellen Selbstbestimmung erbarmungslos verfolgt, erhalten damit nun die Anerkennung, die sie verdienen.

Die Ausstellung begleitet sie auf ihrem Leidensweg, in ihrer Leidenschaft. Sie waren Opfer, aber auch Tatkräftige, und sie werden als Menschen porträtiert. In Anbetracht dessen ehrt und rührt es mich, in dem vorliegenden Katalog nebst den Werken anderer Künstler*innen und Kommentator*innen mit einem Beitrag erscheinen zu dürfen.

Meine Bilder male ich zwar mit Worten, aber meine Botschaft entsteht trotzdem, und gerade deswegen, auf einem grundierten Hintergrund. Maler*innen grundieren für gewöhnlich ihre Leinwand von der Mitte nach außen hin, um die Spannung im Gewebe möglichst gleichmäßig zu verteilen. Von der richtungsweisenden Technik möchte ich ebenfalls Gebrauch machen. Ich beginne vielmehr inmitten der Geschichte und teile nach allen Seiten aus, um die Spannung in meinem eigenen Gewebe zum Ausdruck zu bringen.

Es ergibt sich die Frage, ob dieser Anlass der richtige dafür sei, mit nicht einmal dünn verschleierten Ich-Botschaften aufzuwarten. Die Frage stelle ich mir selbst, während ich in den Spiegel blicke. Geht es nicht eher um andere? Mein schielendes Selbstporträt antwortet, es geht um uns. Um uns alle. Und das stimmt eigentlich auch. Die Menschen, die diese Ausstellung ehrt, konnten über ihr oft fatales Verhängnis kaum ausführlich reden. Dementsprechend haben wir

MICHAELA DUDLEY

WEIMAR 2.0: REFLECTIONS BETWEEN THE RAINBOW AND THE "PINK TRIANGLE"

"Dehumanization begins with a word, but so does emancipation"[1] – I have exhorted people with these words for years now, in interviews, cabaret performances, newspaper columns, lectures, and workshops. The oft-cited slogan from my pen evokes images of a phoenix-like arising. An arising from the ashes, to be sure. Daring, but intentional. For me, this motto is not merely the intoning of a lamentation, but also, as it were, a call for liberation. The quote functions as a maxim for my new volume of essays on racism,[2] but it is also suitable as an appeal against other forms of exclusion and elimination. These clearly include the systematic, centuries-long persecution of the LGBTIQ+ community.

TO BE SEEN. queer lives 1900–1950 is dedicated to this topic, with a focus on the multifaceted and fateful German involvement. The exhibition at the Munich Documentation Center for the History of National Socialism dissolves boundaries with a diverse selection of artworks and exhibits that shed light on a horrifyingly dark history. Visibility is what this is all about. The individuals from that period, mercilessly persecuted for their sexual self-determination, now receive the recognition they deserve. The exhibition accompanies them on their path of suffering, their Passion. They were

victims, but also energetic people, and they are portrayed as human beings. In view of this, I am honored and moved to be able to contribute to this catalog with an essay alongside works by other artists and observers.

Although I paint my pictures with words, my message is nevertheless – and precisely because of this – created on a primed background. Painters usually prime their canvas from the center outward, in order to distribute the tension in the fabric as evenly as possible. I would also like to make use of this directional technique. I will start in the middle of the story, spreading out in all directions, to articulate the tension in my own canvas.

Is this the right occasion to come up with not even thinly veiled "I"-statements? I ask myself this question while looking in the mirror. Isn't this publication about others? My squinting self-portrait answers: it's about us. About all of us. And that is true. The people this exhibition honors could hardly speak at length about their often fatal destiny. Accordingly, we have a moral obligation to record their fates by picking up the fragments of their lives and carefully piecing them together. At the same time, it is our duty to build bridges to those predecessors – indeed, pioneers – by thoughtfully scrutinizing our own lives. Do we

SELF-EMPOWERMENT 61

die moralische Verpflichtung, ihre Schicksale zu protokollieren, indem wir die Mosaiksteine ihrer Leben auflesen und sorgfältig zusammenfügen. Gleichwohl obliegt es uns, Brücken zu jenen Vorgänger*innen, ja Vorreiter*innen zu bauen, indem wir das eigene Leben reflektiert unter die Lupe nehmen. Stehen wir auf ihren Schultern? Oder stehen wir der Sache und somit uns selbst im Wege? Wie nützen wir diese gottverdammte „Gnade der späten Geburt"? Wofür setzen wir uns ein? Und ja, die Gretchenfrage schlechthin: Gelingt es uns, in ihnen uns selbst zu erkennen? Hoffentlich.

Das dafür geeignete Mittel ist meines Erachtens das Storytelling, nämlich die sinnstiftende Erzählung aus dem eigenen Leben, um eine nicht zuletzt generationenübergreifende Gemeinschaft zu bilden und aufrechtzuerhalten. Dabei geht es wohl um Empathie und nicht zuletzt um Empowerment. Also Selbstbemächtigung statt Selbstbemitleidung. Für mich ist das Sujet Diskriminierung alles andere als eine Abstraktion. Diskriminierung erfahre ich mehrfach, nämlich intersektional.[3] Denn ich bin eine Berlinerin mit afroamerikanischen Wurzeln, eine trans* Frau und eine Feministin. Ich komme wortwörtlich „vom anderen Ufer", und zwar in etlicher Hinsicht. Das Licht der Welt erblickte ich 1961 im Schatten der Freiheitsstatue. In kurzer Abfolge erlebte ich, wie die Kennedy-Brüder, Malcolm X und Martin Luther King ermordet wurden. Die Jim-Crow-Segregation erfuhr ich mit fünf Jahren in den Südstaaten. Im vermeintlich offeneren Norden der USA war es aber auch nicht ganz ohne. Gelegentlich spielte ich mit Kindern, deren Eltern Auschwitz-Birkenau und Dachau knapp überlebt hatten. Natürlich waren sie weiß, und gerade deshalb konnte ich nicht verstehen, warum andere Weiße sie böse beleidigten, auf sie einschlugen und noch dazu die Außenwände ihrer

Häuser mit diesem komischen Sonnenrad besprühten. Mein Vater, ein deutschsprechender Kampfveteran der Air Force, der im Zweiten Weltkrieg gekämpft hatte, klärte mich auf: „Leider sind wir Schwarzen nicht die einzigen Menschen, die gehasst werden."

Eine weitere Aufklärung stand mir bevor. Im Sommer 1969, wenige Wochen vor der Mondlandung und Woodstock, brodelte es in der New Yorker Christopher Street. Ebenda wurde die queere Kneipe Stonewall Inn zum Dreh- und Angelpunkt einer Razzia korrupter Polizisten. Eine Schwarze trans* Frau namens Marsha P. Johnson (1945–1992) und eine bunte Palette anderer Gäste hatten von solchen menschenunwürdigen Schikanen die Schnauze voll. Marsha rief zum Widerstand auf. Als sie bei den Stonewall-Unruhen den ersten Stein warf,[4] war das die Initialzündung der modernen LGBTIQ*-Bewegung. Sechs Tage lang tobte es in Greenwich Village, und die Wellen brandeten rund um den Globus auf. Nicht seit der grundlegenden Arbeit des Berliner Arztes und Sexualforschers Magnus Hirschfeld (1868–1935) hatte es so einen bedeutenden Vorstoß in puncto Gay Rights gegeben.

Damals war ich allerdings zu jung, um die Folgen von Stonewall zu begreifen. Doch mit meiner Sozialisierung als Knabe war ich bereits zu dieser Zeit nicht ganz einverstanden. So wagte ich meine ersten Gay-Schritte als präpubertäre Prinzessin. Während die meisten Kerle draußen im Sandkasten wühlten, ergötzte ich mich am Schminktisch meiner Mutter, und ich zog die Mädchenklamotten meiner Cousinen an. Meine Oma väterlicherseits wusste Bescheid. Die Dame, bereits in den 1890er Jahren als Tochter ehemaliger Versklavter geboren, war glücklicherweise tolerant. Ich solle mich nicht schämen, anders zu sein, beteuerte sie, derweil sie mir

stand on their shoulders? Or do we stand in the way of the cause, and thus in our own way? How do we use this goddamned "blessing of a postwar birth"? What are we standing up for? And yes, the one-million-dollar question: do we succeed in recognizing ourselves in them? Hopefully.

In my opinion, the most suitable means for this is storytelling – that is, the meaningful narration of one's own life – in order to create and maintain a community that spans generations. This is probably about empathy, and certainly about empowerment. In other words, self-empowerment instead of self-pity. For me, anyway, the issue of discrimination is anything but an abstraction. I experience discrimination in multiple ways, namely intersectionally[3] – because I am a Berliner woman with African American roots, a trans+ woman, and a feminist. I literally come "from the other shore," as they say here to mean "swing the other way." What's more, I first saw the light of day in 1961 in the shadow (figuratively and literally) of the Statue of Liberty. In quick succession, I witnessed how the Kennedy brothers, Malcolm X, and Martin Luther King were assassinated. I experienced Jim Crow segregation at age five in Southern states. But the supposedly more open northern states weren't without their challenges either. I sometimes played with children whose parents had narrowly survived Auschwitz-Birkenau and Dachau. Of course, they were white, and for that very reason I couldn't understand why other whites would viciously insult them, beat them up, and, on top of that, spray-paint the walls of their houses with that weird sun wheel. My father, a German-speaking Air Force combat veteran who had fought in World War II,

enlightened me: "Unfortunately, we blacks aren't the only people who are hated."

Another illumination lay in store for me. In the summer of 1969, a few weeks before the moon landing and Woodstock, New York's Christopher Street was buzzing. There, the queer bar Stonewall Inn became the target of a crackdown by corrupt police officers. A Black trans+ woman named Marsha P. Johnson (1945–1992) and a colorful array of other patrons were fed up with such inhumane harassment. Marsha called for resistance. When she threw the first stone at the Stonewall uprising,[4] it sparked the modern LGBTIQ+ movement. The uprising raged in Greenwich Village for six days, sending shockwaves around the globe. Not since the seminal work of the Berlin physician and sex researcher Magnus Hirschfeld (1868–1935) had there been such a significant push for gay rights.

I was too young then, however, to understand the consequences of Stonewall. But I already didn't quite agree with my socialization as a boy. So I dared to take my first gay steps as a prepubescent princess. While most boys were outside digging in the sandbox, I indulged in my mother's make-up table, and I put on my girl cousins' clothes. My paternal grandma knew the score. Fortunately, the lady, born in the 1890s as the daughter of former slaves, was tolerant. I shouldn't be ashamed of being different, she affirmed, as she ran her hand through my curls. But I had to protect myself. Absolutely protect myself. So it was a pleasure, but with reservations. In everyday life I could write off my rouge and mascara. "Freedom scares a lot of people, and that fear scars many more." These words proved to be a prophecy. In my youth I was threatened and insulted, cursed,

64 SELBSTERMÄCHTIGUNG

durch die Locken fuhr. Ich müsse mich aber schützen. Unbedingt schützen. Es war also ein Vergnügen mit Vorbehalt. Rouge und Mascara konnte ich mir im Alltag abschminken. „Freedom scares a lot of people, and that fear scars many more." Diese Worte erwiesen sich als Prophezeiung. In meiner Jugend wurde ich bedroht und beschimpft, verwünscht und sogar vergewaltigt, so sehr ich auch versucht hatte, mein Queersein zu verbergen.

Erst eine Dekade nach Stonewall fühlte ich mich so richtig imstande, den Drahtseilakt eines Doppellebens zu bewältigen. Dienstuniform und Drag. Ich war nämlich zur Seeoffiziersausbildung in San Francisco, meinem inneren Kompass gehorchend. Aber auch da in der queeren Hauptstadt verfinsterte sich der Regenbogen, und zwar nicht allein wegen des charakteristischen Küstennebels. Der Bürgermeister George Moscone wie auch der Stadtrat Harvey Milk, ein unermüdlicher Gay-Rights-Aktivist, wurden erschossen. Deren Attentäter, der ehemalige Stadtrat Dan White, erhielt ein skandalös mildes Urteil, woraufhin sich die wütenden *White Night Riots* entfachten. Die Polizei revanchierte sich gegen das Aufbegehren. Beamte überfielen zahlreiche Etablissements, die von Schwulen und Lesben frequentiert wurden, und gossen damit mehr Öl ins Feuer. Das Castro-Viertel lag in Schutt und Asche.

Doch damit nicht genug: Unmittelbar danach brach die AIDS-Krise über San Francisco und über die ganze Welt herein. Die Mainstreamgesellschaft reagierte auf das tödliche Virus mit Händeringen, die Moralisten setzten auf Hetzparolen. Von der Kanzel aus gifteten Hassprediger gegen HIV-Positive. Das Hautkarzinom Kaposi-Sarkom sei „Schwulenkrebs" oder „die Rache Gottes",[5] und man müsse uns verbannen, schlichtweg einsperren. Absurde Forderungen,

die wiederum nicht ohne historische Präzedenz gewesen waren.

Im Jurastudium Mitte der 1980er Jahre ist mir das strukturelle Ausmaß der Anti-Gay-Diskriminierung bewusst geworden. Dort, im Lande der „unbegrenzten Freiheit", wurden einvernehmliche homosexuelle Handlungen zwischen Erwachsenen noch in vielen Bundesstaaten strafrechtlich geahndet. Auch diesbezügliche Zwangseinweisungen in die Psychiatrie und unfreiwillige Konversionstherapien fanden statt. Erst ein paar weitere Jahrzehnte später setzte sich Präsident Obama, nach anfänglichem Zögern, für LGBTIQ*-Rechte ein, darunter für die gleichgeschlechtliche Ehe und für den Schutz der trans* Soldat*innen. Als jedoch Donald Trump ins Weiße Haus einzog, warf er mit ein paar Tweets und Unterschriften die mühsam erkämpften Rechte zur sexuellen Selbstbestimmung de facto und de jure um ein halbes Jahrhundert zurück.[6] Auch heutzutage, nach Trumps Ablösung durch den Demokraten Joe Biden, setzen US-Republikaner*innen ihre Kulturkämpfe fort. Floridas Gouverneur Ron DeSantis will mit dem als *„Don't say Gay" Law* bekannt gewordenen Schulgesetz den Unterricht über Geschlechtsidentität vom Kindergarten bis zur dritten Klasse verbieten.[7] Georgia, Texas und andere Bundesstaaten wetteifern, um trans* Jugendliche in Rekordzeit aus dem Sport auszuschließen.

Der Lesben- und Schwulenverband in Deutschland (LSVD) beklagt: „In vielen Fällen schüren religiöse und politische Führer ein Klima des Hasses."[8] Weltweit wird Homosexualität in sage und schreibe 69 Ländern weiterhin kriminalisiert, und in elf Staaten steht darauf sogar die Todesstrafe.[9] Auf europäischer Ebene zählen die Regierungen in Polen, wegen der Ausrufung sogenannter „LGBTQ-freier Zonen",[10] und Ungarn, angesichts

and even raped, no matter how much I tried to hide my queerness.

It wasn't until a decade after Stonewall that I really felt able to walk the tightrope of a double life. Service uniform and drag. I was in San Francisco, you see, for naval officer training, following my inner compass. But even there, in the queer capital, the rainbow darkened, and not just because of the typical coastal fog. Mayor George Moscone and Councilman Harvey Milk, a tireless gay rights activist, were gunned down. Their murderer, former councilman Dan White, received a scandalously lenient sentence, which ignited the angry White Night riots. The police retaliated against the uprising. Officers raided numerous establishments frequented by gays and lesbians, pouring more fuel on the fire. The Castro neighborhood lay in ruins.

But that was not enough: immediately afterwards, the AIDS crisis hit San Francisco and the whole world. Mainstream society reacted to the deadly virus with handwringing, while moralists reacted with inflammatory slogans. Hate preachers raged against HIV-positive people from their pulpits. The skin carcinoma Kaposi's sarcoma was "gay cancer" or "the vengeance of God";[5] we should be banished, simply locked up. Absurd demands, but ones again with historical precedents.

In law school in the mid-1980s, I became aware of the structural extent of anti-gay discrimination. There, in the "land of the free," consensual homosexual acts between adults were still punishable by criminal law in many states. They could lead to involuntary admission to psychiatric hospitals and forced conversion therapies. It wasn't until a few decades later that President Obama, after initial hesita-

tion, stood up for LGBTIQ+ rights, including same-sex marriage and protections for trans+ soldiers. However, when Donald Trump moved into the White House, he set back hard-won sexual self-determination rights by half a century – de facto as well as de jure – with a few tweets and collected signatures.[6] Even today, after Trump's succession by Democrat Joe Biden, US Republicans continue to wage their culture wars. Florida Governor Ron DeSantis wants to ban teaching about gender identity from kindergarten through third grade with legislation known as "Don't Say Gay."[7] Georgia, Texas, and other states are vying in record time to bar trans+ youth from sports.

The Lesbian and Gay Association in Germany (LSVD) condemns "religious and political leaders [for] fomenting a climate of hatred in many cases."[8] Around the world, homosexuality continues to be criminalized in a staggering sixty-nine countries, and in eleven it is even punishable by death.[9] In Europe, problem children include the governments in Poland, for declaring so-called "LGBTQ-free zones,"[10] and Hungary, given its "propaganda ban"[11] against promoting homosexuality and trans-sexuality. As for the treatment of queer people in the Balkans, countries like Bulgaria and Bosnia and Herzegovina are also under critical scrutiny, at least unofficially.[12]

Yes, I do keep a record. For life has long since made me an activist. So, like it or not, dealing with hate has become my profession as well as my vocation. At times I feel like a kind of Cassandra to others, and even to myself – a quality that I've tried to come to terms with in my chanson "Jubel, Trubel, Heiserkeit" (Jubilation, Turmoil, Hoarseness).[13] In the colorful Republic of Germany, of all

66 SELBSTERMÄCHTIGUNG

des „Werbeverbotes"[11] gegen Homo- und Transsexualität, zu den Problemkindern. Was die Behandlung queerer Menschen auf dem Balkan betrifft, da stehen Länder wie Bulgarien, Bosnien und Herzegowina, zumindest inoffiziell, auch unter kritischer Beobachtung.[12]

Ja, ich führe Buch. Denn das Leben hat mich längst zur Aktivistin gemacht. Die Beschäftigung mit dem Hass ist also nolens volens zu meinem Beruf und zu meiner Berufung geworden. Bisweilen komme ich anderen und sogar mir selbst wie eine Art Kassandra vor. Eine Begebenheit, die ich mit meinem Chanson *Jubel, Trubel, Heiserkeit*[13] aufzuarbeiten versuche. Ausgerechnet in der bunten Republik Deutschland, meiner Wahlheimat, erdreiste ich mich, vor „Weimar 2.0"[14] eindringlich zu warnen. Eine Queerdichterin versus Querdenker*innen? So ähnlich. Denn wir stecken wieder in den Goldenen Zwanzigern, gleichsam zwischen Aufbruch und Apokalypse. Covid-19 übernimmt die Rolle der Spanischen Grippe, und die Politik wurde längst von der Pandemie infiziert.

Diesmal sind die Demagogen digitalisiert. So organisieren wir ein paar Flashmobs gegen die Flammenwerfer, und wir basteln immer wieder mal an neuen Hashtags, um den homo- und transfeindlichen Hetzparolen Einhalt zu gebieten. Toll, wir sind *woke,* aber so was von. Doch aufgewacht bedeutet noch lang nicht durchdacht. In unserer geschichtsvergessenen Spaßgesellschaft bauen wir Safe Spaces auf noch ungeräumten Minenfeldern auf.

Der Tanz auf dem Vulkan entfaltet sich in allen schillernden Farben, und zwar ausgerechnet beim CSD, dem Corporate Sponsor Défilé. Offiziell heißt das Spektakel immer noch Christopher Street Day. Aber die einstige Pride-Parade mausert sich, hierzulande wie auch weltweit, zu einem Event, bei dem Markennamen es schaffen, Menschen

wie Magnus Hirschfeld oder Marsha P. Johnson in den Schatten zu drängen. Party und Konsum statt echter Partnerschaft mit Konsensbildung. Am einfachsten meidet man das Haifischbecken kontroverser Themen überhaupt. Wenn das nicht geht, schwimmt man lieber irgendwie mit dem Strom. Diese Schwarmmentalität pflegt man fürwahr als „Zeitgeist" zu etikettieren. Eine nachvollziehbare Bezeichnung. Dem jetzigen Zeitgeist, der übrigens sowohl innerhalb als auch jenseits der queeren Gemeinschaft herrscht, mangelt es allerdings am Zeitgefühl. Er fließt weitgehend unbekümmert an der Vergangenheit vorbei.

Wer kennt noch die Redewendung „am 17. Mai geboren"? Genau diese kaiserzeitliche Bezeichnung für „homosexuell" fungierte als eine saloppe Anspielung auf Paragraf 175 des im Jahre 1872 in Kraft getreten Reichsstrafgesetzbuches, wodurch sexuelle Handlungen zwischen Personen männlichen Geschlechts verboten waren. Das Gesetz bot den Nationalsozialisten eine Steilvorlage, als sie 1933 an die Schalthebel der Macht gelangten. 1935 hoben sie die Höchststrafe von sechs Monaten bis auf fünf Jahre an. Mittels des Zusatzes 175a gegen die „schwere Unzucht", darunter die männliche Prostitution, wurde die Freiheitsstrafe bis auf zehn Jahre Zuchthaus verschärft.[15] Während der willkürlichen Schreckensherrschaft wurden bis zum Jahre 1945 circa 57.000 Männer gemäß Paragraf 175 von deutschen Gerichten verurteilt. Davon landeten Tausende in Konzentrationslagern, wo sie den berüchtigten „Rosa Winkel" als Kainsmal tragen mussten. Dabei war die Gestapo, im Unterschied zur Kriminalpolizei, zu jedweder Zeit dazu berechtigt, Schutzhaft gegen männliche Homosexuelle anzuordnen, und zwar trotz eines Freispruches.[16] Überdies wurden zum Teil auch Frauen, die als lesbisch galten, von den Nazis verfolgt, inhaftiert,

places, my adopted country, I presume to warn urgently against "Weimar 2.0."[14] A queer poet versus the *Querdenker*innen*?[15] Something like that. Because we are stuck once again in the Golden Twenties, between awakening and apocalypse, so to speak. COVID-19 takes on the role of the Spanish flu, and politics has long since been infected by the pandemic.

This time the demagogues are digitalized. So we're organizing some flash mobs now against the flamethrowers, and we're constantly tinkering with new hashtags to put a stop to the homophobic and transphobic hate slogans. Great, we are "woke," but so what? Woken up does not mean thought out. In our history-forgetting pleasure society we are building safe spaces on still uncleared minefields.

This life on the edge unfolds in all its dazzling colors at the CSD, of all things: the "Corporate Sponsor Défilé." The spectacle is still officially called Christopher Street Day, but the former Gay Pride parade is turning into an event, both in Germany and worldwide, where brand names manage to push people like Magnus Hirschfeld and Marsha P. Johnson into the shadows. Partying and consumption, instead of real partnership and forging consensus. The easiest way is to avoid the shark tank of controversial issues altogether. If you can't do that, then better go with the flow somehow. This swarm mentality is labeled the "Zeitgeist." An understandable term. The current spirit of the time – which prevails, by the way, both within and beyond the queer community – lacks a sense of time, though. It flows, mostly indifferently, around the past.

Does anybody still know what the phrase "born on the 17th of May" means? It was precisely this imperial-era term for "homosexual" that functioned as a casual allusion to Paragraph 175 (17 = 17th, 5 = May) of the Imperial criminal code, which came into force in 1872 and prohibited sexual acts between persons of the male sex. The law furnished the Nazis with a welcome opportunity when they took power in 1933. In 1935 they raised the maximum penalty from six months to five years. By means of the Paragraph 175a amendment against "serious fornication," including male prostitution, the prison sentence was increased to ten years.[16] During the arbitrary reign of terror that lasted until 1945, approximately 53,000 men were sentenced by German courts under Paragraph 175. Thousands of them ended up in concentration camps, where they had to wear the notorious "pink triangle" as a mark of Cain. In contrast to the criminal police, the Gestapo were entitled to take male homosexuals into protective custody at any time, even if they were acquitted.[17] Furthermore, some women who were considered lesbians were persecuted, imprisoned, condemned to forced labor, and murdered by the Nazis. Some ended up in the Ravensbrück concentration camp, for example, or became victims of Nazi "euthanasia" as psychiatric inmates in the so-called sanatoriums in Bernburg, in accordance with Action 14f13, also known as the "special treatment."[18]

This exhibition deals with the historical situation until the beginning of the 1950s. But even after that, the demon had not disappeared. In 1951, Richard Gatzweiler, a district court judge in Bonn, and the Roman Catholic Volkswartbund association demanded that lesbian sexual acts be criminalized. "What is to be done with a tree denied fertility?" they

68 SELBSTERMÄCHTIGUNG

zur Zwangsarbeit verdammt und ermordet. Einige endeten beispielsweise im KZ Ravensbrück oder wurden als Psychiatrieinsassinnen in sogenannten Heilstätten wie Bernburg gemäß der auch als „Sonderbehandlung" bezeichneten Aktion 14f13 Opfer der NS-„Euthanasie".[17]

Diese Ausstellung beschäftigt sich mit der historischen Situation bis Anfang der 1950er Jahre. Doch auch im Anschluss war der Spuk noch nicht vorbei. Der Bonner Amtsgerichtsrat Richard Gatzweiler und der römisch-katholische Volkswartbund forderten 1951, lesbische sexuelle Handlungen unter Strafe zu stellen. „Was soll man aber mit einem Baum tun, dem die Fruchtbarkeit versagt ist?", hieß es in Anlehnung an biblische Metaphern.[18] Misogynie und patriarchales Gedankengut bilden seit eh und je wohl auch integrale Bestandteile der Homofeindlichkeit.

Es dauerte vier weitere Dekaden, bis die Weltgesundheitsorganisation (WHO) die Homosexualität aus ihrem Diagnoseschlüssel für Krankheiten strich. Die Ironie des Schicksals dabei: Es geschah ausgerechnet am 17. Mai 1990. Beschämenderweise wurde in Deutschland der Paragraf 175 erst 1994 abgeschafft. 2006 wurde der 17. Mai von der UNO zum internationalen Aktionstag gegen die Homophobie erklärt, namentlich auf Geheiß der damaligen LSVD-Sprecherin Sabine Gilleßen und des Franzosen Louis-Georges Tin. Die WHO brauchte wiederum bis 2018, um die Transsexualität nicht mehr als psychische Störung zu charakterisieren.

In Deutschland hoffen wir nun auf die Abschaffung des menschenunwürdigen Transsexuellengesetzes und dessen Ersatz durch das Selbstbestimmungsgesetz. Hierzulande wächst eigentlich die Zustimmung für die Regenbogen-Community insgesamt, die Akzeptanz wird sogar auf 86 Prozent taxiert.[19] Gleichzeitig aber sinkt bei denjeni-

gen, die uns nicht wohlgesonnen sind, die Hemmschwelle zur Hetze und zur Gewalt. Wir Betroffenen müssen uns entlang verschiedener Fronten verteidigen. Nicht nur gegen die Tätlichkeiten und das Gegeifer der üblichen, üblen Verdächtigen aus dem braunen Sumpf. Nein, wir haben es leider auch mit den etwas salonfähigeren Fundamentalist*innen zu tun, die allerdings nicht davor zurückschrecken, sich der Pseudowissenschaft und des Populismus zu bedienen. Beispielsweise zum angeblichen Schutz des Feminismus. J.K. Rowling und Alice Schwarzer lassen grüßen, und zwar aus dem Bunker der Binarität beziehungsweise dem Tante-Emma-Laden des vorigen Jahrhunderts. Meinungsfreiheit? Ja, aber wie wäre es mit der Meinungsverantwortung, mit der historisch verankerten Meinungsverantwortung? Auch die „rechtskonforme" Polemik gegenüber marginalisierten Menschen kann für diese gravierende Konsequenzen haben. Das bekam ein gewisser Herr namens Rudolf Brazda auf brutale Weise zu spüren, wobei seine Geschichte und sein robuster Wille zum Überleben gerade deswegen inspirieren. Rudolf Brazda, der im KZ Buchenwald inhaftiert war, gilt nämlich als der letzte noch lebende Zeitzeuge, der als KZ-Häftling den „Rosa Winkel" tragen musste.[20] Er starb fast hundertjährig im Jahre 2011. Der Regenbogen kommt nach dem Sturm, aber die trügerische Ruhe vor dem nächsten Sturm sollten wir nicht verkennen.

1 Michaela Dudley, Race Relations: Essays über Rassismus, Bad Lippspringe 2022, S. iii. Siehe auch S. 166.

2 Ebd. Siehe auch Michaela Dudley, Marathonlauf der Mehrfachdiskriminierung, in: das goethe, Kulturmagazin des Goethe-Instituts (Beilage in: Die Zeit), 2022/1, S. 22.

asked, echoing biblical metaphors.[19] Misogyny and patriarchal ideas have intertwined as integral components of homophobia since time immemorial.

It took four more decades for the World Health Organization (WHO) to delete homosexuality from its diagnosis codes for diseases. The irony is that it happened on May 17, 1990, of all days. Shamefully, Paragraph 175 was not abolished in Germany until 1994. May 17 was declared an international day of action against homophobia by the UN in 2006, namely at the behest of the then LSVD spokesperson Sabine Gillessen and the Frenchman Louis-Georges Tin. In turn, it took the WHO until 2018 to stop characterizing transsexuality as a mental disorder.

In Germany, we now hope for the abolition of the inhumane Transsexuality Act and its replacement by the Self-Determination Act. In this country, approval for the rainbow community as a whole is in fact growing, with acceptance even estimated at 86 percent.[20] At the same time, however, the inhibition threshold for agitation and violence is sinking among those who are not well-disposed towards us. Those of us who are affected have to defend ourselves on various fronts. Not only against the assaults and the demagogic rantings of the usual evil suspects from the brown swamp. No, unfortunately we also have to deal with the somewhat more respectable fundamentalists, who do not shy away from utilizing pseudo-science and populism. For example, for the alleged protection of feminism. J. K. Rowling and Alice Schwarzer send their regards, from the bunker of binarity and the corner store of the last century respectively. Freedom of expression? Yes, but what about responsibility of opinion, a historically anchored responsibility of opinion? Even polemics "in accordance with the law" against marginalized people can have serious consequences for them. A certain gentleman named Rudolf Brazda experienced this in a brutal manner, although his story and his robust will to survive are inspiring precisely because of this. Rudolf Brazda, who was imprisoned in the Buchenwald concentration camp, is considered the last prisoner who had to wear the "pink triangle".[21] He died in 2011 at almost one hundred years old. The rainbow comes after the storm, but we should not misjudge the deceptive calm before the next storm.

Author's note: this English version of the essay is a translation from the original German.

1 Michaela Dudley, *Race Relations: Essays über Rassismus* (Bad Lippspringe: GrünerSinn, 2022), iii. See also p. 166.

2 Ibid. See also Michaela Dudley, "Marathonlauf der Mehrfachdiskriminierung," *das goethe, Kulturmagazin des Goethe-Instituts*, supplement in *Die Zeit* 1 (2022): 22.

3 See Kimberlé Crenshaw, *On Intersectionality: Essential Writings* (New York: The New Press, 2017).

4 Michaela Dudley, "Und sie warf den ersten Stein von Stonewall," *Glitter – die Gala der Literaturzeitschriften* 4 (2020): 27–34. On this, see the musical homage Michaela Dudley, "Owed to Marsha," GEMA work number 24392279, transmitted by *Kulturzeit*, 3sat-Fernsehen, Mainz (first performed on August 25, 2021).

5 Arndt Peltner, "Manche starben im Gottesdienst: AIDS und Religion in San Francisco," *Deutschlandfunk Kultur*, https://www.deutschlandfunkkultur.de/aids-und-religion-in-san-francisco-manche-starben-im100.html (accessed April 24, 2022).

6 Michaela Dudley, "Wie wollen wir leben?," *Die Tageszeitung*, https://taz.de/Christopher-Street-Day-2021/!5787695/ (accessed April 28, 2022).

7 Sonja Thomaser, "'Don't Say Gay Gesetz'-Gesetz: Disney-Erb:in outet sich als trans," *Frankfurter Rundschau*, https://www.fr.de/politik/disney-dont-say-gay-gesetz-florida-erbin-outet-sich-als-trans-usa-91473096.html (accessed April 22, 2022).

70 SELBSTERMÄCHTIGUNG

3 Siehe Kimberlé Crenshaw, On Intersectionality: Essential Writings, New York 2017.

4 Michaela Dudley, Und sie warf den ersten Stein von Stonewall, in: Glitter – die Gala der Literaturzeitschriften, 2020/4, S. 27–34. Dazu die musikalische Hommage: Michaela Dudley, Owed to Marsha. GEMA-Werknummer 24392279. Uraufführung am 25.8.2021, Sendung Kulturzeit, 3sat-Fernsehen, Mainz.

5 Arndt Peltner, Manche starben im Gottesdienst: AIDS und Religion in San Francisco, in: Deutschlandfunk Kultur, URL: https://www.deutschlandfunkkultur.de/aids-und-religion-in-san-francisco-manche-starben-im100.html [gelesen am 24.4.2022].

6 Michaela Dudley, Wie wollen wir leben?, in: TAZ, URL: https://taz.de/Christopher-Street-Day-2021/!5787695/ [gelesen am 28.4.2022].

7 Sonja Thomaser, „Don't Say Gay Gesetz"-Gesetz: Disney-Erb:in outet sich als trans, in: Frankfurter Rundschau, URL: https://www.fr.de/politik/disney-dont-say-gay-gesetz-florida-erbin-outet-sich-als-trans-usa-91473096.html [gelesen am 22.4.2022].

8 LGBT-Rechte weltweit: Wo droht Todesstrafe oder Gefängnis für Homosexualität, in: LSVD, URL: https://www.lsvd.de/de/ct/1245-LGBT-Rechte-weltweit [gelesen am 22.4.2022].

9 Ebd. Siehe auch Lucas Ramón Mendas u.a., ILGA World, State-Sponsored Homophobia: Global Legislation Overview Update, Genf 2020.

10 Tagesschau, Diskriminierung: EU geht gegen Ungarn und Polen vor, in: Tagesschau, 15.7.2021, URL: https://www.tagesschau.de/ausland/europa/eu-ungarn-polen-101.html [gelesen am 15.7.2021]. Parallel zum Fernsehbeitrag von Astrid Corral, NDR Brüssel.

11 Ebd.

12 Deutsche Welle, Queer Balkan – Im Kampf um gleiche Rechte, in: DW, URL: https://www.dw.com/de/queer-balkan-im-kampf-um-gleiche-rechte/a-61216470 [gelesen am 11.4.2022].

13 Michaela Dudley, Jubel, Trubel, Heiserkeit, GEMA-Werknummer 20909652.

14 Michaela Dudley, Der Tanz auf dem Vulkan: Berlin in den Goldenen Zwanzigern, in: taz, URL: https://www.taz.de/Berlin-in-den-Goldenen-Zwanzigern/!5853303/ [gelesen 20.5.2022].

15 Michaela Dudley, Der Regenbogen und die Wolken, in: Veganverlag, URL: https://dudley.veganverlag.de/der-regenbogen-und-die-wolken/ [gelesen am 20.05.2020].

16 Ebd. Siehe auch Laurie Marhoefer, Lesbianism, Transvestitism, and the Nazi State: A Microhistory of a Gestapo Investigation, 1939–1943, in: The American Historical Review, 2016/121, S. 1167–1195, URL: https://doi.org/10.1093/ahr/121.4.1167 [gelesen am 14.3.2022].

17 Stiftung Brandenburgische Gedenkstätten, Mahn- und Gedenkstätte Ravensbrück, Gedenkzeichen für die lesbischen Häftlinge im Frauen-Konzentrationslager Ravensbrück, URL: https://www.ravensbrueck-sbg.de/meldungen/gedenkzeichen-fuer-die-lesbischen-haeftlinge-im-frauen-konzentrationslager-ravensbrueck/ [gelesen am 12.5.2022].

18 Andreas Pretzel, NS-Opfer unter Vorbehalt: Homosexuelle Männer in Berlin nach 1945, Berlin u.a. 2002, S. 306f. Siehe auch Gottfried Lorenz, Homosexuellenverfolgung in Hamburg, Ausstellung Staatsbibliothek Hamburg, 27.2.2007.

19 Jacob Poushter und Nicholas Kent, The Global Divide on Homosexuality persists, in: Pew Research Center, URL: https://www.pewresearch.org/global/2020/06/25/global-divide-on-homosexuality-persists/ [gelesen am 28.5.2022].

20 Dudley (wie Anm. 6).

8 "LGBT-Rechte weltweit: Wo droht Todesstrafe oder Gefängnis für Homosexualität," *LSVD*, https://www.lsvd.de/de/ct/1245-LGBT-Rechte-weltweit (accessed April 22, 2022).

9 Ibid. See also Lucas Ramón Mendas et al., *ILGA World, State-Sponsored Homophobia: Global Legislation Overview Update* (Geneva: ILGA, 2020).

10 "Tagesschau, Diskriminierung: EU geht gegen Ungarn und Polen vor," *Tagesschau* (July 15, 2021), https://www.tagesschau.de/ausland/europa/eu-ungarn-polen-101.html (accessed July 15, 2021). Parallel with TV report by Astrid Corral, NDR Brussels.

11 Ibid.

12 "Deutsche Welle, Queer Balkan – Im Kampf um gleiche Rechte," *DW*, https://www.dw.com/de/queer-balkan-im-kampf-um-gleiche-rechte/a-61216470 (accessed April 11, 2021).

13 Michaela Dudley, "Jubel, Trubel, Heiserkeit," GEMA work number 20909652.

14 Michaela Dudley, "Der Tanz auf dem Vulkan: Berlin in den Goldenen Zwanzigern," *Die Tageszeitung*, https://www.taz.de/Berlin-in-den-Goldenen-Zwanzigern/!5853303/ (accessed May 20, 2022).

15 The German "Querdenker" movement began in 2020 in reaction to COVID-19-related restrictions, and grew to embrace conspiracy theories and bigoted rhetoric.

16 Michaela Dudley, "Der Regenbogen und die Wolken," *Veganverlag*, https://dudley.veganverlag.de/der-regenbogen-und-die-wolken/ (accessed May 20, 2022).

17 Ibid. See also Laurie Marhoefer, "Lesbianism, Transvestitism, and the Nazi State: A Microhistory of a Gestapo Investigation, 1939–1943," *The American Historical Review* 121, no. 4 (October 2016): 1167–95, https://doi.org/10.1093/ahr/121.4.1167 (accessed March 14, 2022).

18 Stiftung Brandenburgische Gedenkstätten, Mahn- und Gedenkstätte Ravensbrück, "Gedenkzeichen für die lesbischen Häftlinge im Frauen-Konzentrationslager Ravensbrück," https://www.ravensbrueck-sbg.de/meldungen/gedenkzeichen-fuer-die-lesbischen-haeftlinge-im-frauen-konzentrationslager-ravensbrueck/ (accessed May 12, 2022).

19 Andreas Pretzel, *NS-Opfer unter Vorbehalt: Homosexuelle Männer in Berlin nach 1945* (Berlin: Lit, 2002), 306ff. See also Gottfried Lorenz, *Homosexuellenverfolgung in Hamburg*, exhibition Staatsbibliothek Hamburg (February 27, 2007).

20 Jacob Poushter and Nicholas Kent, "The Global Divide on Homosexuality persists," *Pew Research Center*, https://www.pewresearch.org/global/2020/06/25/global-divide-on-homosexuality-persists (accessed May 28, 2022).

21 Dudley, "Wie wollen wir Leben?" (see note 6).

BEGEGNEN, BEWEGEN – BANDEN BILDEN

MEETING, MOVING = FORGING BONDS

Bars und Clubs, Zeitschriften, Organisationen, private oder öffentliche Orte: Seit der Jahrhundertwende und insbesondere in den 1920er Jahren entstehen queere Subkulturen und Netzwerke. Gemeinsam werden politische Ziele formuliert. Kommuniziert wird über eigene Codes, Chiffren und Symbole.

Der öffentliche Raum ist weiterhin vor allem Männern vorbehalten – heterosexuellen, weißen und christlichen Männern. Doch die Erfahrung, gegen alle gesellschaftlichen Widerstände eigene Räume zu erobern, sich zu verbinden und gemeinsam in die Öffentlichkeit zu treten, führt zu einem erstarkenden Selbstbewusstsein queerer Szenen.

Dabei wird nicht nur für jeweils eigene Interessen gekämpft; es werden auch politische Bande geknüpft und über Differenzen hinweg Koalitionen gebildet. Visionen für eine Gesellschaft mit gleichen Rechten für alle Menschen werden entworfen und bestehende Herrschaftsstrukturen infrage gestellt. Aber auch innere Konflikte treten zutage, und nicht alle queeren Vereinigungen ziehen an einem Strang.

Bars and clubs, magazines, organizations, private or public places: queer subcultures and networks emerged in Germany beginning at the turn of the century and especially in the 1920s. Political goals were formulated together. People communicated using their own codes, ciphers, and symbols.

The public sphere continued to be reserved primarily for men – heterosexual, white, and Christian men. But the experience of conquering one's own spaces against all social opposition, of joining forces and stepping into the public sphere together, led to a growing self-confidence in the queer scenes. In the process, they not only fought for their own interests; political bonds were forged and coalitions formed that bridged differences.

Visions for a society with equal rights for all people were drafted, and existing structures of power were questioned. But internal conflicts emerged as well, and not all queer groups pulled together.

„NICHT GESEHEN, NICHT ERKANNT ZU WERDEN, UNSICHTBAR ZU SEIN FÜR ANDERE, IST WIRKLICH DIE EXISTENTIELLSTE FORM DER MISSACHTUNG."

Carolin Emcke, 2019
Autorin und Journalistin

"BEING UNSEEN, UNRECOGNIZED, INVISIBLE TO OTHERS, IS REALLY THE MOST EXISTENTIAL FORM OF DISRESPECT."

Carolin Emcke, 2019
Author and Journalist

ORGANISATIONEN

Schwule Männer schließen sich ab Ende des 19. Jahrhunderts zusammen, um gegen die Strafverfolgung aufgrund von Paragraf 175 anzugehen. Sie gründen Vereine und Verbände und suchen Unterstützer*innen, um ihre Vision einer offeneren Gesellschaft zu verwirklichen. Berlin ist das Zentrum dieser Bewegung und entwickelt sich zu einem wichtigen Anziehungspunkt für queere Menschen. 1897 wird dort das Wissenschaftlich-humanitäre Komitee gegründet, das die rechtliche und gesellschaftliche Gleichstellung homosexueller und trans*identer Menschen erreichen will.

Einzelne Aktivistinnen der Frauenbewegungen schließen sich diesem Kampf an, besonders als 1909 die Ausweitung von Paragraf 175 auf Frauen diskutiert wird. In der Weimarer Republik blühen queere Subkulturen auf. Eine vielfältige Vereinslandschaft entsteht, die die Interessen von Schwulen, Lesben und trans* Personen vertritt. Der Kampf gegen Paragraf 175 ist jedoch nicht immer gleichbedeutend mit dem Eintreten für eine offene Gesellschaft. Unter den schwulen Aktivisten gibt es auch solche, die einem homoerotischen Männerkult huldigen. Sie schließen neben Frauen all diejenigen aus, die nicht ihrem maskulinen, zum Teil rassistisch geprägten Heldenideal entsprechen.

ORGANIZATIONS

At the end of the nineteenth century, gay men joined forces to fight against persecution based on Paragraph 175. They founded clubs and associations and sought supporters to achieve their vision of a more open society. Berlin became the hub of this movement and developed into a leading center of attraction for queer people. It was in Berlin that, in 1897, the Scientific-Humanitarian Committee was founded, which aimed to achieve legal and social equality for homosexual and trans+ people.

Some activists from the women's movements joined this struggle, especially when the extension of Paragraph 175 to encompass women was debated in 1909. Queer subcultures flourished in the Weimar Republic. A diverse landscape of organizations emerged that represented the interests of gays, lesbians, and trans+ people. However, the struggle against Paragraph 175 was not always synonymous with advocacy for an open society. Among gay activists there were also those who paid homage to a homoerotic male cult. They excluded – in addition to women – all those who did not conform to their heroic, in some cases also racist, ideas of masculinity.

Struggle against Paragraph 175: The Scientific-Humanitarian Committee

The physician Magnus Hirschfeld (1868–1935) came from a liberal Jewish family and began actively campaigning for the abolition of Paragraph 175 at the end of the nineteenth century. His actions were motivated by the persecution to which gay men were subjected. As a sexual reformer and founder of the Scientific-Humanitarian Committee, he fought against the prevailing rigid sexual morality and contributed significantly to the visibility of queer people. As a Jew, social democrat, and homosexual activist he became a target of right-wing extremist and racist forces at an early stage.

Founded in 1897, the Scientific-Humanitarian Committee was the first organization of homosexuals in the world. It lobbied throughout Germany and sent, in its founding year, a petition to the German Reichstag demanding the abolition of Paragraph 175. This was repeated several times until 1933, but the attempts ultimately remained in vain.

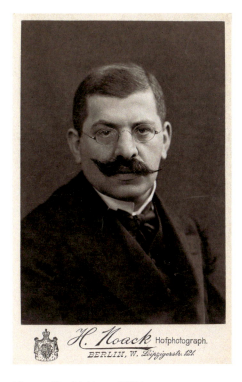

Magnus Hirschfeld, ca. 1900

MEETING, MOVING – FORGING BONDS

Artikel über einen rechtsextremen Überfall auf Magnus Hirschfeld, in: *Die Freundschaft. Wochenschrift für Unterhaltung u. geistige Hebung der idealen Freundschaft*, 1920/41 | Article about an attack on Magnus Hirschfeld by right-wing extremists (title: "Knavery in Munich"), in *Die Freundschaft. Wochenschrift für Unterhaltung u. geistige Hebung der idealen Freundschaft*, vol. 41, 1920

Magnus Hirschfeld hält über 3.000 Vorträge im In- und Ausland. Mit steigender Bekanntheit nimmt auch die Hetze gegen seine Person zu. Nach einem Vortrag in der Münchner Tonhalle wird Hirschfeld am 4. Oktober 1920 von Rechtsextremen überfallen und bewusstlos geschlagen. In rechten, nationalistischen und antisemitischen Kreisen wird applaudiert. Die rechtslastige Münchner Polizei ermittelt nur halbherzig, sodass die Täter nie gefasst werden.

Magnus Hirschfeld gave over three thousand lectures in Germany and abroad. As his fame increased, so did agitation against him. After a lecture in the Tonhalle concert hall in Munich on October 4, 1920, Hirschfeld was attacked and left unconscious by right-wing extremists. Right-wing, nationalist, and antisemitic circles applauded. The Munich police, who tended to be right-wing, investigated only half-heartedly, so that the perpetrators were never caught.

Magnus Hirschfeld bedient sich in seiner Aufklärungsarbeit moderner Mittel. Unter seiner Beteiligung entsteht 1919 das Stummfilm-Drama *Anders als die Andern*. Es gilt als erster Film, der sich offen mit dem Thema Homosexualität auseinandersetzt. Von konservativer und rechtsextremer Seite heftig und teils mit antisemitischer Stoßrichtung skandalisiert, wird der Film zum Anlass genommen, die nach der Revolution von 1918 eingeführte Kunstfreiheit wieder zu beschneiden. Nach einem guten Jahr Spielzeit wird der Film 1920 durch die Zensur verboten, fast alle Kopien werden vernichtet.

Anders als die Andern handelt von einem Musiker, der wegen homosexueller Handlungen erpresst wird. Als er sich nicht mehr zu helfen weiß und Anzeige erstattet, wird nicht nur der Erpresser verurteilt, sondern auch er selbst – wegen Verstoßes gegen Paragraph 175. Er zerbricht an dem Urteil und nimmt sich das Leben. Am Grab des Musikers tritt Magnus Hirschfeld auf und fordert eindringlich, die Rechte von Homosexuellen anzuerkennen.

Magnus Hirschfeld utilized modern means in his educational activities. The silent film drama *Anders als die Andern* (Different from the Others) was shot in 1919 with his active participation. It is considered the first film to deal openly with the subject of homosexuality. Heavily attacked by conservative and right-wing extremists, and by some with antisemitic motives, the film was used as an opportunity to curtail the artistic freedom introduced after the 1918 revolution. After being screened publicly for a full year, the film was banned by censors in 1920 and almost all copies were destroyed.

Anders als die Andern is about a homosexual musician who is subject to blackmail. When he no longer knows what to do and files charges, not only is the blackmailer convicted, but he himself is also sentenced – for violating Paragraph 175. He is shattered by the verdict and takes his own life. Magnus Hirschfeld appears at the musician's grave and urgently demands that the rights of homosexuals be recognized.

Anzeige zum Film *Anders als die Andern*, Aufklärungsfilm, Regie und Produktion Richard Oswald, Drehbuch Richard Oswald und Magnus Hirschfeld, Deutschland 1919, in: *Lichtbild-Bühne*, 1919/18 | **Advertisement** for the film *Anders als die Andern* (Different from the Others), educational film, direction and production Richard Oswald, script Richard Oswald and Magnus Hirschfeld, Germany, 1919, in *Lichtbild Bühne*, vol. 18, 1919

MEETING, MOVING – FORGING BONDS

Joseph Schedel und das Subkomitee München

„Man muß, wenn einem ein Recht vorenthalten wird[,] kämpfen und nicht nachgeben; das ist eine sittliche Pflicht." – Mit diesen Worten des Juristen Rudolf von Jhering eröffnet Joseph Schedel (1856–1943) am 24. September 1902 die erste Sitzung des Wissenschaftlich-humanitären Komitees München. Der Apotheker aus Bamberg ist Hauptinitiator und Vorsitzender des ersten bayerischen Ablegers von Magnus Hirschfelds Vereinigung.

Joseph Schedel and the Munich Subcommittee

"When a right is withheld from you, you must fight and not give in; that is a moral duty." In quoting these words by the jurist Rudolf von Jhering, Joseph Schedel (1856–1943) opened the first meeting of the Scientific-Humanitarian Committee of Munich on September 24, 1902. The pharmacist from Bamberg was the main initiator and chairman of the first Bavarian branch of Magnus Hirschfeld's association.

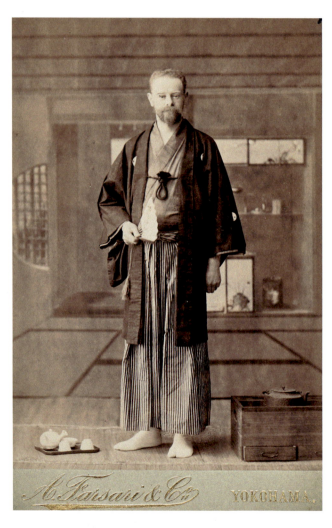

Joseph Schedel in Samurai-Kleidung, Yokohama 1890 | **Joseph Schedel in samurai clothing, Yokohama 1890**

Protokoll der 1. Sitzung des Wissenschaftlich-humanitären Komitees München, 24.9.1902 | Minutes of the First Meeting of the Scientific-Humanitarian Committee Munich, September 24, 1902

1908 gibt Joseph Schedel seinen Kampf für die Rechte der Homosexuellen in Deutschland auf. Er geht nach China und übernimmt dort eine Apotheke. Bereits zuvor hat er jahrelang in Japan als Apotheker gelebt. Während seiner Auslandsaufenthalte sammelt er ostasiatisches Kunst- und Kulturgut. Sein Forschungs- und Sammelinteresse steht dabei auch im Kontext seiner Homosexualität.

In 1908, Joseph Schedel gave up his fight for homosexual rights in Germany. He moved to China and took over a pharmacy there. He had previously lived for several years in Japan as a pharmacist. During his stays abroad, he collected East Asian art and cultural objects. His research and collecting interests reflect his homosexuality.

MEETING, MOVING – FORGING BONDS 81

Frauenbewegungen und Homosexualität

Als mutmaßlich erste Frau bekennt sich die Autorin und Frauenrechtlerin Theodora Anna Sprüngli alias Anna Rüling (1880–1953) 1904 öffentlich zu ihrer Homosexualität und ruft zur lesbischen Emanzipation auf. Auf der Jahresversammlung des Wissenschaftlich-humanitären Komitees in Berlin bringt sie vor rund 300 Anwesenden die Belange „urnischer" – lesbischer – Frauen vor: Sie fordert die führenden Köpfe der Frauenbewegung auf, sich des Themas anzunehmen, und macht sich für einen Schulterschluss von Frauen- und Homosexuellenbewegung stark.

„Wenn wir alle Verdienste, die sich homosexuelle Frauen seit Jahrzehnten um die Frauenbewegung erworben haben, betrachten, so muß es sehr erstaunen, daß die großen und einflußreichen Organisationen dieser Bewegung bis heute keinen Finger gerührt haben, der nicht geringen Anzahl ihrer urnischen Mitglieder ihr gutes Recht in Staat und Gesellschaft zu verschaffen […]."

Theodora Anna Sprüngli alias Anna Rüling, *Welches Interesse hat die Frauenbewegung an der Lösung des homosexuellen Problems?*, 1910

"If we consider all the merits that homosexual women have for decades rendered to the women's movement, it must be very surprising that the large and influential organizations of this movement have not lifted a finger to this day to give the not insignificant number of their *urnisch* [homosexual] members their due in state and society."

Theodora Anna Sprüngli, alias Anna Rüling, *What Interest Does the Women's Rights Movement Have in Solving the Homosexual Problem?*, 1910

Women's Rights Movements and Homosexuality

In 1904, the author and women's rights activist Theodora Anna Sprüngli, alias Anna Rüling (1880–1953), became presumably the first woman to publicly announce her homosexuality and call for lesbian emancipation. At the annual meeting of the Scientific-Humanitarian Committee in Berlin, she raised the concerns of lesbian women in front of approximately three hundred attendees. She called on the leaders of the women's movement to take up the issue and made the case for a closing of ranks between the women's rights and homosexual rights movements.

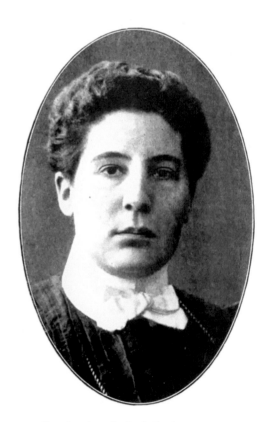

Theodora Anna Sprüngli alias Anna Rüling, 1910

„Welch finsteres Mittelalter liegt doch allein darin, daß man sich überhaupt noch erlaubt, in das privateste Privatleben, das Liebesleben, von Staats wegen einzugreifen, daß man sich vorzuschreiben erdreistet, in welcher Art und Form sich dieses Leben abzuspielen hat?"

Helene Stöcker, Die beabsichtigte Ausdehnung des § 175 auf die Frau, in: Die neue Generation, 7. Jg., 1911/3

"What dark Middle Ages lies in the fact that the state is still allowed to intervene in the most intimate sphere of the private life, in the love life, such that it dares to prescribe in what manner and form this life must take place?"

Helene Stöcker, "The Intended Extension of Paragraph 175 to Women," Die neue Generation, vol. 7, no. 3, 1911

Helene Stöcker, 1920er Jahre, aus: Magnus Hirschfeld, Geschlechtskunde, Bd. 4, Stuttgart 1930 | **Helene Stöcker, 1920s, from Magnus Hirschfeld, *Sexology*, vol. 4, Stuttgart, 1930**

Die Frauenrechtlerin, Sexualreformerin und promovierte Literaturwissenschaftlerin Helene Stöcker (1869–1943) ist eine der wenigen Protagonistinnen der radikalen Frauenbewegung, die sich dem Kampf der Homosexuellenbewegung anschließt. Ihren 1905 gegründeten Bund für Mutterschutz und Sexualreform und dessen Zeitschrift Mutterschutz (später Die neue Generation) stellt sie ganz in den Dienst einer neuen Sexualethik, deren Kern das Recht auf sexuelle Selbstbestimmung ist.

The women's rights activist, sexual reformer, and PhD in literary studies Helene Stöcker (1869–1943) was one of the few figures from the radical women's movement to contribute to the homosexual rights movement. She put her Bund für Mutterschutz und Sexualreform (Association for Maternity Protection and Sexual Reform), founded in 1905, and its journal *Mutterschutz* (Maternity Protection), later *Die neue Generation* (The New Generation), entirely at the service of a new sexual ethics, the core of which was the right to sexual self-determination.

MEETING, MOVING – FORGING BONDS

Johanna Elberskirchen, um 1905, aus: *Kinderheil. Zeitschrift für Mütter zur leiblichen und geistigen Gesundung und Gesunderhaltung der Kinder*, München 1905 | **Johanna Elberskirchen, ca. 1905, from *Kinderheil. Zeitschrift für Mütter zur leiblichen und geistigen Gesundung und Gesunderhaltung der Kinder*, Munich, 1905**

Die radikale Feministin, Medizinerin und Publizistin Johanna Elberskirchen (1864–1943) bezeichnet 1904 in *Die Liebe des dritten Geschlechts* Homosexualität als naturgegeben und damit auch gottgewollt. Die Sozialdemokratin lebt selbst offen lesbisch und steht in engem Kontakt mit Magnus Hirschfeld und dem Wissenschaftlich-humanitären Komitee, dessen erweitertem Vorstand sie seit 1914 angehört.

In 1904, the radical feminist, physician, and publicist Johanna Elberskirchen (1864–1943) described homosexuality in *Die Liebe des dritten Geschlechts* (The Love of the Third Sex) as occurring in nature and, consequently, willed by God. The Social Democrat lived as an open lesbian herself and was in close contact with Magnus Hirschfeld and the Scientific-Humanitarian Committee, on whose extended board she became a member in 1914.

Vereinswesen: Politik und Geselligkeit

Die Gemeinschaft der Eigenen

Adolf Brand (1874–1945), Buchhändler, Verleger, Schriftsteller und homosexueller Aktivist, gründet 1903 den elitären Männerbund Gemeinschaft der Eigenen. In Abgrenzung zu Magnus Hirschfelds Theorie des dritten Geschlechts, das zwischen Mann und Frau steht, propagiert Brand das Ideal des virilen, besonders „mannhaften" Homosexuellen. Er strebt eine spezifisch „männliche Kultur" an und weist dem schwulen Mann eine führende Rolle in Staat und Gesellschaft zu. 1932 beendet er seinen Aktivismus. Sein Verlagsarchiv wird 1933 beschlagnahmt und vernichtet.

Associations: Politics and Society

The Society of One's Own

Adolf Brand (1874–1945), bookseller, publisher, writer, and homosexual activist, founded the elitist men's association Gemeinschaft der Eigenen (The Society of One's Own) in 1903. In contrast to Magnus Hirschfeld's theory of the third sex, one positioned between man and woman, Brand propagated the ideal of the virile, particularly "manly" homosexual. He strove for a specifically "masculine culture" and allocated the gay man a leading role in state and society. In 1932 he ceased his activism. His publishing archives were confiscated and destroyed in 1933.

Adolf Brand, um 1900 | **Adolf Brand, ca. 1900**

Bestellpostkarte mit Publikationen im Verlag Adolf Brand, ohne Jahr | Postcard for ordering publications from Adolf Brand Publishers, undated

Die Gemeinschaft der Eigenen tritt für sexuelle Selbstbestimmung und die Straffreiheit homosexueller Handlungen ein. Ihr geht es um die gesellschaftliche Anerkennung mann-männlicher Liebe. Ideologisch unterfüttert wird dies durch den Rückgriff auf die griechische Antike, die als Nachweis einer mann-männlichen Hochkultur dient, aber auch der Rechtfertigung sexueller Ausbeutung von Minderjährigen Vorschub leistet.

The Gemeinschaft der Eigenen advocated sexual self-determination and immunity from prosecution of homosexual acts. It was concerned with the social recognition of "male–male" love. This was ideologically underpinned by recourse to Greek antiquity, which served as proof of an advanced male–male civilization, but also encouraged the justification of the sexual exploitation of minors.

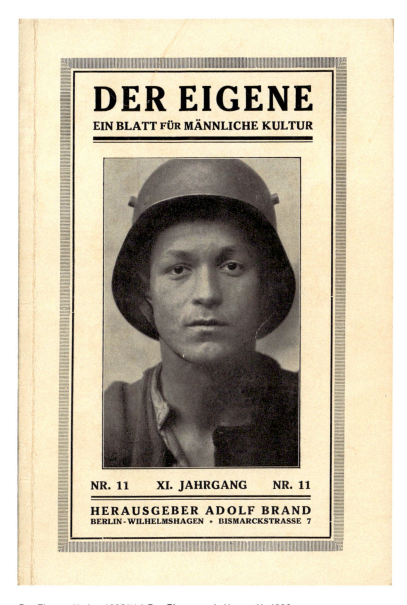

Der Eigene, 11. Jg., 1926/11 | *Der Eigene*, vol. 11, no. 11, 1926

Die 1896 von Adolf Brand gegründete Zeitschrift *Der Eigene* ist das am längsten herausgegebene Homosexuellenblatt. Es erscheint, wiederholt verboten und beschlagnahmt, mit Unterbrechungen bis 1932. Mit seinen literarisch-künstlerischen Beiträgen, die das Bild heroischer Männlichkeit beschwören, richtet es sich an ein wohlsituiertes, akademisches Publikum. Neben anderen veröffentlicht auch Klaus Mann in der Zeitschrift.

Founded in 1896 by Adolf Brand, *Der Eigene* was the longest-running homosexual journal. Repeatedly banned and confiscated, it came out intermittently until 1932. With its literary-artistic contributions evoking the image of heroic masculinity, it was aimed at an affluent, academic audience. Klaus Mann, among other authors, published in the journal.

Freundschaftsvereine und der Bund für Menschenrecht

Friendship Associations and the Alliance for Human Rights

Friedrich Radszuweit (1876–1932) ist Herausgeber und Verleger zahlreicher Zeitschriften für Schwule, Lesben und trans* Personen mit bis zu 48.000 Abonnent*innen, darunter die *Blätter für Menschenrecht*, *Das Freundschaftsblatt*, *Die Freundin* und *Das 3. Geschlecht*. Daneben verlegt er homosexuelle Literatur und erste Schallplatten mit homosexuellen Liedern.

Friedrich Radszuweit (1876–1932) was editor and publisher of numerous magazines for gays, lesbians, and trans+ people with up to 48,000 subscribers. His titles included *Blätter für Menschenrecht*, *Das Freundschaftsblatt*, *Die Freundin*, and *Das 3. Geschlecht*. In addition, he published homosexual literature and issued the first records with homosexual songs.

Friedrich Radszuweit, um 1929 | Friedrich Radszuweit, ca. 1929

Gleichgeschlechtlich begehrende Männer, aber auch Frauen organisieren sich in Berlin und anderen Städten in Freundschaftsvereinen. 1919 schließen sich diese im Deutschen Freundschafts-Verband – seit 1923 Bund für Menschenrecht – zusammen, der über eine eigene „Damen-Abteilung" verfügt. Unter dem Unternehmer, Schriftsteller und Verleger Friedrich Radszuweit entwickelt sich der Bund zur ersten homosexuellen Massenorganisation mit zehntausenden Mitgliedern.

Der Bund, aus dem 1930 der Bund für ideale Frauenfreundschaft hervorgeht, organisiert Tanzabende, Ausflüge und Vorträge. Aber er tritt auch direkt für die Gleichstellung homo- und bisexueller sowie trans* Menschen ein. So ruft er in den 1920er Jahren wiederholt zur Wahl von SPD, KPD und DDP auf – jener Parteien, die sich für die Abschaffung

Men, and women as well, who desired same-sex partners organized themselves in "friendship associations" in Berlin and other cities. In 1919, these united in the "German Friendship Association" – since 1923 known as the "Bund für Menschenrecht" (Alliance for Human Rights) – which had its own "Ladies' Section." Under the entrepreneur, writer, and publisher Friedrich Radszuweit, it developed into the first homosexual mass organization with tens of thousands of members.

The Bund für Menschenrecht, from which the Bund für ideale Frauenfreundschaft (Alliance for Ideal Female Friendship) emerged in 1930, organized dance evenings, excursions, and lectures. But it also directly advocated equality for homosexual, bisexual, and trans+ people. In the 1920s, for example, it repeatedly called for the

Aufruf
an alle gleichgeschlechtlich liebenden Frauen

Frauen, ihr alle, die ihr das gleiche Geschlecht liebt, werdet von den Heterosexuellen wegen eurer Veranlagung ebenso verlacht und verspottet wie die homosexuellen Männer.

Frauen, empfindet ihr nicht die schwere Schmach, die wegen eurer schuldlosen Veranlagung auf euch und eurem Namen lastet?

Empfindet ihr nicht das Schmachvolle eurer Lage, eure Freundin im Dunkeln verbergen und eure Liebe vor den Menschen verheimlichen zu müssen?

Wer von euch all die Ungerechtigkeit und Schmach, die euch fort und fort angetan wird, nicht empfindet, hat kein Ehrgefühl.

Nicht nur Tanz und gesellige Veranstaltungen können euch Gleichberechtigung bringen, sondern auch Kampf ist nötig, wenn ihr Ansehen und Achtung haben wollt.

Kampfeslust muß eure Herzen erfüllen und aus euren Augen leuchten. Darum organisiert euch im Bund für ideale Frauenfreundschaft, der dem B. f. M., E. V., korporativ angeschlossen ist.

Eure Führerin Lotte Hahm arbeitet gemeinsam mit dem Hauptvorstand des B.f.M., E.V., zu eurem Wohl, und nur hier werden eure Interessen sachgemäß und energisch vertreten.

Fort mit allen Eigenbröteleien aus euren Reihen. Besucht keine Veranstaltungen von sogenannten „Damenklubs", die nicht dem Bund angeschlossen sind.

Der B.f.M., E.V., repräsentiert allein die gesamte, ernstzunehmende homosexuelle Bewegung Deutschlands, und dazu gehört auch ihr.

Gleichgeschlechtlichliebende Frauen zeigt, daß ihr nicht nur da seid, um geduldet zu werden, sondern, daß ihr auch bereit seid, zum Kampf für eure Freiheit.

Bund für ideale Frauenfreundschaft.
Der Hauptvorstand.
gez. Lotte Hahm.
Bund für Menschenrecht, E. V.-
Beide Sitz Berlin S 14, Neue Jakobstr. 9.
Der Hauptvorstand.
gez Friedrich Radszuweit.

Statuten des
„Bund für ideale Frauenfreundschaft"

§ 1.
Die Vereinigung führt den Namen Bund für ideale Frauenfreundschaft, Sitz Berlin.

§ 2.
Der Bund bezweckt die Pflege der ideellen Freundschaft, die Vervollkommnung des inneren und äußeren Lebens, sowie Veranstaltungen von wissenschaftlichen Vorträgen, insbesondere über die gleichgeschlechtliche Liebe.

Die Zwecke des Bundes sollen erreicht werden:
a) durch organisatorischen Zusammenschluß aller Frauen, die sich für diese Fragen interessieren;
b) durch Gründung von Ortsgruppen im ganzen Deutschen Reich;
c) durch korporativen Anschluß von Vereinen, die die Zwecke des Bundes fördern und unterstützen.

Mitgliedschaft.
§ 3.
Mitglied kann jede Person werden, die das 18. Lebensjahr erreicht hat (ohne Rücksicht auf politische und religiöse Gesinnung) und die Satzungen des Bundes anerkennt.

§ 4.
Die Aufnahme erfolgt durch den Hauptvorstand in Berlin oder die Ortsgruppen.

Vereine, welche sich korporativ anschließen wollen, haben beim Hauptvorstand einen Antrag zu stellen welcher von sämtlichen Verstandsmitgliedern unterzeichnet werden nuß.

§ 5.
Bei Ablehnung des Aufnahmeantrages durch den Hauptvorstand bzw. die Ortsgruppen, steht den Betreffenden Beschwerde beim nächstfolgenden Bundestag zu.

§ 6.
Die Mitgliedschaft erlischt:
a) durch Austritt;
b) durch Ausschluß. Ausschluß kann nur durch den Hauptvorstand bzw. die Ortsgruppenvorstände erfolgen, und zwar:
1. wenn ein Mitglied mit seinem Beitrag länger als drei Monate im Rückstand ist;
2. wenn ein Mitglied gegen die Interessen des Bundes handelt. Beschwerde gegen den Ausschluß kann von den Betreffenden beim nächstfolgenden Bundestag erhoben werden;
c) durch Tod.
Bei Beendigung der Mitgliedschaft muß die Mitgliedskarte an den Hauptvorstand bzw. an die Ortsgruppe zurückgegeben werden.

Beiträge.
§ 7.
Die Aufnahmegebühr sowie der Beitrag werden alljährlich auf dem Bundestag für ein Jahr festgesetzt.

Bundesleitung.
§ 8.
Die Leitung des Bundes sind:
a) der Hauptvorstand;
b) die Ortsgruppenvorstände.

§ 9.
Vorstand des Bundes ist der I. Vorsitzende., im Falle seiner Verhinderung sein Stellvertreter. Außerdem besteht der erweiterte Vorstand aus zwei Schriftführern, einem Kassierer und zwei Beisitzern.

Die gesamte Bundesleitung übt ihre Tätigkeit ehrenamtlich aus.

§ 10.
Als Geschäftsjahr des Bundes gilt das Kalenderjahr. Der Hauptvorstand hat auf dem Bundestag einen Geschäftsbericht über das verflossene Geschäftsjahr vorzulegen.

§ 11.
Zur Prüfung der Bundeskasse werden auf dem Bundestag zwei Kassenprüfer gewählt, die nicht dem Hauptvorstand angehören dürfen. Die Prüfung der Kasse wird halbjährlich vorgenommen, doch bleibt es den Prüfern unbenommen, jederzeit außerordentliche Prüfungen der Kasse vorzunehmen.

Lotte Hahm und Friedrich Radszuweit, *Aufruf an alle gleichgeschlechtlich liebenden Frauen*, in: *Die Freundin*, 1930/22 | Lotte Hahm and Friedrich Radszuweit, "Appeal to All Same-Sex Loving Women," *Die Freundin*, no. 22, 1930

von Paragraf 175 starkmachen. Allerdings öffnet er sich ab Ende der 1920er Jahre auch gegenüber der NSDAP und nimmt antisemitisches und rassistisches Gedankengut auf. Die nationalsozialistische Machtübernahme setzt der Vereinstätigkeit jedoch ein Ende.

election of Social Democrats, Communists, and German Democrats – parties that advocated the abolition of Paragraph 175. From the end of the 1920s, however, it also opened up to the Nazi party and adopted antisemitic and racist ideas. However, the Nazi seizure of power put an end to the association's activities.

„Transvestiten-Vereinigung" D'Eon

"Transvestite Association" D'Eon

1929/30 wird mit D'Eon die erste bekannte „transvestitische Vereinigung" gegründet, benannt nach dem französischen Offizier Charles d'Éon de Beaumont (1728–1810), der jahrzehntelang offen als Frau lebte. Die Gruppe fasst homo- wie heterosexuelle „Transvestit*innen" und trans* Personen zu einer eigenen Interessengemeinschaft zusammen. Sie ist eng mit Hirschfelds Institut für Sexualwissenschaft verbunden. Spätestens 1933 enden diese Versuche der Selbstorganisation.

D'Eon, the first known "transvestite association," was founded in 1929/30 and named after the French officer Charles d'Éon de Beaumont (1728–1810), who lived openly as a woman for decades. The group linked homosexual as well as heterosexual "transvestites" and trans+ people into one interest group. It was closely associated with Hirschfeld's Institute for Sexology. These attempts at self-organization came to an end by 1933 at the latest.

Aufruf der „Transvestiten-Vereinigung" D'Eon zum Beitritt, in: *Liebende Frauen*, 5. Jg., 1930/13 | Appeal for members from the D'Eon "transvestite association," in *Liebende Frauen*, vol. 5, no. 13, 1930

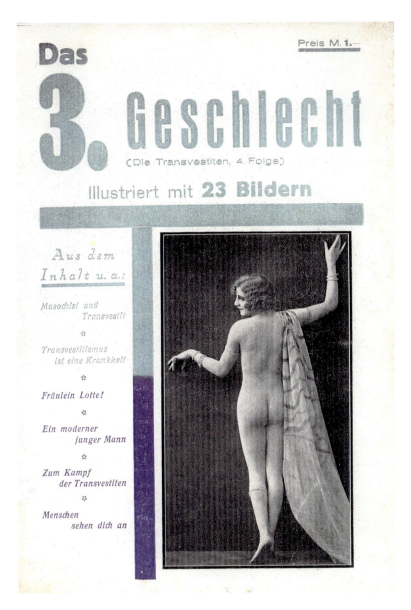

Das 3. Geschlecht, 4. Folge, 1931 | *Das 3. Geschlecht*, fourth issue, 1931

Die Zeitschrift *Das 3. Geschlecht* erscheint von 1930 bis 1932. Sie verleiht dem Wunsch der „transvestitischen" Szene Ausdruck, sich intensiver zusammenzuschließen und sichtbarer zu werden. Bereits seit Mitte der 1920er Jahre gibt es spezielle Themenseiten namens „Der Transvestit" oder „Die Welt der Transvestiten" in den etablierten Homosexuellenblättern wie *Die Freundin* oder *Garçonne*.

The journal *Das 3. Geschlecht* (The Third Sex) was published from 1930 to 1932, reflecting the desire of the "transvestite" scene to join together more intensively and become more visible. Since the mid-1920s at the latest, special theme pages called "The Transvestite" or "The World of Transvestites" appeared in established homosexual magazines such as *Die Freundin* or *Garçonne*.

MEETING, MOVING – FORGING BONDS

Zwiespältige Banden: Homoerotik und rechtes Denken

In den 1910er Jahren erregt Hans Blüher (1888–1955) Aufsehen mit Schriften, die den männlichen Eros verherrlichen. Blüher preist die Homoerotik als grundlegendes Element der Jugenderziehung und der Staatsbildung – die Ausübung sexualisierter Gewalt an Kindern und Jugendlichen mit einbegriffen. Seine elitären, antifeministischen und antisemitisch unterlegten Männerbund-Ideen werden in den 1920er Jahren von Teilen der deutschvölkischen und nationalsozialistischen Bewegung sowie von rechten Homosexuellen aufgenommen.

Ambivalent Bonds: Homoeroticism and Right-Wing Thinking

In the 1910s, Hans Blüher (1888–1955) caused a stir with writings glorifying the male "eros." Blüher praised homoeroticism as a fundamental element of youth education and state building – including the practice of sexualized violence against children and adolescents. The elitist, anti-feminist, and antisemitic ideas of his Männerbund (League of Men) were taken up in the 1920s by parts of the German nationalist and Nazi movements as well as by right-wing homosexuals.

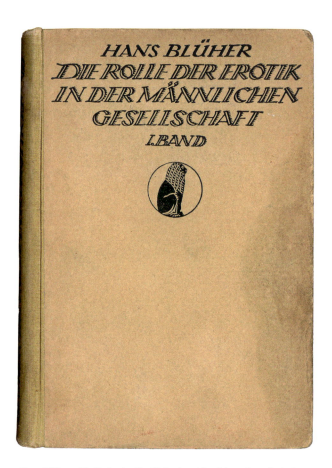

Hans Blüher, *Die Rolle der Erotik in der männlichen Gesellschaft*, 1917/19 | **Hans Blüher,** *The Role of Eroticism in Male Society*, 1917/19

Adolf Brand's idea of an elitist male culture excluded not only women, but all men, who did not conform to the masculine ideal he propagated. Such men were derogatorily referred to as "feminized" and "degenerate." In *Die Tante* (The Aunt), a satirical special edition of *Der Eigene*, Hirschfeld's sexological theory of "sexual intermediates," which proposed men with feminine and women with masculine qualities, is caricatured in a rabidly antisemitic manner. Brand sets Blüher's "Männerheld" (male hero) in contrast to the "Weibling."

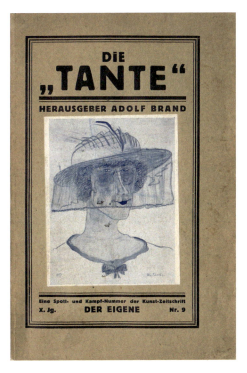

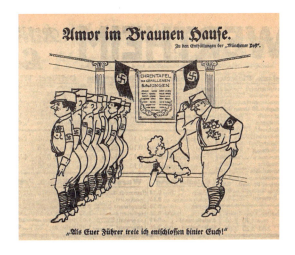

Die "Tante", a satirical and polemical issue of the magazine *Der Eigene*, vol. 10, no. 9, 1925

Caricature in the Social Democratic newspaper *Vorwärts*, vol. 48, no. 293, June 26, 1931

Before the Reichstag elections of 1932, the homosexuality of Ernst Röhm, now chief of staff of the SA (Storm Troopers), was used by various sides in the political fighting against the Nazi Party. The Social Democrats, who were actually in favor of abolishing Paragraph 175, made a scandal out of the homosexuality in the "Röhm case." In an attempt to discredit the antidemocratic SA chief and his troops, they catered to homophobic attitudes in society.

MEETING, MOVING – FORGING BONDS

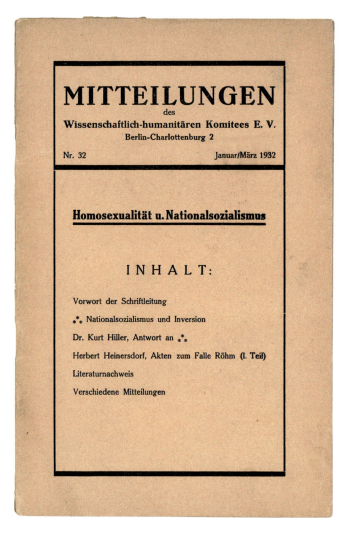

Mitteilungen des Wissenschaftlich-humanitären Komitees, 1932/32 |
Bulletin of the Scientific-Humanitarian Committee, no. 32, 1932

1932 erscheint im Mitteilungsblatt des Wissenschaftlich-humanitären Komitees ein anonymer Beitrag mit dem Titel *Nationalsozialismus und Inversion*. Er stammt von einem homosexuellen SA-Angehörigen, der die Ideologie des homoerotischen Männerbunds anpreist. Die als heroisch beschworene „Freundesliebe" wird darin gegen „Homosexualität" ausgespielt, Letztere mit Hirschfeld, dem verhassten demokratischen Staat, Marxismus und Judentum gleichgesetzt. Die Veröffentlichung ist eine Ausnahme: Die offizielle nationalsozialistische Parteilinie bleibt konsequent homofeindlich.

In 1932, an anonymous article titled "National Socialism and Inversion" appeared in the newsletter of the Scientific-Humanitarian Committee. It was authored by a homosexual SA member and extolled the ideology of the homoerotic *Männerbund*. In it, the "love of friends" was invoked as heroic and contrasted against "homosexuality," equated with Hirschfeld, the hated democratic state, Marxism, and Judaism. The publication remained an exception: the official National Socialist party line was consistently homophobic.

Wiedergabe des vorstehenden Briefes.

München, Herzogstraße 4/3. 3. 12. 28.

Lieber Herr Dr. Heimsoth!

Meinen Handschlag zuvor! Sie haben mich voll verstanden! Natürlich kämpfe ich mit dem Absatz über Moral vor allem gegen den § 175. Sie meinen aber, nicht deutlich genug? Ich hatte in dem ersten Entwurf eine nähere Ausführung über dieses Thema; habe es aber auf den Rat von Freunden, die sich von dieser Art, zu schreiben, mehr Wirkung versprechen, in die jetzige Fassung geändert.

Mit dem Vorwurf, daß ich vor „Zwangsglaubenssätzen", die Ehe betreffend, zurückweiche, tun Sie mir, glaube ich, Unrecht.

Mit dem Herrn Alfred Rosenberg, dem tölpelhaften Moralathleten, stehe ich in schärfstem Kampf. Seine Artikel sind auch vor allem an meine Adresse gerichtet; da ich aus meiner Einstellung kein Hehl mache. Das mögen Sie daraus ersehen, daß „man" sich bei mir eben an diese verbrecherische Eigenheit in den nat. soz. Kreisen gewöhnen hat müssen. Uebrigens arbeite ich auch mit Herrn Radsuweit zusammen und bin natürlich Mitglied seines Bundes.

Blüher würde ich sehr gerne kennenlernen.

Ihr Buch, für das ich Ihnen, ebenso wie für Ihre lieben Zeilen, herzlichst danke, interessiert mich natürlich außerordentlich. Bis jetzt habe ich nur weniges darinnen lesen können; aber offen gestanden: es ist etwas zu schwer für mich. Könnt Ihr verflixten Doktoren nicht deutsch schreiben und müßt immer gelehrte Fremdworte gebrauchen, die ein harmloser Erdenbürger nicht kapiert?

Morgen fahre ich nach Berlin und wohne „Stuttgarter Hof". Wenn wir uns sehen könnten (ich bin bis Freitag in B.), teilen Sie mir's bitte doch ins Hotel mit. Ich würde mich herzlichst freuen, dann mit Ihnen ein paar Stunden plaudern zu können.

Ich danke Ihnen nochmals für Ihre Zeilen und bin Ihr ganz ergebener

Ernst Röhm.

Ernst Röhm an Karl-Günther Heimsoth, 3.12.1928, in: Helmuth Klotz, *Der Fall Röhm*, 1932 | **Ernst Röhm to Karl-Günther Heimsoth, December 3, 1928, in Helmuth Klotz, *Der Fall Röhm*, 1932**

Der frühe Nationalsozialist Ernst Röhm (1887–1934) steht ab 1928 in Kontakt mit Karl-Günther Heimsoth (1899–1934), einem rechtsradikalen und antisemitischen Mediziner und homosexuellen Aktivisten. Heimsoth gehört dem Kreis um Adolf Brand an. Er will Röhm, dessen Homosexualität ihm bekannt ist, als Bundesgenossen innerhalb der NSDAP für den Kampf gegen Paragraf 175 gewinnen.

1931 werden Briefe Röhms an Heimsoth, aus denen seine Homosexualität hervorgeht, bei einer Hausdurchsuchung beschlagnahmt und der SPD zugespielt. Der sozialdemokratische Publizist Helmuth Klotz veröffentlicht den Schriftwechsel 1932, um den politischen Gegner unter Druck zu setzen.

Since 1928 Ernst Röhm (1887–1934), an early Nazi, was in contact with Karl-Günther Heimsoth (1899–1934), a right-wing radical and antisemitic physician and homosexual activist. Heimsoth belonged to the circle around Adolf Brand. He wanted to win Röhm, whose homosexuality was known to him, as an ally within the Nazi party for the struggle against Paragraph 175.

Röhm's letters to Heimsoth, which reveal his homosexuality, were confiscated in 1931 during a house search and leaked to the SPD. The Social Democratic publicist Helmuth Klotz published the correspondence in 1932 in order to put pressure on his political opponents.

MEETING, MOVING – FORGING BONDS

TREFFPUNKTE

In den 1920er Jahren entwickelt sich eine lebendige Szene für Homosexuelle und trans* Personen. Vor allem in den Großstädten entsteht eine Reihe von Vereinslokalen, Bars und Clubs, die als Treffpunkte dienen. Unangefochtener Mittelpunkt queeren Lebens ist Berlin. Die Polizeibehörden verfolgen dort seit Ende des 19. Jahrhunderts einen liberaleren Kurs als andernorts. Nahezu 200 subkulturelle Orte sind zwischen 1919 und 1933 in der Reichshauptstadt nachgewiesen, davon rund 80 für lesbische Frauen.

Im konservativen München gibt es, wie in kleineren Städten und im ländlichen Raum, nur einzelne Lokale. Homosexuelle Männer sind wegen der anhaltenden strafrechtlichen Verfolgung auf informelle Treffpunkte angewiesen. Sie nutzen öffentliche Parks und Toiletten (Klappen), um Kontakte zu knüpfen oder Sex zu haben. Dabei laufen sie stets Gefahr, polizeilich kontrolliert und angezeigt zu werden.

MEETING PLACES

A lively scene for homosexuals and trans+ people emerged in Germany during the 1920s. Especially in major cities, a number of clubhouses, bars, and clubs functioned as meeting places. The undisputed center of queer life was Berlin. Police authorities there followed a more liberal course than elsewhere after the end of the nineteenth century. Nearly two hundred subcultural venues are documented in the imperial capital between 1919 and 1933, about eighty of them for lesbian women.

In conservative Munich, as in smaller cities and rural areas, fewer venues existed. Homosexual men had to resort to informal meeting places, due to ongoing persecution by the authorities. They used public parks and toilets as "pick-up spots" to socialize or have sex. In doing so, they always ran the risk of being denounced or stopped by the police.

Der Schwarzfischer ist eines der wenigen bekannten Szenelokale in München. Zwischen 1928 und Mitte der 1930er Jahre treffen sich hier vor allem schwule Männer und trans* Personen. Das Lokal wird von der Polizei überwacht und ist stets von Razzien bedroht.

The Schwarzfischer is one of the few known gay venues in Munich. Between 1928 and the mid-1930s, it was a gathering spot primarily for gay men and trans+ people. The bar was under surveillance by the police and constantly threatened with raids.

Anzeige des Schwarzfischer, in: *Das 3. Geschlecht*, 1931/4 | Advertisement for the Schwarzfischer, *Das 3. Geschlecht*, no. 4, 1931

Gaststätte Schwarzfischer in der Dultstraße am Oberanger, München, Innenansicht von 1925 | Schwarzfischer Inn on Dultstrasse at Oberanger, Munich, interior view from 1925

MEETING, MOVING – FORGING BONDS

In der Berliner Szene, aber auch in anderen Städten entstehen zahlreiche schwule und lesbische Clubs, die sich in Lokale einmieten, zu geselligen Unternehmungen aufrufen, aber auch ausdrücklich politisch-emanzipatorische Ziele verfolgen. Einer der größten „Damenklubs" ist der 1926 in Berlin ins Leben gerufene Damenklub Violetta mit über 400 Mitgliedern.

Numerous gay and lesbian clubs emerged In the Berlin gay scene, but also in other cities – renting premises, calling for social activities, but also pursuing explicitly political-emancipatory goals. One of the largest "ladies' clubs" was the Damenklub Violetta, founded in Berlin in 1926, with over four hundred members.

Ein Maskenball im Damenklub Violetta, in: *Frauenliebe*, 2. Jg., 1927/8 | "A masked ball at the Damenklub Violetta," in *Frauenliebe*, vol. 2, no. 8, 1927

Gründerin des Damenklubs Violetta ist die lesbische Aktivistin Lotte Hahm (1890–1967), die auch für *Die Freundin* schreibt. Gemeinsam mit ihrer jüdischen Lebensgefährtin Käthe Fleischmann (1899–1967) betreibt sie in Berlin unter anderem das Lesbenlokal Monokel-Diele. Nach 1933 versuchen beide zunächst, lesbische Netzwerke und Treffpunkte unter Tarnbezeichnungen aufrechtzuerhalten. Fleischmann, als Jüdin verfolgt, überlebt die NS-Zeit in verschiedenen Verstecken.

The founder of the Damenklub Violetta was the lesbian activist Lotte Hahm (1890–1967), who also wrote for *Die Freundin*. Together with her Jewish partner Käthe Fleischmann (1899–1967), she managed, among other venues, the lesbian pub Monokel-Diele in Berlin. After 1933, they initially tried to keep lesbian networks and meeting places alive using cover names. Fleischmann, persecuted as a Jew, survived the Nazi period in various hiding places.

Einladungen zu Monokelfesten des Damenklubs Violetta in Berlin und der Damen-Vereinigung Geselligkeit in Chemnitz, in: *Die Freundin*, 1929/20 und *Garçonne*, 1931/9 | **Invitations to monocle parties at the Damenklub Violetta in Berlin and the ladies' association Geselligkeit in Chemnitz, in** *Die Freundin*, **no. 20, 1929, and** *Garçonne*, **no. 9, 1931**

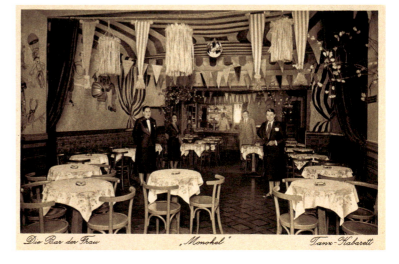

Innenansicht der Monokel-Diele in der Budapester Straße 14, Berlin-Tiergarten, Ansichtskarte, frühe 1930er Jahre | **Interior view of the Monokel-Diele at Budapester Strasse 14, Berlin-Tiergarten, picture postcard, early 1930s**

Beliebtes Accessoire lesbischer Frauen: Tanzmonokel in Originaltüte, 1920er Jahre | **A popular accessory of lesbian women: dance monocle in the original case, 1920s**

Monokel, kurze Haare, Krawatte, Frack und Zylinder sind Erkennungszeichen innerhalb eines Teils der lesbischen Szene – und bald auch unter modernen heterosexuellen Frauen verbreitet. Die „Neue Frau" der 1920er Jahre löst sich von traditionellen Geschlechterbildern und eignet sich neue, bislang männlich besetzte Dinge und Räume an.

Monocles, short hair, ties, tailcoats, and top hats served as identifying features within a part of the lesbian scene – and soon became common among modern heterosexual women. The "New Woman" of the 1920s freed herself from traditional gender images and appropriated new objects and spaces previously occupied by men.

MEETING, MOVING – FORGING BONDS

Auch für „Transvestit*innen" – Menschen, die die Kleidung des jeweils anderen Geschlechts bevorzugen, darunter trans* Personen, entsteht in den 1920er Jahren eine eigene Infrastruktur. Zum deutschlandweiten Anziehungspunkt wird das Maßatelier von Hella Knabe (1879–?). Die Friseurin und Schneiderin, deren Ehemann selbst „transvestitisch" veranlagt ist, annonciert nicht nur in Szene-Blättern, sondern auch in überregionalen Zeitschriften wie *Die Jugend* und *Simplicissimus*.

A dedicated infrastructure emerged in the 1920s for "transvestites" – people who preferred the clothing of the other sex, including trans+ people. The tailoring studio of Hella Knabe (1879–?) became a center of attraction for all Germany. The hairdresser and dressmaker, whose husband was himself a "transvestite," advertised not only in gay newspapers, but also in national magazines such as *Jugend* and *Simplicissimus*.

Transvestiten! Frau Dr. Hella Knabe „Die Helferin der Transvestiten", Berlin W, Habsburgerstraße 4, Hochparterre, Pallas 3730. (Spezialarzt immer zur Verfügung.) Aus meiner Preisliste: Perücken nach Maß von 30 bis 120 Mk., Korsetts von 2.50 bis 30 Mk. Die perfekte Pariser „Lia-Büste" 20 Mk. Die letzte ärztliche Erfindung! „Emikreme". Geprüftes Mittel zur Entwicklung der Büste. Erfolg schon in 2 Monaten, Preis der Dose 10 Mk., portofrei, Kurpackung 3 Dosen 25 Mk., portofrei. Große Auswahl von Kleidern, Mänteln, Hüten, Schuhen, Unterwäsche usw., zu Kaufhauspreisen. Friseur-, Schönheitsalon und Schneider-Atelier im Hause. Angeschlossen Garderoben-Verleih und Umkleideräume. Jeden Nachmittag geselliges Zusammensein in meinem Privatzirkel. Auskünfte und Beratung diskret und kostenlos. Bei schriftlichen Anfragen, Rückporto beilegen. Alle Sendungen erfolgen in unauffälliger Verpackung.

Werbeanzeige Hella Knabe, in: *Die Freundin*, 1931/39 | Advertisement Hella Knabe, in *Die Freundin*, no. 39, 1931

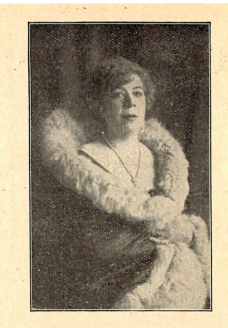

Allen meinen lieben Kunden und verehrten Freunden nah und fern wünsche ich ein frohes Weihnachtsfest und ein glückliches neues Jahr. Die Helferin d. Transvestiten Frau Dr. Hella Knabe Berlin W 30, Habsburgerstraße 4, hochptr. Telefon Pallas B 7 3730

Anzeige des Maßateliers Hella Knabe, in: *Die Freundin*, 31.12.1932 | Advertisement for the tailoring studio of Hella Knabe, in *Die Freundin*, December 31, 1932

Verkaufsbroschüre des Maßateliers Hella Knabe, 1930er Jahre | **Sales brochure from the tailoring studio of Hella Knabe, 1930s**

Hella Knabe fertigt für ihre Kundschaft Damenunterwäsche, künstliche Büsten und Korsetts an und betreibt einen Versandhandel. Daneben empfängt sie Pensionsgäste bei sich, kleidet sie ein, schminkt sie und ermöglicht ihnen kurzzeitig ein Leben im anderen Geschlecht. Auch nach 1933 offeriert sie ihre Dienste und hält durch eine eigene Zeitschrift mit subkulturellen Inhalten Kontakt mit ihren Kund*innen. 1938 wird sie deshalb wegen Verbreitung „unzüchtigen Schrifttums" zu einer Geldstrafe verurteilt.

Hella Knabe made women's underwear, false breasts, and corsets for her clients, and ran a mail-order business. In addition, she had boarding house guests in her home, whom she dressed up, applied make-up to, and enabled them to briefly live in the opposite sex. Even after 1933 she continued to offer her services, keeping in touch with her customers through her own magazine, which offered subcultural content. In 1938, she was sentenced to a fine for disseminating "lewd literature."

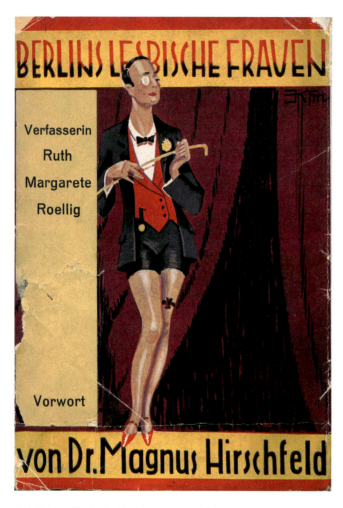

Ruth Roellig, *Berlins lesbische Frauen*, 1928 |
Ruth Roellig, *Berlin's Lesbian Women*, 1928

Ruth Roelligs (1878–1969) Buch gibt die Vielfalt lesbischer Orte und Netzwerke in der Stadt wieder. Die selbst in einer Frauenbeziehung lebende Schriftstellerin ist eine Kennerin der Szene und durch Artikel in einschlägigen Zeitschriften bekannt. Mit ihrem Stadtführer will sie einen Beitrag zur Sichtbarkeit lesbischen Lebens leisten.

Ruth Roellig's (1878–1969) book reflects the diversity of lesbian places and networks in the city. The writer, who herself lived in a relationship with a woman, was a connoisseur of the scene and was known for her articles in relevant magazines. She strove to contribute to the visibility of lesbian life with her city guide.

Das 1926 in der Lutherstraße in Berlin-Schöneberg eröffnete Eldorado ist – samt seinem Pendant, dem „neuen Eldorado" in der Motzstraße – eines der auch international bekanntesten Szenelokale seiner Zeit. Magnus Hirschfeld, Claire Waldoff, Anita Berber und Marlene Dietrich besuchen das Eldorado oft und gern, ebenso der prominente Nationalsozialist Ernst Röhm. Mit seinen Shows zieht es ein zahlungskräftiges Publikum an, das bald nicht nur aus Homosexuellen und trans* Personen besteht, sondern vor allem aus schaulustigen Heterosexuellen.

The Eldorado, which opened in 1926 in Lutherstrasse in the Berlin quarter of Schöneberg, along with its counterpart, the New Eldorado in Motzstrasse, is one of the most internationally known gay clubs of its time. Magnus Hirschfeld, Claire Waldoff, Anita Berber, and Marlene Dietrich were frequent visitors to the Eldorado, as was the prominent Nazi Ernst Röhm. Its shows drew an affluent audience that soon consisted not only of homosexuals and trans+ people, but also, and indeed mainly, of curious heterosexuals.

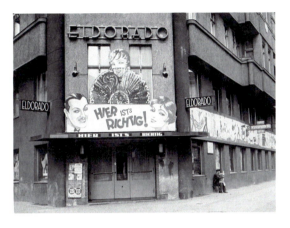

Das Eldorado in der Motzstraße, Ecke Kalckreuthstraße, 1932 | **The Eldorado in Motzstrasse, corner of Kalckreuthstrasse, 1932**

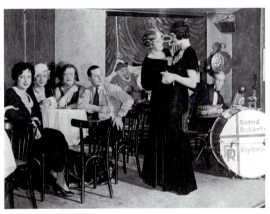

Im Eldorado in Berlin, 1926 | **In the Eldorado in Berlin, 1926**

Jeton aus dem Eldorado mit gleichgeschlechtlichem Tanzpaar, um 1930 | **Token from the Eldorado with same-sex dancing couple, ca. 1930**

Die Gäste können Jetons erwerben, die sich gegen einen Tanz mit den „transvestitischen" Angestellten des Eldorado eintauschen lassen.

Patrons could purchase tokens that could be exchanged for a dance with the Eldorado's "transvestite" employees.

MEETING, MOVING – FORGING BONDS

ZEITSCHRIFTEN UND INFORMELLE NETZWERKE

Zeitschriften sind ein wichtiges Kommunikationsmittel der queeren Subkulturen. Sie verweisen auf einschlägige Lokale, Buchhandlungen und Vereinigungen und dienen als Kontaktbörsen. Vor allem für queere Menschen im ländlichen Raum, wo es keine funktionierenden Netzwerke gibt, sind diese Hinweise und Möglichkeiten essenziell.

Allerdings müssen die Herausgeber*innen jederzeit mit dem Verbot ihrer Druckerzeugnisse rechnen. Nicht selten werden ganze Auflagen oder Jahrgänge als „Schund- und Schmutzschriften" gekennzeichnet und beschlagnahmt. Um polizeilicher Verfolgung und gesellschaftlicher Ausgrenzung zu entgehen, bedient sich die Szene eigener sprachlicher Codes. Tarnbezeichnungen wie „Freund", „Freundin", „ideale Freundschaft", „freundschaftlicher Gedankenaustausch" oder „idealgesinnt" verweisen auf lesbische und schwule Zusammenhänge.

MAGAZINES AND INFORMAL NETWORKS

Magazines were an important means of communication for queer subcultures. They listed relevant clubs and bars, bookstores, and associations, and served as contact exchanges. These references and opportunities were essential particularly for queer people in rural areas, where there were no functioning networks.

However, the publishers had to reckon with the banning of their print products at any time. It was not uncommon for entire print runs or volumes to be labeled as "trash texts" and confiscated. In order to avoid police persecution and social exclusion, the scene employed its own linguistic codes. Camouflage terms such as "friend," "girlfriend," "ideal friendship," "friendly exchange of ideas," or "ideal-minded" were used to refer to lesbian and gay connections.

Nicht überall werden die Szeneblätter so offen verkauft wie am Potsdamer Platz in Berlin. Die meisten Leser*innen beziehen die Zeitschriften im Abonnement und lassen sie sich im verschlossenen Umschlag zusenden. Zum Teil liegen sie auch in Szenelokalen aus, in München etwa in der Zehner-Diele im Westend. Einige Blätter sind zumindest zeitweise auch am Zeitungsstand vor dem Café Luitpold in der Brienner Straße erhältlich.

Gay magazines were not sold everywhere as openly as they were at Potsdamer Platz in Berlin. Most readers subscribed to the magazines and had them sent to them in sealed envelopes. Some of them were also available in fashionable venues, such as the Zehner-Diele in Munich's Westend district. Some magazines were also available, at least temporarily, at the newspaper stand in front of Café Luitpold in Munich's Brienner Strasse.

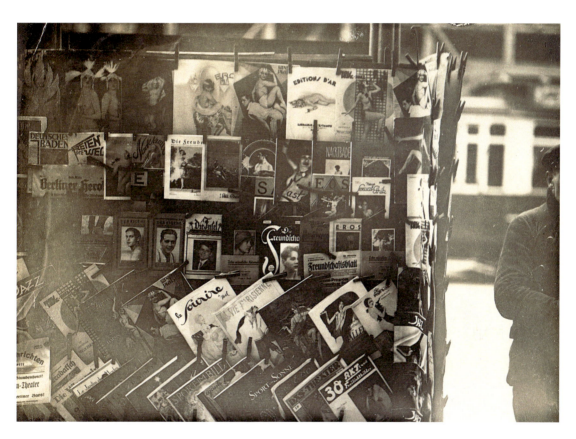

Zeitungsstand am Potsdamer Platz mit den Szenezeitschriften *Der Eigene*, *Die Insel*, *Die Freundschaft*, *Das Freundschaftsblatt* und *Eros*, 1926 | Newsstand at Potsdamer Platz with the gay magazines *Der Eigene*, *Die Insel*, *Die Freundschaft*, *Das Freundschaftsblatt*, and *Eros*, 1926

MEETING, MOVING – FORGING BONDS 105

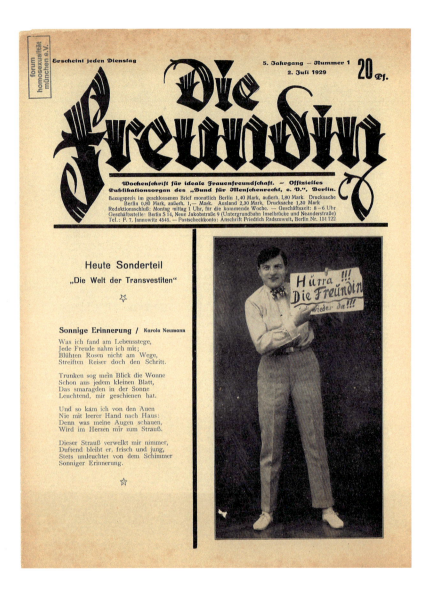

Titelblatt der Lesben-Zeitschrift *Die Freundin*, 5. Jg., 1929/1 | Cover page of the lesbian magazine *Die Freundin*, vol. 5, no. 1, 1929

Die Freundin erscheint von 1924 bis 1933 als Publikationsorgan des Bunds für Menschenrecht und wird im Verlag Friedrich Radszuweit in Berlin herausgegeben. Neben der Konkurrentin *Frauenliebe* und mit einer Auflage von geschätzten 7.000 bis 10.000 Exemplaren ist sie das meistgelesene Blatt unter Lesben und trans* Personen. Wie andere Szeneblätter auch ist *Die Freundin* immer wieder von der Zensur bedroht. 1929 wirbt die Aktivistin Lotte Hahm auf dem Titel der *Freundin* für das nach einem vorübergehenden Verbot wiedererscheinende Blatt.

Die Freundin (The Female Friend) appeared from 1924 to 1933 as the organ of the Bund für Menschenrecht (Alliance for Human Rights) and was published by Friedrich Radszuweit in Berlin. Alongside its competitor *Frauenliebe*, and with a circulation estimated at seven to ten thousand, it was the most widely read magazine among lesbians and trans+ people. Like other gay scene publications, *Die Freundin* was repeatedly threatened by censorship. In 1929, activist Lotte Hahm advertised on the cover of *Die Freundin* for the paper, which reappeared after a temporary ban.

Anzeigen von auf Erpressungen spezialisierter Detekteien, in: *Die Freundschaft,* 1926/2 | Advertisements from detective agencies specializing in blackmail, in *Die Freundschaft*, no. 2, 1926

Subkulturelle Blätter wie *Die Freundschaft* (1919–1933) erreichen eine Auflage von bis zu 50.000 Exemplaren und werden sogar ins Ausland verschickt. Sie liefern wichtige Informationen – wie hier die Adressen von Detektivbüros – und sind für die Vernetzung queerer Menschen und Szenen unverzichtbar.

Subcultural papers such as *Die Freundschaft* (1919–33) reached a circulation of up to fifty thousand copies and were even sent abroad. They provided important information – as in this case the addresses of detective agencies – and were indispensable for the networking of queer people and scenes.

Kontaktanzeigen in einschlägigen Zeitschriften sind vor allem in kleineren Städten und auf dem Land oft die einzige Möglichkeit, Gleichgesinnte zu finden. Der damals 27-jährige Kaufmann Leonhard Junginger aus Heidenheim inseriert 1924 im *Kleinen Blatt*. 1925 wird er wegen Verdacht auf „widernatürliche Unzucht" verhaftet. Bei einer Wohnungsdurchsuchung werden Zuschriften von Männern bei ihm gefunden. Auf der Suche nach Unterstützung wendet er sich an Adolf Brand *(Der Eigene)*, der ihm Hinweise auf Rechtsanwälte und Verteidigungsstrategien gibt.

Lonely hearts ads in relevant magazines were often the only way to find like-minded people, especially in smaller towns and in the countryside. The then twenty-seven-year-old merchant Leonhard Junginger from Heidenheim advertised in the *Kleinen Blatt* in 1924. In 1925, he was arrested on suspicion of "perverse fornication." A police search of his apartment discovered incriminating letters from men. For support, he turned to Adolf Brand *(Der Eigene)*, who gave him advice on lawyers and defense strategies.

Das Kleine Blatt. Monatsschrift für Freundschaft, 1. Jg., 1924/2, mit angestrichenen Kontaktanzeigen | *Das Kleine Blatt. Monatsschrift für Freundschaft*, vol. 1, no. 2, 1924, with underlined personal advertisements

Foto und Zuschrift eines jungen Mannes aus St. Blasien an Leonhard Junginger, 12.9.1924 | Photo and letter from a young man in St. Blasien to Leonhard Junginger, September 12, 1924

ADOLF BRAND **DER EIGENE** KUNSTVERLAG

POSTSCHECKKONTO: BERLIN NW, NR. 51257 • BANKKONTO: CÖPENICKER BANK, DEP.-KASSE FRIEDRICHSHAGEN

MITGLIEDS NUMMER
BITTE AUF JED. ZUSENDUNG ANGEBEN

BERLIN-WILHELMSHAGEN
BISMARCKSTRASSE 7 • TELEFON: AMT ERKNER NR. 43 ____ 11. Februar 1925

Herrn

Leonhard Junginger,

Heidenheim, a.d.Br.

Sehr geehrter Herr Junginger!

Ihre Briefe v.26.11.,v.3.1. und ebenso den letzten,indem Sie mich
nach einem Rechtsanwalt fragen,habe ich erhalten.

Ich hätte Ihnen gern geholfen und Ihnen Ihre Wünsche erfüllt,wenn
Sie nur Zeit und Geduld gehabt hätten. Nun scheinen Sie eine Dummheit ge-
macht zu haben,weil ich nicht gleich auf Ihre Wünsche eingegangen bin.Und
da Sie sich nicht offen und ehrlich aussprechen in Ihrem letzten Briefe,
weiss ich auch nicht einmal,was vorgefallen ist.

Leider muss ich Ihnen mitteilen,dass jetzt kaum ein Tag vergeht,an
dem nicht mehrere meiner Anhänger mir mitteilen,dass sie im Gefängnis sitze
oder dass und dort wegen § 175 Denunziationen oder Verhaftungen vorgekommen
sind. Ein Verfolgungswahnsinn gegen die sogenannten Homosexuellen ist im
Gange,wie er noch niemals in Erscheinung getreten ist. Und ich müsste ein
Krösus sein,wenn ich persönlich aus eigenen Mitteln helfen sollte,jedesmal
einen Rechtsanwalt zu stellen.

Die Gemeinschaft der Eigenen ist angesichts der vielen Strafverfol-
gungen auch nicht in der Lage. Und ein Berliner Rechtsanwalt,der nach Wür-
ttemberg reisen müsste,würde natürlich viel zu teuer kommen. Ich könnte Ih-
nen natürlich ausserordentlich Herrn Rechtsanwalt Walter Bahn empfehlen,der
in Berlin,Alt Moabit 10 b wohnt. Bei ihm wäre Ihre Verteidigung in guten
Händen. Aber er ist in Strafprozessen einer der gesuchtesten Anwält in Ber-
lin,und Sie müssen darauf gefasst sein,dass Sie ihn anständig zu bezahlen
haben. Sollten Sie sich dagegen dazu entschliessen,einen dortigen Anwalt zu
nehmen--vielleicht wenden Sie sich an einen der drei Rechtsanwälte: Angst,
Benz oder Rehn in Heidenheim-- und den einen oder den andern mit Ihrer Ve-
teidigung betrauen,so teilen Sie mir seine Adresse sofort mit,damit ich ihm
mit Rat und Tat zur Seite stehen kann.

Verlieren Sie vor allen Dingen nicht den Kopf,sondern denken Sie
daran,dass jetzt jeder sein Schicksal mutig zu tragen hat,und dass es so
wie Ihnen Tausenden geht.

Wenn Sie nichts weiter begangen haben,als gegenseitige Onanie,so
können Sie nicht bestraft werden. Jeder andere geschlechtliche Verkehr
zwischen Mann und Mann dagegen würde nach reichsgerichtlicher Entscheidung
strafbar sein.

Mit allen guten Wünschen für Sie und Ihre Sache recht herzlich
Ihr *Adolf Brand*
Der Eigene

Empfehlungen von Adolf Brand an Leonhard Junginger, 11.2.1925 |
Recommendations from Adolf Brand to Leonhard Junginger, February 11, 1925

NICHOLAS GRAFIA

Nicholas Grafias (*1990, Philippinen) Zeichnungen rücken Figuren, Orte und Praktiken queeren Lebens in den Fokus, die oft aus Prozessen der Erinnerung ausgeschlossen bleiben. Er nimmt Bezug auf die vielfältige homosexuelle Subkultur, die sich im Berlin der Weimarer Republik entwickelte, zahlreiche internationale Wegbegleiter*innen, Sextourist*innen und Schaulustige anzog und Schriftsteller*innen wie Christopher Isherwood dazu anregten, in ihren Arbeiten der Szene ein Denkmal zu setzen. Er verweist aber auch auf die Verfolgungen von Menschen aufgrund ihrer Sexualität während des Nationalsozialismus, die fehlende Anerkennung in den Nachkriegsjahren und Stigmatisierungen im Kontext der Aids-Krise. Mit seinen an Comics erinnernden, seriellen Tintenzeichnungen schafft er visuelle Narrative, die die Protagonist*innen selbst zum Sprechen bringen. Das ihnen anmutende Groteske, Exzentrische und Verzerrte verweist auf das Maskieren, Verstellen und Verbergen, das ein queerfeindliches Umfeld häufig erforderte und noch immer erfordert. Grafias Arbeit wirft zugleich Fragen danach auf, welche Ausdrucksformen, Gesten und Körper von der Gesellschaft als bedrohlich wahrgenommen werden. Humorvoll deutet er die damit verbundene Gewalt in Momente der Selbstbestimmtheit um.

Nicholas Grafia arbeitet mit Performances, Malerei, Installationen und zeitbasierten Medien. In seinen Werken befragt er die kollektive Erinnerung, die Konstruktion von Fremdbildern und damit verbundene rassistische wie sexuelle Zuschreibungen sowie den Ein- und Ausschluss von Subjekten in Rechtssysteme und Geschichtsschreibung.

Nicholas Grafia's (b. 1990, Philippines) drawings focus on figures, places, and practices of queer life that often remain excluded from processes of memory. He makes reference to the varied homosexual subculture that developed in Berlin during the Weimar Republic, which attracted numerous international participants, sex tourists, and onlookers, and inspired writers such as Christopher Isherwood to celebrate the scene in their works. But he also refers to the persecution of people on account of their sexuality during the Nazi period, the lack of recognition in the postwar years, and stigmatization during the AIDS crisis. Grafia creates visual narratives that allow the protagonists themselves to speak in his serial ink drawings, which evoke comic art. The grotesque, eccentric, and distorted elements appearing in them refer to the masking, dissimulation, and concealment that a queer-hostile environment often required and still requires today. Grafia's work simultaneously raises questions about which expressions, gestures, and bodies are perceived by society as threatening. He humorously reinterprets the violence involved into moments of self-determination.

Nicholas Grafia works in performance, painting, installation, and time-based media. In his works he questions collective memory, the construction of images of others, and associated racist and sexual attributions, as well as the inclusion and exclusion of subjects in legal systems and historiography.

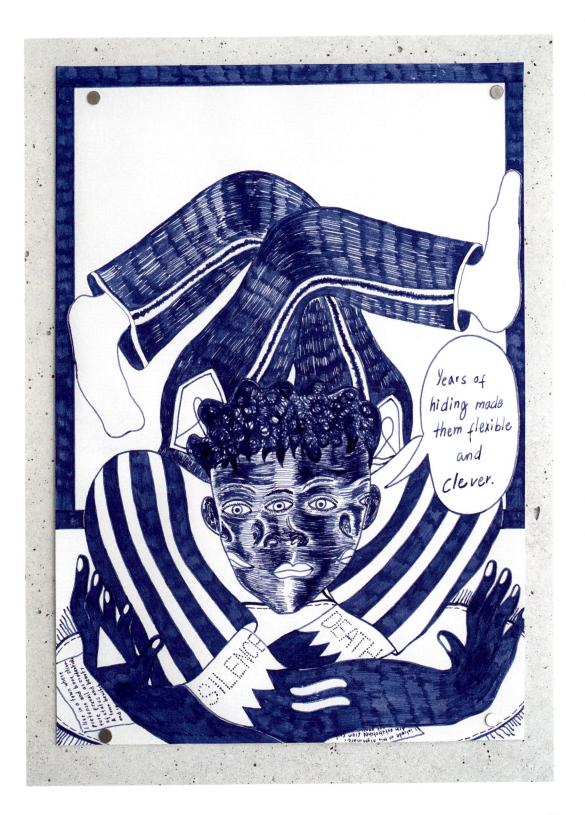

Partners in Crime, seit 2019 (fortlaufend) | since 2019 (ongoing)
Serie von Zeichnungen, Tinte und Tusche auf Papier | Series of drawings, ink on paper
Courtesy the artist and Peres Projects (Berlin, Seoul, Milan)

LENA ROSA HÄNDLE

Lena Rosa Händle (*1978, Deutschland) beschäftigt sich mit Fragen von (queer-feministischen) Sichtbarkeiten und verschränkt dabei soziale Realitäten und kulturelle Codes mit utopischen Momenten. Ihre Arbeiten reflektieren soziale, politische, historische und ökologische Gegebenheiten für eine lebbare Zukunft.

Für ihre Arbeit *Mädchen unter Bäumen* greift Lena Rosa Händle auf das Motiv eines Wandteppichs zurück, den Schülerinnen 1941 im damals für Mädchen verpflichtenden Handarbeitsunterricht in mühevoller gemeinschaftlicher Arbeit bestickten.

Händle fügt dem Motiv zwei Kontaktanzeigen aus der 1942 in Wien erschienenen *Wochenschau* hinzu: „Fräulein sucht Briefwechsel mit Freundin unter modern" und „Dame wünscht Freundin zwecks Kino und Theater". Inserate wie diese sind Zeugnisse für die wenigen verschlüsselten Zeichen lesbischer Subkultur während der NS-Zeit. Begriffe wie „Fräulein", „Freundin" und „Dame" dienten als lesbische Erkennungscodes, ebenso wie die Farben Lila und Violett. Im Zusammenspiel des eingestickten Zitats auf dem Wandteppich mit den verschlüsselten Bedeutungen der in den Zeitungsannoncen verwendeten Begriffe verweist die Künstlerin sensibel auf Themen wie politische Machtstrukturen, gesellschaftlich erzwungene Erwartungshaltungen und die daraus resultierende Subtilität lesbischer Ästhetik.

Lena Rosa Händle (b. 1978, Germany) is concerned with questions of (queer-feminist) visibilities, interweaving social realities and cultural codes with utopian elements. Her works are critical reflections on the social, political, historical, and ecological conditions for a livable future.

For her work *Mädchen unter Bäumen* (Girls under Trees), Lena Rosa Händle uses the motif of a tapestry that schoolgirls embroidered in 1941 in painstaking collaborative work during the handicrafts classes that were compulsory for girls at the time.

Händle adds two classified ads from the 1942 Vienna *Wochenschau* to the motif: "Young woman looking for correspondence with female friend under modern" and "Lady seeks female friend for movies and theater." Advertisements like these are evidence of the few coded signs of lesbian subculture during the Nazi era. Terms like "Fräulein" (young woman, "Freundin" (female friend), and "Dame" (lady) served as lesbian identification codes, as did the colors purple and violet. By juxtaposing the embroidered quotation on the tapestry with the coded meanings of the terms used in the newspaper advertisements, the artist subtly refers to themes such as political power structures, socially enforced expectations, and the resulting nuances of lesbian aesthetics.

Mädchen unter Bäumen | Girls under Trees, 2016
Digitaldruck auf Polyacryl, Stickerei | Digital print on polyacrylic, embroidery
Courtesy the artist

Claude Cahun, *Sans titre (Mains)*, 1936–1939

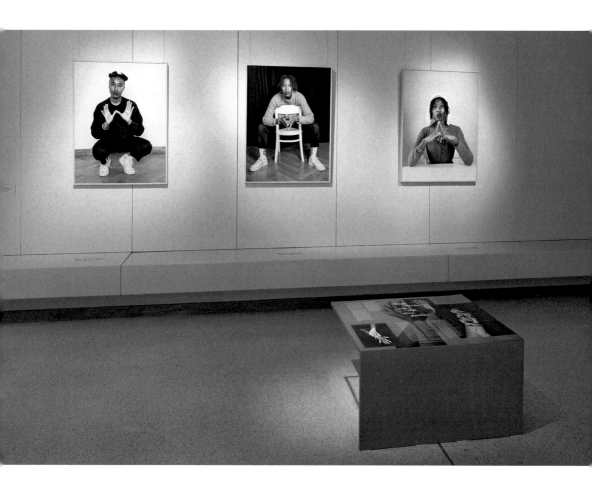

Diese Hände – eine Welt ohnegleichen | *These Hands – An Inimitable World*, 2022
Fotografien: Inkjet-Druck | Photographs: inkjet print
Plakat: Offsetdruck | Poster: offset print
Courtesy the artist

Text auf dem Plakat aus *Hände* von Valery Boothby, *Das Leben*, 7. Jg., 1929/5 |
Poster text from *Hands* by Valery Boothby, *Das Leben*, vol. 7, no. 5, 1929
Modell: Tonica Hunter | Model: Tonica Hunter
Grafik: Lena Rosa Händle, Marie Artaker | Design: Lena Rose Händle, Marije Artaker

Für *TO BE SEEN* erkundet die Künstlerin die Fortschreibung verborgener lesbischer Codes aus den 1920er Jahren bis heute. Händle bezieht sich dabei auf die Tänzerin Tilly Losch (1903–1975), die Malerin Mariette Lydis (1887–1970) und die Künstlerin Claude Cahun (1894–1954) und rückt das Motiv der Hände als Geste und Code von lesbischen Menschen in den Fokus. In ihren Fotografien reinterpretiert Händle zusammen mit der DJane und Kulturproduzentin Tonica Hunter die überlieferten Gesten neu und erinnert an die ersten weiblich geführten Foto-Ateliers der 1920er Jahre. Durch die Kombination des unterschiedlichen Bildmaterials auf dem Plakat treten ihre Fotografien in einen zeitgeschichtlichen Dialog, aktivieren die historischen Codes und bieten den Betrachter*innen die Möglichkeit, jene Gesten in öffentliche und private Räume weiterzutragen.

For *TO BE SEEN* Händle explores the continuity of veiled lesbian codes from the 1920s to the present day. With reference to the dancer Tilly Losch (1903–1975), painter Mariette Lydis (1887–1970), and artist Claude Cahun (1894–1954), she focuses on the motif of hands as lesbian gesture and code. Together with DJane and the cultural producer Tonica Hunter, she reinterprets these historical gestures in her photographs, recalling the first female-managed photo studios of the 1920s. By combining the diverse imagery on a poster, her photographs engage in a dialogue with the historical material, offering the viewer an opportunity to transport these gestures into public and private spaces.

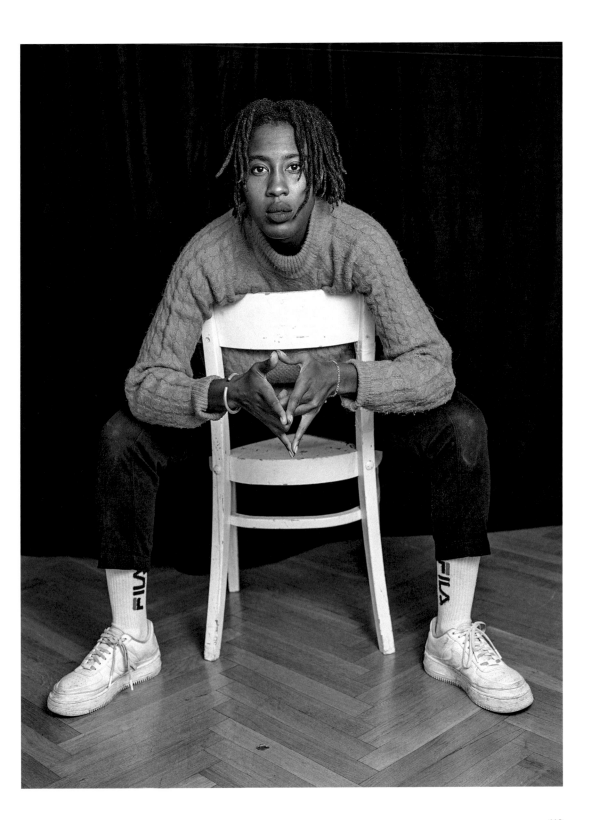

ZOLTÁN LESI & RICARDO PORTILHO

Zoltán Lesi (*1982, Ungarn) und Ricardo Portilho (*1979, Brasilien) arbeiten in ihrer künstlerischen Praxis kollaborativ und spielen mit unterschiedlichen Kontexten aus Kunst, Literatur und Archiv. Zoltán Lesi veröffentlichte bisher zwei Gedichtbände sowie das Kinderbuch *Karton und Matild*. Ricardo Portilho studierte Sozialkommunikation und Grafikdesign an der Universidade Federal de Minas Gerais in Belo Horizonte, Brasilien, und am Sandberg Instituut in Amsterdam. Beide lernten sich während eines Aufenthalts in der Akademie Schloss Solitude kennen.

Der Gedichtband *In Frauenkleidung* ist ein Gemeinschaftswerk von Lyriker und Designer und widmet sich den Lebenswegen intergeschlechtlicher Sportler*innen zu Beginn der 1930er Jahre. Beide Künstler kombinieren in ihrem Buch dokumentarische Sprache mit historischen Fotografien und Zeitungsausschnitten, die auf dem seit 2017 entstandenen Bildarchiv Lesis basieren. Die daraus resultierende, surrealistisch anmutende Collage stellt mithilfe historischer Distanz Fakten, Konstruktion und Wahrheit auf humorvolle und zugleich sensible Weise infrage. Parallel zu der Publikation entstand die Audioinstallation *Ein Sprung und der Hummer*, die in Form einer dadaistisch inspirierten Assemblage nach Joseph Cornell die Grenze zwischen Fiktion und Dokumentation der biografischen Geschichten der Sportler*innen verwischt und der narrativen Ebene des Gedichtbands eine weitere Ebene hinzufügt.

Zoltán Lesi (b. 1982, Hungary) and Ricardo Portilho (b. 1979, Brazil) work collaboratively in their artistic practice, playing with different contexts of art, literature, and archive. Lesi has published two volumes of poetry and the children's book *Karton és Matild* (Karton and Matild). Ricardo Portilho studied social communication and graphic design at the Universidade Federal de Minas Gerais in Belo Horizonte, Brazil, and at the Sandberg Instituut in Amsterdam. Both met during a residency at the Akademie Schloss Solitude in Germany.

The poetry collection *In Frauenkleidung* (In Women's Clothing) is a joint work by the lyricist and the designer and is dedicated to the lives of intergender athletes in the early 1930s. In their book, both artists combine documentary language with historical photographs and newspaper clippings drawn from Lesi's image archive, which has been in the making since 2017. The resulting surrealistic collage uses historical distance to question facts, construction, and truth in a humorous yet sensitive way. Parallel to the publication, they have created the audio installation *Ein Sprung und der Hummer* (A Jump and the Lobster) which, in the form of a Dadaist assemblage inspired by Joseph Cornell, blurs the line between fiction and the documentation of the biographies of the athletes, contributing another layer to the narrative level of the book of poems.

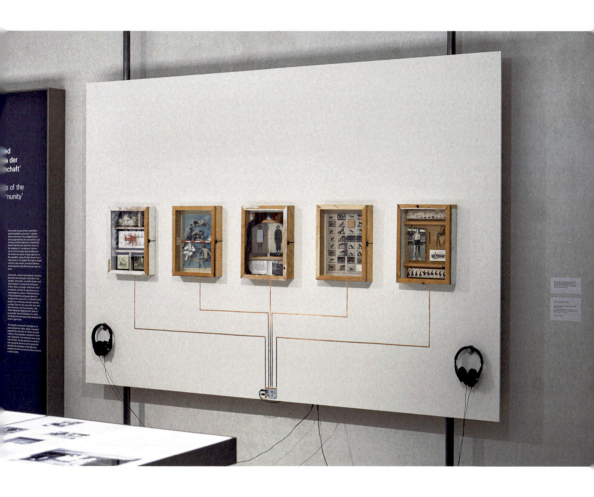

Ein Sprung und der Hummer | *A Jump and the Lobster,* 2018/22
Mixed Media Installation mit Assemblagen, Ton | Mixed media installation with assemblages, sound
Courtesy the artists

121

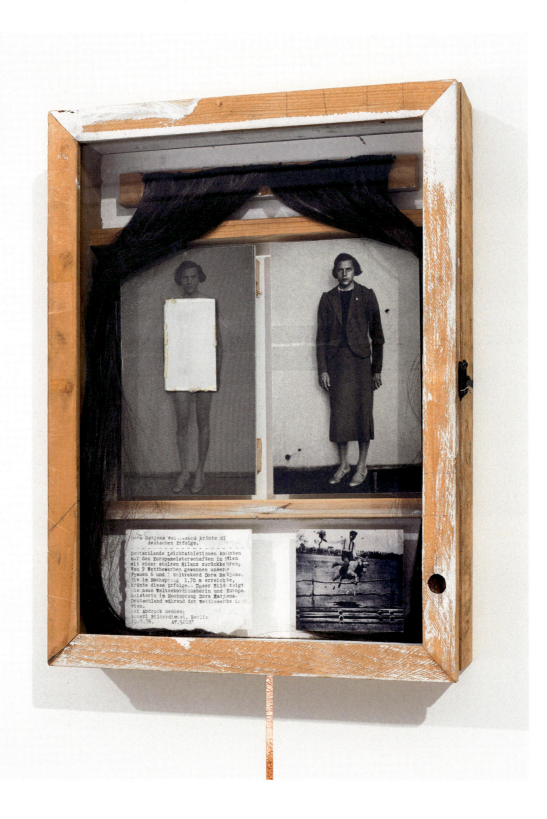

In Frauenkleidung | *In Women's Clothing*, 2019
Buchcollage | Book collage
Courtesy the artists and Edition Mosaik Salzburg

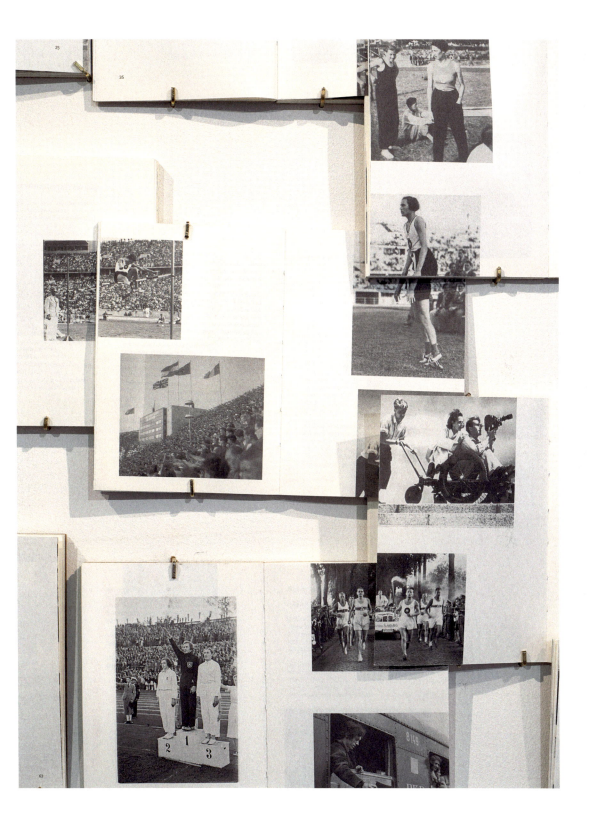

125

GÜRSOY DOĞTAŞ

MISHIMAS RÖHM-AFFÄRE.
EINE MATERIALSAMMLUNG

T-Shirts

Ein Foto vom 25. November 1970 dient Online-Verkaufsplattformen der Rechten in Deutschland, Österreich und den USA als T-Shirt-Motiv. Es zeigt Yukio Mishima mitten in einer Ansprache. Szene eines realen Putschversuchs.

Yukio Mishima (1925–1970) ist nicht nur ein weltberühmter Schriftsteller von kanonisch gewordenen Romanen, Regisseur von Theaterstücken und Spielfilmen und Schauspieler, sondern Anführer sowie Financier der privat-paramilitärischen Organisation *Tate no Kai* (Schildgesellschaft), die nichts Geringeres will als die Wiedereinführung der Kaiserherrschaft in Japan.

An jenem Novembertag im Jahr 1970 besetzt Mishima mit einigen Kadetten seiner kleinen Miliz das Hauptquartier der japanischen Selbstverteidigungskräfte *(Jieitai)* in Tokio. Er steigt auf die Brüstung des Balkons und spricht zu dem im Hof versammelten *Jieitai*-Soldaten. Eine autoritäre Handgeste lässt das Gesprochene erahnen. Die zu seiner Uniform passende geschwungene Schirmmütze hat Mishima für diesen Anlass gegen ein Stirnband mit dem mittelalterlichen Samurai-Schlachtruf *shichishō hōkoku* (Diene der Nation sieben Leben lang) ausgetauscht. Das nationalistische Motiv der Sonne in der Mitte des Stirnbands greift auch das T-Shirt gesondert auf. Um Mishimas Konterfei im Zentrum entwickelt sie sich zum Strahlenkranz und nimmt die Vorderseite des Shirts ein. Die Erhöhung, die Mishima hier zuteilwird, fußt auf einer Selbstaufopferung nach dem Vorbild der Piloten der Kamikaze-Spezialangriffstruppe während des Pazifikkrieges (1941–1945). So wie sie dem Schlachtruf folgend Suizid begingen, so nimmt sich auch Mishima am gleichen Tag seiner Rede das Leben. Sein Adjutant und mutmaßlicher Liebhaber Masakatsu Morita folgt ihm in den Tod.

Die „Nipster" – eine Wortschöpfung aus Neonazi und Hipster – tragen ihre suizidale Kultfigur Mishima auf eng geschnittenen T-Shirts. Bevor Mishima ins Pantheon der internationalen „Neuen Rechten" aufrückte, hatte er sich wiederum zu seinen Lebzeiten – sei es als Schriftsteller oder Regisseur – von allen möglichen rechten Persönlichkeiten Europas begeistern lassen. Angefangen mit Gabriele d'Annunzio, dem Ideengeber des italienischen Faschismus, über Otto Weininger und dessen misogynes Hauptwerk *Geschlecht und Charakter* (1903) bis hin zum führenden Nationalsozialisten und Stabschef der SA Ernst Röhm.

Uniformen

Das Leben von Mishima schreibt Geschichte, indem es Fiktion in Realität verwandelt.

Am 31. Januar 1969 wurde in der Kinokuniya Hall in Tokio das Theaterstück *Mein Freund Hitler (Waga tomo Hittorā)* nach einer zweiwöchigen

GÜRSOY DOĞTAŞ

MISHIMA'S RÖHM AFFAIR: A MATERIAL COLLECTION

T-shirts
A photograph from November 25, 1970, serves as a T-shirt motif for right-wing online sales platforms in Germany, Austria, and the US. It depicts Yukio Mishima (1925–1970) in the middle of a speech: the scene of an actual putsch attempt.

Mishima was not only a world-famous author of canonical novels, a director of plays and feature films, and an actor. He was also the leader and sponsor of the private paramilitary organization *Tate no Kai* ("Shield Society"), which strove for nothing less than the re-instatement of imperial rule in Japan.

On that November day in 1970, Mishima and a few cadets from his small militia occupied the headquarters of the Japanese Self-Defense Forces (*Jieitai*) in Tokyo. The photograph depicts him standing on the balustrade of the balcony as he speaks to the *Jieitai* soldiers gathered in the courtyard. An authoritarian hand gesture alludes to what is being said. For this occasion, Mishima has substituted the curved visor cap belonging to his uniform with a headband bearing the medieval samurai battle cry *shichishō hōkoku* (serve the nation for seven lifetimes). The nationalist motif of the sun in the center of the headband is repeated on the T-shirt, growing into a halo of rays surrounding Mishima's face at the middle and occupying the front of the T-shirt. The exaltation bestowed upon Mishima here is based on the self-sacrifice of the pilots of the Kamikaze Special Attack Force during the Pacific War (1941–45). Just as they committed suicide while uttering the battle cry, on the same day of his speech Mishima also took his own life. His aide-de-camp, and presumed lover, Masakatsu Morita, followed him to his death.

The "nipsters" – a neologism combining neo-Nazi and hipster – wear their suicidal cult figure of Mishima on tight-fitting T-shirts. Before Mishima ascended to the pantheon of the international "New Right," he had in turn been inspired during his lifetime – whether as writer or director – by all manner of right-wing figures in Europe, from Gabriele D'Annunzio, the generator of ideas for Italian fascism, to Otto Weininger and his misogynist magnum opus *Geschlecht und Charakter* (Sex and Character, 1903), to the prominent Nazi and chief of staff of the SA, Ernst Röhm.

Uniforms
Mishima's life makes history by turning fiction into reality.

On January 31, 1969, the play *My Friend Hitler* (Waga tomo Hittorā) was performed for the last time after a two-week run at Kinokuniya Hall in Tokyo. It is set in June 1934 and ends with the

MEETING, MOVING – FORGING BONDS 127

Spielzeit zum letzten Mal aufgeführt. Es spielt im Juni 1934 und endet mit der „Nacht der langen Messer" vom 30. Juni auf den 1. Juli 1934. Adolf Hitler hatte damals ehemalige Weggefährten, die er mittlerweile als Gefahr ansah, ermorden lassen. Mishima, der Verfasser des Stücks, platziert das Geschehen in der Berliner Reichskanzlei und gruppiert es um die vier Charaktere Adolf Hitler, Gustav Krupp, einem Großindustriellen und Waffenproduzenten, sowie die zwei Opfer der Mordaktion, Gregor Strasser als ehemaligen „Reichsorganisationsleiter" der NSDAP und Ernst Röhm.

Beim Schlussapplaus des letzten Vorhangs betritt Mishima die Bühne und salutiert dem Publikum in der Militäruniform der *Tate no Kai*, so erinnert sich Takeshi Muramatsu, ein ebenfalls rechtsgerichteter Autor und langjähriger Freund Mishimas.[1] Die gelbbraune Uniform zitiert die Farben und Silhouette der Vorkriegsarmee Japans. Zugleich scheint sich Mishima an jenem Abend in die vestimentäre Genealogie des deutschen Faschismus einzureihen: Eine zum Verwechseln ähnlich geschwungene Schirmmütze hatte das Publikum zuvor bei der Figur Röhm gesehen – als hebe Mishima am Ende des Theaterstücks die Grenzen zwischen Fiktion und Realität auf und suggeriere die Kontinuität eines Nazi-Vermächtnisses. Andere Referenzen finden sich in der englischen Übersetzung des Namens *Tate no Kai*: „Shield Society" rekurriert auf die Initialen der nationalsozialistischen Organisation Schutzstaffel (SS).[2]

Manche Anspielungen wiederum sind falsch. Etwa wenn Mishima Röhm in der Uniform der SS auftreten lässt, obwohl dieser die paramilitärische Kampforganisation Sturmabteilung (SA) angeführt hat. Ein schwerer Irrtum, da doch die SS an Röhms Ermordung beteiligt war.

Hauptmann 1
Intoxikiert vom Faschismus übergeht Mishima dessen Verbrechen an der Menschlichkeit.

Muramatsu ist überzeugt, dass Röhm Mishima als Projektionsfläche diente, dessen Homosexualität hingegen streitet er ab. In dem Schriftsteller sieht er allein den Ehemann und Vater von zwei Kindern. Auch Mishima lässt Röhms Homosexualität unerwähnt. Die „Nacht der langen Messer" fügt er in die Struktur seines wiederkehrenden Narrativs von tragischen Loyalitätskonflikten ein, zeichnet ihn als eine Führungspersönlichkeit, die den politischen Moment falsch einschätzt. Im Rückblick ist es ein Scheideweg mit weitreichenden Folgen für das Land.

Mishima heroisiert Röhm als einen treuen Gefolgsmann und Hitler als einen Verräter an den Idealen seiner Bewegung. Am Ende des Stücks lässt der Dramatiker erahnen, dass Hitler den Mord an Röhm propagandistisch verkehren wird. Er lässt Hitler sagen: „[...] am allerschlimmsten und unverzeihlich aber ist, daß Röhm einen Putsch plante. Wenn ich das aufdecke, dann kann das deutsche Volk nicht anders, als meine Maßnahmen gutzuheißen."[3] Was auf die Niederschlagung des sogenannten Röhm-Putsches folgte, lässt Mishima aus. Die Diffamierung, Verfolgung, Inhaftierung und Ermordung in Gefängnissen, Konzentrations- oder Vernichtungslagern von Tausenden Schwulen, egal, ob sie sich als Anhänger, Beamte, Offiziere und Ideologen des Nationalsozialismus in Sicherheit wähnten, ob sie dessen Gegner waren oder sich als unpolitisch verstanden.

Exotisierung
Größer als Mishimas Ultra-Nationalismus ist die phallische Ordnung des weißen Mannes.

Night of the Long Knives from June 30 to July 1, 1934, when Adolf Hitler had former companions, whom he had come to regard as dangerous, murdered. Mishima, the author of the play, situates the action in the Reich Chancellery in Berlin and peoples it with four characters: Adolf Hitler; Gustav Krupp, a leading industrialist and arms manufacturer; and the two victims of the assassinations, Gregor Strasser, the former "Reich Organization Leader" of the Nazi party, and Ernst Röhm.

At the final curtain call, Mishima went on stage and saluted the audience in the military uniform of the *Tate no Kai*, recalls Takeshi Muramatsu, another right-wing author and longtime friend of Mishima.[1] The tawny uniform cited the color and silhouette of Japan's prewar army. At the same time, Mishima seemed to connect with the vestimentary genealogy of German fascism that evening: the audience had seen an almost identical curved visor cap on the figure of Röhm before – as if Mishima were erasing the boundaries between fiction and reality at the end of the play, suggesting the continuity of a Nazi legacy. Other references are found in the English translation of the name *Tate no Kai*: "Shield Society" recurs to the initials of the Nazi organization *Schutzstaffel* (SS).[2]

Some allusions, on the other hand, are mistaken. For example, when Mishima has Röhm appear in the uniform of the SS, even though he actually led the paramilitary fighting organization *Sturmabteilung* (SA): a significant error, since the SS was involved in Röhm's murder.

Captain 1
Intoxicated by fascism, Mishima ignores its crimes against humanity.

Muramatsu was convinced that Röhm served Mishima as a projection screen, but denied his homosexuality. He saw the writer only as a husband and father of two children. Mishima too failed to mention Röhm's homosexuality. He inserted the Night of the Long Knives into the structure of his recurring narrative of tragic conflicts of loyalty, sketching him as a leader who misjudged the political moment. In retrospect, it was a crossroads with far-reaching consequences for Germany.

Mishima heroized Röhm as a loyal follower and Hitler as a traitor to the ideals of his movement. At the end of the play, the author foreshadows that Hitler will turn Röhm's murder into propaganda. He has Hitler say, "But the most terrible and unforgivable thing is that Röhm planned a putsch. If I expose this, then the German people cannot but approve of my measures."[3] Mishima omits what followed the so-called Röhm putsch: the defamation, persecution, imprisonment, and murder in prisons and concentration or extermination camps of thousands of gays, whether they assumed themselves safe as supporters, civil servants, officers, and ideologues of Nazism, whether they were its opponents, or whether they regarded themselves as apolitical.

Exoticization
Greater than Mishima's ultra-nationalism is the phallic order of the white man.

A week after Mishima took his own life, Faubion Bowers, an expert on Japanese theater, wrote the following anecdote in the New York weekly *The Village Voice* on December 3, 1970: "One night Mishima flew

Eine Woche nachdem sich Mishima das Leben genommen hat, schreibt Faubion Bowers, ein Experte auf dem Gebiet des Japanischen Theaters, am 3. Dezember 1970 in der New Yorker Wochenzeitung *The Village Voice* folgende Anekdote: „Eines Nachts flog Mishima nur für Sex nach Amerika [die New-York-Reise von 1964, Anm. des Verf.]. Er kam zu mir und aß mit mir zu Abend. Er beschrieb mir ganz unverblümt, was er wollte, und fragte mich, ob ich ihn an den richtigen Ort führen könnte. [...] Er brauchte an diesem Abend unbedingt einen weißen Mann, und seine Angaben waren sehr detailliert."[4] In einer weiteren Episode kommt Mishima dann in San Francisco auf seine Kosten.

Bowers war während der Besetzung Japans der Adjutant und persönliche Dolmetscher von General Douglas MacArthur. Damals lernten sich die beiden Männer kennen. Mit gerade einmal 20 Jahren fiel Mishima 1945 den weißen schwulen *(faggot)* Soldaten der Besatzungsmacht gleich auf. Weil er anscheinend nicht „japanisch" wirkte, fand ihn der sieben Jahre ältere Bowers attraktiv. Bowers impliziert, dass Mishima erst eine Art Beute der *weißen* Soldaten war, bevor er später, auf den Geschmack gekommen, ihnen hinterherreist. Überlegenheitsrhetoriken der *weißen* Schwulen.

Hitler spielen
Der Tod wird idealisiert, um den Krieg zu beschönigen.

In einer der Inszenierungen spielt Mishima selbst Hitler, den er allerdings nicht als Helden begreift. In einem Statement bekennt er, er sei zwar von ihm fasziniert, aber weder verehre er ihn noch sympathisiere er mit ihm. Den Nazis habe es an der Samurai-Tugend der Selbstaufopferung

gemangelt, so sein Fazit. Kein Wort verliert er zu den Verbrechen der Nazis, ebenso wenig erwähnt er die faschistische Allianz zwischen Deutschland und Japan. Dabei ging die Affinität des NS-Regimes für Japan sehr weit. Die Nazis sahen sogar eine Gesinnungsverwandtschaft zwischen den Samurai und der SS. Die deutschen Autoren preisen ausdrücklich den Ehrenkodex und im Besonderen die Todesbereitschaft der Samurai wie auch der japanischen Soldaten. Das Vorwort zu dem Buch *Die Samurai – Ritter des Reiches in Ehre und Treue* (1942) von Heinz Corazza schreibt Heinrich Himmler, der Reichsführer der SS. Auch er verherrlicht den Tod als Zeichen soldatischer Treue. Aus solchen historischen Linien der Japanrezeption lässt sich auch die heutige Anziehungskraft erklären.

Hauptmann 2
Ein verborgener Bildband aus dem Schrank des Vaters startet die sexuelle Erweckung.

Ahnungslos durchblättert Kochan, der Ich-Erzähler aus Yukio Mishimas *Bekenntnisse einer Maske* (*Kamen no Kokuhaku,* 1949), die Seiten des Bandes. Als er darin ein Blatt mit dem Martyrium des hl. Sebastian von Guido Reni aufschlägt, ist er plötzlich gebannt. Eingehend schaut er sich die Abbildung an. Vor einem düsteren abendlichen Himmel hebt sich der helle Körper eines hübschen Jünglings ab. Seine gekreuzten Hände sind über seinem Kopf an einen Baumstamm gefesselt. Bis auf ein locker sitzendes Lendentuch ist er nackt. Zwei Pfeile durchbohren seinen Körper. Doch schaut der Gemarterte entrückt in „melancholischer Wonne"[5] gen Himmel. Die Qualen der äußersten Agonie, gepaart mit Ekstase, erregen den heranwachsenden Kochan sexuell. Beim Anblick des Heiligen ejakuliert er. Es war das erste

to the United States [in his 1964 trip to New York] just for sex. He came over and had dinner with me. He bluntly described to me what he wanted and asked me if I could lead him to the right place.... He really needed a white man that night and his requirements were very detailed."[4] In a subsequent episode, Mishima gets his money's worth in San Francisco.

Bowers was General Douglas MacArthur's aide-de-camp and personal interpreter during the US occupation of Japan. It was then that the two men met. In 1945, just twenty years old, Mishima immediately caught the eye of the occupying *white* gay ("faggot") soldiers. Because he allegedly did not seem "Japanese," Bowers, who was seven years older, found him attractive. Bowers implies that Mishima was first a kind of prey for white soldiers before he later, having acquired a taste for them, traveled in search of them. The rhetoric of *white* gay superiority.

Playing Hitler
Death is idealized to whitewash the war.

In one of the stage productions, Mishima himself played Hitler, but he did not regard him as a hero. He admitted in a statement that he was fascinated by him, but that he neither worshipped him nor sympathized with him. The Nazis lacked the samurai virtue of self-sacrifice, he concluded. He did not say a word about the crimes of the Nazis, nor did he mention the fascist alliance between Germany and Japan. Yet the Nazi regime's affinity for Japan went deep. The Nazis even identified a kindred spirit between the samurai and the SS. German authors explicitly praised the code of honor and in particular the readiness to die of

the samurai, as well as of the Japanese soldiers. The preface to Heinz Corazza's book *Die Samurai. Ritter des Reiches in Ehre und Treue* (The Samurai: Knights of the Empire in Honor and Loyalty, 1942) was written by Heinrich Himmler, the *Reichsführer* (national leader) of the SS. In it, he too glorifies death as a sign of soldierly loyalty. Such a historical perspective on how Japan has been perceived in the West helps to explain the country's ongoing appeal to the right wing.

Captain 2
A hidden illustrated book from his father's closet initiates a sexual awakening.

Kochan, the first-person narrator of Mishima's *Confessions of a Mask* (Kamen no Kokuhaku, 1949), unsuspectingly flips through the pages of the book. When he opens a page showing the martyrdom of St. Sebastian by Guido Reni, he is suddenly spellbound. He takes a close look at the illustration. The bright body of a handsome youth stands out against a gloomy evening sky. His crossed hands are tied above his head to a tree trunk. Except for a loosely fitting loincloth, he is naked. Two arrows pierce his body. Yet the martyred man looks up to heaven in "melancholy bliss."[5] The agonies of extreme pain, coupled with ecstasy, sexually arouse the adolescent Kochan. At the sight of the saint, he ejaculates. It is the first time he has ever masturbated – according to one of his confessions.

Before Sebastian suffered his martyrdom, he served as a captain under Emperor Diocletian in Rome. He pursued his Christian faith in secret, converting others or ensuring the burial of fellow Christians. When the emperor

MEETING, MOVING – FORGING BONDS 131

Mal, dass er je masturbierte – so eines seiner Bekenntnisse.

Bevor Sebastian sein Martyrium erlitt, diente er unter Kaiser Diokletian als Hauptmann in Rom. Im Geheimen ging er seinem christlichen Glauben nach, bekehrte Menschen oder kümmerte sich um die Bestattung von Gleichgesinnten. Als der Kaiser von diesen verbotenen Taten erfuhr, ließ er Sebastian zur Strafe an einen Baum binden und von Bogenschützen erschießen. Der hl. Sebastian ist bei den Schwulen Europas ein gängiges Motiv oder auch Erkennungszeichen, wie der Sexualwissenschaftler Magnus Hirschfeld feststellte. In seiner Schrift *Die Homosexualität des Mannes und des Weibes* führte er 1914 aus, dass effeminierte Homosexuelle ihre Inneneinrichtung bevorzugt mit entsprechenden künstlerischen Darstellungen dekorieren. Mishima paraphrasiert Hirschfeld in seinem Werk *Bekenntnisse einer Maske*. Die Rechten erliegen ebenfalls diesem Motiv. Den Text *Le Martyre de Saint Sébastien (Das Martyrium des Heiligen Sebastian)*, den Gabriele D'Annunzio, der Ideengeber des (italienischen) Faschismus, 1911 verfasste, übersetzte Mishima sogar ins Japanische.

Für die Erstausgabe des japanischen Magazins *Le Sang et la Rose (Chi to bara)* – einer Zeitschrift „zum umfassenden Studium von Erotik und Grausamkeit" – posiert Mishima 1968 als hl. Sebastian. Es ist Renis Gemälde, das er hier in Gemeinschaftsarbeit mit dem Fotografen Shinoyama Kishin nachstellt. Ein weiteres Foto zeigt ihn als eine ins Meer gespülte nackte Leiche. Zusammen bilden diese Aufnahmen die Serie *Der Tod eines Mannes (Otoko no shi)*. Schon bevor sich Mishima das Leben nimmt, hat er seinen eigenen Tod unzählige Male inszeniert.

Während einer weiteren New-York-Reise bittet Mishima seinen Reiseführer und Kollegen Donald Richie, ihm alle hl. Sebastians der Stadt zu zeigen – in der Kunst wie auch in echten Schwulenbars.

Heimliche Liebe

„Die höchste Form der Liebe liegt darin, die brennende Liebe für sich zu behalten und nicht einmal der geliebten Person sein Herz zu öffnen. […] Die Liebe, die einem Geliebten offenbart wird, wenn man noch lebt, ist nicht tief; mit der geheimgehaltenen Liebe zu sterben, ist die höchste Form der Liebe."[6] Dies sind Weisheiten, die Mishima aus seiner Lieblingslektüre *Hagakure (Verborgen unter den Blättern)* zitiert, einem Buch über den Ehrenkodex der Samurai aus dem frühen 18. Jahrhundert. Der Verfasser Tsunetomo Yamamoto gibt auch Anweisungen zur gleichgeschlechtlichen Liebe – dem *shudo* – zwischen einem angehenden und einem lehrenden Samurai.

Für die SS entfernte Corazza alle Hinweise auf die verborgene und somit wahre Liebe zwischen den Angehörigen des japanischen Kriegeradels.

Shinjū

Manche vermuten, der Suizid von Mishima und Masakatsu Morita sei der Tod zweier Liebender – shinjū.

In seiner Kurzgeschichte *Patriotismus* von 1960 erzählt Mishima vom Liebestod eines fiktiven jungen Ehepaars am Ende eines realen, gescheiterten Februarputsches – dem *Ni-Ni-Roku*-Zwischenfall. Wieder nimmt er den eigenen Tod vorweg. Der Staatsstreich beginnt am 26. Februar 1936 und markiert die Fraktionskämpfe unter den japanischen Streitkräften. Der Leutnant Shinji Takeyama – Anhänger der aufständischen Offiziere – und seine Ehefrau Reiko nehmen sich im privaten Wohnhaus zusammen das Leben. Detailliert beschreibt Mishima den loyalen Suizid

learned of these forbidden actions, he had Sebastian tied to a tree and shot at by archers as punishment. St. Sebastian is a common motif or identifying mark among gays in Europe, as noted by the sexologist Magnus Hirschfeld. In his 1914 paper "The Homosexuality of Man and Woman," he explains that effeminate homosexuals like to decorate their rooms with such pictures. Mishima paraphrases Hirschfeld in his work *Confessions of a Mask*. Right-wingers also succumb to this motif. Mishima even translated into Japanese *Le Martyre de Saint Sébastien* (The Martyrdom of Saint Sebastian), a play written in 1911 by Gabriele D'Annunzio, the supplier of ideas for (Italian) fascism.

In 1968, Mishima posed as St. Sebastian for the first issue of the Japanese magazine *Le Sang et la Rose* (Chi to bara) – a magazine "for the comprehensive study of eroticism and cruelty." It is Reni's painting that he recreated here in collaboration with the photographer Shinoyama Kishin. Another photograph depicts him as a naked corpse floating in the sea. Together, these photographs form the series *The Death of a Man* (Otoko no shi). Before Mishima took his own life, he staged his own death countless times.

During another New York trip, Mishima asked his guide and colleague Donald Richie to show him all the portraits of St. Sebastian in the city – in art as well as in real gay bars.

Secret Love
"The highest form of love lies in keeping one's burning love to oneself and not even opening one's heart to the beloved.... A love revealed to a beloved when one is still alive is not deep; to die with one's love kept secret is the highest

form of love."[6] These are words of wisdom Mishima quoted from his favorite book, *Hagakure* (Hidden among the Leaves), an early eighteenth-century guide to the samurai code of honor. The author, Tsunetomo Yamamoto, also provides instructions on same-sex love – *shudo* – between an aspiring and a teaching samurai.

For the SS, Corazza removed all references to the hidden, and thus true, love between members of the Japanese warrior class.

Shinjū
Some suggest that the suicide of Mishima and Masakatsu Morita was the death of two lovers – shinjū.

In his 1960 short story "Patriotism," Mishima recounts the *Liebestod* of a fictional young couple at the end of a real, failed February coup – the "Ni-Ni Roku" incident. Again, he anticipates his own death. The coup began on February 26, 1936, and reflected factional fighting among the Japanese armed forces. Lieutenant Shinji Takeyama – a supporter of the rebel officers – and his wife Reiko together take their own lives in their home. Mishima describes the lieutenant's loyal suicide in detail. When Mishima filmed the short story six years later, he played Takeyama himself.

Double Superiority
Mishima totalized the virile virtues of the warrior: discipline, muscularity, severity with oneself, and fanatical reverence for the fatherland. To embody these exaggerated values, he sometimes struck monumental poses. Today's right-wing extremists glorify Mishima for this image of masculinity, at

BEGEGNEN, BEWEGEN – BANDEN BILDEN

des Leutnants. Als Mishima sechs Jahre später die Kurzgeschichte verfilmt, spielt er selbst Takeyama.

Doppelte Überlegenheit

Mishima totalisiert die virilen Tugenden des Kriegers: Disziplin, Muskelkraft, Härte gegen sich selbst und fanatische Verehrung des Vaterlandes. Um diese übersteigerten Werte zu verkörpern, erstarrt er bisweilen in monumentalen Posen. Die Rechtsextremen von heute glorifizieren Mishima für dieses Männlichkeitsbild und filtern zugleich dessen homoerotische Schwingungen aus.

In den Männerbünden der Weimarer Republik, zu denen auch Röhm und weitere SA-Mitglieder zählen, herrscht ein ähnliches Überlegenheitsgefühl. Aus dieser elitären Perspektive schauen sie auch auf feminisierte schwule Männer herab, pathologisieren sie als „degeneriert" und „entartet".

Maskulinistische Schwule bedienen auch in der heutigen Zeit ähnliche Rhetoriken, um die linkspolitischen Anliegen von Queeren zu disqualifizieren.

Sterben wie Mishima

Am 21. Mai 2013 erschießt sich Dominique Venner, ein rechtsextremer Historiker, traditionalistischer Katholik und überzeugter Faschist, vor dem Altar der Pariser Kathedrale Notre-Dame in Gegenwart zahlreicher Besucher*innen. Seine Absicht war, auf diese Weise gegen das Inkrafttreten des Gesetzes zur gleichgeschlechtlichen Ehe zu protestieren. Venners Verleger Pierre-Guillaume de Roux beeilt sich zu erklären, dass Venner seinen Tod in einen größeren kulturellen Dienst gestellt habe. Und vergleicht die Tragweite der politischen Botschaft mit Mishimas rituellem Suizid.[7]

Es sind Widersprüche, in die er sich verfängt: Als katholischer Faschist einen schwulen Autor zu verehren und sich an dessen („romantischem") Doppelsuizid ein Beispiel nehmen, um so gegen die „Schwulenehe" ein Zeichen zu setzen …

1 Naoki Inose und Sato Hiroaki, Persona. A Biography of Yukio Mishima, Berkeley 2012, S. 598.

2 Henry Scott Stokes, The Life and Death of Yukio Mishima, New York 2000, S. 232.

3 Yukio Mishima, Mein Freund Hitler, Reinbek 2000, S. 22.

4 Faubion Bowers, A memory of Mishima, in: The Village Voice, URL: https://www.villagevoice.com/2010/11/04/i-knew-mishima-yukio-very-well/ [gelesen am 22.5.2022].

5 Yukio Mishima, Geständnis einer Maske, Reinbek 2002, S. 30.

6 Tsunetomo Yamamoto, Hagakure, München/Zürich 2000, S. 69.

7 Vgl. u.a. Judith Thurman, Dominique Venner's Final Solution, in: The New Yorker, URL: https://www.newyorker.com/news/news-desk/dominique-venners-final-solution [gelesen am 22.5.2022].

the same time filtering out its homoerotic tones.

A similar sense of superiority prevailed in the male alliances of the Weimar Republic, which included Röhm and other SA members. From this elitist perspective, they also looked down on feminized gay men, pathologizing them as "debased" and "degenerate."

Masculinist gays continue to employ a similar rhetoric today to disqualify the leftist political concerns of queer people.

To Die like Mishima

On May 21, 2013, Dominique Venner, a right-wing historian, traditional Catholic, and convinced fascist, shot himself in front of the altar of the Notre Dame cathedral in Paris, in the presence of numerous visitors. His aim was to protest the legalization of same-sex marriage. Venner's publisher, Pierre-Guillaume de Roux, hastened to explain that Venner had put his death to greater cultural service. He compared the impact of the political message with Mishima's ritual suicide.[7]

Such were the contradictions that Venner had become entangled in: a Catholic fascist honoring a gay author and taking his ("romantic") double suicide as a model for taking a stand against "gay marriage."

Author's note: this English version of the essay is a translation from the original German.

1 Naoki Inose and Sato Hiroaki, *Persona: A Biography of Yukio Mishima* (Berkeley, CA: Stone Bridge Press, 2012), 598.

2 Henry Scott Stokes, *The Life and Death of Yukio Mishima* (New York: Cooper Square Press, 2000), 232.

3 Yukio Mishima, *Mein Freund Hitler* (Reinbek: Rowohlt, 2000), 22.

4 Faubion Bowers, "A Memory of Mishima," *The Village Voice* (November 4, 2010), https://www.villagevoice.com/2010/11/04/i-knew-mishima-yukio-very-well/.

5 Yukio Mishima, *Geständnis einer Maske* (Reinbek: Rowohlt, 2002), 30.

6 Tsunetomo Yamamoto, *Hagakure* (Munich/Zurich: Piper, 2000), 69.

7 See Judith Thurman, "Dominique Venner's Final Solution," *The New Yorker* (May 22, 2013), https://www.newyorker.com/news/news-desk/dominique-venners-final-solution.

SANDER L. GILMAN

QUEERE KÖRPERHALTUNG: DIE AMBIGUITÄT DES ANDERSSEINS ERKENNEN

Lillian Curtis Drew von der New Yorker Central School of Physical Education schrieb 1923 in der renommierten Fachzeitschrift *American Physical Education Review* über den zentralen Stellenwert der Körperhaltung als Spiegel des Charakters. Darin berief sie sich auf Robert Louis Stevensons Erzählung *Der seltsame Fall des Dr. Jekyll und Mr. Hyde (The Strange Case of Dr. Jekyll and Mr. Hyde)* von 1886 als klassische viktorianische Fallstudie eines „Doppelbewusstseins":

„Das Verhältnis zwischen Körperhaltung und Persönlichkeit lässt sich nicht treffender illustrieren als mit dem altehrwürdigen Fall von Dr. Jekyll und Mr. Hyde. Wir haben es hier mit zwei Persönlichkeiten zu tun: auf der einen Seite Jekyll als Inbegriff der Gesundheit, hoch angesehen, mit aufrechter Haltung und hehren Ambitionen. Auf der anderen Seite Hyde mit seiner kriecherischen, geduckten Haltung, in der sich seine Persönlichkeit ausdrückt, in jeder Beziehung sein Gegenstück!"[1]

Doch wie sieht Mr. Hyde eigentlich aus? Auf der Bühne wird er unverkennbar als Gegenpol zum bürgerlichen Dr. Jekyll inszeniert. In welcher Form aber lässt sich ein solcher Gegensatz ausdrücken? Für Hydes physisches Erscheinungsbild gibt uns Stevenson einige Anhaltspunkte: Er ist „irgendwie missgestaltet" und vermittelt „das starke Gefühl von Missbildung, auch wenn ich es nicht genau in Worte fassen kann". An einer anderen Stelle heißt es, Mr. Hyde sei „fahl und zwergenhaft, er hinterließ den Eindruck von Missgestaltung ohne nennenswerte Anomalien [...]". Deshalb vermittle er „das gespenstige Gefühl einer unerklärlichen Missgestaltung", wecke somit „widerwillige Neugier" und habe „etwas Anomales und Abscheuliches" an sich – „etwas Ergreifendes, Überraschendes und Ekelerregendes". Er wirkt so primitiv, dass er „kaum menschlicher Natur" zu sein scheint, sondern eher „etwas Troglodytisches" an sich hat. Er erinnert in der Tat an einen Höhlenmenschen, denn er handelt „wie ein Tollwütiger", und seine Hand ist „mager, verkrümmt, knochig, von düsterer Blässe und dicht mit schwarzen Haaren bedeckt".[2] Urtümlich, missgestaltet, kränkelnd ... und doch bleibt weitgehend vage, was genau diesen Eindruck auslöst. Selbst Martha Stoddard Holmes kommt in *Fictions of Affliction* nur zu dem Schluss, er gehöre zu den Figuren mit „unspezifischen Behinderungen".[3]

Lillian Curtis Drew wertet eine gute Körperhaltung schlicht als Indiz für einen guten Charakter, und im damaligen New York mit seinen zahllosen jüdischen Einwanderer*innen aus Osteuropa, die gern mit krummem Rücken karikiert wurden, war das Antrainieren einer aufrechten Haltung gleichbedeutend mit der Erziehung zu anständigen,

SANDER L. GILMAN

QUEER POSTURE: SEEING THE AMBIGUITY OF DIFFERENCE

In 1923, Lillian Curtis Drew of the Central School of Physical Education in New York, writing in the authoritative *American Physical Education Review*, evoked the classic Victorian case of "double-consciousness," Robert Louis Stevenson's *Strange Case of Dr. Jekyll and Mr. Hyde* (1886), in arguing for the centrality of posture as an index of personality: "There is no better illustration of posture vs. personality than the time-honored one of Dr. Jekyll and Mr. Hyde. Here were two personalities – that of Jekyll, erect in bearing, expressive of health. Socially respected, with noble aspirations; and the opposite, Hyde, – the groveling, crouching posture expressing his personality – an absolutely antithesis!"[1]

But what does Hyde actually look like? The theatrical representation of Mr. Hyde would clearly be the antithesis of the middle-class Dr. Jekyll. How does one represent such difference? Stevenson provides a series of clues to Hyde's physical appearance. Mr. Hyde is "deformed somewhere." He gives "an impression of deformity although I couldn't specify the point." At another point, Mr. Hyde is described as "pale and dwarfish, he gave an impression of deformity without any nameable malformation." Overall, there is "the haunting sense of unexpressed deformity." He is there-

fore "a disgustful curiosity" and appears as "something abnormal and misbegotten ... something seizing, surprising and revolting." He was primitive as "the man seems hardly human! Something troglodytic." Indeed, a troglodyte he was, "ape-like," and his hand was "lean, corded, knuckly, of a dusky pallor and thickly shaded with a swart growth of hair."[2] Primeval, deformed, unhealthy – yet there is little specificity as to how this affect is triggered. Indeed, even Martha Stoddard Holmes, in her *Fictions of Affliction*, states that he is one of the characters with "unspecified disabilities."[3]

For Drew, good posture is simply an indicator of good character, and in a New York teeming with Jewish immigrants from Eastern Europe caricatured as having bad posture, education in posture meant creating moral citizens with "mental and physical fitness": "The objective is to establish in the individual such powers of motor control as will make the erect carriage a permanent habit, an integral part of the individual rather than a static position to be assumed in the gymnasium and associated only with this environment, or to be taken on admonition to 'stand up straight!' To be of any real value it must 'function in life.'"[4]

MEETING, MOVING – FORGING BONDS 137

138 BEGEGNEN, BEWEGEN – BANDEN BILDEN

„geistig und körperlich tüchtigen" Bürger*innen: „Das Ziel ist, in der Person motorische Fähigkeiten aufzubauen, durch die eine aufrechte Haltung zur ständigen Gewohnheit wird, zu einem integralen Wesenszug anstelle einer statischen Haltung, wie man sie in der Turnhalle und nur dort annimmt, oder mit der man auf die Ermahnung ‚Steh gerade!' reagiert. Um wirklich von Wert zu sein, muss sie in Fleisch und Blut übergehen."[4]

Drews Deutung von Stevensons Text unterschlägt natürlich, dass die beiden Figuren zwei Seiten einer einzigen Persönlichkeit verkörpern. Für das Publikum war dies jedoch unverkennbar, als das Stück 1888 in New York und London auf die Bühne kam, während Jack the Ripper im Londoner East End mordete. Beide Inszenierungen stellten Hyde als Buckligen dar und damit als das genaue Gegenstück zur „aufrechten" Figur Jekylls. Schon seine Körperhaltung sprach Bände: schlechte Haltung gleich schlechter Charakter.

In Stevensons Geschichte ist die Frage der Körperhaltung jedoch vielschichtig. Wir müssen bedenken, dass die damalige Presse wohlhabenden Dandys eine ebenso ungesunde Körperhaltung unterstellte wie mordenden Arbeitern. Auch die Dandys „ließen sich hängen", wenngleich ganz anders konnotiert. Die aufrechte Haltung, die man Kindern in viktorianischer Zeit mit Haltungsbrettern und Zuchtstühlen aufzwang, sahen sie als Wegbereiter für die aufgesetzte Fassade eines „anständigen Charakters". Genauso lehnte Jane Austen die gesellschaftliche Konvention der steifen Körperhaltung ab. In ihrem Roman *Sanditon* von 1817 schrieb sie: „[Sie waren] genau der Typ von junger Dame, den man in Großbritannien mindestens in jeder dritten Familie findet. Sie hatten einen annehmbaren Teint, eine prächtige Figur, eine aufrechte, stolze Haltung und einen selbstbewussten Blick; sie waren zugleich sehr

gebildet und sehr unwissend und verwandten ihre Zeit entweder auf Beschäftigungen, mit denen sie Bewunderung erregen konnten, oder auf so einfallsreich und geschickt ausgeführte Handarbeiten, dass sie sich in einem Stil kleiden konnten, der ihre Mittel eigentlich weit überstieg. Sie gehörten immer zu den ersten, die eine Mode mitmachten, und das Ziel all dieser Bemühungen war es, einen Mann zu fesseln, der erheblich reicher war als sie selbst."[5]

Die aufrechte Haltung der jungen Damen bezeugt ihre moralische Leere ebenso wie ihre völlige Ignoranz. Austens Vorbehalte gegen eine „gute Haltung" als Aushängeschild eines guten Charakters finden sich im 19. Jahrhundert in einem alternativen „Lebensstil" wieder: betonter Lässigkeit, auf Englisch *slouch*.

Gegen Ende des 19. Jahrhunderts wurden „weitere Eckpfeiler der viktorianischen Gesellschaft infrage gestellt oder ganz über Bord geworfen, darunter auch die Normen für gute Körperhaltung und die Vorstellung von ätherischer Liebe".[6] In einer der bekanntesten Satiren des Ästhetizismus gehört die „nachlässige Haltung" des Ästheten zum Image der Avantgarde, darin George du Mauriers zeichnerische Spitzen gegen den ultimativen Ästheten Oscar Wilde, der schon als Student meinte, es falle ihm „von Tag zu Tag schwerer, auf dem hohen Niveau meines blauen Porzellans zu leben". Diese Feststellung belegt eine Reihe zeitgenössischer Fotografien und Karikaturen, die ihn in betont lässiger Haltung zeigen. Als Student „ließ Wilde sein Haar wachsen; es hieß, er habe seine *Körperhaltung* verändert, damit sie zu der schlaffen Sensibilität passte, die den Ästheten so wichtig war. Er konnte – oder wollte – den Kopf nicht gerade halten." Ein Klassenkamerad Wildes bestätigte: „Er hing zur Seite wie eine Lilienblüte, die zu

Drew's reading of Stevenson, of course, misses the point of *both* characters being aspects of one personality, something not lost on the theater audiences in New York and London where the piece was staged in 1888. In London, the dramatization of the story appeared simultaneously with the Jack the Ripper murders in the East End. On both stages, Hyde is played as a hunchback, the mirror opposite of Jekyll's "upright" character. And this is made explicit by his posture. Bad posture: bad character.

Yet the question of posture in Stevenson's tale is many layered. We need to remember that wealthy "toffs" and working-class murderers were equally imagined in the press of the day as having an unhealthy posture. Toffs too slouched, but with very different meanings attached to their posture. Formal posture, that of the posture back boards and the deportment chairs, had been disqualified as producing superficial images of "good character." The rejection of the social conventions of a rigid posture is part of the world of Jane Austen, who comments in *Sanditon* (1817) about "just such young Ladies as may be met with, in at least one family out of three, throughout the Kingdom; they had tolerable complexions, shewey figures, an upright decided carriage & an assured Look; – they were very accomplished & very Ignorant, their time being divided between such pursuits as might attract admiration, & those Labours & Expedients of dexterous Ingenuity, by which they could dress in a stile much beyond what they *ought* to have afforded; they were some of the first in every change of fashion – & the object of all, was to captivate some Man of much better fortune than their own."[5]

Their upright carriage marks their moral void as much as their complete ignorance of the world. Austen's dismissal of "good posture" as a sign of good character gave way in the nineteenth century to an alternative "lifestyle," the slouch.

By the close of the nineteenth century, "other Victorian staples, including norms of posture and definitions of ethereal love, began to be attacked or jettisoned as well."[6] In one of the best-known satires of the aesthetic movement, the "poor posture" of the aesthete is part of the image of the avant-garde. Here we have George du Maurier's response to the ultimate aesthete Oscar Wilde, who remarked as a student that he found it "harder and harder every day to live up to my blue china." The position is one that reflects a number of contemporary photographs and caricatures of Wilde slouching. As a student, Wilde "let his hair grow; some said he altered his *posture* to match the languid sensibility prized by aesthetes. He couldn't – or wouldn't – keep his head upright" (emphasis mine). As one of his classmates observed, "It fell sideways like a lily bloom too heavy for its stalk."[7] The aesthete's posture was halfway between a stoop and a swoon and was read as effeminate.[8] Indeed, the image of the slouching male as gay seems to be in answer to the more or less rigid posture ascribed to the bodies (and the morals) of Victorian bourgeois society.

For the Quaker preacher and moralist Joseph John Gurney in 1845, "young people" must develop the habit "of looking every man in the face…. [It] is a matter of no trifling importance…. It promotes mental vigour, a proper boldness of demeanour, and above all, openness and candour…. Stooping must

MEETING, MOVING – FORGING BONDS 139

schwer für ihren Stängel ist." [7] Die Haltung eines Ästheten wirkte halb wie ein Bücken, halb wie eine Ohnmacht und wurde als geziert empfunden.[8] In der Tat galt eine lässige Haltung bei einem Mann als Indiz für Homosexualität, offenbar als Gegenpol zu der mehr oder weniger aufrechten Haltung, die man Körper (und Moral) des viktorianischen Bürgertums zuschrieb.

Der Quäkerprediger und Moralist Joseph John Gurney äußerte 1845, „die Jugend" solle sich angewöhnen, „jedermann ins Gesicht zu sehen [...]. [Das] ist durchaus keine banale Sache [...]. Es stärkt die geistige Spannkraft, fördert ein angemessen kühnes Auftreten und vor allem Offenheit und Freimütigkeit [...]. Die gebückte Haltung ist als eine Art Nebeneffekt von Trägheit, Schüchternheit und Verschlagenheit zu betrachten. [...] Nach ihrer ständigen Neigung zu nachlässiger Körperhaltung zu urteilen, könnte man meinen, viele kernige junge Menschen würden in der heutigen Zeit plötzlich von den Gebrechen des hohen Alters heimgesucht."[9] Junge Männer der gehobenen Gesellschaft trainierten sich deshalb für ihre Zukunft eine aufrechte Körperhaltung an: Lass dich nicht hängen, sonst verrätst du dich!

Drew vertrat die Meinung, man müsse den „Hydes" – den neuen Einwanderern, die damals die East Side von New York City bevölkerten – in erster Linie das aufrechte Stehen beibringen und sie damit zu charakterstarken jungen Menschen erziehen. In diese Betrachtung eingeschlossen ist das Verhältnis zwischen den neuen Städtern und den neuen Einwanderern – „Juden und Homosexuelle waren nicht die einzigen Gegentypen, dafür jedoch die sichtbarsten, erschreckendsten Beispiele".[10]

Die Kennzeichnung der Körperhaltung von Jüdinnen*Juden als „abnorm" oder „mangelhaft"

hat eine lange Tradition. Sie basierte zum Teil auf dem Stereotyp, die Männer seien von einer so schwachen, nutzlosen Konstitution, dass sie schon aufgrund ihrer miserablen Haltung für den Dienst in europäischen Armeen nicht taugten. Ein anderer Punkt war die vermeintlich mangelnde Sauberkeit der „Ostjuden." Die jüdische Aufklärung und später der Zionismus legten deshalb großen Wert auf Körperkultur als ersten Schritt zum Bürgerrecht. Im späten 19. und frühen 20. Jahrhundert hieß es, jüdische Einwanderer könnten zumindest in der zweiten Generation nach diesem Modell durch körperliche Ertüchtigung zu vollwertigen Bürgern werden. Andernfalls gehörten sie nicht etwa zur Avantgarde, sondern riskierten, im für sie neuen amerikanischen Umfeld als Gefahr wahrgenommen zu werden. Durch die Aneignung der erwünschten Körperhaltung bewiesen sie, dass sie ihre ererbte primitive Herkunft überwunden hatten und nun als „aufrechte Bürger" in die Gesellschaft integriert werden konnten. Dandys hingegen gehörten natürlich längst zur Gesellschaft und empörten die Bourgeoisie mit ihrer lässigen Körperhaltung.

Jack London thematisierte 1903 in seiner Reportage *Menschen am Abgrund (The People of the Abyss)* die Kehrseite der Medaille auf den Straßen des Londoner East End. Dort verkehrten keine Dandys – außer, glaubt man den Anschuldigungen in den Strafverfahren gegen Oscar Wilde, um junge Männer aus der Arbeiterschicht „aufzugabeln" und mit Champagner und goldenen Zigarettenetuis für Sexdienste zu entlohnen:[11] „Die Straßen waren mit einer neuen und andersartigen Rasse von Menschen angefüllt. [...] Sie verbringen ihr Leben bei der Arbeit und auf der Straße. [...] Sie sind überall anzutreffen, stehen an Bordsteinkanten und Ecken und starren ins Leere. Beobachtet einen von ihnen. Stundenlang

be regarded as a sort of auxiliary to indolence, bashfulness, and slyness.... We might suppose that many robust young people in the present day, had been suddenly overtaken by the infirmities of extreme old age were we to form a judgment, from their perpetual inclination to an indolent posture of their bodies."[9] So good posture became a goal of the elite young man in training. Slouch not, it reveals too much!

Drew's point is that to transform the "Hydes" – the new immigrants that then populated the East Side of New York City – into young people of character, standing up straight had to become an essential part of their habituation. The link between the new city dwellers and the new immigrants was implicit in his view. "Jews and homosexuals were not the only countertypes, but they were the most readily visible and frightening examples."[10]

That Jewish posture was defined as "abnormal" or "deficient" has a long history. Some of it associated with stereotypes of a weak, ineffectual masculinity whose poor posture excluded them from army service in Europe; some of it associated with the presumed poor hygiene of the Eastern Jews (thus the Jewish Enlightenment and then Zionism stressed physical improvement as the first stage of citizenship). In the late nineteenth and early twentieth century, immigrant Jews, or at least their children, could be transformed according to the latter model through the training of the body. The alternative was not being of the avant-garde but being someone threatening to the new American context. Learning correct posture meant that they could overcome the inherited primitive nature of their background, become "upright people," and be integrated into the society. The toffs, who of course were already integrated into society, threw the bourgeoisie into panic with their posture.

Jack London's *In the Abyss*, published in 1903, sees the other side of the coin on the streets of London's East End, where the "toffs" did not go, except, if the arguments in Oscar Wilde's trials are to be believed, to pick up young working class boys for sex and treat them to champagne and gold cigarette boxes.[11] They are "a new race ... a street people. They pass their lives at work and in the streets.... They are to be met with everywhere, standing on curbs and corners, and staring into vacancy. Watch one of them. He will stand there, motionless, for hours, and when you go away you will leave him still staring into vacancy."[12] Posture reveals all and tells the viewer that these are not "upright people."

Standing "upright" is being "upright." The pun is purposeful and exists in most European languages. But an awareness of being seen as different, as Rosemarie Garland-Thomson notes in her study *Staring: How We Look*, may mean that you can manipulate the world about you by using others' images to your advantage, not disadvantage.[13] Susan Sontag had noted this first in her classic 1964 essay "Notes on 'Camp'." She writes that "the two pioneering forces of modern sensibility are Jewish moral seriousness and homosexual aestheticism and irony.... The reason for the flourishing of the aristocratic posture among homosexuals also seems to parallel the Jewish case."[14] When you are marginalized you adapt, ironically or not, to the image of perfection in your world. An ironic stance signals your self-awareness of this acceptance of norms. The way you stand defines who you are in terms of your character, or in the case of gay men, "seemingly recent is

wird er unbeweglich stehen bleiben, und wenn man fortgeht, wird man ihn immer noch ins Leere starren sehen."[12] Die Körperhaltung ist verräterisch. Wer sie sieht, weiß gleich, dass er es nicht mit „aufrechten Leuten" zu tun hat.

Wer aufrecht steht, *ist* auch aufrecht. Diese Doppeldeutigkeit kennen die meisten europäischen Sprachen. Wer sich aber bewusst ist, „anders" zu sein als die anderen, kann laut Rosemarie Garland-Thomsons Studie *Staring: How We Look* sein Umfeld auch manipulieren, indem er das scheinbar gewohnte Bild zu seinem Vorteil ummünzt.[13] Susan Sontag erkannte dies schon 1964 in ihrem klassischen Essay *Anmerkungen zu „Camp" (Notes on „Camp")*: „Die beiden bahnbrechenden Kräfte der modernen Erlebnisweise sind der moralische Ernst der Juden auf der einen, der Ästhetizismus und die Ironie der Homosexuellen auf der anderen Seite. […] Die Ursache für die Blüte der aristokratischen Haltung unter den Homosexuellen scheint ebenfalls ihre Entsprechung bei den Juden zu haben."[14] Wer von anderen ausgegrenzt wird, passt sich – ironisch oder ernsthaft – dem an, was sein Umfeld unter Perfektion versteht. Eine ironische Haltung signalisiert, dass man sich der Akzeptanz dieser Normen bewusst ist. Die Art zu stehen offenbart die charakterliche Identität. Bei schwulen Männern heißt das: „Seit neuestem wirft man sich augenscheinlich in *Positur*. Es ist eine Körperhaltung, wie man sie in Schwulenbars sieht, die Hochmut und Verachtung vermitteln soll. In früheren Jahrzehnten neigten Tunten eher zu einer Gestik, die mit den Salons der feinen Gesellschaft und mit der schicken Café-Society konnotiert wurde."[15]

Diese selbstbewusst als *camp* und queer zur Schau gestellte Lässigkeit führt uns zurück zu Dr. Jekyll und Mr. Hyde.[16] Der Kritiker Richard Dury entdeckte in seiner Einführung zu Stevensons Novelle vor allem in diversen „gesellschaftlich geächteten Aktivitäten", die Hyde unterstellt werden, „sehr oft versteckte Anspielungen auf Homosexualität".[17] Schwul zu sein in einer Welt, in der man eine heterosexuelle Fassade zu haben hatte (wie etwa Oscar Wilde mithilfe seiner Ehefrau), veranlasste in Durys Augen „den viktorianischen Homosexuellen zwangsläufig dazu, ein Doppelleben zu führen". Verweise auf ein Schwulsein finden sich an vielen Stellen: die vermeintliche Erpressung Jekylls durch seinen „jungen Mann", seinen „Günstling", oder die „ausgesprochene Höflichkeit", mit der er Sir Danvers Carew auf der Straße anspricht. In seinen ersten Überarbeitungen machte Stevenson Carew vom Täter zum Opfer; er „verstärkte [hierdurch] das Motiv von Hydes Auflehnung gegen patriarchalische Kontrolle und schwächte die Fingerzeige für seine Homosexualität ab" (S. XXXI). Stevenson strich zudem mehrere Anspielungen auf Jekylls Veranlagung, Verweise „auf Masturbation und Homosexualität in Sätzen wie: 'Von einem sehr frühen Alter an wurde ich jedoch heimlich zum Sklaven schändlicher Lüste', 'die eiserne Hand der eingefleischten Gewohnheit' und 'Laster [, die] vor dem Gesetze kriminell und an sich abscheulich [sind]'" (S. XXXI). Er beließ es jedoch dabei, dass Hyde Jekylls Haus durch den „Hintereingang" betritt, ja sogar „durch den hintern Korridor" (S. XXXI). Die Körpersprache enthüllt dennoch, wie es um die beiden bestellt ist, denn Hyde ist „enger an [Jekyll] gebunden […] als eine Ehefrau"; er geht „mit einem gewissen Schwanken", und sein Weinen klingt „wie das einer Frau". Jekylls Hand hingegen ist „weiß und ansehnlich" (S. XXXI). Carolyn Laubender merkte dazu an: „Hyde dient in der Novelle als Archetyp für Homosexualität im Allgemeinen und wird als animalisch und lasterhaft charakterisiert, weil

attitude, a bodily posture found in makeout bars conveying hauteur and disdain. The queen of former decades was inclined to adopt gestures associated with the gentility of upper-class drawing rooms and café society."[15]

Slouching self-consciously as a camp and queer posture brings us back to Robert Louis Stevenson and his Mr. Hyde.[16] The critic Richard Dury, in an introduction to the novel, notes that of several "socially condemned activities" Hyde is associated with, "veiled allusions to homosexuality are particularly frequent."[17] Being queer in a world where you had to appear straight (think of the uxorious Oscar Wilde) mirrors for Dury "the necessarily double life of the Victorian homosexual" (xxix). There are gestures towards a gay posture throughout the novel: the suspected blackmail of Jekyll by his "young man," his "favourite"; the "very pretty manner of politeness of Sir Danvers Carew" when approached in the street. Indeed, Stevenson makes Carew a victim, not an aggressor, in his early revisions, which "strengthens the theme of Hyde's opposition to patriarchal control and tones down the hints of homosexuality" (xxxi). Stevenson also eliminates a series of references about Jekyll's early predisposition through allusions "to masturbation and homosexuality, contained in phrases such as 'From a very early age, however, I became in secret the slave of disgraceful pleasures,' 'the iron hand of indurated habit,' and 'vices ... criminal in the sight of the law and abhorrent in themselves'" (xxxi). Still Hyde enters Jekyll's house through the "back way," even "the back passage" (xxxi). Posture, however, reveals the character of both as Hyde is "closer than a wife" to Jekyll, walks "with a certain swing," and weeps "like a woman"; Jekyll's hand, meanwhile, is "white and comely" (xxxi). As Carolyn Laubender notes: "Hyde serves, within the novella, as an archetype for homosexuality more generally and is seen as both animalistic and amoral because of his selfish desire to satisfy personal pleasure instead of catering to more productive or transcendent values."[18]

Certainly, these images echoed the public discussions of gay street activity that haunted the public sphere in England. *The Reynolds News* in July 1885 attacked the corruption of youths by "sated voluptuaries" in London in much the same vocabulary.[19] In the various trials following the adoption of Section 11, commonly known as the Labouchere Amendment, of the Criminal Law Amendment Act of 1885, the year the novel was written, made "gross indecency" a crime in the United Kingdom. The image of the corrupt and corrupting gay man was echoed by analogous images in Oscar Wilde's trial a decade later. Stevenson's novel was an immediate success, selling almost 100,000 copies in the United States and Great Britain the year it appeared. The queer posture and the Jewish posture were linked by the East End in London, the world of Jack the Ripper, inhabited by Eastern European Jews, one of whom was the only person ever accused of Jack's crimes.[20] Indeed it was the world of "Jekyll's back street, where 'tramps slouched'" (xlv). And not only tramps....

The role that bodily posture played in the visibility (and self-parody) of gay men through the present has rarely been as forcefully presented as in Stevenson's images of Hyde and Jekyll, part of the culture of physical bearing in the Victorian age. In his edition of

er egoistisch nach Lustbefriedigung strebt statt nach produktiveren oder transzendenten Werten."[18]

Diese Metaphern spiegelten natürlich den in der englischen Öffentlichkeit verbreiteten Argwohn gegen das Treiben schwuler Männer auf den Straßen wider. Mit ganz ähnlichen Worten warnte die Zeitung *Reynolds News* im Juli 1885 eindringlich vor den Gefahren, die Jugendlichen in London durch „übersättigte Lüstlinge" drohten.[19] 1885, also in dem Jahr, als Stevenson seine Novelle schrieb, wurde das sogenannte Labouchere Amendment verabschiedet, das Paragraf 11 des Anpassungsgesetzes zum Strafgesetzbuch *(Criminal Law Amendment Act)* insoweit abänderte, dass „grob unsittliches Verhalten" im Vereinigten Königreich nun als Verbrechen geahndet wurde. Das Bild des schwulen Mannes als sittenloser Verführer findet sich zehn Jahre später im Prozess gegen Oscar Wilde in ganz ähnlicher Form. Stevensons Geschichte wurde auf Anhieb zum Bestseller. Allein im Erscheinungsjahr gingen in den USA und Großbritannien fast 100.000 Exemplare über den Ladentisch. Das Bindeglied zwischen „queerer" und „jüdischer" Körperhaltung bildete das Londoner East End, wo Jack the Ripper sein Unwesen trieb. Dort waren viele osteuropäische Jüdinnen*Juden ansässig, und einen von ihnen hielt die Polizei – als einzigen Verdächtigen – für den Ripper.[20] Genau dieser Teil Londons war auch „Jekylls Hintergasse, in der 'Landstreicher […] krumm in der Türnische [hockten]'" (S. XLV). Und nicht nur Landstreicher lungerten dort herum …

Die Rolle der Körperhaltung für die Sichtbarkeit (und Selbstparodie) schwuler Männer bis in unsere Zeit ist selten so eindringlich beschrieben worden wie in *Dr. Jekyll und Mr. Hyde.* Den Hintergrund bildete dabei das viktorianische Zeitalter mit seinem Kult der aufrechten Haltung.

Richard Drury, Herausgeber einer Ausgabe von Stevensons Novelle, fand in dem darin verwendeten gefühlsbetonten Vokabular zahlreiche „Begriffe mit potenziell anstößigen Bedeutungen, vorrangig in Passagen mit *camp*-typisch 'ausschweifenden' Schilderungen" (S. L). Susan Sontag bemerkte treffend: „Die aristokratische Haltung gegenüber der Kultur kann nicht sterben, wenn sie vielleicht auch immer willkürlicher und scharfsinnigere Methoden braucht, um sich behaupten zu können."[21] Entfremdung ist immer ein Aspekt der gekünstelten Haltung, die man als *camp* bezeichnet, kann aber als angemessene, notwendige Seinsweise den Körper formen. Die tuntenhafte Haltung des *Camp* ist zwar per se gekünstelt, doch wird „Gekünsteltheit und Übertreibung" schnell als Wesenszug angesehen und empfunden, und das ist der wesentliche Punkt. Der Begriff „Haltung" (engl. *posture*) hat zwei Bedeutungen: Zum einen bezeichnet er die Art und Weise, wie wir uns durch Raum und Zeit bewegen, zum anderen das selbstbewusste und „aufrechte" Verhalten, das wir an den Tag legen. Aufrecht sein bedeutet nach landläufiger Meinung auch, moralisch untadelig zu sein. In viktorianischer Zeit war jemand mit strammer Haltung ohne Weiteres ein „großer, aufrechter Mann von schlanker Gestalt"[22] oder ein „weißhaariger Geistlicher […], der den Bitten, die Gebete zu sprechen, hoch aufgerichtet nachkam".[23] Es wurde so gut wie nicht unterschieden von moralischer Aufrichtigkeit, etwa „einer Anzahl mutiger, aufrechter Burschen, die sich wie Männer hervortaten".[24] Im Zentrum solcher Metaphern stehen aufrechte Männer, deren Haltung bereits unübersehbar ihre moralische Aura ausdrückt, selbst wenn sie nur scheinheilig ist wie bei Uriah Heep in Charles Dickens' *David Copperfield.* Aber auch eine romantisch verklärte Umkehrung ist möglich:

the text, Richard Drury labels Stevenson's affective vocabulary as full of "words with potentially transgressive meanings [as] is found especially in the passages of campishly 'excessive' description" (I). Sontag's observation that "The aristocratic posture with relation to culture cannot die, though it may persist only in increasingly arbitrary and ingenious ways,"[21] proves to be true. While alienation is inherent to camp posture, it can also come to form the body as the appropriate and necessary way of being. Artifice on one level is inherent to a camp posture, but, and this is the key, "artifice and exaggeration" soon come to be seen and experienced as a way of being. Posture, as has been noted, has two meanings: one is the way we move through space and time, the other is to be self-consciously "posturing," of seeming to be "upstanding." We think of being upstanding as the preferable moral position. The Victorians saw no problem with seeing an erect person as "a tall, upstanding man of spare figure,"[22] or indeed seeing "a white-headed clergyman ... called upon to say prayers, which he did upstanding."[23] This was hardly differentiated from the moral uprightness of "a lot of game upstanding chaps, that acted like men."[24] Upright men are at the core of such images, with their moral presence writ large on their posture. Even if, as with Dickens's Uriah Heep, such posturing takes the form of mere sanctimoniousness. But the Romantic reversal is also true. In spite of a misshapen posture, moral action is also possible, indeed may prove the radical falsity of physical uprightness being the equivalent of morality. And gays and Jews could not be moral exemplars unless they were transformed into healthy, upright, heterosexual, white citizens.

But no matter how hard they tried, they could never achieve this ideal state, whether in the Wilhelminian or Victorian world or in the Third Reich. Their ideal, blond, blue-eyed, rigidly held bodies, once revealed to be gay or Jewish or, indeed, both, were never quite blond or blue-eyed or rigid enough. As gay identity, in Germany as elsewhere, responded to the stereotyping of gay posture, it was of little surprise that conflicts arose between the ultra-masculine images of gay identity (think Tom of Finland) and the "limp-wristed" feminized one (think Quentin Crisp or the idealized drag queen). That gender identity was and is much more nuanced made and makes such bifurcation uncomfortable and often unusable. Our sense of self is shaped by how you are seen in society as well as how you understand yourself.[25] And this was revealed to the observer through their posture, be it camp or otherwise. This vocabulary of images still haunts the public sphere in its representation of ideal normative bodies. Indeed, when an advertiser today wishes to seem "woke," they employ countertypes (blond, blue-eyed young men in wheelchairs), acknowledging the normative power of these ideas of posture even in today's social media.

1 Lillian C. Drew, "Ways and Means of Overcoming Inefficient Posture," *American Physical Education Review* XXVIII (1923): 3–8 (4).

2 Robert Louis Stevenson, *Strange Case of Dr. Jekyll and Mr. Hyde* (New York: Scribners, 1903), 12, 25, 37, 43, 97, 118.

3 Martha Stoddard Holmes, *Fictions of Affliction: Physical Disability in Victorian Culture* (Ann Arbor: University of Michigan Press, 2007), 199.

4 Drew, "Ways and Means," 4.

146 BEGEGNEN, BEWEGEN – BANDEN BILDEN

Ungeachtet einer unglücklichen Haltung, ist moralische Handlung möglich und kann sogar den Beweis liefern, dass physische Aufrichtung manchmal das genaue Gegenteil von Moral ist. Schwule und Jüdinnen*Juden konnten per se keine moralischen Vorbilder sein, es sei denn, man erzog sie zu gesunden, aufrechten, heterosexuellen weißen Bürger*innen. Doch ganz gleich, wie sehr sie sich auch anstrengten, konnten sie diesen Idealzustand weder in der wilhelminischen oder viktorianischen Welt noch im „Dritten Reich" je erlangen. Mochten ihre Körper auch noch so ideal, blond, blauäugig und stramm aufrecht sein – sobald sie sich als schwul oder jüdisch oder gar beides entpuppten, waren sie nie mehr „richtig" blond, blauäugig oder stramm. In dem Maße, wie die schwule Identität in Deutschland und andernorts auf die Stereotypisierung der schwulen Haltung reagierte, waren Konflikte vorprogrammiert, nicht zuletzt zwischen ultramaskulinen Identitäten wie etwa Tom of Finland und gezierten feminisierten Identitäten wie etwa Quentin Crisp oder dem Stereotyp der Drag Queen. Geschlechtsidentität war und ist jedoch weitaus nuancenreicher, und das macht eine solche Dualität fragwürdig und weitgehend nutzlos. Unser Selbstverständnis wird gleichermaßen dadurch geprägt, wie die Gesellschaft uns wahrnimmt und wie wir uns selbst sehen.[25] Und genau das offenbart die Körperhaltung, ob *camp* oder ganz anders. Dass dieses Bildvokabular bis heute durch den öffentlichen Raum geistert, belegen die Darstellungen genormter idealer Körper. Um heutzutage *woke* zu erscheinen, setzen Werbeagenturen oft auf Gegentypen wie blonde, blauäugige junge Männer im Rollstuhl. Sie beugen sich damit dem normativen Einfluss, den solche Vorstellungen von Körperhaltung selbst in den modernen sozialen Medien ausüben.

1 Lillian C. Drew, Ways and Means of Overcoming Inefficient Posture, in: American Physical Education Review 1923/28, S. 3–8, hier S. 4.

2 Robert Louis Stevenson, The Strange Case of Dr. Jekyll and Mr. Hyde, New York 1903, S. 12, 25, 37, 43, 97, 118 [dt. Zitate aus: Der seltsame Fall des Dr. Jeckyll und Mr. Hyde, Hamburg 2016, übers. von Hannelore Eisenhofer und Ailin Konrad].

3 Martha Stoddard Holmes, Fictions of Affliction: Physical Disability in Victorian Culture, Ann Arbor 2007, S. 199.

4 Drew 1923 (wie Anm. 1), S. 4.

5 Jane Austen, The Works of Jane Austen, hg. von R. W. Chapman, Bd. 6, Oxford 1954, S. 421 [dt. Ausgabe: Jane Austen, Sanditon, in: Die Watsons – Lady Susan – Sanditon. Die unvollendeten Romane, Stuttgart 2017, übers. von Ursula und Christian Grawe, S. 224].

6 Peter N. Stearns, Battleground of Desire. The Struggle for Self-control in Modern America, New York 1999, S. 4.

7 David M. Friedman, Wilde in America. Oscar Wilde and the Invention of Modern Celebrity, New York 2014, S. 24.

8 Michèle Mendelssohn, Henry James, Oscar Wilde and Aesthetic Culture, Edinburgh 2007, S. 64.

9 Joseph John Gurney, Thoughts on Habit and Discipline, London 1845, S. 65f.

10 George Mosse, The Image of Man. The Creation of Modern Masculinity, New York 1996, S. 70.

11 Kerwin Kaye, Male Sex Work in Modern Times, in: Victor Minichiello und John Scott (Hg.), Male Sex Work and Society, New York 2014, S. 34–50, hier S. 42.

12 Jack London, The People of the Abyss, New York 1903, S. 229 [dt. Ausgabe: Menschen am Abgrund, Norderstedt, 2. Aufl. 2021, übers. von Maria Weber, S. 14, 167f.].

13 Rosemarie Garland-Thomson, Staring. How We Look, New York 2009.

14 Susan Sontag, Notes on „Camp", in: A Susan Sontag Reader, New York 1982, S. 105–120, hier S. 118 [dt. Anm. zu „Camp", in: Susan Sontag, Kunst und Antikunst. 24 literarische Analysen, München 2003, übers. von Mark W. Riehn, S. 283].

15 Gestures and Body Language, in: Wayne R. Dynes (Hg.), Encyclopedia of Homosexuality, Bd. 1, New York 1990, S. 474.

16 Wayne Koestenbaum, The Shadow of the Bed. Dr. Jekyll, Mr. Hyde, and the Labouchère Amendment, in: Critical Matrix 1, Sonderausgabe (Frühling 1988), S. 31–55; William Veeder, Children of the Night: Stevenson and Patriarchy, in: William Veeder und Gordon Hirsch (Hg.), Dr. Jekyll and Mr. Hyde after One Hundred Years, Chicago 1988, S. 143–148; Elaine Showalter, Sexual Anarchy, London 1990, S. 106–109; Robert Mighall, Einleitung zu Robert Louis Stevenson, The Strange Case of Dr. Jekyll and Mr. Hyde and Other Tales of Terror, hg. von Robert Mighall, New York 2002, S. XVIII–XIX.

17 Alle hier aufgeführten Zitate aus Richard Durys Einleitung zu Robert Louis Stevenson, The Strange Case of Dr. Jekyll and

5 Jane Austen, *The Works of Jane Austen*, ed. R. W. Chapman, vol. VI (Oxford: Oxford University Press, 1954), 421.

6 Peter N. Stearns, *Battleground of Desire: The Struggle for Self-control in Modern America* (New York: New York University Press, 1999), 4.

7 David M. Friedman, *Wilde in America: Oscar Wilde and the Invention of Modern Celebrity* (New York: W. W. Norton, 2014), 24.

8 Michele Mendelssohn, *Henry James, Oscar Wilde and Aesthetic Culture* (Edinburgh: University of Edinburgh Press, 2007), 64.

9 Joseph John Gurney, *Thoughts on Habit and Discipline* (London: Hamilton, Adams, and Co., 1845), 65–66.

10 George Mosse, *The Image of Man: The Creation of Modern Masculinity* (New York: Oxford University Press, 1996), 70.

11 Kerwin Kaye, "Male Sex Work in Modern Times," in *Male Sex Work and Society*, eds. Victor Minichiello and John Scott (New York: Harrington Park Press, 2014), 34–50 (42).

12 Jack London, *In the Abyss* (New York: Macmillan, 1903), 229.

13 Rosemarie Garland-Thomson, *Staring: How We Look* (New York: Oxford University Press, 2009).

14 Susan Sontag, "Notes on 'Camp'," in *A Susan Sontag Reader* (New York: Farrar, Straus, and Giroux, 1982), 105–20 (118).

15 "Gestures and Body Language," in *Encyclopedia of Homosexuality,* ed. Wayne R. Dynes, vol. 1 (New York: Garland, 1990), 474.

16 Wayne Koestenbaum, "The Shadow of the Bed: Dr. Jekyll, Mr. Hyde, and the Labouchère Amendment," *Critical Matrix* 1, special issue (Spring 1988): 31–55; William Veeder, "Children of the Night: Stevenson and Patriarchy," in *Dr. Jekyll and Mr. Hyde after One Hundred Years*, eds. William Veeder and Gordon Hirsch (Chicago: University of Chicago

Press, 1988), 143–48; Elaine Showalter, *Sexual Anarchy* (London: Virago, 1990), 106–9; Robert Mighall, "Introduction," in Robert Louis Stevenson, *The Strange Case of Dr. Jekyll and Mr. Hyde and Other Tales of Terror*, ed. Robert Mighall (New York: Penguin, 2002), xviii–xix.

17 All quotes here to Richard Dury, "Introduction," in Robert Louis Stevenson, *Strange Case of Dr. Jekyll and Mr. Hyde,* ed. Richard Dury (Edinburgh: Edinburgh University Press, 2004), xix–lxii (xxix).

18 Carolyn Laubender, "The Baser Urge: Homosexual Desire in *The Strange Case of Dr. Jekyll and Mr. Hyde*," *Lehigh Review* 17 (2009), http://preserve.lehigh.edu/cas-lehighreview-vol-17/12 (accessed March 7, 2022).

19 Judith R. Walkowitz, *City of Dreadful Delight, Narratives of Sexual Danger in Late-Victorian London* (Chicago: University of Chicago Press, 1992), 278–9, n. 123.

20 Sander L. Gilman, "'I'm Down on Whores': Race and Gender in Victorian London," in *Anatomy of Racism*, ed. David Theo Goldberg (Minneapolis: University of Minneapolis Press, 1990), 146–70.

21 Sontag, "Notes on 'Camp'," 118.

22 "The Marquis was a tall, upstanding man of spare figure," *Strand Magazine* VIII (1894): 156, from www.oed.com (accessed March 7, 2022).

23 "A white-headed clergyman was called upon to say prayers, which he did upstanding." *Illustrated London News* (June 1, 1861): p. 505, col. 1, from www.oed.com (accessed March 7, 2022).

24 "A lot of game upstanding chaps, that acted like men." Rolf Boldrewood, *Robbery Under Arms: A Story of Life and Adventure in the Bush and in the Goldfields of Australia* (London: Remington and Co Publishers, 1888), from www.oed.com (accessed March 7, 2022).

25 Robert Beachy, *Gay Berlin: Birthplace of a Modern Identity* (New York: Vintage Books, 2014), see especially chapter 5 on Hans Blüher, the Wandervogel movement, and the Männerbund.

148 BEGEGNEN, BEWEGEN – BANDEN BILDEN

Mr. Hyde, hg. von Richard Dury, Edinburgh 2004, S. XIX–LXII, hier S. XXIX.

18 Carolyn Laubender, The Baser Urge. Homosexual Desire in The Strange Case of Dr. Jekyll and Mr. Hyde, in: Lehigh Review 2009/17, URL: http://preserve.lehigh.edu/cas-lehighr-eview-vol-17/12 [gelesen am 7.3.2022].

19 Judith R. Walkowitz, City of Dreadful Delight, Narratives of Sexual Danger in Late-Victorian London, Chicago 1992, S. 278f., Anm. 123.

20 Sander L. Gilman, „I'm Down on Whores". Race and Gender in Victorian London, in: David Theo Goldberg (Hg.), Anatomy of Racism, Minneapolis 1990, S. 146–170.

21 Sontag 1982 (wie Anm. 14), S. 118 [dt. Ausgabe: S. 283.]

22 „The Marquis was a tall, upstanding man of spare figure", in: Strand Magazine 1894/8, S. 156, URL: www.oed.com [gelesen am 7.3.2022].

23 „A white-headed clergyman was called upon to say prayers, which he did upstanding", in: Illustrated London News, 1.6.1861, S. 505, Sp. 1, URL: www.oed.com [gelesen am 7.3.2022].

24 „A lot of game upstanding chaps, that acted like men", in: Rolf Boldrewood, Robbery Under Arms. A Story of Life and Adventure in the Bush and in the Goldfields of Australia, London 1888, URL: www.oed.com [gelesen am 7.3.2022].

25 Robert Beachy, Gay Berlin. Birthplace of a Modern Identity, New York 2014; siehe insbes. Kapitel 5 zu Hans Blüher, zur Wandervogel-Bewegung und zum Männerbund.

WISSEN, DIAGNOSE, KONTROLLE

KNOWLEDGE, DIAGNOSIS, CONTROL

Um 1900 wächst das Interesse an Sexualität und Geschlecht in der Wissenschaft. Die Zahl sexualwissenschaftlicher Forschungen und Veröffentlichungen steigt.

In den meisten Schriften werden Homosexualität oder Trans-identitäten als „krankhafte" Zustände beschrieben. Diese Annahme ist inzwischen wissenschaftlich widerlegt. Daneben entstehen damals auch wegweisende Theorien, beispielsweise das Modell der „sexuellen Zwischenstufen" von Magnus Hirschfeld. Der Sexualwissenschaftler nimmt darin die spätere Erkenntnis vorweg, dass es neben Mann und Frau zahlreiche andere Geschlechtsidentitäten gibt.

Wissen bedeutet damals wie heute jedoch auch Macht und Kontrolle. Menschen werden als Patient*innen untersucht, beschrieben, eingeordnet und beurteilt. Einige Sexualwissenschaftler*innen nehmen in ihre Forschungen biologistische und eugenische Vorstellungen auf. Diese werden quer durch die Gesellschaft vertreten und spielen später für die Nationalsozialist*innen eine zentrale Rolle: Ihre sogenannte „Rassenhygiene" unterscheidet zwischen „wertem" und „unwertem" Leben.

Scientific interest in sexuality and gender was expanding around the turn of the century. The amount of sexological research and number of publications increased. Most writings described homosexuality or trans+ identities as "pathological" conditions. This assumption has since been scientifically refuted. At the same time, groundbreaking theories emerged, for example Magnus Hirschfeld's model of "sexual intermediates." In it, the sexologist anticipated the later realization that numerous other gender identities besides man and woman exist.

Yet, then as now, knowledge also meant power and control. People were examined, described, classified, and judged as patients. Some sexologists incorporated ideas in their research that drew on biologism and eugenics. These were spread throughout society and later played a central role for the Nazis: their conception of so-called "racial hygiene" distinguished between "valuable" and "unworthy" life.

„IN DEN LGBTQ-COMMUNITYS HÄLT SICH HARTNÄCKIG DIE ÜBERZEUGUNG, WIR WÜRDEN VON DER GESELLSCHAFT AKZEPTIERT, WENN WIR BEWEISEN KÖNNEN, DASS UNSERE IDENTITÄTEN ANGEBOREN SIND. DIE GESCHICHTE LEHRT UNS JEDOCH, DASS BIOLOGISCHER DETERMINISMUS […] UNS NICHT RETTET, SONDERN IM GEGENTEIL DAZU BENUTZT WIRD, UNS ZU SCHADEN."

Alok Vaid-Menon, 2020
Performance-Künstler*in und Autor*in

"THERE IS A PERSISTENT BELIEF IN LGBTQ COMMUNITIES THAT IF WE CAN PROVE THAT OUR IDENTITIES ARE INNATE WE WILL OBTAIN SOCIAL ACCEPTANCE. HOWEVER, HISTORY TEACHES US THAT BIOLOGICAL DETERMINISM [....] WILL NOT SAVE US. IN FACT IT HAS BEEN USED TO HARM US."

Alok Vaid-Menon, 2020
Performance Artist and Author

FRÜHE SEXUALWISSENSCHAFT

Die Sexualwissenschaft entwickelt sich im 19. Jahrhundert zu einer eigenständigen multidisziplinären Wissenschaft außerhalb der Universitäten. In diesem neuen Bereich arbeiten Fachleute aus Medizin und Biologie ebenso wie Sozial- und Geisteswissenschaftler*innen. Sie vertreten teils gegenläufige Theorien, die oft auch politisch aufgeladen sind.

Wichtige Impulsgeber im deutschsprachigen Raum sind ab den 1860er Jahren der Jurist Karl Heinrich Ulrichs (1825–1895) und der Mediziner Richard von Krafft-Ebing (1840–1902). Insbesondere Ulrichs kämpft für die Ent-kriminalisierung und Anerkennung der Homosexualität. Andere Wissenschaftler begreifen das „dritte Geschlecht" als krankhafte Erscheinung und wollen mit teils fragwürdigen Methoden eine „Umerziehung" und „Heilung" der Patient*innen bewirken. Oft sind körperliche oder psychische Traumata die Folge.

Viele Vertreter*innen der frühen Sexualwissenschaft sind jüdisch. Ab 1933 werden sie und die gesamte Disziplin von nationalsozialistischer Seite vehement angegriffen. Angesichts der zunehmenden antisemitischen Gewalt flüchten die meisten von ihnen ins Exil.

EARLY SEXOLOGY

In the nineteenth century, sexology developed into an independent, multi-disciplinary science outside the universities. Experts from medicine and biology as well as social scientists and humanists worked in this new field. They espoused theories that occasionally contradicted each other and which were often politically charged as well.

The driving forces in the German-speaking world from the 1860s on were the lawyer Karl Heinrich Ulrichs (1825–1895) and the physician Richard von Krafft-Ebing (1840–1902). Ulrichs in particular fought for the decriminali-zation and recognition of homosexuality. Other scientists understood the "third sex" as a pathological phenomenon and wanted to effect the "re-education" and "healing" of their patients with methods that were sometimes questionable. The result was often physical or psychological trauma.

Many figures from the early history of sexology were Jewish. From 1933 on, they and the entire discipline were vehemently attacked by the Nazis. In the face of increasing antisemitic violence, most of them fled into exile.

Der Professor für Psychiatrie Richard von Krafft-Ebing wird durch Karl Heinrich Ulrichs auf das Thema Homosexualität aufmerksam und unterstützt die Petition des Wissenschaftlich-humanitären Komitees gegen Paragraf 175. Während Ulrichs davon ausgeht, dass Homosexualität eine natürliche Variante der menschlichen Existenz ist, sieht Krafft-Ebing sie als erblich bedingt, aber krankhaft an.

In seinem Hauptwerk *Psychopathia Sexualis* verbindet Krafft-Ebing Psychiatrie und Gerichtsmedizin. Er vertritt die Ansicht, dass Homosexualität nicht strafrechtlich verfolgt werden dürfe. Als Erkrankung müsse sie vielmehr therapiert werden. Das Buch wird zum Standardwerk der Sexualwissenschaft.

The professor of psychiatry Richard von Krafft-Ebing became aware of the subject of homosexuality through Karl Heinrich Ulrichs and supported the petition of the Scientific-Humanitarian Committee against Paragraph 175. While Ulrichs assumed that homosexuality was a natural variant of human existence, Krafft-Ebing saw it as hereditary but pathological.

Krafft-Ebing drew on psychiatry and forensic medicine in his chief work, *Psychopathia Sexualis*. In it he argues that homosexuality should not be prosecuted. Rather, as an illness, it must be treated. The book became a standard work of sexology.

Richard von Krafft-Ebing, *Psychopathia Sexualis*, 1901

Sándor Vay (1859–1918) ist einer der zahlreichen „Fälle", die Krafft-Ebing in seinem Buch behandelt. Vay wird bei der Geburt das weibliche Geschlecht zugewiesen und schließt unter dem Vornamen Sarolta als eine der ersten Frauen in Ungarn ein Universitätsstudium ab, auch wenn Vay größtenteils als Mann lebt. Vay arbeitet als Journalist und heiratet 1889 eine Frau.

Sándor Vay (1859–1918) was one of the many "cases" Krafft-Ebing discussed in his book. Vay was assigned the female gender at birth and, under the first name Sarolta, became one of the first women in Hungary to graduate from university, even though Vay mostly lived as a man. Vay worked as a journalist and married a woman in 1889.

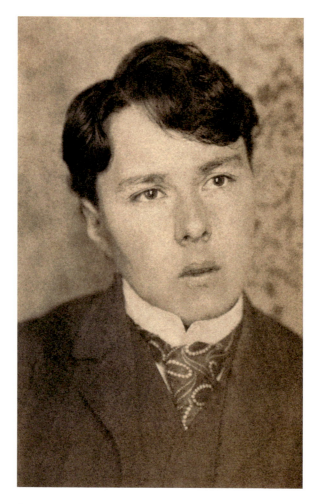

Sándor Vay, um 1890 | Sándor Vay, ca. 1890

Über Sandór Vay erscheinen noch zu Lebzeiten zahlreiche Zeitungsartikel. Wie viele andere Menschen, die zu dieser Zeit nicht dem Geschlecht entsprechend leben, das ihnen bei Geburt zugewiesen wird, wird auch Vay wegen Betrugs vor Gericht gestellt.

Numerous newspaper articles appeared about Sandór Vay during their lifetime. Along with many others who did not live according to the sex they were assigned at birth, Vay was tried as an alleged impostor.

END OF A MAD CAREER

THE STRANGE CASE OF THE ECCENTRIC COUNTESS SAROLTA VAY.

Result of the Investigations of a Learned Professor—The Most Notorious European Woman of Her Generation—She Threatened to Tear Up All Austria with Her Pranks, and She Kept Her Word—An Unparalleled Record of Deception and Duplicity.

New York *Sun:* The young Hungarian Countess, Sarolta Vay, closed her mad career last January. Without money and without credit, shattered by dissipation and disheartened by disappointment, restrained at every turn by the inflexible hand of the law, and notorious beyond any other European woman of her generation, she then took refuge from the sporting world in the seclusion of a friend's house in Pesth. She abjured drinking, betting, and gambling, fighting, dueling, and debt-making. She continued to wear trousers and cutaways, but ceased to woo and win young women under such false pretenses. Her retirement from the sporting world, which she had helped to lead, caused the revival of many reminiscences of her bizarre record in the high life of Vienna, Pesth, and Prague. But the Countess and her family and friends kept their mouths shut so tight concerning her carousals that only desultory bits of her history could be picked up here and there by the continental dailies.

COUNTESS SAROLTA VAY.

Recently, however, Prof. von Krafft-Ebing got at the records of the Vay family, from the tenth century founder down to Countess Sarolta, and collected from them the facts for a "psychological and physiological study," which he has just published. His book is far from being as heavy and abstract as its title might indicate. It contains a wealth of raw material for simon-pure gossip in the finer drawing-rooms of Emperor Franz Joseph's subjects.

Artikel über Sándor Vay, *Chicago Tribune,* 30.8.1890 | Article about Sándor Vay, *Chicago Tribune,* August 30, 1890

Sigmund Freud, *Drei Abhandlungen zur Sexualtheorie*, 1. Aufl. 1905 | **Sigmund Freud,** *Three Treatises on the Theory of Sex*, 1st ed., 1905

Der Begründer der Psychoanalyse Sigmund Freud (1856–1939) sieht den Sexualtrieb als entscheidende menschliche Antriebskraft. Sein Verhältnis zu Magnus Hirschfeld ist gespalten: Auf der einen Seite schätzt er ihn, auf der anderen ist er in einem wesentlichen Aspekt uneins mit ihm. Für Hirschfeld ist Homosexualität konstitutionell-organisch, also natürlich und angeboren. Freud geht eher davon aus, dass sie größtenteils im Laufe des Lebens erworben wird.

Freud wendet sich ab Mitte der 1890er Jahre der „sexuellen Frage" zu. Seine Überlegungen fasst er 1905 in den *Abhandlungen zur Sexualtheorie* zusammen. Freud verbindet Sexualwissenschaft und Psychoanalyse und entwickelt unter anderem seine These von der Existenz einer frühkindlichen Sexualität. Die erste Abhandlung ist den „sexuellen Abirrungen" gewidmet und beginnt mit der als „Inversion" bezeichneten männlichen Homosexualität.

The founder of psychoanalysis, Sigmund Freud (1856–1939), regarded the sexual instinct as the decisive human driving force. His relationship with Magnus Hirschfeld was divided: on the one hand, he respected him; on the other, he disagreed with him on one essential aspect. For Hirschfeld, homosexuality is constitutional-organic, that is, natural and innate. Freud by contrast assumed that it is principally acquired in the course of one's life.

Freud focused on the "sexual question" from the mid-1890s on. He summarized his reflections in 1905 in the *Abhandlungen zur Sexualtheorie* (Treatises on the Theory of Sex). Freud combined sexology and psychoanalysis, and he developed, among other things, a theory of the existence of an early childhood sexuality. The first treatise is devoted to "sexual aberrations" and begins with male homosexuality, which he calls "inversion."

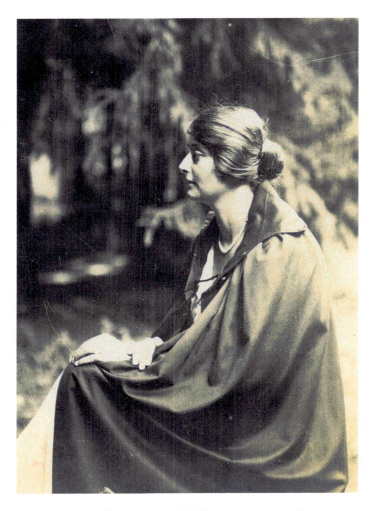

Margarethe Csonka-Trautenegg, um 1919 | **Margarethe Csonka-Trautenegg, ca. 1919**

Geprägt von den frauenfeindlichen Diskursen seiner Zeit ist Freud an der weiblichen Sexualentwicklung lange kaum interessiert. 1900 analysiert er die Patientin „Dora". Es dauert 15 Jahre, bis er wieder vereinzelt von Patientinnen berichtet. 1920 stellt er mit „Sidonie C." einen Fall weiblicher Homosexualität vor. Sidonie C. alias Margarethe Csonka-Trautenegg (1900–1999) wehrt sich jedoch gegen die bevormundende Behandlung und beendet sie nach wenigen Monaten.

Influenced by the misogynistic discourse of his time, Freud was at first little interested in female sexual development. In 1900 he analyzed a patient known as "Dora." Fifteen years passed before he reported on a female patient again. In 1920 he presented a case of female homosexuality with Sidonie C., also known as Margarethe Csonka-Trautenegg (1900–1999). She resisted the patronizing treatment and ended it after a few months.

KNOWLEDGE, DIAGNOSIS, CONTROL

Hope Bridges Adams Lehmann in ihrer Praxis in München, 1901 | Hope Bridges Adams Lehmann in her office in Munich, 1901

Die gebürtige Engländerin Hope Bridges Adams Lehmann (1855–1916) ist eine der ersten Frauen, die in Deutschland Medizin studieren. Sie ist neben Helene Stöcker, Johanna Elberskirchen und Mathilde Vaerting eine Pionierin der Sexualwissenschaft. In München plant sie ein Frauenkrankenhaus, sie engagiert sich in der Frauenbewegung und für den Mutterschutz.

Bridges Adams Lehmann ist die erste praktische Ärztin und Gynäkologin Bayerns. Von 1893 bis 1916 führt sie eine Praxis in München. Wegen ihres Engagements für Geburtenkontrolle und die Lockerung des Abtreibungsverbots wird sie 1914 wegen „fortgesetzten Verbrechens wider das Leben" angezeigt. Die Vorwürfe erweisen sich als haltlos.

Born in England, Hope Bridges Adams Lehmann (1855–1916) was one of the first women to study medicine in Germany. Together with Helene Stöcker, Johanna Elberskirchen, and Mathilde Vaerting, she was one of sexology's early female pioneers. In Munich she planned a women's hospital and was active in the women's movement as well as in maternity protection.

Bridges Adams Lehmann was the first female general practitioner and gynecologist in Bavaria. She ran a practice in Munich from 1893 to 1916. Because of her commitment to birth control and easing the ban on abortion, she was denounced in 1914 for "continued crimes against life." The charges have been shown to be groundless.

Hope Bridges Adams Lehmann, *Das Frauenbuch. Ein ärztlicher Ratgeber für die Frau in der Familie und bei Frauenkrankheiten*, Bd. 1, 6. Aufl. 1897 | Hope Bridges Adams Lehmann, *The Woman's Book: A Medical Guidebook for the Woman in the Family and on Female Diseases*, vol. 1, 6th ed., 1897

„Ein Gefühl können wir nur dadurch nicht für unnatürlich erklären, weil es von den meisten nicht geteilt wird […]."

Hope Bridges Adams Lehmann,
Das Frauenbuch, 1896

"We cannot declare a feeling unnatural just because it is not shared by most people."

Hope Bridges Adams Lehmann,
Das Frauenbuch, 1896

Im zweibändigen *Frauenbuch*, einem „ärztlichen Ratgeber für die Frau", plädiert Bridges Adams Lehmann für ein partnerschaftliches Zusammenleben der Geschlechter und für ein neues Verhältnis zur Sexualität. Sie bespricht dabei auch tabuisierte Themen wie Masturbation und lesbische Liebe.

In the two-volume *Frauenbuch*, a "medical guidebook for women," Bridges Adams Lehmann called for a friendly coexistence of the sexes and a new relationship to sexuality. She also discussed taboo topics such as masturbation and lesbian love.

KNOWLEDGE, DIAGNOSIS, CONTROL 161

DAS INSTITUT FÜR SEXUALWISSENSCHAFT UND SEINE PATIENT*INNEN

Magnus Hirschfeld ist der bekannteste Vertreter der Sexualwissenschaft im deutschsprachigen Raum. Er verbindet das Streben nach Emanzipation und die wissenschaftliche Perspektive, er ist Vorkämpfer der Entkriminalisierung und Mediziner zugleich. Sein 1919 in Berlin gegründetes Institut für Sexualwissenschaft wird zum Zentrum der linksliberalen Sexualreformbewegung der Weimarer Republik. Neben Forschung und medizinischer Beratung betreibt das Institut eine Bibliothek, ein Archiv und ein Museum. Anders als konservative Sexualwissenschaftler*innen wirken Hirschfeld und seine Mitarbeiter*innen auf Selbstakzeptanz Homosexueller und trans* Personen hin. In dieser „Adaptionstherapie" oder „Milieutherapie" sollen sich die Personen an das queere Milieu anpassen, das ihnen entspricht, anstatt sich zu verbiegen. Viele wichtige Personen aus der Szene, wie zum Beispiel Lili Elbe, werden hier behandelt. Homosexuelle Schriftsteller wie André Gide oder Christopher Isherwood sind zu Gast. Auch Menschen, die man heute als intergeschlechtlich bezeichnen würde, werden beraten. Schon früh stören sich die Nationalsozialist*innen an der liberalen Sexualwissenschaft, Hirschfeld und seinem Institut. Wie Hirschfeld sind viele der Mitarbeitenden jüdisch. 1933 zerstören nationalsozialistische Student*innen und SA-Leute das Institut, Hirschfeld befindet sich zu dieser Zeit auf Weltreise und bleibt im Exil in Frankreich.

THE INSTITUTE FOR SEXOLOGY AND ITS PATIENTS

Magnus Hirschfeld was the best-known representative of sexology in the German-speaking world. He combined a pursuit for emancipation and a scientific perspective, was a champion of decriminalization and a physician at the same time. His Institute for Sexology, founded in Berlin in 1919, became the center of the liberal-leftist sexual reform movement of the Weimar Republic. In addition to research and medical consulting, the institute operated a library, an archive, and a museum. Unlike conservative sexologists, Hirschfeld and his staff worked towards the self-acceptance of homosexuals and trans+ people. This "adaptation therapy" or "milieu therapy" aimed to help people adapt to the queer milieu that suited them, instead of repressing their identity. Many important people from the gay community, such as Lili Elbe, were treated here. Homosexual writers such as André Gide and Christopher Isherwood visited the institute. People who today would be considered intersex were also counseled. From the beginning, the Nazis were disturbed by liberal sexology, Hirschfeld, and his institute. Many of the institute's employees were, like Hirschfeld himself, Jewish. In 1933, Nazi students and SA members demolished the institute; Hirschfeld was on a world tour at the time and remained in exile in France.

164 WISSEN, DIAGNOSE, KONTROLLE

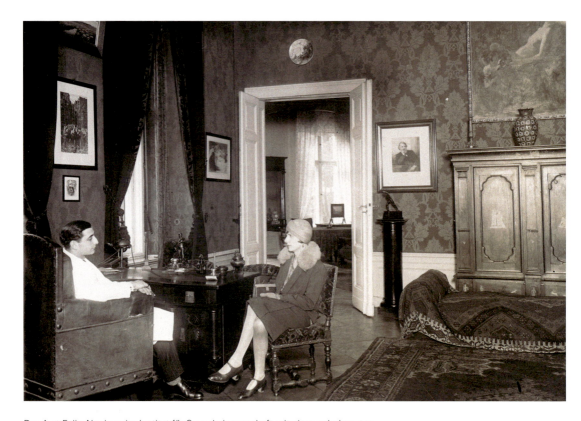

Der Arzt Felix Abraham im Institut für Sexualwissenschaft mit einer unbekannten Person, mutmaßlich eine trans* Frau, Berlin um 1930 | **The physician Felix Abraham in the Institute for Sexology with an unknown person, presumably a trans+ woman, Berlin, ca. 1930**

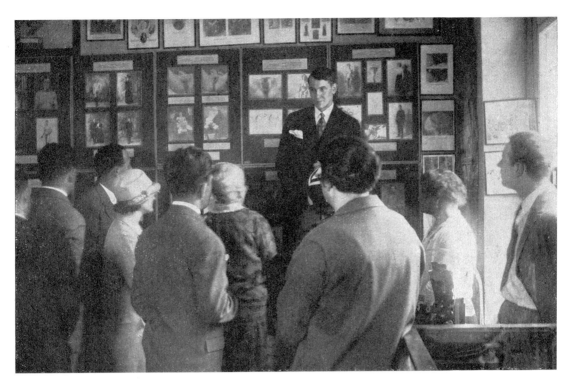

Der Archivar und Museumsleiter Karl Giese bei einer der zahlreichen Führungen durch die Institutssammlungen, 1929 | The archivist and museum director Karl Giese during one of the many tours of the institute's collections, 1929

166 WISSEN, DIAGNOSE, KONTROLLE

Die Zwischenstufenwand im Institut für Sexualwissenschaft veranschaulicht Hirschfelds Theorie, dass alle Menschen männliche und weibliche Anteile in sich tragen. Zwischen „Vollmann" und „Vollweib" gibt es viele Varianten hinsichtlich Sexualität und Geschlecht.

The "Zwischenstufenwand" (sexual transitions wall) in the Institute for Sexology illustrated Hirschfeld's theory that all people have male and female qualities in them. Between "fully man" and "fully woman" there are many variations in terms of sexuality and gender.

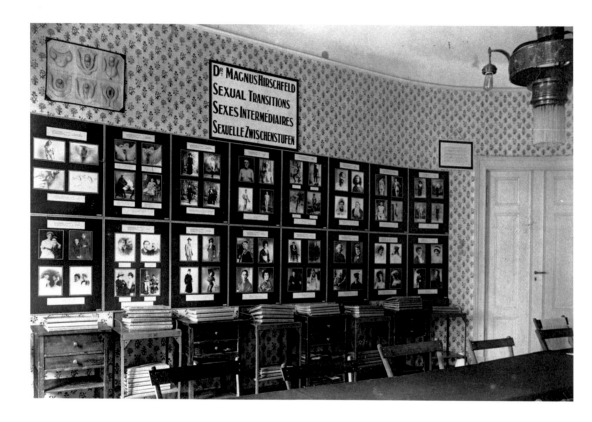

„Das Geschlecht des Menschen ruht viel mehr in seiner Seele als in seinem Körper, oder, um mich einer medizinischen Ausdrucksweise zu bedienen, vielmehr im Gehirn als in den Genitalien."

Magnus Hirschfeld, Nachwort zu N.O. Body, *Aus eines Mannes Mädchenjahren*, 1907

"A human's gender lies much more in their soul than in their body, or, to use a medical expression, much more in the brain than in the genitals."

Magnus Hirschfeld, afterword to N.O. Body, *From a Man's Girlhood Years*, 1907

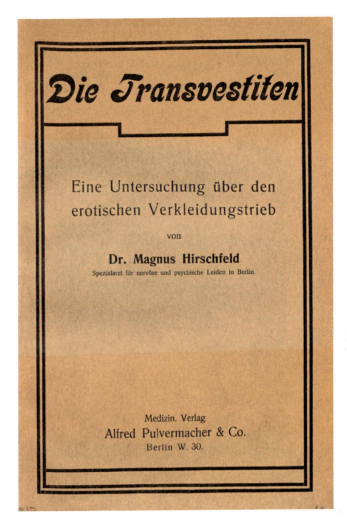

Magnus Hirschfeld, *Die Transvestiten. Untersuchung über den erotischen Verkleidungstrieb*, 1910/12 | **Magnus Hirschfeld**, *Transvestites: Investigation of the Erotic Disguising Drive*, 1910/12

Bereits 1910 hebt Hirschfeld die Bedeutung von Kleidung für „Transvestiten" hervor. Mit diesem Begriff bezeichnet er zunächst Menschen, die privat oder öffentlich in der Kleidung des jeweils anderen Geschlechts leben wollen. Später versteht er, dass es für viele seiner Patient* innen nicht nur um einen „erotischen Verkleidungstrieb" geht. Manche wollen mit ihrem „Kleidergeschlecht" auch ihre selbstempfundene Geschlechtsidentität leben.

As early as 1910, Hirschfeld emphasized the importance of clothing for "transvestites" – a term that he initially used to describe people who wanted to live privately or publicly in the clothing of the opposite sex. Later, he understood that for many of his patients it was not only about an "erotic disguising drive." Some also wanted to live their self-perceived gender identity with their "dress gender."

KNOWLEDGE, DIAGNOSIS, CONTROL

168 WISSEN, DIAGNOSE, KONTROLLE

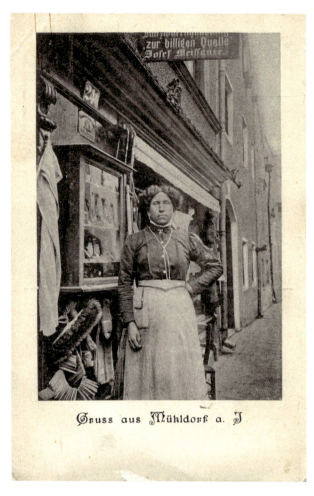

Josef Meissauer vor seinem*ihrem Laden, um 1912 | **Josef Meissauer in front of their store, ca. 1912**

1910 berichten Zeitungen über die Verhaftung eines Kaufmanns aus Mühldorf am Inn wegen „groben Unfugs". Josef Meissauer (1863–?) war auf einer Fronleichnamsprozession in einem Kleid erschienen. 1911 wendet sich Meissauer an Hirschfeld, um ein Gutachten für einen „Transvestitenschein" zu erhalten – mit Erfolg.

In 1910, newspapers reported the arrest of a merchant from Mühldorf am Inn for being a "public nuisance." Josef Meissauer (1863–?) had appeared at a Corpus Christi procession in a women's dress. In 1911, Meissauer approached Hirschfeld for an expert's report for a "Transvestite Certificate" – with success.

"Psychobiologischer Fragebogen", 1911 |
"Psychobiological questionnaire", 1911

Der Fragebogen dient im Institut für Sexualwissenschaft zur Erfassung der Vorgeschichte der Patient*innen. Dabei wird neben Persönlichkeitseigenschaften auch das Sexualleben der Familienangehörigen erfragt.

The questionnaire was used in the Institute for Sexology to record the history of patients. In addition to personality traits, the questionnaire also inquired about the sexual life of family members.

KNOWLEDGE, DIAGNOSIS, CONTROL 169

170 WISSEN, DIAGNOSE, KONTROLLE

Diese Aufnahme entstand wahrscheinlich im Zuge der Dreharbeiten zum Film *Anders als die Andern*, in dem Hirschfeld (2. von rechts) als Sexualtherapeut auftritt. Auch sein damaliger Lebensgefährte Karl Giese (5. von rechts), dessen Hand Hirschfeld hält, spielt darin eine Rolle.

This photograph was probably taken during the filming of *Anders als die Andern*, in which Hirschfeld (second from right) appears as a sex therapist. His partner Karl Giese (fifth from right), whose hand Hirschfeld holds, played the role of the violinist as a young man.

Entspanntes Zusammensein, um 1919 |
Relaxed gathering, ca. 1919

Anlässlich seines 60. Geburtstags werden Magnus Hirschfelds Lebensleistungen gewürdigt. Richard Linsert vom Wissenschaftlich-humanitären Komitee feiert den Wissenschaftler, Sexualreformer und Aktivisten 1928 in der kommunistischen *Arbeiter-Illustrierten Zeitung* und macht Hirschfeld und sein Institut in der Arbeiter*innenschaft bekannt.

Homages to Magnus Hirschfeld's life achievements appeared in 1928, on the occasion of his sixtieth birthday. Richard Linsert of the Scientific-Humanitarian Committee celebrated the scientist, sexual reformer, and activist in the communist newspaper *Arbeiter-Illustrierte Zeitung* and made Hirschfeld and his institute known among workers.

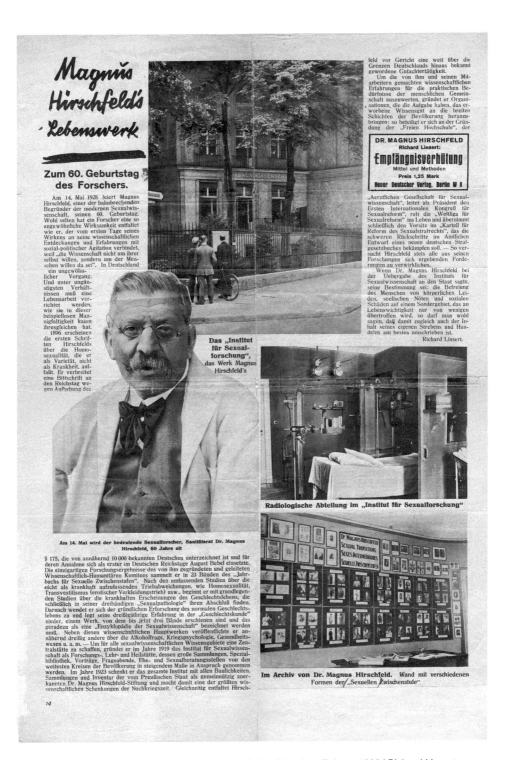

Richard Linsert, Magnus Hirschfelds Lebenswerk, *Arbeiter-Illustrierte-Zeitung*, 1928 | Richard Linsert, "Magnus Hirschfeld's Lifework," *Arbeiter-Illustrierte-Zeitung*, 1928

Das Institut entwickelt sich zum Zufluchtsort für „Transvestit*innen". So werden damals unter anderem Menschen genannt, die wir heute als trans* Personen verstehen. Einige von ihnen wohnen im Institut und verdienen dort ihren Lebensunterhalt. Gerade sie stehen in einer großen Abhängigkeit zum Institut. Trotz der großen Verdienste ist das Verhältnis zwischen Mediziner*innen und „Patient*innen" am Institut aus heutiger Sicht nicht unproblematisch. Indem Hirschfeld und seine Mitarbeiter*innen zwischen queeren Personen und staatlicher Macht vermitteln, können sie ihre „Patient*innen" einerseits schützen und für sie mehr Rechte und Freiräume erstreiten. Doch dazu kooperieren sie mit Polizei und Gerichten und ermöglichen den staatlichen Institutionen so Zugriff und Kontrolle. Damals wie heute werden inter* und trans* Menschen nur selten als Expert*innen ihrer selbst wahrgenommen und sind auf die Anerkennung durch Medizin und Justiz angewiesen. Damit geht ein wissenschaftlicher und staatlich-regulierender Blick auf ihre Körper einher, der sie in die Rolle von Patient*innen, also fremdbestimmter Objekte drängt, anstatt ihnen Autonomie über ihren Körper sowie eine eigene Stimme zuzugestehen.

The institute grew to become a refuge for "transvestites," which is how people we understand today as trans+ were called at the time. Some of them lived in the institute and earned their living there. They were particularly dependent on it. Despite the institute's great merits, the relationship between doctors and "patients" was not unproblematic from today's point of view. By mediating between queer people and state power, Hirschfeld and his colleagues were able to protect their patients and fight for more rights and freedom for them. But in order to do so, they cooperated with the police and the courts, thus providing the state institutions with access and control. Then as now, intersex and trans+ people were rarely perceived as experts on themselves, making them dependent on the recognition bestowed by medicine and the justice system. This was accompanied by a scientific and state-regulatory view of their bodies that pushed them into the role of patients, externally controlled subjects, instead of granting them autonomy over their bodies as well as their own voice.

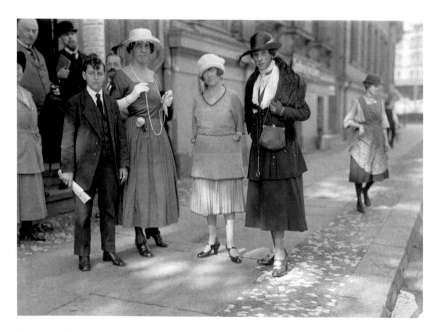

Unter dem Titel *Transvestiten vor dem Eingang des Instituts für Sexualwissenschaft* veröffentlichte Fotografie, aufgenommen anlässlich der Ersten Internationalen Tagung für Sexualreform auf sexualwissenschaftlicher Grundlage, Berlin 1921 | **Photograph published under the title** *Transvestites in front of the entrance to the Institute for Sexology*, **taken on the occasion of the First International Conference for Sexual Reform on the Basis of Sexology, Berlin, 1921**

Gerd Katter (1910–1995) kommt mit 16 Jahren – damals noch mit weiblichem Geburtsnamen – in das Institut für Sexualwissenschaft. Er bittet Ludwig Levy-Lenz um eine Amputation seiner Brüste. Da ihm dies wegen seines jugendlichen Alters verwehrt wird, versucht Katter, sich selbst zu operieren, woraufhin eine Notamputation vorgenommen werden muss. Gerd Katter absolviert später eine Tischlerlehre und lebt in der DDR.

Gerd Katter (1910–1995) came to the Institute for Sexology at the age of sixteen – then still using the female name given at birth. He asked Ludwig Levy-Lenz to amputate his breasts. Since he was denied this because of his young age, Katter tried to operate on himself, whereupon an emergency amputation had to be performed. Gerd Katter later completed a carpentry apprenticeship and lived in East Germany.

Rezept für Gerd Katter, ausgestellt von Felix Abraham, um 1928 | **Prescription for Gerd Katter, issued by Felix Abraham, ca. 1928**

Gerd Katter, um 1928 | **Gerd Katter, ca. 1928**

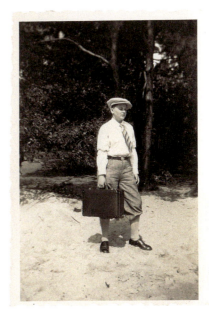

Katter ist einer von vielen Menschen, denen im Institut konkret, wenn auch unkonventionell geholfen wird. So verschreibt ihm Felix Abraham den Besuch von Bars, in denen sich „Transvestiten" treffen. Gemäß der am Institut verfolgten Adaptionstherapie sollen Ratsuchende in Kontakt mit Gleichgesinnten gebracht werden. So sollen sie lernen, sich selbst zu akzeptieren.

Katter was one of many people for whom the institute provided concrete, if unconventional, assistance. Felix Abraham, for example, prescribed that he visit bars where "transvestites" meet. According to the "adaptation therapy" practiced at the institute, those seeking advice were to be brought into contact with like-minded people. In this way, they should learn to accept themselves.

KNOWLEDGE, DIAGNOSIS, CONTROL 173

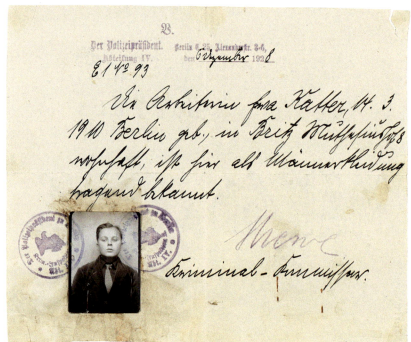

Ärztliche Bescheinigung und „Transvestitenschein" für Gerd Katter, 1928 | Medical certificate and "Transvestite Certificate" for Gerd Katter, 1928

Ab 1900 werden in einigen Städten „Transvestitenscheine" ausgestellt. Es handelt sich dabei um eine ärztlich bescheinigte amtliche Bestätigung, dass eine Person als „Männerkleidung tragend" oder „Frauenkleidung tragend" bekannt ist. Bei Kontrollen vorgezeigt, sehen die Behörden von einer Verhaftung ab. Allerdings sind die Betroffenen damit polizeilich erfasst und können leichter überwacht werden.

Starting in 1900, "Transvestite Certificates" were issued in some cities. This was an official confirmation, certified by a doctor, that a person was known to be "wearing men's clothing" or "wearing women's clothing." When shown during police checks, the authorities refrained from arresting the person. However, the persons concerned were thus registered with the police and could be monitored more easily.

Gründe zur Aenderung des Vornamens.
Schon seit vielen Jahren habe ich eine Abneigung gegen weibliche
Kleidung,wodurch im Elternhause fortwährend Streitigkeiten ent=
standen.Ich fühlte mich unglücklich in Mädchenkleidern,von Eitel=
keit und Putzsucht war keine Spur,da ich auch garnicht das Verlan=
genhatte durch schöne Kleider die Blicke des männlichen Geschlechts
auf mich zu lenken.Ich verlor jede Freude am Leben,da ich keine
Aussicht vor mir sah,eine Aenderung zuschaffen.Ich war daher von
Flucht und Selbstmordgedanken beherrscht.Ich wurde scheu und
 eingeschüchtert,denn ich war als Aussenseiter bekannt,ich wur=
de angestaunt,angepöbeltund ausgelacht;denn ich fiel auf durch
 absonderliche Kleidung,durch jungenhaftes Benehmensowie durch
eine verhältnismässig tiefe Stimme.Meine näheren Bekannten be=
trachteten mich als Phänomen,da meineFähigkeiten und Interressen
auf für Frauen fernliegenden Gebieten liegen.
Al s ich Ende 1928 auf Grund eines ärztlichen Gutachtensvon
Dr.Hirschfeld,auf dem Polizeipräsidiumdie Genehmigung zum Tragen
vonMännerkleidung erhielt,konnte ich wie befreit aufatmen.Von
nun an falle ich nicht mehr auf,niemand dreht sich nach mir
um und die stereotype Frage:"Was sind sie denn eigentlich?"
qwält mich nicht mehr.Niemand zweifelt daran,dass ich ein Junge
bin.Aber wenn ich meinen Namen nennen muss und sagen soll,dass
ichEva heisse,dann entstehen sofort Schwierigkeiten und unange=
nehme Situationen,die mich veranlassen,eine Aenderung meines
Vornamens zu beantragen.Denn mein jetziger Zustand ist unhalt=
bar,da mein Vorname nicht mit meiner Kleidung übereinstimmt,.
wAs die Notwendigkeit einer Umschreibung verständlich macht..

Begründung von Gerd Katter, die amtliche Anerkennung
seines selbstgewählten Vornamens betreffend, um 1929 |
Statement by Gerd Katter concerning the official
recognition of his first name as chosen by himself,
ca. 1929

Ab 1921 ist es durch Beschluss des preußischen Innen-
ministeriums möglich, Vornamen anzugleichen oder
geschlechtsneutrale zu wählen. Der Weg dahin ist teuer
und bürokratisch aufwendig. Zudem werden solche
Änderungen behördlich angezeigt und damit öffentlich
gemacht, was einem bloßstellenden Zwangsouting
gleichkommt.

As of 1921, a decision by the Prussian Ministry of the
Interior made it possible to modify first names or to
choose gender-neutral ones. The process was expensive
and bureaucratically complex. In addition, such changes
were reported to the authorities and thus made public,
which was tantamount to the social exposure of a forced
outing.

KNOWLEDGE, DIAGNOSIS, CONTROL 175

Der Film *Mysterium des Geschlechts* läuft im April 1933 etwa zwei Wochen in Wiener Kinos, bevor er verboten wird. Der Film ist eine Mischung aus Romanze und medizinischem Schulungsfilm. Unter den Protagonist*innen sind – ohne Nennung ihres Namens – Toni Ebel, Charlotte Charlaque und Dora Richter.

The film *Mystery of Sex* was screened in Viennese cinemas for about two weeks in April 1933 before it was banned. The film is a mixture of romance and medical training film. Toni Ebel, Charlotte Charlaque, and Dora Richter were part of its cast – although not mentioned by name.

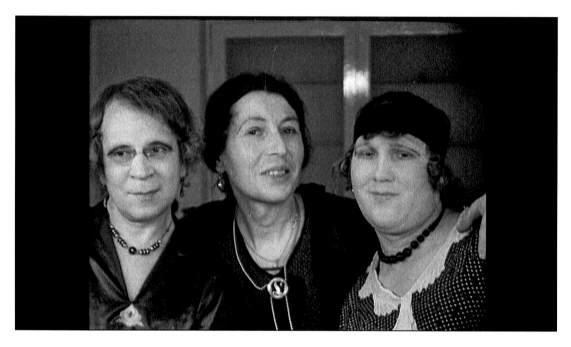

Filmstill aus *Mysterium des Geschlechts*, Österreich 1933 | Film still from *Mystery of Sex*, Austria, 1933

Dora Richter bei der Handarbeit, ohne Jahr, in: Magnus Hirschfeld, *Geschlechtskunde*, Bd. 4, Bildteil, 1930 | **Dora Richter doing needlework, undated, in Magnus Hirschfeld, *Sexology*, vol. 4, plates, 1930**

Dorchen, eigentlich Dora Richter (1891–?), kommt 1923 ans Institut für Sexualwissenschaft. Sie wird als eine der ersten trans* Frauen bekannt, die sich einer operativen Geschlechtsangleichung unterziehen. Da die Arbeitssuche für trans* Personen schwierig ist, nimmt sie eine Anstellung als Hausmädchen am Institut an, das 1933 durch nationalsozialistische Gruppen geplündert wird. Nach 1933 ist über Richters Schicksal nichts bekannt.

Dorchen, actually Dora Richter (1891–?), came to the Institute for Sexology in 1923. She became known as one of the first trans+ women to undergo surgical gender reassignment. Finding work was difficult for trans+ people, so she took a job as a maid at the institute, which was sacked by Nazi groups in 1933. Nothing is known about Richter's fate after 1933.

KNOWLEDGE, DIAGNOSIS, CONTROL

Toni Ebel und Charlotte Charlaque in ihrer Wohnung in Berlin-Schöneberg, fotografiert von Ragnar Ahlstedt für einen Artikel in der Zeitung *Tranås Tidning*, 28.10.1933 | Toni Ebel and Charlotte Charlaque in their apartment in the Berlin neighborhood of Schöneberg, photographed by Ragnar Ahlstedt for an article in the newspaper *Tranås Tidning*, October 28, 1933

Die trans* Frauen Toni Ebel (1881–1961) und Charlotte Charlaque (geb. Scharlach, 1892–1963) wissen schon früh, dass sie Frauen sind. Ebel ist Absolventin einer Kunstschule in München, Charlaque tritt als „Damendarsteller" in Bars und Varietés auf. Da sie Jüdin ist, wird Charlaque nach 1933 verfolgt. 1934 flieht sie mit Ebel in die Tschechoslowakei. 1942 verhaftet, entkommt Charlaque als Deutsch-Amerikanerin der Deportation. Ihr gelingt die Ausreise in die USA. Ebel überlebt den Krieg in Europa und lässt sich in der DDR nieder, wo sie weiter als Künstlerin tätig ist.

The trans+ women Toni Ebel (1881–1961) and Charlotte Charlaque (née Scharlach, 1892–1963) knew from an early age that they were women. Ebel was a graduate of an art school in Munich, Charlaque performed as a "lady actor" in bars and vaudevilles. Because she was Jewish, Charlaque was subject to persecution after 1933. In 1934 she fled with Ebel to Czechoslovakia. Arrested in 1942, Charlaque escaped deportation as a German-American, emigrating to the United States. Ebel survived the war in Europe and settled in East Germany, where she continued to work as an artist.

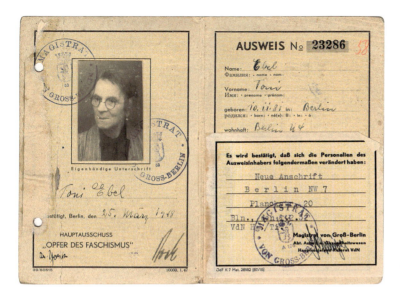

Ausweis von Toni Ebel als Opfer des Faschismus, 1948 | Identity card of Toni Ebel as a victim of fascism, 1948

Toni Ebel, *Selbstbildnis*, Öl auf Hartfaser, 1955 | Toni Ebel, *Self Portrait*, oil on hard fiber, 1955

Toni Ebel konvertiert Anfang 1933 zum Judentum, macht die Konversion aber mit zunehmendem Verfolgungsdruck rückgängig. Nach 1945 wird sie als Opfer des Faschismus anerkannt. Ebel kann sich in der DDR eine neue Existenz als Malerin aufbauen.

Toni Ebel converted to Judaism in early 1933, but reversed the conversion when the pressure of persecution increased. After 1945, she was recognized as a victim of fascism. Ebel was eventually able to build a new life as a painter in East Germany.

KNOWLEDGE, DIAGNOSIS, CONTROL 179

180 WISSEN, DIAGNOSE, KONTROLLE

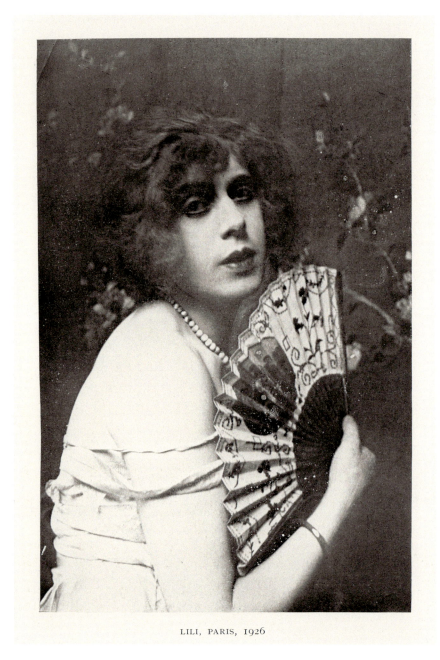

LILI, PARIS, 1926

Lili Elbe, 1926

Lili Elbe (1882–1931) wird als Einar Wegener in Dänemark geboren. Bekanntheit erlangt die Malerin durch ihre Geschlechtsangleichung, die 1931 auch zum Thema ihrer Autobiografie wird.

Lili Elbe (1882–1931) was born Einar Wegener in Denmark. The painter gained public attention for her gender reassignment, which also became the subject of her autobiography in 1931.

„Ich kämpfe gegen die Voreingenommenheit des Spießbürgers, der in mir ein Phänomen, eine Abnormität sucht. Wie ich jetzt bin, so bin ich eine ganz gewöhnliche Frau unter Frauen."

Lili Elbe, *Ein Mensch wechselt sein Geschlecht*, 1932

"I am fighting against the prepossession of the Philistine who looks upon me as a phenomenon, as an abnormality. As I am now, I am a perfectly ordinary woman among other women."

Lili Elbe, *Man into Woman*, 1933

Gerda und Einar Wegener (Lili Elbe) vor Gerda Wegeners Gemälde *Sur la route d'Anacapri*, 1924 | Gerda and Einar Wegener (Lili Elbe) in front of Gerda Wegener's painting *Sur la route d'Anacapri*, 1924.

Einar Wegener (Lili Elbe) ist mit der Malerin Gerda Gottlieb (1886–1940) verheiratet. Gerda unterstützt die Geschlechtsangleichung und porträtiert Lili Elbe in glamourösen und sinnlichen Posen. Das Paar lebt in verschiedenen Städten Europas.

Einar Wegener (Lili Elbe) was married to the painter Gerda Gottlieb (1886–1940). Gerda supported her partners gender reassignment and portrayed Lili Elbe in glamorous and sensual poses. The couple lived in various cities in Europe.

KNOWLEDGE, DIAGNOSIS, CONTROL 181

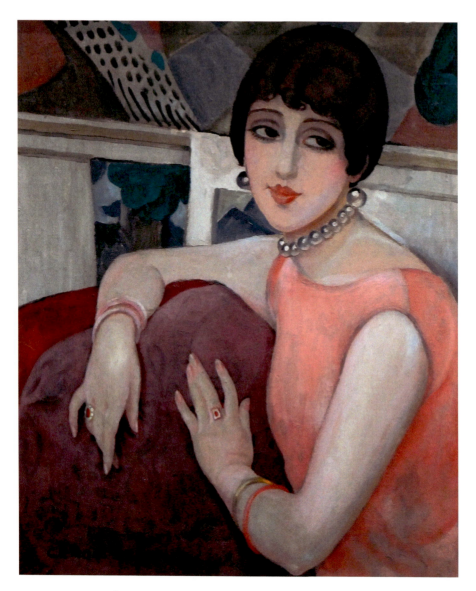

Gerda Wegener, *Lily*, Öl auf Leinwand, 1922 |
Gerda Wegener, *Lily*, oil on canvas, 1922

Die ersten genitalchirurgischen Eingriffe bei trans* Personen sind ab 1912 belegt. Lili Elbe besucht das Institut für Sexualwissenschaft erstmals Anfang 1930 und lässt sich in Berlin operieren, vermutlich in der Praxis von Ludwig Levy-Lenz. 1931 erfolgen mehrere Eingriffe durch Kurt Warnekros in der Dresdener Frauenklinik. Zuvor operiert er bereits Charlotte Charlaque in Berlin.

The first genital surgical procedures on trans+ people were documented in 1912. Lili Elbe first visited the Institute for Sexology in early 1930 and underwent surgery in Berlin, presumably in the practice of Ludwig Levy-Lenz. In 1931, several operations were performed by Kurt Warnekros at the Königliche Frauenklinik in Dresden. He had previously operated on Charlotte Charlaque in Berlin.

Lili Elbe, *Ein Mensch wechselt sein Geschlecht. Eine Lebensbeichte*, hg. von Niels Hoyer, 1932 | Lili Elbe, *Ein Mensch wechselt sein Geschlecht. Eine Lebensbeichte*, ed. Niels Hoyer, 1932; published in English as *Man into Woman: An Authentic Record of a Change of Sex*, 1933

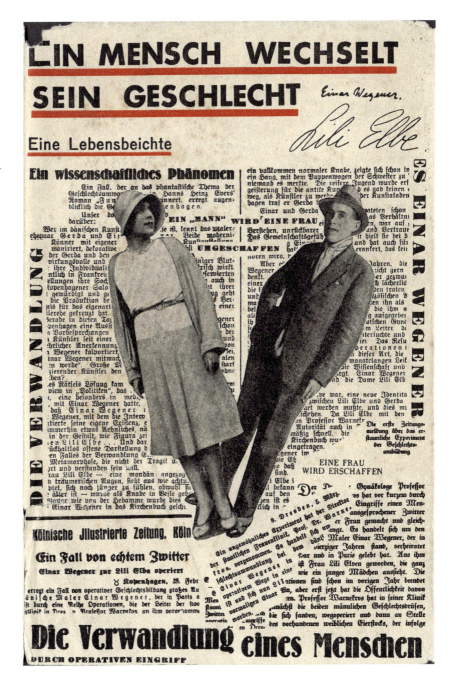

Durch ihren kurz vor ihrem Tod veröffentlichten Lebensbericht wird Lili Elbe bereits früh einem breiten Publikum bekannt. 2016 wird ihre Geschichte in dem Film *The Danish Girl* nacherzählt.

Through her autobiography, published shortly before her death, Lili Elbe quickly became known to a wide audience. In 2016, her story was retold in the film *The Danish Girl*.

CHARLOTTE WOLFF – SEXUALWISSENSCHAFT IM EXIL

In der von Männern dominierten Sexualwissenschaft werden weibliche Homosexualität und Bisexualität wenig beachtet. Eine Ausnahme bildet die Forschung von Charlotte Wolff (1897–1986). Die Medizinerin stellt das Thema ins Zentrum ihrer Arbeit.

Charlotte Wolff studiert Philosophie und Medizin in Berlin und promoviert 1928. Anschließend ist sie in der Sozialmedizin und Sexualreform tätig. Unter anderem arbeitet sie im Rudolf-Virchow-Krankenhaus (heute Charité) im Bereich Schwangerschaftsfürsorge und Verhütung. 1933 emigriert die jüdische Ärztin zunächst nach Paris, 1936 nach London. Ihre Forschungen zu lesbischer Sexualität und Bisexualität tragen ihr ab den 1960er Jahren internationale Anerkennung ein.

Durch die Flucht deutscher Akademiker*innen wie Charlotte Wolff ins Exil entwickelt sich die Wissenschaft im Ausland weiter, während die Forschung in Deutschland stagniert. Ab den 1950er Jahren wird die Sexualforschung maßgeblich von Wissenschaftler*innen wie dem US-Amerikaner Alfred Kinsey und seinem 1947 gegründeten Institute for Sex Research geprägt.

CHARLOTTE WOLFF = SEXOLOGY IN EXILE

Female homosexuality and bisexuality received little attention in the male-dominated field of sexology. An exception was the research of Charlotte Wolff (1897–1986). The physician situated precisely these topics at the center of her work.

Charlotte Wolff studied philosophy and medicine in Berlin and received her doctorate in 1928, after which she worked in social medicine and sexual reform. Among other things, she worked in Berlin's Rudolf Virchow Hospital (now Charité) in the fields of pregnancy care and contraception. Being Jewish, she emigrated to Paris in 1933, and to London in 1936. Her research on lesbian sexuality and bisexuality earned her international recognition beginning in the 1960s.

Because of the flight into exile of German academics such as Charlotte Wolff, science continued to progress abroad while research in Germany stagnated. From the 1950s onwards, sexology was significantly influenced by scientists such as the American Alfred Kinsey and his Institute for Sex Research, founded in 1947.

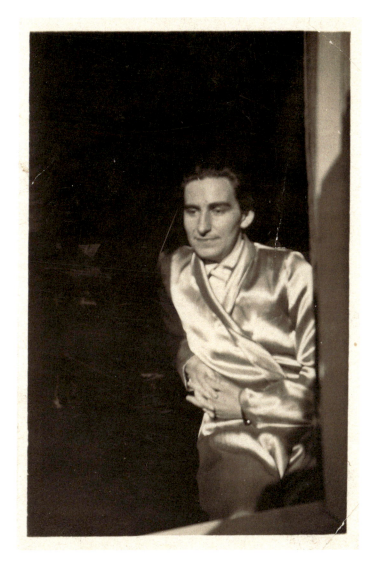

Charlotte Wolff, Berlin 1924

Ab 1933 geraten linke, jüdische und offen lesbische Frauen in Deutschland zunehmend ins Visier der Nationalsozialist*innen. Die Sexualwissenschaftlerin Charlotte Wolff wird unter anderem wegen Spionage und Tragens männlich konnotierter Kleidung verhaftet, ihre Berliner Wohnung durchsucht. Sie beschließt, nach Paris zu gehen, und es gelingt ihr 1935, eine Aufenthaltserlaubnis zu erhalten.

After 1933, left-wing, Jewish, and openly lesbian women in Germany were increasingly targeted by the Nazis. The sexologist Charlotte Wolff too was arrested for espionage and for wearing clothing with masculine connotations, and her Berlin apartment was searched. She decided to leave for Paris and succeeded in obtaining a residence permit there in 1935.

KNOWLEDGE, DIAGNOSIS, CONTROL

186 WISSEN, DIAGNOSE, KONTROLLE

Charlotte Wolff in London, fotografiert von John Vickers, 1943 |
Charlotte Wolff in London, photographed by John Vickers, 1943

„Etiketts wie 'lesbisch', 'hetero'- oder 'homosexuell' hatten in meiner Welt keinen Platz. […] [Und ich] wandte […] solche Begriffe niemals auf mich selbst an. […] Ich konnte in meiner sexologischen Forschung nachweisen, daß alle gesellschaftlich definierten sexuellen Kategorien falsch und unsinnig sind."

Charlotte Wolff, *Augenblicke verändern uns mehr als die Zeit*, 1982

"Labels like 'lesbian,' 'hetero,' or 'homosexual' were out of place in my world.... [And I] never applied … them to myself.... I have shown in my sexological research that sexual categories imposed by society are erroneous and nonsensical."

Charlotte Wolff, *Hindsight: An Autobiography*, 1980

188 WISSEN, DIAGNOSE, KONTROLLE

Handabdrücke des Boxers C. Dimitrios aus
dem Palais des Sports, Paris 1936–1940 |
Handprints of boxer C. Dimitrios from the
Palais des Sports, Paris, 1936–40

Seit ihrer Studienzeit in Berlin widmet sich Charlotte Wolff dem Handlesen und entwickelt Theorien, die Verbindungen zwischen Händen und Psyche offenlegen. Im Exil in Frankreich und dem Vereinigten Königreich forscht und veröffentlicht sie weiter zum Thema. Sie sammelt Handabdrücke von Boxern, französischen Adeligen, Psychologen und sogar Schimpansen.

Ever since her student days in Berlin, Charlotte Wolff had devoted herself to palmistry, developing theories that revealed connections between the hands and the psyche. In exile in France and the United Kingdom, she continued to research and publish on the subject. She collected handprints from boxers, French aristocrats, psychologists, and even chimpanzees.

Charlotte Wolff, *Bisexualität*, deutsche Ausgabe von 1981 | Charlotte Wolff, *Bisexuality*, German edition from 1981

Im Exil in London wird Charlotte Wolffs Doktortitel wie in Frankreich zunächst nicht anerkannt. Sie liest gegen Honorar in den Händen von Berühmtheiten wie Maria und Aldous Huxley oder Virginia Woolf. 1937 erhält Wolff eine unbefristete Aufenthaltsgenehmigung und die Zulassung für die Arbeit als Psychotherapeutin. In den folgenden Jahren widmet sie sich verstärkt der Erforschung von Homosexualität. 1971 erscheint *Love between Women*, 1977 dann Charlotte Wolffs Studie *Bisexuality*, eines der ersten umfassenden Werke zum Thema überhaupt.

In exile in London, Charlotte Wolff was initially unable to have her doctorate recognized, as it had been in France. For a fee she read the hands of celebrities such as Maria and Aldous Huxley or Virginia Woolf. In 1937 Wolff received a permanent residence permit and a license to work as a psychotherapist. In the years that followed, she devoted herself increasingly to researching homosexuality. In 1971, *Love between Women* was published, followed in 1977 by her study *Bisexuality*, one of the first ever comprehensive works on the subject.

KNOWLEDGE, DIAGNOSIS, CONTROL

JONATHAN PENCA

Jonathan Penca (*1988, Deutschland) arbeitet in den Medien Zeichnung, Skulptur, Performance und Video. Sein Interesse an Bühnen- und Kostümbild und Dramaturgie spiegelt sich in seiner künstlerischen Praxis wider, in der er die Grenzen zwischen Realität und Inszenierung verhandelt. Themen aus Naturwissenschaft, Popkultur und Science-Fiction bilden die Grundlage für Pencas Arbeit. Mit ihrer Hilfe lotet er das Verhältnis queerer und nicht eindeutig festgelegter Körperinszenierungen als widersetzlichen Moment zwischen gesellschaftlichen Normierungsversuchen und individueller Identitätssuche aus.

In seiner Serie *other observations* nimmt Penca das Motiv einer Seidenmottengattung auf. Der intersexuelle Schmetterling wurde 1929 von dem Entomologen und Anthropologen Felix Bryk (1882–1957) nach Magnus Hirschfeld benannt. Anhand dieses Schmetterlings wurden zentrale Fragen der deutschen Sexualwissenschaft diskutiert, wie die juristische Debatte um die Kriminalisierung der Homosexualität nach Paragraf 175 oder die Methodik zwischen psychiatrischen, biologischen und soziologischen Ansätzen. Die Debatte über sexuelle Vielfalt anhand nicht-menschlicher Akteur*innen offenbart das damalige tiefgreifende Interesse an der Frage nach der Natur und Natürlichkeit von Homosexualität, sexueller Intermedialität und ihren politischen Konsequenzen.

In Pencas Arbeit werden die Labormotten zu Protagonist*innen ihrer eigenen Geschichte. Zudem stellt die Serie Bezüge zu dem Film *Anders als die Andern* her, der 1919 unter der Regie Richard Oswalds zusammen mit Hirschfeld entstand. Hirschfeld und Oswald wurden 1933 aufgrund ihrer jüdischen Herkunft und Homosexualität ins Exil gezwungen, ihre Arbeit als „entartet" verboten. Im Sinne einer Warnung vor der Kriminalisierung gleichgeschlechtlicher Liebe, die dieser Geschichte innewohnt, und der Motivation, sich immer wieder neu zu (er)finden, ist Pencas Arbeit eine Hommage an Zärtlichkeit und Anpassungsfähigkeit.

Jonathan Penca (b. 1988, Germany) works in the media of drawing, sculpture, performance, and video. His interest in stage and costume design and dramaturgy is reflected in an artistic practice that negotiates the boundaries between reality and staging. Themes from natural science, pop culture, and science fiction are the basis for Penca's work. With them he explores the relationship of queer and ambiguously defined representations of the body as a moment of resistance between societal efforts at standardization and the individual search for identity.

In his series *other observations*, Penca takes up the motif of a butterfly species. The intersexual butterfly was discovered in the 1910s, and later another butterfly was named after Magnus Hirschfeld in 1929 by the entomologist and anthropologist Felix Bryk (1882–1957). This butterfly was used to discuss central issues of German sexology, such as the legal debate about the criminalization of homosexuality in Paragraph 175 or the scientific methodology of sexology between psychiatric, biological, and sociological approaches. The debate on sexual diversity using non-human agents reveals what was then a profound interest in the question of the nature and naturalness of homosexuality, sexual intermediality, and its political consequences.

In Penca's work, the "lab moths" become the protagonists of their own story. In addition, the series references the 1919 film *Anders als die Andern* (Different from the Others), directed by Richard Oswald together with Hirschfeld. Hirschfeld and Oswald were forced into exile in 1933 on account of their Jewish origins and homosexuality, and their work was banned as "degenerate." Penca's work is a tribute to tenderness and adaptability, in that it warns against the criminalization of same-sex love, inherent in the film's story, and acknowledges the motivation to continuously (re-)invent oneself.

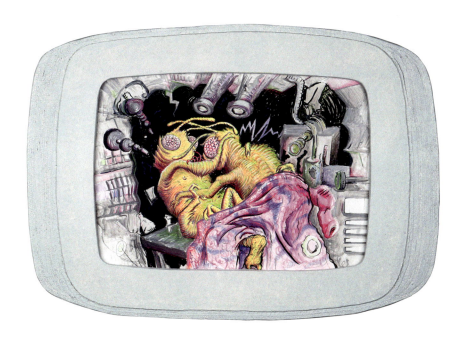

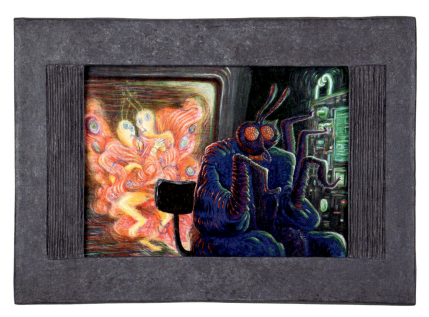

other observations (I), 2022
Gouache, Tusche, Buntstift, Bleistift auf Steinpapier | Gouache, ink, colored pencil, pencil on stone paper
Rahmen: Karton, Papiermaché, Tusche | Frame: cardboard, papier mâché, ink

other observations (III), 2022
Gouache, Tusche, Buntstift, Ölpastellkreide auf Steinpapier | Gouache, ink, colored pencil, oil pastel on stone paper | Rahmen: Karton, Papiermaché, Tusche | Frame: cardboard, papier mâché, ink

other observations (II), 2022
Gouache, Tusche, Buntstift, Ölpastellkreide auf Steinpapier | Gouache, ink, colored pencil, oil pastel on stone paper | Rahmen: Karton, Papiermaché, Tusche | Frame: cardboard, papier mâché, ink

other observations (IV), 2022
Gouache, Tusche, Buntstift, Ölpastellkreide auf Steinpapier | Gouache, ink, colored pencil, oil pastel on stone paper | Rahmen: Karton, Papiermaché, Tusche | Frame: cardboard, papier mâché, ink
Courtesy the artist and Deborah Schamoni

HENRIK OLESEN

In der Arbeit *Some Illustrations to the Life of Alan Turing* erzählt Henrik Olesen (*1967, Dänemark) die Geschichte von Alan Turing (1912–1954), eines englischen Mathematikers, Logikers und Theoretikers der frühen Computerentwicklung, der während des Zweiten Weltkriegs maßgeblich an der Dekodierung der durch die Rotor-Chiffriermaschine Enigma verschlüsselten deutschen Funksprüche beteiligt war. Als Turings Homosexualität bekannt wurde, stellte man ihn vor die Wahl, ins Gefängnis zu gehen oder sich durch die Behandlung mit dem weiblichen Sexualhormon Östrogen chemisch kastrieren zu lassen. Turing wählte die Hormonbehandlung, unter deren körperlichen Folgen er litt, bis er sich selbst das Leben nahm. Olesen bezeichnet Turings Leben als ein „nicht dechiffrierbares Puzzle aus sehr verschiedenen und gleichzeitig eng miteinander in Verbindung stehenden Themen und Ereignissen historischer und persönlicher Art". Turings Geschichte bietet Olesen damit eine Möglichkeit, sich von der Vorstellung unveränderbarer Körper *(fixed bodies)* zu lösen und stattdessen über mögliche Körper *(possible bodies)* zu fantasieren. Die künstlerisch auseinandergenommene und wieder neu zusammengestellte Biografie Turings schafft somit einen assoziativen Rahmen für die Idee eines „postmodernen" Körpers, der sich zwischen Männlichkeit und Weiblichkeit bewegt.

Nicht zuletzt beschäftigt sich der Künstler mit Turings Modell einer Maschine, die die Basis aller späteren Computer bildet, im Sinne eines Apparates, der allein aus seiner Funktion heraus existiert, Aufgaben zu erfüllen, nicht jedoch als ein eigenständiges Wesen.

Henrik Olesen greift in seinen konzeptuellen Skulpturen, Rauminstallationen und Collagen aktuelle und historische Themen aus der Kunst- und Kulturgeschichte sowie der Naturwissenschaft auf, die Ausgangspunkt für die Auseinandersetzung mit der Ausgrenzung von Minderheiten und gesellschaftlichen Kategorisierungen sind.

In *Some Illustrations to the Life of Alan Turing*, Henrik Olesen (b. 1967, Denmark) tells the story of Alan Turing (1912–1954), an English mathematician, logician, and theorist of early computer development who was instrumental in decoding German radio messages encrypted by the Enigma rotor cipher machine during World War II. When Turing's homosexuality became known, he was given the choice of going to prison or being chemically castrated by treatment with the female sex hormone estrogen. Turing chose the hormone treatment, and he suffered the physical consequences of this until he took his own life. Olesen describes Turing's life as an "indecipherable puzzle of very different and at the same time closely related themes and events of a historical and personal nature." Turing's story thus offers Olesen a way to break away from the notion of fixed bodies and instead fantasize about possible bodies. Turing's biography, artistically taken apart and reassembled, thus creates an associative framework for the idea of a "postmodern" body that moves between masculinity and femininity.

Last but not least, the artist deals with Turing's model of a machine, which formed the foundation for all later computers. This machine existed solely in its function of performing tasks, not as an independent being.

In his conceptual sculptures, spatial installations, and collages, Henrik Olesen takes up current and historical themes from the history of art and culture as well as natural science, which are the starting point for an examination of the exclusion of minorities and social categorizations.

Some Illustrations to the Life of Alan Turing, 2008
Inkjet-Druck auf Zeitungspapier,
16 Teile (Ausstellungskopie) | Inkjet
print on newsprint, 16 parts
(exhibition copy)

Spoon, 2008
Löffel (Ausstellungskopie) | Spoon
(exhibition copy)
Collection of Wolfgang Tillmans

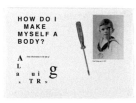 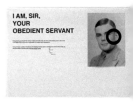

I AM, SIR,
YOUR
OBEDIENT SERVANT

During the Second World War Turing worked at Bletchley Park, the UK's code breaking centre, and was for a time head of Hut 8, the section responsible for German naval cryptanalysis.

Turing devised a number of techniques for breaking German ciphers, including the method of the bombe, an electromechanical machine that could find settings for the E
 ni g m
 a
 M a c
 hin e

MACHINES ARE SLAVES

THE BODY UNDERNEATH THE SKIN IS AN OVERHEATED FACTORY

MACHINES AT WORK
1952

THE FIGURE OF THE SUFFERING SERVANT IS A TROUBLING INHERITANCE

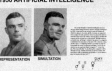

1950 ARTIFICIAL INTELLIGENCE

REPRESENTATION SIMULTATION

1952

1954

THE FIGURE OF THE SUFFERING SERVANT IS A TROUBLING INHERITANCE

'This is the spoon which I found in Alan Turing's laboratory. It is similar to the one which he gold-plated himself. It seems quite probable he was intending to gold-plate this one using cyanide of potassium of his own manufacture. E. Sara Turing.'

The verdict of the inquest on A.T. was suicide. Alan Turing's mother never accepted this, believing that his death was an accidental consequence of scientific experiments carelessly conducted.

Turing was found death on the 8th of June by his cleaner. He has died the day before. In his room was found an apple laced with

 c y
 a
 n i
 d e like in Snow White. In 1938 came out the Disney movie and it's told that Turing was fascinated by it and he enjoyed chanting these lines by the evil Queen:

Dip the apple in the brew,
Let the sleeping death seep through,
Look at the skin,
A symbol of what lies within

May this carnation tell you
 the laws of odours
 which has not yet
 been announced and which
 one day
 will come
 to rule +
 in our minds
 far more
 precisely & + more subtly
 than the
I p sounds i d e
 that gu
 r us.
 e f
 r your nose to all your
 ORG
 ANS
 O My e
It is love. t u r
 the throne of f u
 KN
 OW
 LE
 D
 GE

1954

ULRIKE KLÖPPEL

DIE „INTERSEXUALITÄTSLEHRE" IN DER WEIMARER REPUBLIK. ZUR VERSCHRÄNKTEN GESCHICHTE VON SEXUALITÄTS- UND GESCHLECHTERNORMEN

Bis heute hält sich die Behauptung, dass Homosexualität eine geschlechtliche „Fehlentwicklung" sei. Umgekehrt wird unterstellt, dass Variationen der körperlichen Geschlechtsmerkmale, mit denen intergeschlechtliche Menschen geboren werden, Homosexualität befördern würden.[1] Feindliche Einstellungen gegen Homosexuelle und intergeschlechtliche Menschen sind insofern eng miteinander verknüpft. Wie kommt das? Über Jahrhunderte hat die Medizin problematische Begründungen dafür geliefert. In der ersten Hälfte des 20. Jahrhunderts kulminierte die wissenschaftliche Verknüpfung sexueller und geschlechtlicher „Abweichungen" in der sogenannten „Intersexualitätslehre" und der davon abgeleiteten „intersexuellen Konstitution". Diese Konzepte spielten „rassenhygienischen" Forderungen nach staatlichen Eingriffen zur Verhinderung der Fortpflanzung Homosexueller und intergeschlechtlicher Menschen in die Hände, die darauf zielten, „Abweichungen" zum Verschwinden zu bringen.[2]

Mit der „Intersexualitätslehre" postulierten Ärzte[3] in der Zeit der Weimarer Republik und bis in die 1950er Jahre hinein eine gemeinsame genetische Ursache für die Entstehung verschiedener „Abweichungen" von den sexuellen Normen und Geschlechtervorstellungen. Der Begriff „Intersexuelle" bezog sich nicht nur auf Menschen mit angeborenen Variationen der körperlichen Geschlechtsmerkmale – nach damaliger Terminologie „(Pseudo-)Hermaphroditen". Vielmehr waren damit auch, um bei den heute üblichen Begriffen zu bleiben, Lesben, Schwule und Bisexuelle gemeint sowie Menschen, deren Verhalten und Lebensweise den eng gesteckten Erwartungen an Weiblichkeit und Männlichkeit nicht entsprachen. Wie kam es zu der Verschränkung von Sexualitäts- und Geschlechternormen in der „Intersexualitätslehre" und was bedeuteten die medizinischen und „rassenhygienischen" Adaptionen für intergeschlechtliche Menschen?[4]

„Tribadie" und „Hermaphroditismus" im 19. Jahrhundert

Verknüpfungen von sexuellen Überschreitungen und geschlechtlicher Uneindeutigkeit beschäftigten die Medizin und Naturforschung unter den Begriffen „Tribadie" und „Hermaphroditismus" bereits seit der Frühen Neuzeit.[5] Um 1800

ULRIKE KLÖPPEL

THE "THEORY OF INTERSEXUALITY" IN THE WEIMAR REPUBLIC: ON THE ENTANGLED HISTORY OF SEXUAL AND GENDER NORMS

The claim that homosexuality is an "aberration" of sex development persists to this day. Conversely, it is believed that variations in physical sexual characteristics that intersex people are born with encourage homosexuality.[1] Hostile attitudes toward homosexuals and intersex people, consequently, are closely interlinked. Why is this? For centuries, medical science has supplied problematic scientific justification for this connection. In the first half of the twentieth century, the scientific linking of sexual and gender "deviations" culminated in the so-called "theory of intersexuality" and the concept of "intersexual constitution" that derived from it. These concepts played into the hands of "racial hygiene" campaigns for state intervention to prevent the reproduction of homosexuals and intersex people, with the goal of eliminating "deviations."[2]

During the Weimar Republic and well into the 1950s, physicians employed the "theory of intersexuality" to postulate a common genetic cause for the development of various "deviations" from sex, gender, and sexuality norms. The term "intersex" referred not only to people with congenital variations in physical sex characteristics – "(pseudo)hermaphrodites"

according to the terminology of the time. Rather, it also meant – in today's commonly used terms – lesbians, gays, and bisexuals, as well as people whose behavior and lifestyle did not conform to narrowly defined expectations of femininity and masculinity. How did the entanglement of sex, gender, and sexuality norms in the "theory of intersexuality" come about, and what did its adaptations for medical science and "racial hygiene" mean for intersex people?[3]

"Tribadism" and "hermaphroditism" in the nineteenth century

Connections between sexual transgressions and ambiguity of the sex, dealt with under the terms "tribadism" and "hermaphroditism," have concerned medicine and the natural sciences since the early modern period.[4] Around 1800, there was a fundamental shift in the scientific view. While in the eighteenth century a dimorphic understanding of sex – that is, of two clearly separated sexes – was predominant, this changed at the beginning of the nineteenth century due to intensified embryological research. Scientists described how female and male sex characteristics

200 WISSEN, DIAGNOSE, KONTROLLE

wandelte sich die wissenschaftliche Sichtweise grundlegend. Während im 18. Jahrhundert ein dimorphes Geschlechtsverständnis, also klar getrennte Zweigeschlechtlichkeit, vorherrschend war, änderte sich dies zu Beginn des 19. Jahrhunderts auf der Grundlage intensivierter embryologischer Forschungen. Wissenschaftler beschrieben, wie sich erst allmählich die weiblichen und männlichen Geschlechtscharaktere entwickelten und vermuteten daher – in den Worten des Göttinger Physiologen Arnold Adolph Bertholds (1803–1861) – „Geschlechtslosigkeit" oder „Geschlechtsgleichheit", das heißt eine geschlechtlich indifferente Anlage des Embryos. Zugleich postulierten sie, dass die polare Differenz von männlichem und weiblichem Geschlecht die höchste biologische Entwicklungsstufe sei. „Hermaphroditen" stellten hingegen ein Stehenbleiben auf der „primitivsten" Entwicklungsstufe dar. Ebenfalls als „unvollkommen" entwickelt galten den Ärzten sogenannte „Mannweiber" und „Weibmänner", bei denen im Vergleich zu den „Hermaphroditen" die Abweichungen der körperlichen Geschlechtsmerkmale als geringfügiger wahrgenommen wurden. Johann Friedrich Meckel d. J. (1781–1833), Professor für Anatomie und Chirurgie an der Universität Halle, und verschiedene seiner Kollegen zählten zu dieser Kategorie auch Menschen, bei denen sie einen „Contrast zwischen der Richtung des Geschlechtstriebes und der Totalform, so wie der Form der Genitalien" feststellten.[6] Mit der Einordnung von „Hermaphroditismus" und geringfügigen geschlechtlich-sexuellen „Abweichungen" als „unvollkommene" Entwicklungsstufen entstand ein Denken, auf das spätere „rassenhygienische" Behauptungen aufbauen konnten, die aus der „unvollkommenen" Entwicklung biologische „Minderwertigkeit"

ableiteten.[7] Das Modell kontinuierlicher Übergänge zwischen einer männlichen und weiblichen Idealgestalt sorgte mithin nicht dafür, dass alle geschlechtlichen Variationen als gleichwertig angesehen wurden.

Im frühen 19. Jahrhundert begannen zudem manche Ärzte, die Naturgesetzlichkeit der Übereinstimmung von (binär gelesenem) Geschlechtskörper und aufs „andere" Geschlecht gerichtetem Geschlechtstrieb zu hinterfragen. Sie spekulierten, dass „Hermaphroditen" gleichgeschlechtliche „Neigungen" aus „Zufall" (bei „falscher" Geschlechtszuordnung bei Geburt) oder lasterhafter „Gewohnheit" entwickelt haben könnten.[8] Der geschlechtlich „uneindeutige" Körper prädestiniere „Hermaphroditen", „Mannweiber" und „Weibmänner" für sexuelle Übertretungen. Diese Sichtweise verwebte sich zum Ende des 19. Jahrhunderts mit der vorwiegend von Psychiatern geführten Diskussion über die angeborene „conträre Sexualempfindung" – „die Empfindung, dem ganzen inneren Wesen nach dem eigenen Geschlechte entfremdet zu sein".[9] Richard von Krafft-Ebing (1840–1902) und andere nahmen ein für die „psychischen Vorgänge des Geschlechtslebens" zuständiges Zentrum im Gehirn an, das sich unabhängig von der geschlechtlichen Ausprägung des restlichen Körpers entwickeln könne.[10] „Conträre Sexualempfindungen" konnten zwar aus Sicht der Mediziner auch „erworben" statt „angeboren" sein. Doch im konkreten Fall bedurfte es einer Abklärung, ob nicht eine „uneindeutige" Biologie zugrunde liegen könnte. Umgekehrt stand bei Menschen mit geschlechtlich „uneindeutigen" Körpern grundsätzlich zu vermuten, dass sie zu sexuellen Übertretungen neigten. Geschlechtlich „uneindeutige" Biologie und sexuelle Übertretungen waren somit eng miteinander verschränkt.

develop only gradually, thus assuming – in the words of the Göttingen physiologist Arnold Adolph Berthold (1803–1861) – a state of "sexlessness" or "sexual equality," that is, a disposition of the embryo that is sexually indifferent. At the same time, they hypothesized that the antipodal difference between male and female sex represented the highest biological stage of development. "Hermaphrodites," by contrast, represented to them a standstill at the "most primitive" stage of development. Physicians regarded so-called "male-females" and "female-males," in whom the differences in the physical sexual characteristics were perceived as minor in comparison to the "hermaphrodites," to be "imperfectly" developed, too. Johann Friedrich Meckel the Younger (1781–1833), professor of anatomy and surgery at the University of Halle, along with various of his colleagues, also put into this category those who manifested a "contrast between the direction of the sex drive and the overall form, as well as the form of the genitals."[5] The classification of "hermaphroditism" and minor sexual "deviations" as "imperfect" stages of evolution allowed a manner of thinking to emerge on which later "racial hygienic" assertions could be built, deriving biological "inferiority" from "imperfect" development.[6] The model of continuous transition between an ideal male and female figure did not at all ensure that all gender and sexual variations were regarded as equal.

In the early nineteenth century, moreover, some physicians began to question whether the correspondence between the (binarily regarded) physical sex of the body and the sex drive directed toward the "other" sex was a natural law without exceptions. They specu-

lated that "hermaphrodites" might have developed same-sex "inclinations" by "accident" (in the case of a "wrong" sex assignment at birth) or by licentious "vice."[7] The sexually "ambiguous" body, they postulated, predestined "hermaphrodites," "male-females," and "female-males" for sexual transgressions. At the end of the nineteenth century this view was interwoven with the debate, conducted primarily by psychiatrists, about the innate "contrary sexual instinct" – "the sensation of being, in one's entire inner being, alienated from one's own sex."[8] Richard von Krafft-Ebing (1840–1902) and others assumed there was a center in the brain responsible for the "psychic processes of sexual life" that could develop independently of the sexual expression of the rest of the body.[9] In the view of medical experts, "contrary sexual instincts" could indeed be "acquired" instead of being "innate." But each specific case required clarifying whether an "ambiguous" biology was not the basis for this. Conversely, people with sexually "ambiguous" bodies were generally suspected of being prone to sexual transgressions. Sexually "ambiguous" biology and sexual transgressions were thus closely intertwined.

Goldschmidt's "theory of intersexuality" and its reception

Sex models based on a continuum were further developed at the beginning of the twentieth century, for example by the Berlin physician and sexologist Magnus Hirschfeld (1868–1935) with the concept of "sexual intermediacy." At the same time, the debate about the origin and development of sex was given new impetus by genetic research. The biologist Richard Goldschmidt (1878–1958) performed research on the

Goldschmidts „Intersexualitätslehre" und ihre Rezeption

Kontinuum-Geschlechtermodelle wurden zu Beginn des 20. Jahrhunderts weiterentwickelt, so etwa durch den Berliner Mediziner und Sexualwissenschaftler Magnus Hirschfeld (1868–1935) unter dem Begriff der „Sexuellen Zwischenstufen". Gleichzeitig erhielt die Debatte über die Geschlechtsentstehung und -entwicklung durch die genetische Forschung neue Impulse. Der Biologe Richard Goldschmidt (1878–1958) forschte zur Frage der genetischen Geschlechtsdetermination am Kaiser-Wilhelm-Institut für Biologie in Berlin. Er führte Kreuzungsexperimente mit unterschiedlichen Populationen einer Mottenart durch, die er als „Rassen" bezeichnete, um deren Geschlechtsmerkmale zu manipulieren. 1915 veröffentlichte Goldschmidt dazu eine Theorie, wonach die quantitative Balance genetischer „männlichkeits-" und „weiblichkeitsbestimmer" Männlichkeit und Weiblichkeit wie auch geschlechtliche „Zwischenformen" festlegt. Für Letztere verwendete er den Begriff „Intersexe".[11] Goldschmidt übertrug seine Theorie auch auf den Menschen. Er erklärte, dass es eine kontinuierliche Stufenfolge der „Intersexualität" gebe, die vom „Hermaphroditismus" bis zur völligen körperlichen „Geschlechtsumwandlung" bei „entgegengesetzten" Geschlechtschromosomen reiche. Die völlige „Geschlechtsumwandlung" sei, so der Biologe, nur noch an verschiedenen Graden „psychischer Intersexualität", insbesondere „Homosexualität", erkennbar.[12]

Goldschmidts Mottenexperimente und seine „Intersexualitätslehre" wurden bis in die 1950er Jahre hinein von vielen Ärzten zitiert. Zur großen Resonanz trug nicht zuletzt bei, dass Goldschmidt von seinen Kreuzungsexperimenten mit Motten-„Rassen" eine Analogie zum Menschen zog. Gestützt auf Angaben von Hirschfeld zu einem angeblich gehäuften Auftreten „konträrer Sexualität" bei „kurländischen Deutschen und Oberbayern im Gebirge" spekulierte er über eine „Zunahme der Intersexualität" als Folge sogenannter „Rassenkreuzungen".[13] Zwar warnte er vor einer Überschätzung von „Rassenkreuzungen" als alleiniger Ursache. Dessen ungeachtet stellten ab den 20er Jahren viele Ärzte mit Bezugnahme auf Goldschmidt „Rassenkreuzungen" als Hauptursache geschlechtlicher und sexueller „Abweichungen" dar. Die Geschichte der Rezeption von Goldschmidts „Intersexualitätslehre" ist widersprüchlich und komplex. Manche Mediziner übten deutliche Kritik an den genetischen Erklärungen oder lehnten sie in diffuser Weise ab, weil sie ihr dichotomes Geschlechterverständnis durch die Theorie gefährdet sahen.[14] Ebenso häufig griffen Ärzte die Lehre auf, wenn auch meistens selektiv, das heißt in Kombination mit anderen, teils im Widerspruch stehenden Erklärungsmustern für geschlechtliche und sexuelle Ausprägungen, ohne dass sie dies weiter diskutiert hätten.

Historiker*innen haben dargestellt, wie die „Intersexualitätslehre", obschon es auch prominente Kritiker gab, in den medizinischen Diskurs zu Homosexualität Einzug hielt. Hirschfeld und andere Sexualwissenschaftler sahen Goldschmidts Forschung als Beleg dafür an, dass Homosexualität und intergeschlechtliche körperliche Variationen zur natürlichen menschlichen Vielfalt gehörten.[15] Häufiger jedoch diskutierten Ärzte die „Intersexualitätslehre" – oder auch Versatzstücke derselben – als Grundlage „rassenhygienischer" Forderungen und Maßnahmen, insbesondere der Sterilisation männlicher Homosexueller.[16] Manche zogen die Theorie genetischer Intersexualität auch zur Einordnung von Menschen heran, die sich dem „anderen"[17] als dem ihnen bei Geburt zugewiesenen Geschlecht zugehörig fühlten.[18] Die

question of genetic sex determination at the Kaiser Wilhelm Institute for Biology in Berlin. He conducted crossbreeding experiments with different populations of a moth species, which he called "races," in order to manipulate their sexual characteristics. In 1915, Goldschmidt published a theory on this subject, according to which the quantitative balance of genetic "masculinity" and "femininity" determinants decides masculinity and femininity, as well as sexual "intermediate forms." For the latter he used the term "intersexes."[10] Goldschmidt also applied his theory to humans. He explained that there was a continuous sequence of stages of "intersexuality," ranging from "hermaphroditism" to complete physical "sex change" with "contrary" sex chromosomes. The complete "sex change" was, according to the biologist, only recognizable by different degrees of "psychic intersexuality," especially "homosexuality."[11]

Goldschmidt's moth experiments and his "theory of intersexuality" were cited by many physicians well into the 1950s. The fact that Goldschmidt drew an analogy to humans from his crossbreeding experiments with moth "races" contributed not least to the widespread dissemination of his theories. Based on Hirschfeld's data on the allegedly frequent occurrence of a "contrary sexual instinct" among "Courland Germans and Upper Bavarians in the mountains," he speculated about an "increase in intersexuality" as a result of so-called "racial crossbreeding."[12] Although he warned against an overestimation of "racial crossbreeding" as the sole cause, from the 1920s on many physicians, drawing on Goldschmidt, nevertheless proposed "racial crossbreeding" as the main cause of gender

and sexual "deviations." The history of the reception of Goldschmidt's "theory of intersexuality" is contradictory and complex. Some physicians strongly criticized the genetic explanations or rejected them in various ways, because they saw it as a threat to their dichotomous understanding of sex and gender.[13] Just as often, physicians took up the doctrine, but did so selectively and in combination with other, sometimes contradictory, explanations for gender and sexual expression, and without deeper inquiry.

Historians have shown how the "theory of intersexuality" fully entered the medical discourse on homosexuality, despite prominent critics. Hirschfeld and other sexologists viewed Goldschmidt's research as evidence that homosexuality and intersexual physical variations were part of natural human diversity.[14] More often, however, physicians employed the "theory of intersexuality" – or portions of it – to support "racial hygiene" measures, especially the sterilization of male homosexuals.[15] Some also used the theory of genetic intersexuality to classify people who felt they belonged more to the "other"[16] sex than the one assigned to them at birth.[17] The "theory of intersexuality" also allowed medical professionals to discuss the treatment of people with varying physical sex characteristics and to problematize the possibility of their reproduction.[18] How this latter strand of discourse evolved will be exemplified here by the concept of "intersexual constitution," which was derived from Goldschmidt's theory.

"Intersexual constitution"
The construct of "intersexual constitution" was developed by Paul Mathes (1871–1923),

204 WISSEN, DIAGNOSE, KONTROLLE

„Intersexualitätslehre" diente Medizinern außerdem dazu, die Behandlung von Menschen mit Variationen der körperlichen Geschlechtsmerkmale zu diskutieren und die Möglichkeit ihrer Fortpflanzung zu problematisieren.[19] Wie sich dieser letztgenannte Diskursstrang entwickelte, soll hier exemplarisch anhand des von Goldschmidts Theorie abgeleiteten Konzepts der „intersexuellen Konstitution" gezeigt werden.

„Intersexuelle Konstitution"

Das Konstrukt der „intersexuellen Konstitution" entwickelte Paul Mathes (1871–1923), Ordinarius der Universitäts-Frauenklinik in Innsbruck, in einem Kapitel für ein gynäkologisches Handbuch, das 1924, ein Jahr nach seinem Tod, veröffentlicht wurde. Der Begriff der „Konstitution" stand für angeborene „Eigentümlichkeiten" eines Menschen, sofern diese nicht nur individuell, sondern regelmäßig in der Bevölkerung vorfindbar waren.[20] Wie Goldschmidt verstand Mathes unter „Intersexualität" jede auch geringfügige „Abweichung" von der männlichen oder weiblichen körperlichen und psychischen Norm. Er betonte, dass alle Menschen irgendwelche „intersexuellen Stigmen" aufweisen würden. Aber obschon solche leichten Grade der „Intersexualität" das „Gewöhnliche" seien, könnten sie nicht als „normal" gelten: „Behaarte Unterschenkel sind bei der Frau […] das *Gewöhnliche*, die *Regel*, und trotzdem werden wir eine Frau mit behaarten Unterschenkeln nicht dem *normalen* Frauentypus zuzählen […]."[21] Mathes forderte, dass eine „autoritative Gesellschaft", wie es die Deutsche Gesellschaft für Gynäkologie sei, eine „Norm, einen Kanon des Weibes für alle Lebensabschnitte" verbindlich festlegen und „den Zustand der Chromosomen, der zur Bildung dieser Idealgestalt führt, als normale Konstitution des Weibes" definieren solle.[22]

Ausgehend von einer solchen fiktiven „Norm" sah es der Gynäkologe als seine Aufgabe an, durch „intuitives Anschauen […] die ungestalte Masse des Gegebenen" zu ordnen und „Konstitutionstypologien" der „Abweichungen" zusammenzustellen."[23] Als einen dieser „Konstitutionstypen" beschrieb er die „körperlich und seelisch Intersexuelle", bei der das „Verstandesleben" gegenüber dem „Gemütsleben" überwiege und die häufig berufstätig sei.[24] Ehen mit „Intersexuellen", warnte er, seien wegen ihres „Unvermögens, die Pflichten der Gattin, Mutter und Hausfrau reibungslos zu erfüllen", für Zerwürfnisse prädestiniert.[25] Mathes' Charakterisierung des „Status psychicus" der „intersexuellen Konstitution" hatte einen deutlich antifeministischen Tenor, den auch andere Mediziner, die sich mit „intersexuellen Frauen" beschäftigten, anschlugen.[26] Die „Leistung", auf die es Mathes besonders ankam, war die Fortpflanzung, und diese war für ihn offenbar das größte Manko des „intersexuellen Typus". Dazu präsentierte er Zahlenmaterial, das belegen sollte, dass Frauen im gebärfähigen Alter umso seltener schwanger würden, je stärker ihre Unterschenkel behaart seien. In der (angeblich) durch eine „intersexuelle Konstitution" bedingten Unfruchtbarkeit sah Mathes eine große „rassenhygienische" Gefahr. In Übertragung von Goldschmidts Kreuzungsexperimenten erklärte er, dass „die starke Rassenvermischung […] dem Zunehmen der Intersexualität Vorschub leistet […]."[27] Damit lieferte er Argumente für „rassenhygienische" staatliche Eingriffe in die Fortpflanzung.

In dem Handbuchkapitel berichtete Mathes auch konkret von Patient*innen, die er als „intersexuell" einstufte, weil sie zwar funktionsfähige Eierstöcke besäßen, aber ins Männliche hineinspielende Geschlechtsmerkmale aufweisen

professor at the University Gynecological Clinic in Innsbruck, in a chapter for a gynecological manual published in 1924, one year after his death. The term "constitution" referred to the innate "peculiarities" of a human being, insofar as these were found in the population not only individually but regularly.[19] Like Goldschmidt, Mathes understood "intersexuality" to mean any "deviation" – even slight – from the male or female physical and psychological norm. He emphasized that all people would exhibit some kind of "intersexual stigma." But although he conceded that such slight degrees of "intersexuality" were "ordinary," he did not consider them to be "normal": "Hairy lower legs in women ... are *ordinary*, the *rule*, and yet we will not consider a woman with hairy lower legs as belonging to the *normal* type of woman."[20] Mathes called for an "authoritative society," such as the German Society of Gynecology, to establish a binding "norm, a canon of the female for all stages of life" and define "the state of the chromosomes leading to the formation of this ideal figure as the normal constitution of the female."[21]

Starting from such a fictitious "norm," the gynecologist saw it as his task to order the "shapeless mass of the given" by "intuitive looking" and to compile "constitutional typologies" of the "deviations."[22] One of his "constitutional types" was the "physical and psychological intersexual," in whom the "intellectual life" predominates over the "emotional life" and who is often employed.[23] Marriages with "intersexuals," he warned, were predestined for discord because of their "inability to fully perform the duties of spouse, mother, and homemaker."[24] Mathes's characterization of the "status psychicus" of the

"intersexual constitution" had a distinctly antifeminist tenor, which was echoed by other physicians who dealt with "intersexual women."[25] The "performance" that Mathes was particularly concerned with was reproduction, as apparently for him this was the greatest shortcoming of the "intersexual type." For this purpose, he presented figures which were supposed to prove that women of childbearing age became pregnant less frequently the hairier their lower legs were. Mathes foresaw a serious "racial hygiene" danger in the infertility caused by an "intersexual constitution." Transferring Goldschmidt's crossbreeding experiments, he declared that "pervasive interbreeding among races ... encourages the increase of intersexuality."[26] In this manner he provided arguments for state intervention in sexual reproduction for "racial hygienic" reasons.

In the same chapter Mathes also reported specifically on patients whom he classified as "intersexual" because they possessed functioning ovaries but exhibited sexual and gender characteristics that tended towards the male. Their appearance, he claimed, could be attributed to a mismatch in genetic sex determination.[27] He explained in detail the case of a patient – living as woman – with an overall feminine body but who had testicles. This person, according to Mathes, "would have to be classified as a *male pseudo-hermaphrodite*, according to the view still commonly held today." He insisted, however, that from a genetic point of view, "the human being in question is a female, despite the testicles."[28] At the patient's request, he removed the testicles located in the greater labia. As a result, he said, the feminine sexual characteristics became more pronounced and

würden. Ihr Erscheinungsbild lasse sich auf ein Missverhältnis der genetischen Geschlechtsbestimmung zurückführen.[28] Ausführlich ging er auf den Fall einer Patientin ein, die bei einem insgesamt femininen Körper Hoden aufwies. Diese würde, so Mathes, „nach der heute noch geläufigen Auffassung als *männlicher Scheinzwitter* zu bezeichnen sein". Er bestand jedoch darauf, dass aus genetischer Sicht „das fragliche Wesen trotz der Hoden ein Weib ist".[29] Auf Wunsch der Patientin entfernte er die in den großen Labien gelegenen Hoden. Daraufhin hätten sich die femininen Geschlechtsmerkmale deutlicher ausgeprägt und die Patientin sei „voll Dankbarkeit und überströmenden Glücksgefühles" gewesen.[30] Die Entfernung der Hoden, so resümierte Mathes sein Eingreifen, „befreie" die weibliche Grundtendenz und schütze „die Entwicklungs- und Erhaltungsarbeit des Organismus" vor Störungen durch die „illegitimen" hormonellen „Sendlinge" der Hoden.[31] Während also der Gynäkologe einerseits „intersexuelle Frauen" aus „rassenhygienischer" Sicht als „biologische Gefahr" darstellte, bot ihm die „Intersexualitätslehre" andererseits eine Argumentationshilfe, um dem Wunsch seiner Patientin nach einer Operation zu entsprechen.

„Rassenhygienische" Adaptionen

Mathes' Geschlechtsdiagnose und sein chirurgisches Eingreifen wurde seinerzeit von einigen Ärzten intensiv kritisiert, weil sie die Keimdrüsen als das ausschlaggebende Kennzeichen der Geschlechtszugehörigkeit ansahen und daher die Patientin als Mann betrachteten.[32] Dennoch fand das Konzept der „intersexuellen Konstitution" große Resonanz, vor allem in der Gynäkologie und Geburtshilfe. Während des Nationalsozialismus wurden vor allem die mit dem Konzept

verknüpften „rassenhygienischen" Überlegungen aufgegriffen und mit dezidierten Forderungen nach staatlichen Eingriffen in die Fortpflanzung verbunden.[33] Stellvertretend dafür kann Walter Stoeckel, der die Universitäts-Frauenklinik der Charité in Berlin leitete, stehen. Er schrieb 1940: „Die Intersexuelle in starker Ausprägung soll der Ehe fernbleiben. [...] Wäre der Züchterblick, d.h. der Blick für konstitutionelle 'vererbte' Minderwertigkeit, besser geschult oder wenigstens der Instinkt für sie in genügendem Maße vorhanden, so gäbe es sehr viel weniger unglückliche Ehen und sehr viel weniger konstitutionell verkümmerte Kinder!"[34] In dieser Weise diente das Konzept der „intersexuellen Konstitution" dazu, zu problematisieren, dass „intersexuelle Frauen" die „Degeneration" der Bevölkerung befördern würden, weshalb sie von der Fortpflanzung auszuschließen seien.[35]

Auch jenseits der gynäkologischen Konstitutionslehre machten Humanmediziner Anleihen bei der genetischen „Intersexualitätslehre", um hervorzuheben, dass „Rassenmischungen" für die Entstehung von geschlechtlichen „Zwischenstufen", einschließlich Homosexualität, verantwortlich seien. Mit der Radikalisierung der „Rassenhygiene" im Nationalsozialismus verschärften sich auch die Schlussfolgerungen aus der „Intersexualitätslehre". So schrieb etwa der Wiener Pathologe Anton Priesel 1940 über „Intersexualität": „Namentlich bei Verdacht auf noch vorhandene Zeugungsmöglichkeit sollten Eheschließungen unbedingt verboten werden, da auch diese Mißbildungen [sic!] vererbt werden können. [...] Es ist ernsthaft zu erwägen, ob nicht überhaupt grundsätzlich bei Anwesenheit von Fehlbildungen an den äußeren Geschlechtsteilen Sterilisierung der betreffenden Individuen durchzuführen wäre."[36] Aufgrund fehlender Forschung

the patient was "full of gratitude and overflowing happiness."[29] The removal of the testicles, in Mathes's summary of his operative intervention, "liberated" the fundamental female tendency and protected "the developmental and maintenance work of the organism" from interference by the "illegitimate" hormonal "messengers" from the testicles.[30] While on the one hand the gynecologist presented "intersexual women" as a "biological danger" from the point of view of "racial hygiene," the "theory of intersexuality" on the other hand offered him an argument to fulfill his patient's wish for an operation.

"Racial hygienic" adaptions

Mathes's sex diagnosis and his surgical intervention were intensely criticized by some physicians at the time, as they considered the gonads to be the decisive marker of sex and therefore regarded the patient as a man.[31] Nevertheless, the concept of "intersexual constitution" had a great impact, especially in gynecology and obstetrics. During the Nazi period, the "racial hygienic" considerations linked to the concept were taken up and combined with vociferous demands for state intervention in reproduction.[32] Walter Stoeckel, who headed the University Gynecological Clinic of the Charité hospital in Berlin, can be taken as representative of this. In 1940 he wrote, "The markedly intersexual person should stay away from marriage.... If the breeder's eye, that is, the eye for constitutional 'inherited' inferiority, were better trained, or at least the instinct for it were present to a sufficient degree, there would be far fewer unhappy marriages and far fewer constitutionally stunted children!"[33] In this way, the concept

of "intersexual constitution" served to justify that "intersexual women" would promote the "degeneration" of the population and therefore should be excluded from reproduction.[34]

Even beyond the gynecological constitution theory, physicians borrowed from the genetic "theory of intersexuality" in order to emphasize that "miscegenation" was responsible for the emergence of sexual and gender "intermediates," including homosexuality. With the radicalization of "racial hygiene" under Nazism, the conclusions drawn from the "theory of intersexuality" also became more radical. The Viennese pathologist Anton Priesel, for example, wrote about "intersexuality" in 1940 thus: "Especially in the case of suspecting potential possibilities of procreation, such marriages should absolutely be forbidden, because these deformities can be inherited.... It should be seriously considered whether, in the presence of the malformation of the external genitals, in principle sterilization of the individuals concerned should be carried out."[35] Due to a lack of research, it is unclear to what extent marriage bans and forced sterilizations of individuals with variations in physical sex characteristics were implemented during the Nazi period. Similarly, little is known about systematic medical experiments on intersex people or other forms of persecution and extermination.

The history of the "theory of intersexuality" makes it particularly obvious how deeply sexual, gender, and sexuality norms are intertwined. In this respect, it is necessary for a comprehensive understanding of queer history to trace the multiple entanglements of the medicalization of homosexuality, transsexuality, and intersexuality. In particular, it is

208 WISSEN, DIAGNOSE, KONTROLLE

ist es unklar, inwiefern Eheverbote und Zwangs-
sterilisierungen bei Menschen mit Variationen der
körperlichen Geschlechtsmerkmale in der Zeit des
Nationalsozialismus umgesetzt wurden. Ebenso
wenig ist Konkretes zu systematischen medizini-
schen Versuchen an intergeschlechtlichen Men-
schen oder zu anderen Formen der Verfolgung und
Vernichtung bekannt.

An der Geschichte der „Intersexualitätslehre"
wird besonders offenkundig, wie tiefgehend
Geschlechter- und Sexualitätsnormen miteinander
verknüpft sind. Insofern ist es für ein umfassendes
Verständnis queerer Geschichte notwendig, den
vielfältigen Verschränkungen der Medikalisierung
von Homosexualität, Trans- und Intergeschlecht-
lichkeit nachzugehen. Insbesondere kann es nicht
angehen, den medizinischen Umgang mit inter-
geschlechtlichen Menschen zu ignorieren, zumal
sich Ärzt*innen auch heutzutage nur mühsam
von pathologisierenden Zuschreibungen lösen
und normangleichende, von den Betroffenen nicht
selbst eingewilligte Behandlungen trotz inzwi-
schen bestehenden gesetzlichen Verbots noch
nicht der Vergangenheit angehören. Gegen das
Verschweigen und den sozialen Ausschluss, den
intergeschlechtliche Menschen damals wie heute
erleiden, braucht es eine konsequente Sichtbar-
machung ihrer Existenz und Bedeutung in der
queeren Geschichte.

1 Vgl. z.B. URL: https://de-m.iliveok.com/health/
hermaphroditismus-und-hermaphroditen_78086i15945.html
und https://www.kath.net/news/76658 [gelesen am 30.6.2022].

2 Die in Deutschland gegen Ende des 19. Jahrhunderts
aufgekommene und im Nationalsozialismus radikalisierte
„Rassenhygiene" befasste sich damit, wie die „Qualität"
bzw. die Gesundheit und Leistungsfähigkeit der Bevölkerung
verbessert werden könne, wobei die erwünschte Bevölkerung

zunächst anhand der nationalen Grenzen, in den späteren
Diskussionen dann anhand rassistischer Kriterien definiert
wurde.

3 Ärzt*innen waren kaum darunter, weshalb ich hier beim
Maskulinum bleibe.

4 Für Vertiefungen zu den folgenden Ausführungen und
weitere Quellen verweise ich auf zwei meiner Publikationen:
XX0XY ungelöst: Hermaphroditismus, Sex und Gender in der
deutschen Medizin. Eine historische Studie zur Intersexualität,
Bielefeld 2010; Intersex im Nationalsozialismus: ein Überblick
über den Forschungsbedarf, in: Institut für Zeitgeschichte und
Michael Schwartz (Hg.), Homosexuelle im Nationalsozialismus.
Neue Forschungsperspektiven zu Lebenssituationen von
lesbischen, schwulen, bi-, trans- und intersexuellen Menschen
1933 bis 1945, Zeitgeschichte im Gespräch, München 2014,
S. 107–114.

5 Vgl. Katharine Park, The Rediscovery of the Clitoris. French
Medicine and the Tribade, 1570–1620, in: David Hillman und
Carla Mazzio (Hg.), The Body in Parts. Fantasies of Corporeality
in Early Modern Europe, New York, London 1997, S. 171–193.

6 Johann Friedrich Meckel, Über die Zwitterbildungen,
in: Archiv für die Physiologie, 3. Jg., 1812/11, S. 263–340,
hier S. 267.

7 Hugo Otto Kleine, Die Erbpathologie in der Frauenheil-
kunde, in: Ziel und Weg, 1938/8, S. 482–489.

8 Carl Georg Lucas Christian Bergmann, Lehrbuch der
Medicina forensis für Juristen, Braunschweig 1846, S. 258; Carl
Friedrich Burdach, Anatomische Untersuchungen bezogen auf
die Naturwissenschaft und Heilkunst, Leipzig 1814, S. 38.

9 Carl Westphal, Die conträre Sexualempfindung. Symptom
eines neuropathischen (psychopathischen) Zustandes, in: Archiv
für Psychiatrie und Nervenkrankheiten, 1. Jg., 1870/2, S. 73–108,
hier S. 107.

10 Richard von Krafft-Ebing, Psychopathia sexualis. Mit
besonderer Berücksichtigung der conträren Sexualempfindung,
10. überarb. Aufl. Stuttgart 1898, S. 221f.

11 Richard Goldschmidt, Vorläufige Mitteilung über weitere
Versuche zur Vererbung und Bestimmung des Geschlechts, in:
Biologisches Centralblatt, 12. Jg., 1915/35, S. 565–570.

12 Richard Goldschmidt, Die biologischen Grundlagen der
konträren Sexualität und des Hermaphroditismus beim
Menschen, in: Archiv für Rassen- und Gesellschaftsbiologie,
einschließlich Rassen- und Gesellschafts-Hygiene, 1. Jg.,
1916/12, S. 1–14, hier S. 10.

13 Ebd., S. 9.

14 Fritz Lenz, Erfahrungen über Erblichkeit und Entartung bei
Schmetterlingen, in: Archiv für Rassen- und Gesellschaftsbio-
logie 1922/14, S. 249–301; vgl. Helga Satzinger, Rasse, Gene und
Geschlecht. Zur Konstituierung zentraler biologischer Begriffe
bei Richard Goldschmidt und Fritz Lenz, 1916–1936, Berlin 2004,
S. 22f.

not acceptable to ignore the medical treatment of intersex people, especially since even today doctors are reluctant to leave behind pathologizing attributions, and norm-aligning treatments not consented to by the affected persons are not yet a thing of the past, despite the legal prohibitions that now exist. A consistent recognition of the existence and significance of intersex people in queer history is needed to fight against the silence and the social exclusion that intersex people suffered then and suffer now.

Author's note: this English version of the essay is a translation from the original German.

1 See for example https://de-m.iliveok.com/health/hermaphroditismus-und-hermaphroditen_78086i15945.html and https://www.kath.net/news/76658 (accessed June 30, 2022).

2 "Racial hygiene" was developed in Germany at the end of the nineteenth century and radicalized under the Nazis; it was concerned with how the "quality" – that is, the health and performance capability – of the population could be improved. This desired population was initially defined as within the national borders, but by racial criteria in the later debate.

3 For more in-depth information on the following topics and more extensive sources, see my two publications: *XX0XY ungelöst: Hermaphroditismus, Sex und Gender in der deutschen Medizin. Eine historische Studie zur Intersexualität* (Bielefeld: Transcript Verlag, 2010); "Intersex im Nationalsozialismus: ein Überblick über den Forschungsbedarf," in *Homosexuelle im Nationalsozialismus. Neue Forschungsperspektiven zu Lebenssituationen von lesbischen, schwulen, bi-, trans- und intersexuellen Menschen 1933 bis 1945, Zeitgeschichte im Gespräch,* Institut für Zeitgeschichte, ed. Michael Schwartz (Munich: De Gruyter, 2014), 107–14.

4 See Katharine Park, "The Rediscovery of the Clitoris: French Medicine and the Tribade, 1570–1620," in *The Body in Parts: Fantasies of Corporeality in Early Modern Europe,* eds. David Hillman and Carla Mazzio (New York/London: Routledge, 1997), 171–93.

5 Johann Friedrich Meckel, "Über die Zwitterbildungen," *Archiv für die Physiologie* 11, no. 3 (1812): 263–340, here 267.

6 Hugo Otto Kleine, "Die Erbpathologie in der Frauenheilkunde," *Ziel und Weg* 8 (1938): 482–89.

7 Carl Georg Lucas Christian Bergmann, *Lehrbuch der Medicina forensis für Juristen* (Braunschweig: Vieweg, 1846), 258; Carl Friedrich Burdach, *Anatomische Untersuchungen bezogen auf die Naturwissenschaft und Heilkunst* (Leipzig: Hartmann, 1814), 38.

8 Carl Westphal, "Die conträre Sexualempfindung. Symptom eines neuropathischen (psychopathischen) Zustandes," *Archiv für Psychiatrie und Nervenkrankheiten* 2, no. 1 (1870): 73–108, here 107.

9 Richard von Krafft-Ebing, *Psychopathia sexualis. Mit besonderer Berücksichtigung der conträren Sexualempfindung,* 10th rev. ed. (Stuttgart: Ferdinand Enke, 1898), 221ff.

10 Richard Goldschmidt, "Vorläufige Mitteilung über weitere Versuche zur Vererbung und Bestimmung des Geschlechts," *Biologisches Centralblatt* 35, no. 12 (1915): 565–70.

11 Richard Goldschmidt, "Die biologischen Grundlagen der konträren Sexualität und des Hermaphroditismus beim Menschen," *Archiv für Rassen- und Gesellschaftsbiologie, einschließlich Rassen- und Gesellschafts-Hygiene* 12, no. 1 (1916): 1–14, here 10.

12 Ibid., 9.

13 Fritz Lenz, "Erfahrungen über Erblichkeit und Entartung bei Schmetterlingen," *Archiv für Rassen- und Gesellschaftsbiologie* 14 (1922): 249–301; cf. Helga Satzinger, *Rasse, Gene und Geschlecht. Zur Konstituierung zentraler biologischer Begriffe bei Richard Goldschmidt und Fritz Lenz, 1916–1936* (Berlin, 2004), 22ff.

14 See Ina Linge, "The Potency of the Butterfly: The Reception of Richard B. Goldschmidt's Animal Experiments in German Sexology around 1920," *History of the Human Sciences* 34, no. 1 (2021): 40–70.

15 See Florian Mildenberger, "Diskursive Deckungsgleichheit. Hermaphroditismus und Homosexualität im medizinischen Diskurs (1850–1960)," in *Medizin, Geschichte und Geschlecht. Körperhistorische Rekonstruktionen von Identitäten und Differenzen,* eds. Frank Stahnisch and Florian Steger (Stuttgart: Franz Steiner, 2005), 259–83; Susanne zur Nieden, *Erbbiologische Forschungen zur Homosexualität an der Deutschen Forschungsanstalt für Psychiatrie während der Jahre des Nationalsozialismus. Zur Geschichte von Theo Lang* (Berlin, 2005); Claudia Schoppmann, *Nationalsozialistische Sexualpolitik und weibliche Homosexualität,* 2nd rev. ed. (Herbolzheim: Centaurus, 1997).

16 According to binary logic.

17 See Volker Weiß, *"... mit ärztlicher Hilfe zum richtigen Geschlecht?" Zur Kritik der medizinischen Konstruktion der Transsexualität* (Hamburg: Männerschwarm, 2009), chap. 8.2.

210 WISSEN, DIAGNOSE, KONTROLLE

15 Vgl. Ina Linge, The potency of the butterfly: The reception of Richard B. Goldschmidt's animal experiments in German sexology around 1920, in: History of the Human Sciences, 1. Jg., 2021/34, S. 40–70.

16 Vgl. Florian Mildenberger, Diskursive Deckungsgleichheit. Hermaphroditismus und Homosexualität im medizinischen Diskurs (1850–1960), in: Frank Stahnisch und Florian Steger (Hg.), Medizin, Geschichte und Geschlecht. Körperhistorische Rekonstruktionen von Identitäten und Differenzen, Stuttgart 2005, S. 259–283; Susanne zur Nieden, Erbbiologische Forschungen zur Homosexualität an der Deutschen Forschungsanstalt für Psychiatrie während der Jahre des Nationalsozialismus. Zur Geschichte von Theo Lang, Berlin 2005; Claudia Schoppmann, Nationalsozialistische Sexualpolitik und weibliche Homosexualität, 2. überarb. Aufl. Herbolzheim 1997.

17 Der binären Logik entsprechend.

18 Vgl. Volker Weiß, „... mit ärztlicher Hilfe zum richtigen Geschlecht?": zur Kritik der medizinischen Konstruktion der Transsexualität, Hamburg 2009, Kap. 8.2.

19 Vgl. hierzu auch Ralf Bröer, Genitalhypoplasie und Medizin. Über die soziale Konstruktion einer Krankheit, in: Zeitschrift für Sexualforschung 2004/17(3), S. 213–238; Satzinger 2004 (wie Anm. 14). Beide Autor*innen gehen jedoch nicht tiefer auf die Bedeutung dieser Adaptionen für intergeschlechtliche Menschen ein.

20 Vgl. Bröer 2004 (wie Anm. 19), S. 216.

21 Paul Mathes, Die Konstitutionstypen des Weibes, insbesondere der intersexuelle Typus, in: Josef Halban und Ludwig Seitz (Hg.), Biologie und Pathologie des Weibes. Ein Handbuch der Frauenheilkunde und Geburtshilfe, Berlin/Wien 1924, S. 1–112: S. 10.

22 Ebd., S. 9.

23 Ebd., S. 14.

24 Ebd., S. 77, 80.

25 Ebd., S. 292.

26 Vgl. etwa Kleine 1938 (wie Anm. 7).

27 Mathes 1924 (wie Anm. 21), S. 75.

28 Zu Mathes' Abwandlungen der Theorie vgl. Satzinger 2004 (wie Anm. 14), S. 17–19.

29 Mathes 1924 (wie Anm. 21), S. 71.

30 Ebd., S. 70.

31 Ebd., S. 74.

32 Fritz Kermauner, Fehlbildungen der weiblichen Geschlechtsorgane, des Harnapparats und der Kloake. Fragliches Geschlecht, in: Josef Halban und Ludwig Seitz (Hg.), Biologie und Pathologie des Weibes. Ein Handbuch der Frauenheilkunde und Geburtshilfe, Berlin, Wien 1924, S. 281–620, hier S. 563.

33 Dass Goldschmidt nach der Machtübernahme der Nationalsozialisten als Jude in die Emigration gezwungen wurde, tat der Rezeption seiner Theorie in der Humanmedizin keinen Abbruch, vgl. Klöppel 2010 (wie Anm. 4), S. 414–419.

34 Walther Stoeckel, Lehrbuch der Gynäkologie, 7. neubearb. Aufl. Leipzig 1940, S. 110, 112.

35 Vgl. etwa Kleine 1938 (wie Anm. 7), S. 489.

36 Anton Priesel, Zweifelhafte Geschlechtszugehörigkeit, in: Ferdinand von Neureiter u.a. (Hg.), Handwörterbuch der gerichtlichen Medizin und naturwissenschaftlichen Kriminalistik, Berlin 1940, S. 961–969, hier S. 969.

18 On this, see also Ralf Bröer, "Genitalhypoplasie und Medizin. Über die soziale Konstruktion einer Krankheit," *Zeitschrift für Sexualforschung* 17, no. 3 (2004): 213–38; Satzinger, *Rasse, Gene und Geschlecht*. Neither author, however, more deeply explores the significance of these adaptions for intersexual people.

19 See Bröer, "Genitalhypoplasie und Medizin," 216.

20 Paul Mathes, "Die Konstitutionstypen des Weibes, insbesondere der intersexuelle Typus," in *Biologie und Pathologie des Weibes. Ein Handbuch der Frauenheilkunde und Geburtshilfe*, eds. Josef Halban and Ludwig Seitz (Berlin/Vienna: Urban & Schwarzenberg, 1924): 1–112, here 10.

21 Ibid., 9.

22 Ibid., 14.

23 Ibid., 77, 80.

24 Ibid., 292.

25 See for example Kleine, "Die Erbpathologie."

26 Mathes, "Die Konstitutionstypen des Weibes," 75.

27 On Mathes's adaptation of the theory, see Satzinger, *Rasse, Gene und Geschlecht,* 17–19.

28 Mathes, "Die Konstitutionstypen des Weibes," 71.

29 Ibid., 70.

30 Ibid., 74.

31 Fritz Kermauner, "Fehlbildungen der weiblichen Geschlechtsorgane, des Harnapparats und der Kloake. Fragliches Geschlecht," in Halban and Seitz, *Biologie und Pathologie des Weibes,* 281–620, here 563.

32 The fact that after the Nazis took over power, Goldschmidt was forced into exile because he was Jewish did not hinder the acceptance of his theory in medical science; see Klöppel, *XX0XY ungelöst,* 414–19.

33 Walther Stoeckel, *Lehrbuch der Gynäkologie,* 7th rev. ed. (Leipzig: S. Hirzel, 1940), 110, 112.

34 See for example Kleine, "Die Erbpathologie," 489.

35 Anton Priesel, "Zweifelhafte Geschlechtszuge-hörigkeit," in *Handwörterbuch der gerichtlichen Medizin und naturwissenschaftlichen Kriminalistik*, eds. Ferdinand von Neureiter et al. (Berlin, 1940): 961–69, here 969.

DAGMAR HERZOG

SCHWUL, JÜDISCH, „UNZÜCHTIG": DER SEXUALREFORMER MAGNUS HIRSCHFELD ALS HASSFIGUR DER NAZIS

In einer in ihrer Symbolhaftigkeit kaum zu übertreffenden Aktion trugen die Nationalsozialist*innen am 10. Mai 1933 den abgetrennten und aufgespießten Kopf einer Büste des jüdischen Sexualforschers und -aktivisten Magnus Hirschfeld (1868–1935) über den Opernplatz in Berlin. Dort waren gerade die nationalsozialistischen Bücherverbrennungen in vollem Gange.

Nachdem wenige Tage zuvor einige dem Nationalsozialismus nahestehende Student*innen das von Hirschfeld geleitete Institut für Sexualwissenschaft verwüstet und geplündert hatten, wurde der Bestand des Instituts nun im Rahmen der NS-„Aktion wider den undeutschen Geist" zusammen mit mehr als 25.000 Büchern anderer als „undeutsch" geächteter Autor*innen verbrannt. Auch die Büste Hirschfelds wurde in die Flammen geworfen. Die Vernichtung von Hirschfelds Institut für Sexualwissenschaft und die Verbrennung seiner Bücher sowie seiner Büste kann, so die Historikerin Kirsten Leng, als „einer der Gründungsakte des Dritten Reichs" verstanden werden.[1]

Die Bedeutung, die Hirschfeld in der Nazi-Imagination zuteilwurde, war kein Zufall. Im Gegenteil, für die Nazis war Hirschfeld aus verschiedenen Gründen ein willkommenes,

ja sogar „ein bevorzugtes Hassobjekt".[2] Das lag, so meine These, *nicht* in erster Linie an seiner eigenen Homosexualität, sondern vielmehr an seinem Status als Sexualreformer für *alle* – und an seinem mit dem Sexuallibertären in diesem Kontext untrennbar verbundenen Jüdischsein. Als homosexueller Jude und sexualreformerischer Aktivist bot er eine besonders attraktive Projektionsfläche für verschiedene nationalsozialistische Gedankenverknüpfungen, in deren Zentrum die assoziative Verbindung von Judentum und (freizügiger) Sexualität stand. Diese Assoziation kulminierte im Bild der Weimarer Republik als sexuell liberaler „Judenrepublik".

Die sexuelle Dämonisierung von Jüdinnen* Juden war bereits in der Weimarer Republik ein gängiges Merkmal des Antisemitismus. Ausgehend von älteren Vorstellungen, die Jüdinnen* Juden mit Körperlichkeit und Christ*innen mit Spiritualität in Verbindung brachten, beschwor diese Spielart des Antisemitismus im 20. Jahrhundert die Bedrohung unschuldiger deutscher Frauen durch vulgäre, animalische oder diabolische jüdische Vergewaltiger herauf. Daneben stand jedoch eine gegenläufige Assoziation von Sexualität mit dem Judentum: die Wahrnehmung jüdischer Deutscher als Anführer diverser

DAGMAR HERZOG

GAY, JEWISH, "'OBSCENE'": MAGNUS HIRSCHFELD AS A SEXUAL REFORMER AND TARGET OF NAZI HATE

It was an act that could hardly have been surpassed for its symbolic significance: on May 10, 1933, members of the Nazi party decapitated a bust of the Jewish sex researcher and activist Magnus Hirschfeld (1868–1935), then paraded the impaled head across the Berlin Opernplatz, where the book burnings were in full swing.

A few days earlier, a group of students with close ties to Nazism had vandalized and looted the Institute for Sexology directed by Hirschfeld. As part of the Nazi "Campaign against the Un-German Spirit," the institute's holdings were burned, along with more than 25,000 books by other authors labled "un-German." Hirschfeld's bust was also thrown into the flames. The destruction of Hirschfeld's Institute for Sexology and the burning of his books, as well as his bust, can be understood, according to historian Kirsten Leng, as "one of the founding acts of the Third Reich."[1]

The importance given to Hirschfeld in the Nazi imagination was no accident. On the contrary, Hirschfeld was, for various reasons, a welcome and even "a preferred object of hatred" for the Nazis.[2] This was due, I argue, not primarily to his own homosexuality, but rather to his status as a sexual reformer for all – and to his Jewishness, in this context associated very strongly with sexual libertarianism. As a homosexual Jew and sexual reform activist, he offered a particularly attractive surface for Nazi projections, at the center of which was the imagined link between Judaism and (permissive) sexuality. This association culminated in the image of Weimar as a sexually liberal "Jews' republic."

The sexual demonization of Jews was already a common feature of antisemitic in the Weimar Republic. Based on older notions associating Jews with corporeality and Christians with spirituality, this variety of antisemitism in the twentieth century conjured up a threat to innocent German women posed by vulgar, animalistic, or diabolical Jewish rapists. Alongside this, however, was a countervailing association of sexuality with Judaism: the perception of Jewish Germans as leaders of various campaigns for sexual liberation – especially for the poorer classes.

The latter notion contained a kernel of truth: Jewish doctors did indeed spearhead numerous campaigns to abolish Paragraphs 218 and 175, legislation that criminalized abortion and

Kampagnen zur sexuellen Befreiung – gerade für die ärmeren Klassen.

Letztere Vorstellung enthielt einen wahren Kern: Tatsächlich standen jüdische Ärzt*innen an der Spitze zahlreicher Kampagnen zur Abschaffung der Paragrafen 218 und 175, welche Abtreibung und männliche Homosexualität unter Strafe stellten; oft bemühten sie sich, Informationen zum Thema Sexualität und Verhütung bereitzustellen. Durch Aufklärungsfilme und Beratungszentren für Sexualität und Ehe unterstützten sie Paare nicht nur bei der Familienplanung, sondern versuchten zudem, ihnen zu größerer sexueller Befriedigung zu verhelfen.

Neben Max Hodann (1894–1946), Max Marcuse (1877–1963) und Friedrich Wolf (1888–1953) führte auch Hirschfeld selbst die Weimarer Sexualreformbewegung mit an. Er setzte sich unermüdlich für die Entkriminalisierung gleichgeschlechtlicher Liebe und gendernonkonformen Verhaltens ein, für reproduktive Selbstbestimmung und für eine Ethik des Konsenses, die auch die Akzeptanz von vorehelichen heterosexuellen Handlungen mit einschloss: „Was zwischen willensfreien Menschen in geschlechtlicher Beziehung vorgeht", so wiederholte er mehrfach, „ist ihre eigene Sache, das mögen sie unter sich abmachen. [...] Der Staat hat sich der Einmischung zu enthalten".[3]

Doch trotz dieser Beispiele war die Vorstellung, Jüdinnen*Juden seien die Hauptvertreter der sexuellen Befreiung, ein rassistisches Konstrukt der politischen Rechten. Die propagandistische Fantasie von Weimar als „Judenrepublik", in der unter anderem Zeitschriften für homosexuelle Männer und Frauen „wie Pilze nach dem Regen" aus dem Boden geschossen seien und die Jüdinnen*Juden das Recht auf Abtreibung verteidigt hätten, um „ihre Herrschaft gegenüber den arischen Völkern" aufrichten zu können, rückte nach 1933 allmählich ins Zentrum der NS-Darstellung der Weimarer Republik.[4] Die gesamte Ära Weimar wurde auf Sexualität reduziert. Alle Komplexitäten, alle gegensätzlichen politischen und sozialen Impulse, die zwischen 1919 und 1933 das Leben in Deutschland geprägt hatten, wurden verwischt und durch ein Bild Weimars als Treibhaus für Dekadenz und Promiskuität ersetzt, als Ort „größte[r] Aufreizung schwüler, dekadenter Erotik".[5]

Unter Verweis auf die angebliche jüdische Verherrlichung von Sexualität als zentraler Kraft im Leben des Menschen verkündeten die Nazis, sie hätten Deutschland „von diese[m] scheußliche[n] Spuk des Götzendienstes am Sex-Appeal" befreit.[6] In dem Versuch, den Antisemitismus für sexualkonservative Zwecke einzuspannen, behaupteten sie, Jüdinnen*Juden würden Spiritualität und Liebe unter-, Sinnlichkeit und Körperkontakt hingegen überbewerten.[7] Die Jüdinnen*Juden seien weit davon entfernt, sich für eine natürliche Sexualität einzusetzen, und frönten stattdessen einer „ekelhafte[n] Lüsternheit".[8] Oder: „Der Jude hat nun einmal eine andere Sexualität als der Germane."[9] Die Juden seien bestrebt, „die nordische Rasse an ihrem empfindlichsten Punkt, dem Geschlechtsleben, zu treffen".[10]

Auch eine bewusst verzerrende Lesart der Psychoanalyse diente der Verunglimpfung des Judentums. So behauptete beispielsweise der Theologe Heinz Hunger im Jahr 1942, die Psychoanalyse sei „eine nationaljüdische Vergewaltigung der abendländischen Kultur" und habe eine „volksschädigende Wirkung", da sie alles „unterhalb des Nabels" überbewertete.[11] Als jüdische, sexbesessene und zersetzende Wissenschaft wurden auch Sigmund Freuds Schriften

male homosexuality respectively, and they often worked to provide information on sexuality and contraception. Through educational films and counseling centers on sexuality and marriage, they not only assisted couples with family planning, but also sought to help them achieve greater sexual satisfaction.

Along with Max Hodann (1894–1946), Max Marcuse (1877–1963), and Friedrich Wolf (1888–1953), Hirschfeld too helped lead the Weimar-era sexual reform movement. He campaigned tirelessly for the decriminalization of same-sex love and non-conforming gender behavior, for reproductive self-determination, and for an ethics of consent that included acceptance of premarital heterosexual acts: "What goes on between free-willed people in sexual relations," he often repeated, "is their own affair, let them settle that among themselves…. The state must refrain from interfering here."[3]

Yet despite these examples, the idea that Jews were the main agents of sexual liberation was also a racist construct of the political right. The propagandistic fantasy of Weimar as a "Jews' republic," in which, among other things, magazines for homosexual men and women had sprung up "like mushrooms after the rain" and Jews had defended the right to abortion in order to establish "their dominion over the Aryan peoples," gradually moved to the center of the Nazi portrayal of the Weimar Republic after 1933.[4] The entire Weimar era was reduced to sexuality. All the complexities, all the conflicting political and social impulses that had characterized life in Germany between 1919 and 1933 were blurred and replaced by an image of the Weimar Republic as a hothouse of decadence and promiscuity, as the site of "the greatest stimulation of steamy, debauched eroticism."[5]

Referring to the alleged Jewish glorification of sexuality as the central force in human life, the Nazis proclaimed that they had freed Germany from the "abominable specter of the idol worship of sex appeal."[6] In an attempt to harness antisemitism for sexually conservative purposes, they claimed that Jews undervalued spirituality and love, while overvaluing sensuality and physical contact.[7] Far from advocating natural sexuality, Jews instead indulged in "disgusting lechery."[8] Or, "The Jew just has a different sexuality from that of the German."[9] Jews allegedly strove to "strike the Nordic race at its most vulnerable point: sexual life."[10]

A deliberately distorting reading of psychoanalysis also served to denigrate Judaism. In 1942, for example, the theologian Heinz Hunger claimed that "the whole of psychoanalysis is nothing other than the Jewish nation's rape of Western culture" and that psychoanalysis had a "damaging effect on the *Volk*" because it overvalued everything "below the navel."[11] Sigmund Freud's writings were portrayed as a Jewish, sex-obsessed, and subversive science, and – along with Hirschfeld's works – were some of the first to be destroyed in the May 1933 book burnings. As Freud's books were thrown into the flames, a demonstrator who took part in the book burnings pronounced, "Against soul-corroding overestimation of the drive-life [*Triebleben*], for the nobility of the human soul! I give to the flames the writings of Sigmund Freud."[12]

In addition to the often-proclaimed connection between Judaism and sexuality, of which the treatment of psychoanalysis was only *one* example, homosexuality was another central

dargestellt, die – zusammen mit den Arbeiten Hirschfelds – im Mai 1933 als einige der Ersten im Rahmen der Bücherverbrennungen vernichtet wurden. Während Freuds Bücher in die Flammen geworfen wurden, deklamierte ein Demonstrant, der an den Bücherverbrennungen teilnahm: „Gegen seelenzerfressende Überschätzung des Trieblebens, für den Adel der menschlichen Seele! Ich übergebe der Flamme die Schriften des Sigmund Freud."[12]

Neben der oftmals proklamierten Verbindung von Judentum und Sexualität, für die der Umgang mit der Psychoanalyse nur *ein* Beispiel war, war Homosexualität eine weitere zentrale Obsession der Nationalsozialist*innen. Obwohl es anfangs noch Toleranz gegenüber homosexuellen Männern in den höchsten Rängen der NSDAP gab, war seit der Tötung des homosexuellen SA-Stabschefs Ernst Röhm 1934 und insbesondere nach der Gesetzesnovelle Paragraf 175a im Jahr 1935 der Weg frei für eine Eskalation der Strafverfolgungen, besonders ab 1937. Als Homosexualität galten nun auch gegenseitige Onanie oder gar „erotische" Blicke. Bis zum Ende der NS-Herrschaft wurden 100.000 Männer strafrechtlich verfolgt, davon fast die Hälfte verurteilt und in Gefängnisse und Haftanstalten oder – Historiker*innen schätzen, dass es zwischen 5.000 und 15.000 waren – in Konzentrationslager geschickt. Dabei war ein zentraler Grund für die extreme Steigerung der Homophobie in der Mitte der 1930er Jahre die Tatsache, dass den Nazis durchaus sehr bewusst war, dass die distinktiv homosozialen Kontexte der NS-Verbände, im Besonderen der Hitlerjugend, der Wehrmacht und der SS, eine Vielzahl von konkreten Möglichkeiten für homosexuelle Handlungen boten. Zum Beispiel thematisierte die SS-Zeitschrift *Das Schwarze Korps* früh, dass NS-Organisationen, die nur dem einen oder nur dem anderen Geschlecht offenstanden, auf beunruhigende Weise gleichgeschlechtliche Beziehungen förderten.[13]

Interessanterweise war die homophobe Theorie, mit der die nationalsozialistische Forschung und Propaganda diesem Sachverhalt begegneten, eine, die sexuelle Identität als etwas Schwankendes, Flüssiges und Wandelbares sah. Hirschfelds weitaus biologistischere Überzeugung, dass Homosexualität *un*wandelbare Veranlagung sei, wurde damit energisch bestritten. Stattdessen, so schreibt der Mediziner Fritz Mohr 1943, handle es sich bei der Homosexualität um den Ausdruck „einer Neurose, bei der die jedem Menschen innewohnende Bisexualität in abnormer Weise zum Vorschein kommt".[14] In den *Kriminalistischen Monatsheften* war zu lesen, dass es in der Tat „laufende Übergänge" zwischen Homo- und Heterosexualität gebe, und dass eben deswegen „Pseudo-homosexuelle" zur Heterosexualität zurückgeführt werden könnten.[15] In diesem vermeintlich so vererbungsbesessenen Staat ging es also überraschender-, aber auch bezeichnenderweise immer wieder um die Fluidität und Wandelbarkeit der Triebrichtungen.

Von der Vorstellung, dass die sexuelle Orientierung fließend sei, ließ sich auch der NS-Arzt Johannes Schultz leiten. Laut Schultz gab es zwei Arten Homosexueller: Einige seien „erbkrank" und daher unheilbar, die anderen ordnete er dem Typ „liebes Brüderchen" zu; ihnen könne geholfen werden. Einem, wie Schultz es formulierte, „besonnenen Therapeuten" wie ihm sei es möglich, aus einem solchen Mann einen überzeugten Heterosexuellen zu machen. Im Deutschen Institut für psychologische Forschung und Psychotherapie in Berlin, dem sogenannten Göring-Institut, wiesen Schultz und seine Belegschaft die der Homosexualität beschuldigten

obsession of the Nazis. Although initially homosexual men in the highest ranks of the Nazi Party were tolerated, after the murder of the homosexual SA chief of staff Ernst Röhm in 1934, and especially after the Paragraph 175a amendment in 1935, the way was clear for intensified prosecution, especially from 1937 onwards. Mutual masturbation or even "erotic" glances were now also considered prosecutable manifestations of homosexuality. Till the end of Nazi rule, 100,000 men were prosecuted, almost half of them convicted and sent to prisons and detention centers or – historians estimate between 5,000 and 15,000 – to concentration camps. A central reason for the extreme increase in homophobia in the mid-1930s was the fact that the Nazis were well aware that the distinctively homosocial contexts of Nazi groups, especially the Hitler Youth, the Wehrmacht, and the SS, offered a variety of ready opportunities for homosexual acts. For example, the SS journal *Das Schwarze Korps* early on addressed the fact that Nazi organizations only open to one sex were disturbingly conducive to same-sex relationships.[13]

Interestingly, the homophobic theory with which National Socialist research and propaganda confronted this issue was one that saw sexual identity as something fluctuating, fluid, and changeable. Hirschfeld's far more biologistic conviction that homosexuality was an *im*mutable disposition was thus vigorously contested. Instead, wrote the physician Fritz Mohr in 1943, homosexuality was the expression of "a neurosis in which the bisexuality inherent in every human being comes to the fore in an abnormal way."[14] The *Kriminalistische Monatshefte* stated that there were indeed "fluid transitions" between homo-

sexuality and heterosexuality, and that for this very reason "pseudo-homosexuals" could be guided back to heterosexuality.[15] This government, supposedly so obsessed with heredity, thus became concerned – surprisingly but also significantly – with the fluidity and mutability of sexual desire.

The Nazi physician Johannes Schultz was likewise guided by the idea that sexual orientation was fluid. According to Schultz, there were two types of homosexuals: some were "hereditarily ill" and therefore incurable; the others he assigned to the type of "dear little brother," which could be cured. As Schultz put it, a "judicious therapist" like him could turn such a man into a convinced heterosexual. At the German Institute for Psychological Research and Psychotherapy in Berlin, known as the Göring Institute, Schultz and his staff instructed men accused of homosexuality to have sexual intercourse with a prostitute in front of them. Those who performed the heterosexual act to their satisfaction under these conditions were released; those who did not were thus proven to be "incurable" and so transferred to a concentration camp.[16] A perspective that could actually have contributed to a reduction of homophobia, to the alleviation of aversion, and to the affirmative recognition of fluid and permeable boundaries between sexual orientations – that is, the deeply felt realization of how fragile heterosexuality is – instead served to reinforce the boundaries and legitimize the horrifically severe intensification of homosexual persecution to the point of murderous radicalization.

Now, the sexual policy of the Nazi state, with its amalgamation of sexuality with anti-semitism and racism, as well as its intensified

218 WISSEN, DIAGNOSE, KONTROLLE

Männer an, vor ihren Augen Beischlaf mit einer Prostituierten zu vollziehen. Wer den heterosexuellen Akt unter diesen Bedingungen zu ihrer Zufriedenheit ausführte, wurde freigelassen; wer nicht, hatte seine Unheilbarkeit unter Beweis gestellt und wurde in ein Konzentrationslager überstellt.[16] Eine Denkweise, die eigentlich zur Verminderung der Homophobie hätte beitragen können, zur Linderung der Abneigung und zur bejahenden Anerkennung fließender und durchlässiger Grenzen zwischen den sexuellen Orientierungen – also einer tief empfundenen Einsicht, wie fragil Heterosexualität ist – diente stattdessen dazu, die Grenzen zu festigen und die grauenhaft rigorose Intensivierung der Homosexuellenverfolgung bis hin zur mörderischen Radikalisierung zu legitimieren.

Nun war die Sexualpolitik des NS-Staats mit ihrer Verquickung von Sexualität, Antisemitismus und Rassismus sowie ihrer gesteigerten Homophobie zweifellos eine Gegenbewegung zur Fortschrittlichkeit und Toleranz der Weimarer Zeit. Allerdings weitete der Nationalsozialismus vorhandene liberalisierende Tendenzen auch aus, wenngleich er sie für eigene ideologische Zwecke umdefinierte. So basierten sowohl die konservative Sexualmoral, die von einigen Nationalsozialist*innen und Kirchenvertreter*innen propagiert wurde, als auch die NS-Versionen sexualemanzipatorischer Ideen auf antisemitischen Vorstellungen und einem Zerrbild von Weimar als obszöner „Judenrepublik". Entsprechend behauptete *Das Schwarze Korps*, die „Propaganda zur Nacktkultur" in der Weimarer Republik, die mit ihren „semitischen Drahtzieher[n]" eine „Lockerung jeder natürlichen Ordnung, wie Ehe und Familie" verfolgte, habe mit den Zielen des Nationalsozialismus nichts zu tun. Gleichwohl lehne man die Prüderie ab, „die mit dazu beigetragen hat, in

unserem Volk den Instinkt für körperlichen Adel und seine Schönheit zu vernichten", denn das „Reine und Schöne war dem unverdorbenen Deutschen noch nie Sünde".[17]

Immer wieder stritt *Das Schwarze Korps* ab, „freie Liebe" zu befürworten, und beharrte darauf, der Nationalsozialismus setze sich für die Ehe ein und verteidige diese Institution gegen „jüdische" Angriffe.[18] Wiederholt bezeichnete es den Nationalsozialismus als eine Bewegung, die vor allem „Sauberkeit" in „Liebesdingen" und im Bereich des „Sexus" einfordere.[19] Doch gleichzeitig – häufig im gleichen Artikel – verteidigte das Blatt sowohl die Zeugung unehelicher Kinder als auch vor- und außerehelichen Geschlechtsverkehr, der nicht der Fortpflanzung dient. Außerdem druckte die Zeitschrift gerade in den Anfangsjahren immer wieder Aktbilder – Zeichnungen, Skulpturen und Fotos – ab und pries Nacktheit als rein, natürlich und lebensbejahend.

In einer Kombination von Ansporn und Verleugnung stritten die Nazis also genau das ab, wofür sie sich explizit einsetzten. Die sex-affirmative Botschaft von Hirschfeld und anderen Weimarer Aktivisten wurde zugleich abgelehnt *und* angeeignet. Während manche Nazis weiterhin eine konservative Moral vertraten und wiederholt insistierten, dass „Rassereinheit" und das Wiedererstarken der Nation von vorehelicher Keuschheit und der monogamen, kinderreichen Ehe abhingen, versuchten andere, die sehr populären, sexuell emanzipatorischen Tendenzen von ihrer Assoziation mit „Marxismus" und „Judentum" – und nicht zuletzt mit Hirschfeld selber – zu trennen, um dann eheliche wie eben auch lustvolle vor- und außereheliche sexuelle Betätigung umzukodieren als ein „germanisches", „arisches" Privileg, das die „Herrenrasse" genießen sollte.

homophobia, was undoubtedly a countermovement to the progressiveness and tolerance of the Weimar period. However, National Socialism also extended existing liberalizing tendencies, although it redefined them for its own ideological purposes. Thus, both the conservative sexual morality propagated by some Nazis and church representatives, as well as the Nazi versions of sexual emancipatory ideas, were based on antisemitism notions and a distorted image of Weimar as an obscene "Jews' republic." Accordingly, *Das Schwarze Korps* claimed that the "propaganda for nudism" in the Weimar Republic, which with its "Semitic manipulators" pursued the undermining of "every natural order, such as marriage and family," had nothing to do with the goals of Nazism. Nevertheless, at the very same time the newspaper rejected "that prudery ... which has contributed to destroying the instinct for bodily nobility and its beauty in our *Volk*," because "the pure and the beautiful were for the uncorrupted German never a sin."[17]

Time and again, *Das Schwarze Korps* denied advocating "free love," insisting that Nazism championed marriage and defending that institution against "Jewish" attacks.[18] It repeatedly referred to National Socialism as a movement that above all demanded "cleanliness" in "matters of love" and in the realm of "sex."[19] But at the same time – often even in the same article – the paper defended both the fathering of illegitimate children and premarital and extramarital sexual intercourse that was not for procreation. Moreover, especially in the early years, the magazine repeatedly printed images of nudes – drawings, sculptures, and photographs – and praised nudity as pure, natural, and life-enhancing.

In a combination of incitement and disavowal, then, the Nazis denied the very thing they were explicitly advocating. The sex-affirming message of Hirschfeld and other Weimar activists was simultaneously rejected *and* appropriated. While some Nazis continued to espouse a conservative morality and repeatedly insisted that "racial purity" and the nation's resurgence depended on premarital chastity and monogamous, childbearing marriage, others attempted to disconnect the very popular, sexually emancipatory tendencies from their association with "Marxism" and "Judaism" – and not least with Hirschfeld himself – in order to recode marital as well as pleasurable premarital and extramarital sexual activity as a "Germanic," "Aryan" privilege that the "master race" should enjoy.

In the face of these complex sexual-political developments, conservative forces, especially the Christian churches, were confronted with a dilemma. Initially, they had high hopes that the Nazis would put an end to the Weimar period's sexual permissiveness and the movement to decriminalize homosexuality. Many Christians of both denominations also blamed Jews for the sexual immorality that supposedly pervaded Weimar culture. Nazism used these deep-seated associations, which linked sexuality with evil and Jewishness, to win over conservative Christians to Hitler. After only a few years, however, Christian spokesmen expressed disappointment in the face of Nazi sexual policies: the insistence on "race, blood, and soil" was good and sensible, but the new regime was clearly in the process of introducing a new "culture of nudity," and a "swinish" atmosphere of "carnality" and "shamelessness."[20] One Catholic theologian bitingly noted

220 WISSEN, DIAGNOSE, KONTROLLE

Angesichts dieser komplexen sexualpolitischen Entwicklungen waren konservative Kräfte, im Besonderen die Kirchen, vor Probleme gestellt. Diese hatten sich zuerst große Hoffnungen gemacht, die Nazis würden mit der sexuellen Freizügigkeit und den Reformbewegungen zur Entkriminalisierung der Homosexualität der Weimarer Zeit aufräumen. Auch viele Christ*innen beider Konfessionen machten Jüdinnen*Juden für die sexuelle Unmoral, die angeblich die Weimarer Kultur durchdrungen hatte, verantwortlich. Der Nationalsozialismus nutzte diese tiefsitzenden Assoziationen, die Sexualität mit dem Bösen und dem Jüdischsein in Verbindung brachten, um die konservativen Christ*innen für Hitler zu gewinnen. Doch schon nach wenigen Jahren zeigten sich die christlichen Wortführer enttäuscht angesichts der NS-Sexualpolitik: Das Pochen auf „Rasse, Blut und Boden" sei zwar gut und sinnvoll, aber das neue Regime sei offensichtlich dabei, eine neue „Nacktkultur" einzuführen und eine „schweinig[e]" Atmosphäre der „Fleischeslust" und „Schamlosigkeit".[20] Ein katholischer Theologe stellte bissig fest, dass die jüngste NS-Berichterstattung über die vermeintlich schaurigen kirchlichen Lehren zur Sexualität „eine anrüchige Popularität bekommen hat, die ein Magnus Hirschfeld in seiner Sexualpropaganda Maienblüte nie errang".[21]

Als sein Institut geplündert und seine Schriften und seine Büste 1933 verbrannt wurden, war Magnus Hirschfeld glücklicherweise auf einer Weltreise. Er erfuhr von der Zerstörung des Instituts, während er sich schon im Exil in Paris befand. 1935 ist er in Nizza an einem Herzinfarkt – wir könnten auch sagen: an einem gebrochenen Herzen – gestorben.[22]

1 Kirsten Leng, Magnus Hirschfeld's Meanings. Analyzing Biography and the Politics of Representation, in: German History, 35. Jg., 2017/1, S. 96–116.

2 Manfred Herzer, Magnus Hirschfeld, Frankfurt a.M. 1992, S. 7.

3 Theodor Ramien [i.e. Magnus Hirschfeld], Sappho und Sokrates oder Wie erklärt sich die Liebe der Männer und Frauen zu Personen des eigenen Geschlechts?, Leipzig 1896, S. 33f.

4 Walter Tetzlaff, Homosexualität und Jugend, in: Deutsche Jugendhilfe, 34. Jg., 1942/43, S. 5f.

5 Georg Schliebe, Die Reifezeit und ihre Erziehungsprobleme, in: Martin Löpelmann (Hg.), Wege und Ziele der Kindererziehung unserer Zeit, 3. Aufl. Leipzig 1936, S. 148.

6 Martin Staemmler, Das Judentum in der Medizin, in: Sächsisches Ärzteblatt, 1934/104, S. 208.

7 Vgl. Alfred Zeplin, Sexualpädagogik als Grundlage des Familienglücks und des Volkswohls, Rostock 1938, S. 31.

8 Alfred Rosenberg, Unmoral im Talmud, München 1943, S. 19. Das Buch erschien 1933 in erster Auflage.

9 Staemmler 1934 (wie Anm. 6), S. 208.

10 Die Rolle des Juden in der Medizin, in: Deutsche Volksgesundheit aus Blut und Boden, August/September 1933, zit. in: Karen Brecht u.a. (Hg.), „Hier geht das Leben auf eine sehr merkwürdige Weise weiter …". Zur Geschichte der Psychoanalyse in Deutschland, Hamburg 1985, S. 87.

11 Heinz Hunger, Jüdische Psychoanalyse und deutsche Seelsorge, in: Walter Grundmann (Hg.), Germanentum, Judentum und Christentum, Bd. 2, Leipzig 1943, S. 317, 332.

12 Vgl. Inge Brodersen u.a. (Hg.), Wie die Deutschen Hitler zur Macht verhalfen. Ein Lesebuch für Demokraten, Reinbek 1983, S. 34.

13 Was sag ich meinem Kinde?, in: Das Schwarze Korps, 15.4.1937, S. 6.

14 Fritz Mohr, Einige Betrachtungen über Wesen, Entstehung und Behandlung der Homosexualität, in: Zentralblatt für Psychotherapie, 1943/15, S. 13.

15 J. Strüder, Beitrag zur Homosexuellenfrage, in: Kriminalistische Monatshefte, 1937/11, S. 219f.

16 Johannes H. Schultz, zit. in: Bluthaftes Verständnis, in: Der Spiegel, 27. Juni 1994, S. 185, sowie in Ulrich Schultz, Autogenes Training und Gleichschaltung aller Sinne, in: taz, 20.6.1984. Der Überblick über Schultz' Rolle im „Dritten Reich" im Spiegel 1994 geht vermutlich in erster Linie auf die Pionierarbeit von Ulrich Schultz (heute Schultz-Venrath, nicht verwandt mit Johannes H. Schultz) zurück, die 1984 in polemischer Form in der taz erschien. Schultz-Venrath wiederum baute auf der wichtigen Grundlagenarbeit von

that recent Nazi coverage of the supposedly degenerate church teachings on sexuality had achieved a popular notoriety far exceeding even that of "Magnus Hirschfeld at the height of his sexual propaganda!"[21]

At the time his institute was being plundered and his writings and bust were burned in 1933, Magnus Hirschfeld was fortunately on a trip around the world. He learned of the destruction when he was already in exile in Paris. In 1935 he died in Nice from a heart attack. We might also say, he died from a broken heart.[22]

Author's note: this English version of the essay is a translation from the original German.

1 Kirsten Leng, "Magnus Hirschfeld's Meanings: Analyzing Biography and the Politics of Representation," *German History* 35, no. 1 (2017): 96–116.

2 Manfred Herzer, *Magnus Hirschfeld* (Frankfurt am Main: Campus Verlag, 1992), 7.

3 Theodor Ramien [= Magnus Hirschfeld], *Sappho und Sokrates oder Wie erklärt sich die Liebe der Männer und Frauen zu Personen des eigenen Geschlechts?* (Leipzig: M. Spohr, 1896), 33ff.

4 Walter Tetzlaff, "Homosexualität und Jugend," *Deutsche Jugendhilfe* 43, no. 34 (1942): 5ff.

5 Georg Schliebe, "Die Reifezeit und ihre Erziehungs-probleme," in *Wege und Ziele der Kindererziehung unserer Zeit*, ed. Martin Löpelmann, 3rd ed. (Leipzig: Hesse & Becker 1936), 148.

222 WISSEN, DIAGNOSE, KONTROLLE

Regine Lockot auf, deren Dissertation unter dem Titel: Erinnern und Durcharbeiten. Zur Geschichte der Psychoanalyse und Psychotherapie im Nationalsozialismus, Frankfurt a. M. 1985, veröffentlicht wurde. Zu Schultz' Thesen zur Homosexualität siehe Johannes H. Schultz, Geschlecht-Liebe-Ehe, München 1941, S. 56, 96f., 103f.

17 Ist das Nacktkultur? Herr Stapel entrüstet sich!, in: Das Schwarze Korps, 24.4.1935, S. 12. Die Taktik, Bilder nackter Frauen zu drucken und gleichzeitig die Medien der Weimarer Zeit für ihre sexuelle Sensationsmache zu schelten, verfolgte nicht nur Das Schwarze Korps. Siehe beispielsweise Karl Eiland, Deutsche Frauenschönheit, in: Neues Volk, 10. Jg., 1942/9.

18 Vgl. Ehestifter Staat, in: Das Schwarze Korps, 26.3.1936, S. 11; Kinder – außerhalb der Gemeinschaft?, in: Das Schwarze Korps, 9.4.1936, S. 5; Das uneheliche Kind, in: Das Schwarze Korps, 9.4.1936, S. 6; Mütterheim Steinhöring, in: Das Schwarze Korps, 7.1.1937, S. 13f.

19 Frauen sind keine Männer!, in: Das Schwarze Korps, 12.3.1936, S. 1.

20 Matthias Laros, Die Beziehungen der Geschlechter, Köln 1936, S. 167f.; Christliche Kritiker*innen zit. in: Das Schwarze Korps, 24.4.1935, S. 12; Das Schwarze Korps, 26.6.1935, S. 5; Das Schwarze Korps, 20.1.1938, S. 8.

21 Erwin von Kienitz, Katholische Sexualkasuistik und Sexualmoral, in: Schönere Zukunft, 1935/11–13, S. 310.

22 Vgl. Martin Dannecker: Rede zur Einweihung einer Gedenksäule für Magnus Hirschfeld am 14.5.1995, in: Mitteilungen der Magnus-Hirschfeld-Gesellschaft, 1996/22–23, S. 9–12, hier S. 12.

6 Martin Staemmler, "Das Judentum in der Medizin," *Sächsisches Ärzteblatt* 104 (1934): 208.

7 Cf. Alfred Zeplin, *Sexualpädagogik als Grundlage des Familienglücks und des Volkswohls* (Rostock: Hinstorff, 1938), 31.

8 Alfred Rosenberg, *Unmoral im Talmud* (Munich: Centralverlag der NSDAP, 1943), 19. The book's first edition appeared in 1933.

9 Staemmler, "Das Judentum," 208.

10 "Die Rolle des Juden in der Medizin," *Deutsche Volksgesundheit aus Blut und Boden* (August/September 1933); reprinted in *"Hier geht das Leben auf eine sehr merkwürdige Weise weiter ..." Zur Geschichte der Psychoanalyse in Deutschland*, eds. Karen Brecht et al. (Hamburg: Kellner, 1985), 87.

11 Heinz Hunger, "Jüdische Psychoanalyse und deutsche Seelsorge," *Germanentum, Judentum und Christentum*, ed. Walter Grundmann, vol. 2 (Leipzig: G. Wigand, 1943), 317, 332.

12 See *Wie die Deutschen Hitler zur Macht verhalfen. Ein Lesebuch für Demokraten*, eds. Inge Brodersen et al. (Reinbek: Rowohlt, 1983), 34.

13 "Was sag ich meinem Kinde?" *Das Schwarze Korps* (April 15, 1937): 6.

14 Fritz Mohr, "Einige Betrachtungen über Wesen, Entstehung und Behandlung der Homosexualität," *Zentralblatt für Psychotherapie* 15 (1943): 13.

15 J. Strüder, "Beitrag zur Homosexuellenfrage," *Kriminalistische Monatshefte* 11 (1937): 219ff.

16 Johannes H. Schultz, quoted in "Bluthaftes Verständnis," *Der Spiegel* (June 27, 1994): 185; as well as in Ulrich Schultz, "Autogenes Training und Gleichschaltung aller Sinne," *Die Tageszeitung* (June 20, 1984). The overview of Schultz's role in the Third Reich in the 1994 *Der Spiegel*

article is presumabaly based on the pioneering work by Ulrich Schultz (today known as Schultz-Venrath, not related to Johannes H. Schultz), which appeared in a polemic form in 1984 in *Die Tageszeitung*. Schultz-Venrath in turn built on the fundamental research by Regine Lockot, whose dissertation was published under the title of *Erinnern und Durcharbeiten. Zur Geschichte der Psychoanalyse und Psychotherapie im Nationalsozialismus* (Frankfurt am Main: Gießen Psychosozial-Verl., 1985). On Schultz's ideas on homosexuality, see Johannes H. Schultz, *Geschlecht-Liebe-Ehe* (Munich: Reinhardt, 1941) 56, 96ff., 103ff.

17 "Ist das Nacktkultur? Herr Stapel entrüstet sich!," *Das Schwarze Korps* (April 24, 1935): 12. The tactic of reproducing pictures of naked women and at the same time chastising the media of the Weimar period for their sexual sensationalism was not only followed by *Das Schwarze Korps*. See for example Karl Eiland, "Deutsche Frauenschönheit," *Neues Volk* 10, no. 9 (1942).

18 See "Ehestifter Staat," *Das Schwarze Korps* (March 26, 1936): 11; "Kinder – außerhalb der Gemeinschaft?," *Das Schwarze Korps* (April 9, 1936): 5; "Das uneheliche Kind," *Das Schwarze Korps*, (April 9, 1936): 6; "Mütterheim Steinhöring," *Das Schwarze Korps* (January 7, 1937): 13ff.

19 "Frauen sind keine Männer!" *Das Schwarze Korps* (March 12, 1936): 1.

20 Matthias Laros, *Die Beziehungen der Geschlechter* (Cologne, 1936), 167f; Christian critics cited in *Das Schwarze Korps* (April 24, 1935): 12; *Das Schwarze Korps* (June 26, 1935): 5; *Das Schwarze Korps* (January 20, 1938): 8.

21 Erwin von Kienitz, "Katholische Sexualkasuistik und Sexualmoral," *Schönere Zukunft* 11, nos. 12–13 (1935): 310.

22 See Martin Dannecker, "Rede zur Einweihung einer Gedenksäule für Magnus Hirschfeld am 14. Mai 1995," *Mitteilungen der Magnus-Hirschfeld-Gesellschaft* 22–23 (1996): 9–12 (12).

KÖRPER FÜHLEN, BILDER SEHEN

FEELING BODIES, SEEING IMAGES

Zeitgleich zu den Entwicklungen in der Sexualwissenschaft finden neue Vorstellungen von Körper, Geschlecht und Intimität ihren Ausdruck in Kunst und Kultur.

Literatur, Theater, Film und Bildende Kunst bieten die Möglichkeit, geschlechtliche Stereotypen infrage zu stellen und neue Körper- und Rollenbilder zu entwerfen. Diese dienen als Basis für die Imagination freierer Lebensweisen und legen den Grundstein für das, was wir heute als queere Ästhetik wahrnehmen.

Während der Artikel 142 der Weimarer Reichsverfassung weitgehende Kunstfreiheit verspricht, wird gleichzeitig eine Zensur für das neue Medium Film eingeführt. Gerade in München gibt es zahlreiche Verbote von Film- und Theateraufführungen, die als anstößig erachtet werden.

At the same time as the advancements in sexology, new notions of the body, gender, and intimacy were finding expression in art and culture.

Literature, theater, film, and the visual arts offered an opportunity to question gender stereotypes and to create new roles and body images. These served as the basis for imagining freer ways of living and to lay the foundation for what we perceive today as queer aesthetics.

While Article 142 of the Weimar Constitution promised extensive artistic freedom, censorship was simultaneously introduced for the new medium of film. Munich in particular had numerous bans on film and theater performances deemed offensive.

„EINIGE QUEERE KÜNSTLER*INNEN TRÄUMEN IN BILDERN UND TROTZEN SO STRIKTEN HETERO-VORSTELLUNGEN. IHRE AUGEN SEHNEN SICH NACH ERZÄHLUNGEN VON SEHNSUCHT UND LUST, FREI VON TRAUMATA, MIT DEM VERSPRECHEN AUF BEFREIUNG. DURCH IHRE BILDER ERÖFFNEN SICH NEUE WEGE DES SEINS."

Antwaun Sargent, 2020
Autor und Kurator

"SOME QUEER ARTISTS DREAM IN IMAGES, IN DEFIANCE OF THE STRAIGHT IMAGINATION. THEIR EYES DESIRE NARRATIVES OF LONGING AND PLEASURE, FREE OF TRAUMA, WITH ILLUMINATIONS OF RELIEF. THROUGH THEIR PICTURES, OTHER WAYS OF EXISTING ARE POSSIBLE."

Antwaun Sargent, 2020
Author and Curator

NEUE KÖRPERBILDER

In der ersten Hälfte des 20. Jahrhunderts experimentieren Künstler*innen mit neuen Darstellungen von Körperlichkeit. Sie entwerfen ein großes Spektrum möglicher Identitäten und Sexualitäten außerhalb der dominanten Kategorien. Sie unterlaufen binäre Vorstellungen von Geschlecht, sei es durch Doppeldeutigkeiten, geschlechtsneutrale Codes oder das Spiel mit androgynen Körperbildern.

1933 setzen die Nationalsozialist*innen dieser Vielfalt ein Ende. Avantgardistische Werke von Künstler*innen wie Hannah Höch oder Jeanne Mammen werden als „entartet" diffamiert und beschlagnahmt, verboten oder zerstört. Stattdessen würdigt das Regime Künstler*innen wie Arno Breker, Leni Riefenstahl oder Josef Thorak, die traditionelle Geschlechterbilder in monumentalen Darstellungen verewigen. Diese Bilder unterstützen die völkischen Ideale des NS-Regimes und wirken bis lange in die Nachkriegszeit.

NEW IMAGES OF THE BODY

In the first half of the twentieth century, artists experimented with new representations of the human body. They conceived of a wide spectrum of possible identities and sexualities situated outside the dominant categories. Artists subverted binary notions of gender, whether through ambiguities, gender-neutral codes, or playing with androgynous body images.

In 1933, the Nazis put an end to this diversity. Avant-garde works by artists such as Hannah Höch or Jeanne Mammen were denounced as "degenerate" and confiscated, banned, or destroyed. The regime instead honored artists such as Arno Breker, Leni Riefenstahl, and Josef Thorak, who immortalized traditional gender images in monumental depictions. Such images supported the Nazi regime's racial ideals, and endured well into the postwar period.

Hannah Höch (1889–1978) arbeitet in ihrer Kunst mit Klischees und Rollenbildern und prägt die Dada-Bewegung stark mit. Zwei Liebesbeziehungen beeinflussen das Leben der Künstlerin besonders: jene zum Dada-Künstler Raoul Hausmann und jene zur Schriftstellerin Til Brugman. Mit ihrer Kurzhaarfrisur wirkt Höch auf diesem Bild ähnlich androgyn wie ihre Partnerin Brugman, die Hemd und Krawatte trägt. Beide wenden sich fast demonstrativ vom Blick Hausmanns ab, der hinter der Kamera steht.

Hannah Höch (1889–1978) worked with clichés and role models in her art and was a significant influence on the Dada movement. Two love affairs in particular shaped her life: one with the Dada artist Raoul Hausmann and the other with the writer Til Brugman. In this picture, Höch poses as an androgynous figure with her short hairstyle, similar to that of her partner, Brugman, who wears a shirt and tie. Both turn away almost demonstratively from Hausmann's gaze, who is standing behind the camera.

„ich möchte die festen grenzen verwischen, die wir menschen – selbstsicher – um alles uns erreichbare zu ziehen geneigt sind."

Hannah Höch im Vorwort des Katalogs zu ihrer ersten Einzelausstellung, Kunstzaal De Bron, Den Haag, 1929

"I would like to blur the boundaries that we humans – self-confidently – draw around everything we can reach."

Hannah Höch in the foreword to the catalog for her first solo exhibition, Kunstzaal De Bron, The Hague, 1929

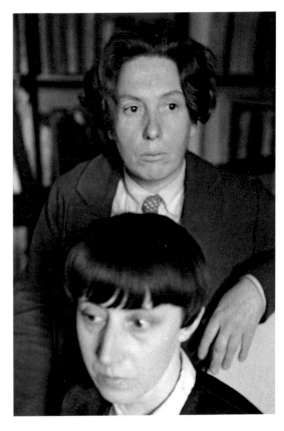

Raoul Hausmann, *Ohne Titel (Porträt Hannah Höch und Til Brugman)*, 1931 | Raoul Hausmann, *Untitled (Portrait of Hannah Höch and Til Brugman)*, 1931

FEELING BODIES, SEEING IMAGES

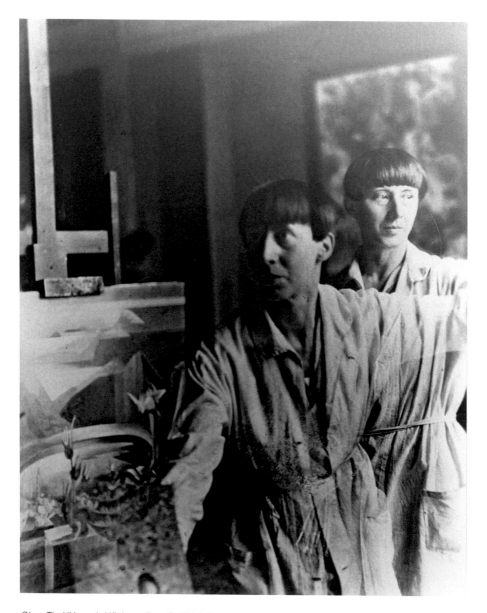

Ohne Titel (Hannah Höch vor ihrer Staffelei, Den Haag; Selbstporträt mit dem Gemälde *Symbolische Landschaft III*), 1930 | *Untitled* (Hannah Höch at her easel, The Hague; self-portrait with the painting *Symbolic Landscape III*), 1930

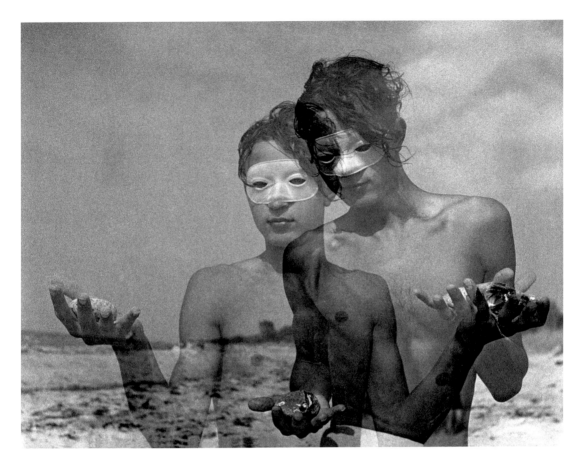

Herbert List, *Strandläufer*, Ostsee 1933 | Herbert List, *Beachcomber*, Baltic Sea, 1933

Der Fotograf Herbert List (1903–1975) ist bekannt für Landschaftsaufnahmen, Stillleben, Porträts und Bildreportagen sowie Männerakte. Das zu Beginn seines Schaffens im privaten Umfeld entstandene Bild dokumentiert seine persönliche Auseinandersetzung mit Homosexualität. Die traumhafte Anmutung der doppelt belichteten Fotografie ist dabei nicht eindeutig zu lesen. Die Mehrdeutigkeit der Realität und das Auflösen von Geschlechtergrenzen lassen sich hier ebenso finden wie antike Bild- und Körperideale.

The photographer Herbert List (1903–1975) is known for his landscape photographs, still lifes, portraits, and pictorial reportages, as well as male nudes. This photograph, taken in private at the beginning of his photographic career, documents his personal confrontation with his homosexuality. The dreamlike impression of the double-exposure cannot be read clearly. The ambiguity of reality and the dissolution of gender boundaries can be found here just as much as ideals of the image and body from antiquity.

FEELING BODIES, SEEING IMAGES

232 KÖRPER FÜHLEN, BILDER SEHEN

„In die Irre führen. Männlich? Weiblich? Aber
das kommt auf den jeweiligen Fall an. Neutrum
ist das einzige Geschlecht, das mir immer
entspricht. Existierte es in unserer Sprache,
würde man die Unentschlossenheit meiner
Gedanken nicht wahrnehmen."

Claude Cahun, *Aveux non avenus* (Nichtige Geständnisse), 1930

"To mislead. Male? Female? But it depends
on the case. Neuter is the only gender that
always corresponds to me. If it existed in
our language, one would not perceive the
indecision of my thoughts."

Claude Cahun, *Aveux non avenus* (Disavowals or Canceled
Confessions), 1930

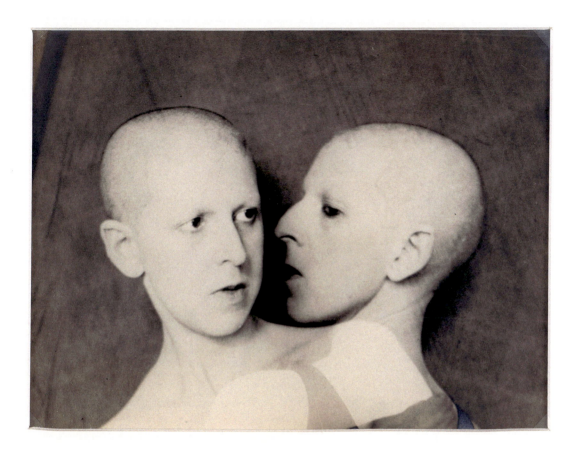

Claude Cahun, *Que me veux-tu?*, 1928

Claude Cahun (1894–1954), Schriftsteller*in und Künstler*in, wird als Lucy Schwob im französischen Nantes geboren. Der Name Claude Cahun taucht erstmals im teils autobiografischen Text *Les Jeux Uraniens* auf, in dem sich Cahun auf Karl Heinrich Ulrichs' Begriff der „Urninge" bezieht. In Fotografien und Collagen erforscht Cahun die eigene Geschlechtsidentität, die sie*er selbst als „Neutrum" benennt – ein radikaler Akt der Selbstbestimmung. Die Arbeit *Que me veux-tu?* (Was willst du von mir?) belegt bildlich und wörtlich Cahuns Abkehr von binär geprägten Normen.

The writer and artist Claude Cahun (1894–1954) was born Lucy Schwob in Nantes, France. The name Claude Cahun first appeared in the partly autobiographical text *Les Jeux Uraniens*, in which Cahun refers to Karl Heinrich Ulrichs's concept of *Urninge*. In photographs and collages, Cahun explored her own gender identity, which they termed "Neuter" – a radical act of self-determination. The work *Que me veux-tu?* (What Do You Want from Me?) demonstrates Cahun's rejection – visually and literally – of binary norms.

FEELING BODIES, SEEING IMAGES

Paul Hoecker (1854–1910) prägt die Münchner Kunstszene des späten 19. Jahrhunderts. Nach Bekanntwerden seiner Homosexualität wird der Künstler ausgeschlossen und gerät in Vergessenheit. Das Forum Queeres Archiv erforscht Hoeckers Geschichte, um sein Leben und Arbeiten zu würdigen und an ihn zu erinnern.

Als Professor an der Münchner Akademie der Bildenden Künste hat Hoecker zu Lebzeiten großen Einfluss: Nahezu alle Maler*innen der Künstlergruppe Die Scholle sowie viele Illustrator*innen der Zeitschriften *Simplicissimus* und *Die Jugend* zählen zu seinen Schüler*innen. Auch für sein künstlerisches Werk wird dem Mitbegründer der Münchner Secession große Anerkennung zuteil.

Mit dem Sexualwissenschaftler Magnus Hirschfeld tauscht sich Hoecker privat darüber aus, dass er „konträrsexuell veranlagt", also schwul ist. Als wenige Jahre später ein Gerücht zu einem seiner Gemälde Fragen zu Paul Hoeckers Sexualität aufwirft, wird er unfreiwillig geoutet.

Paul Hoecker (1854–1910) left his mark on the Munich art scene of the late nineteenth century. After his homosexuality was revealed, the artist was ostracized and fell into oblivion. The Forum Queeres Archiv researched his history in order to honor and remember his life and work.

As a professor at the Munich Academy of Fine Arts, Hoecker exerted great influence during his lifetime. Almost all of the painters in the artist group Die Scholle, as well as many illustrators of the magazines *Simplicissimus* and *Die Jugend*, were among his students. Hoecker, a cofounder of the Munich Secession, also earned widespread recognition for his own artistic work.

Hoecker privately exchanged views with the sexologist Magnus Hirschfeld about the fact that he was "of a contrary-sexual disposition," that is, gay. When a few years later a rumor about one of his paintings raised questions about Paul Hoecker's sexuality, he was involuntarily outed.

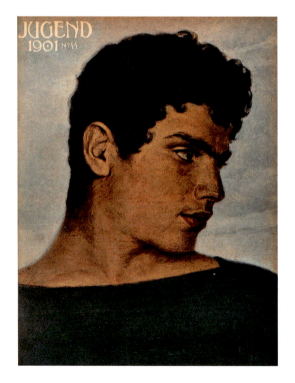

Titelbild *Die Jugend*, 1901/44, mit einem Gemälde von Paul Hoecker | *Die Jugend*, no. 44, 1901, with a painting by Paul Hoecker

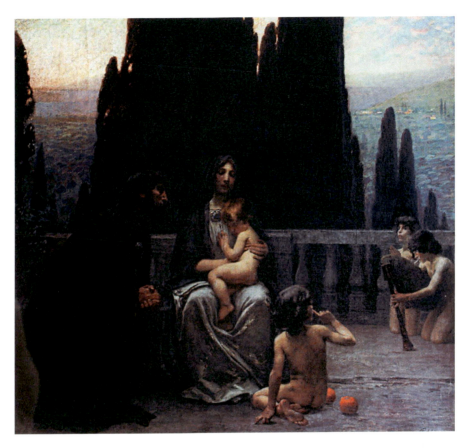

Paul Hoecker, *Ave Maria*, Öl auf Leinwand, um 1898 | Paul Hoecker, *Ave Maria*, oil on canvas, ca. 1898

Dieses zunächst viel gelobte Marienbildnis *Ave Maria* bereitet Hoeckers Karriere ein Ende. Man erzählt sich, dass ein unbekannter Sexarbeiter ihm für die Figur der Jungfrau Maria Modell gestanden hat. Hoecker äußert sich dazu nicht, da er hohe Strafen zu erwarten hat, wenn er das Verhältnis mit einem anderen Mann zugibt. Deshalb reicht er seine Kündigung an der Akademie ein und zieht sich aus München zurück. Erst geht er nach Italien und später in seine schlesische Heimat Oberlangenau zurück. An seine früheren Erfolge kann er nach dem Skandal nie wieder anknüpfen. Nachdem zumindest Paul Hoeckers frühere Schüler ihn in München noch eine Weile weiter in Ehren halten, gerät der Künstler über die Jahre immer mehr in Vergessenheit.

Paul Hoecker's painting of the Virgin Mary was initially highly praised, but proved to be the undoing of his career. A rumor circulated that an unknown male sex worker had posed as the model for the Virgin Mary. Hoecker did not comment on this, since he would face heavy penalties if he admitted to having a relationship with another man. He thus submitted his resignation to the academy and left Munich, traveling first to Italy and later to his hometown of Oberlangenau in Silesia. After the scandal he was never able to achieve the success he had previously enjoyed. While his students continued to revere him for some time, over the years the artist increasingly fell into oblivion.

FEELING BODIES, SEEING IMAGES

Der deutsch-baltische Künstler, Schriftsteller und Herausgeber Elisàr von Kupffer (1872, Estland – 1942, Schweiz) verwendet für den Großteil seines schriftlichen Werks das geschlechtsneutrale Pseudonym „Elisarion". Seinen späteren Lebenspartner, den Historiker und Philosophen Eduard von Mayer (1873, Russland – 1960, Schweiz), lernt er bereits in seiner Jugend im heutigen Russland kennen. 1894 ziehen sie gemeinsam nach Deutschland.

1900 ruft Kupffer die religiöse Bewegung des Klarismus ins Leben und erklärt sich selbst zu ihrem gottgewollten Oberhaupt. Der Klarismus tritt für die Homosexuellen-emanzipation ein, hat jedoch starke frauenfeindliche und antisemitische Tendenzen. Als Intellektueller steht Kupffer sowohl mit Akteuren wie Adolf Brand als auch progressiven Kräften wie Magnus Hirschfeld in Kontakt.

1926 gründen Kupffer und von Mayer in der Schweiz offiziell das Sanctuarium Artis Elisarion. In direkter räumlicher Anbindung zum Monte Verità in Ascona und im Geist der Lebensreformbewegung beherbergt das Gebäude bis heute den Großteil des bildnerischen Schaffens von Elisàr von Kupffer. Vornehmlich zwischen 1905 und 1930 entstanden, stellt sein Werk zahlreiche kunsthistorische Bezüge sowohl zur Antike als auch zum französischen Symbolismus her. Kupffer inszeniert sich in vielen seiner Arbeiten auf provozierende Weise selbst und proklamiert eine emanzipatorische Gleichstellung der Geschlechter, mit der er eine entscheidende Vorreiterstellung in der Kunstgeschichte einnimmt.

Sein 1939 fertiggestelltes Hauptwerk *Klarwelt der Seligen* präsentierte der Kurator Harald Szeemann bereits 1978 im Rahmen der Ausstellung *Monte Verità – Die Brüste der Wahrheit* in Basel und Wien. Seit 2020 ist es fester und restaurierter Bestandteil der auf dem Monte Verità installierten Dauerausstellung. Während das wandfüllende Rundbild auf 26 Metern ein schwules Paradies imaginiert, zeigt die hier ausgestellte Arbeit eine intime Szene: ein Porträt in bewusst provozierender Nacktheit und verspielter Jungenhaftigkeit inmitten eines von weichen Textilien eingefassten Interieurs. Mit erhobenem Glas prostet Kupffer sich selbst und der*dem Betrachter*in über das Spiegelbild fragend zu: „Dove sei?", „Wo bist du?".

Elisàr von Kupffer (Elisarion) und Eduard von Mayer, ohne Jahr | **Elisàr von Kupffer (Elisarion) and Eduard von Mayer, undated**

The Baltic German artist, writer, and editor Elisàr von Kupffer (1872, Estonia – 1942, Switzerland) went by the gender-neutral pseudonym "Elisarion," especially as a nom de plume for his written work. When still a young man, he met his future life partner, the historian and philosopher Eduard von Mayer (1873, Russia – 1960, Switzerland) in Russia; in 1894 they moved to Germany together.

In 1900 Kupffer founded the religious movement Klarismus (from German "klar," meaning "clear") and declared himself its divinely ordained spiritual head. Klarismus advocated homosexual emancipation, but also espoused virulent misogynist and antisemitic positions. Kupffer cultivated intellectual contact with individuals such as Adolf Brand but also progressive figures like Magnus Hirschfeld.

In 1926 Kupffer and Mayer officially established the Sanctuarium Artis Elisarion in Switzerland. In close proximity to Monte Verità in Ascona, and in the spirit of the Lebensreform (Life-Reform) movement, the building continues to house the majority of Elisàr von Kupffer's

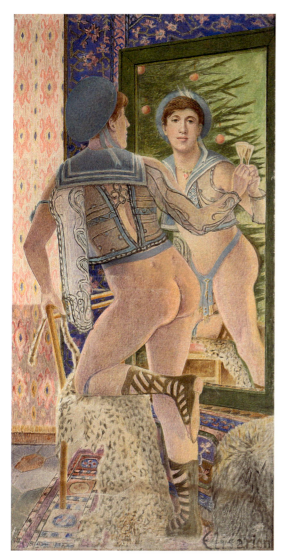

Elisàr von Kupffer, *Dove Sei? / Wo bist du?*, Öl auf Leinwand, 1914/18 | Elisàr von Kupffer, *Dove Sei? / Where Are You?*, oil on canvas, 1914/18

visual works. Created primarily between 1905 and 1930, his visual art makes numerous art historical references to antiquity and French Symbolism. In many of his works Kupffer presents himself in a provocative manner, proclaiming the emancipatory equality of the sexes, which has earned him an important pioneering position in art history.

His monumental magnum opus, *Klarwelt der Seligen* (Clear World of the Blissful), completed in 1939, was displayed by the renowned curator Harald Szeemann in 1978 as part of the exhibition *Monte Verità – The Breasts of Truth*, in Basel and Vienna; since 2020 it has been a permanent and restored part of the exhibition installed at Monte Verità. While the twenty-six-meter cyclorama covering the entire wall imagines a gay paradise, the painting shown here focuses on an intimate scene: a portrait in deliberately provocative, playful nudity and boyishness amidst an interior framed by soft fabrics. Raising his glass, Kupffer toasts himself and the viewer via the reflection, asking, "Dove sei?" ("Where are you?").

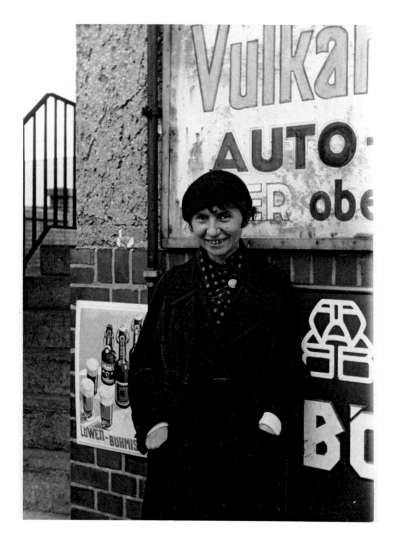

Jeanne Mammen, um 1920 |
Jeanne Mammen, ca. 1920

In der Weimarer Republik eine erfolgreiche Künstlerin, hat Jeanne Mammen (1890–1976) nach 1933 kaum noch Möglichkeiten, öffentlich künstlerisch zu arbeiten. Die Skulptur stammt aus den späten Jahren des NS-Regimes. Zu dieser Zeit arbeitet Mammen zunehmend abstrakt und wendet sich damit einer vom Regime diffamierten Ästhetik zu. Ihre Skulptur *Hermaphrodit* ist das Ergebnis ihrer Experimente mit neuen Materialien und Formen und kann als Verkörperung jener Vielfalt gedeutet werden, die in der NS-Zeit gewaltsam unterdrückt wurde.

A successful artist during the Weimar Republic, Jeanne Mammen (1890–1976) had few opportunities to work publicly as an artist after 1933. This sculpture dates from the late years of the Nazi regime. At this time, Mammen increasingly worked in abstract forms, turning to an aesthetic defamed by the regime. Her sculpture *Hermaphrodite* is the result of her experiments with new materials and forms and can be interpreted as an embodiment of the diversity that was forcibly suppressed during the Nazi era.

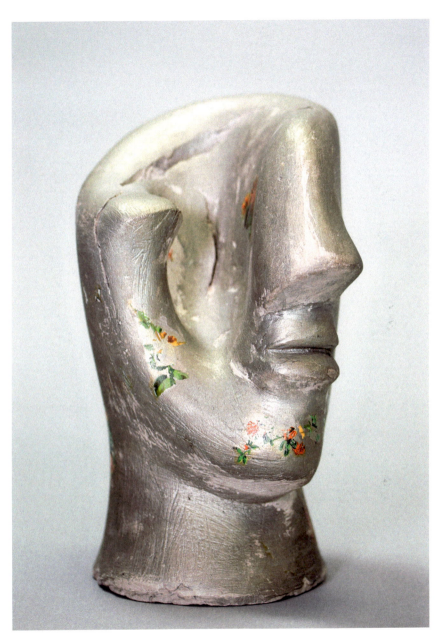

Jeanne Mammen, *Hermaphrodit*, Ton, ungebrannt, bemalt und mit Abziehbildchen beklebt, um 1945 | Jeanne Mammen, *Hermaphrodite*, clay, unfired, painted, and pasted with stickers, ca. 1945

LIEBENDE

Die hier versammelten Arbeiten zeigen homosexuelle Paare und deren intime Beziehung zueinander. In einer Zeit, in der schwule und lesbische Liebe fast ausschließlich im Verborgenen stattfinden kann, wird das Festhalten queerer Intimität innerhalb der Kunst zu einem politischen Bekenntnis. Die Bilder stellen einen Akt der Selbstbehauptung in einem diskriminierenden Umfeld dar. Sie entwerfen Utopien und alternative Realitäten, die ein Zusammensein ermöglichen – teils im Rückgriff auf die Antike, teils mit visionärem Blick auf zukünftige Formen des Liebens und Seins.

LOVERS

The works gathered here show homosexual couples and their intimate relationship with each other. At a time when gay and lesbian love could almost solely take place in secret, capturing queer intimacy within art became a political statement. The images represent an act of self-assertion within a discriminatory environment. They propose utopias and alternative realities that make togetherness possible – partly with recourse to antiquity, partly with a visionary view of future forms of loving and being.

Christian Schad, *Liebende Knaben*, Silberstiftzeichnung, 1929 | **Christian Schad**, *Loving Boys*, silver pen drawing, 1929

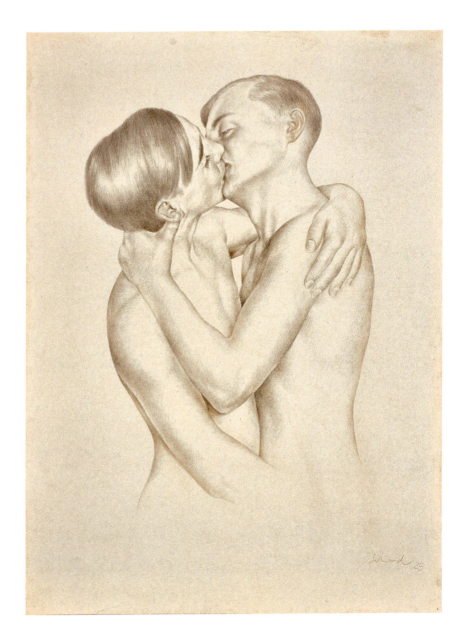

Zwei männliche Jugendliche, die sich küssen und umarmen: Christian Schad (1894–1982) hält Details wie die Beschaffenheit der Haut, die Wimpern und die Frisuren in seiner Zeichnung naturalistisch und detailliert fest. Die Arbeit entsteht in Berlin, wo der im bayerischen Miesbach geborene Künstler ab 1928 lebt und sich der Abbildung der sozialen Wirklichkeit verschreibt, was ihn mit Otto Dix, George Grosz, Rudolf Schlichter und auch Jeanne Mammen verbindet.

Two male youths kissing and embracing. In his drawing, Christian Schad (1894–1982) captures details such as the texture of the skin, eyelashes, and hairstyles in a naturalistic and detailed manner. The work was made in Berlin, where the artist, who was born in the Bavarian town of Miesbach, moved to in 1928. In Berlin he devoted his art to depicting the social reality, linking him to Otto Dix, George Grosz, Rudolf Schlichter, and Jeanne Mammen.

FEELING BODIES, SEEING IMAGES

242 KÖRPER FÜHLEN, BILDER SEHEN

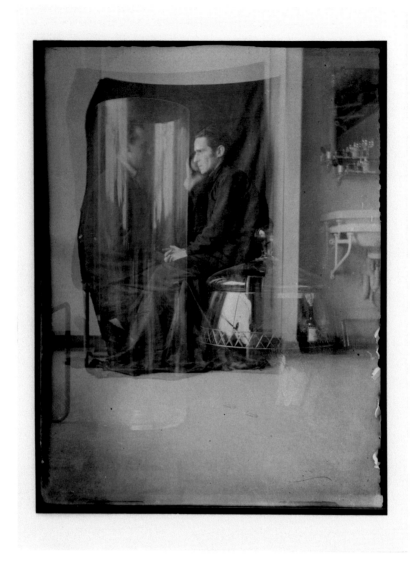

Heinz Loew, *Doppelporträt Heinz Loew und Karl Hermann Trinkaus im Atelier*, 1927 | **Heinz Loew, *Double Portrait of Heinz Loew and Karl Hermann Trinkaus in the Studio*, 1927**

Am Bauhaus in Dessau experimentiert Heinz Loew (1903–1981) in der Fotografie mit der Doppelbelichtung als künstlerischem Element. Die dabei entstehende Vielschichtigkeit und Doppeldeutigkeit ermöglicht es dem Künstler, homosexuelle Liebe trotz gesetzlicher Verbote darzustellen. Die Arbeit gehört zu den wenigen künstlerisch-bildlichen Zeugnissen queerer Identität der damaligen Zeit.

At the Bauhaus in Dessau, Heinz Loew (1903–1981) experimented with double exposure as an artistic tool in photography. The resulting complexity and ambiguity enabled the artist to depict homosexual love despite legal prohibitions. This work is one of the few artistic pictorial testimonies of queer identity of the time.

Der Künstlerin Gertrude Sandmann (1893–1981) droht wegen ihrer jüdischen Herkunft 1942 die Deportation. Mithilfe ihrer Lebensgefährtin Hedwig Koslowski taucht sie unter und überlebt in verschiedenen Verstecken. Sie schafft ein umfangreiches und vielfältiges malerisches Werk.

The artist Gertrude Sandmann (1893–1981) was threatened with deportation in 1942 because of her Jewish origins. With the help of her partner Hedwig Koslowski, she went underground and survived in various hiding places. She created an extensive and varied body of painterly work.

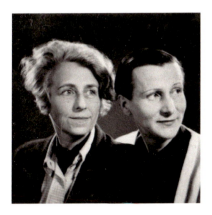

Gertrude Sandmann mit ihrer Partnerin Hedwig Koslowski, 1952 | **Gertrude Sandmann with her partner Hedwig Koslowski, 1952**

Gertrude Sandmann, *Nachthemd und Schwarzer Pyjama*, Kohlestift auf Papier, 1928 | **Gertrude Sandmann, *Nightshirt and Black Pajamas*, charcoal on paper, 1928**

Das Bild zeigt einen flüchtigen, intimen Moment zwischen zwei Frauen in ruhiger und vertrauter Atmosphäre. Mit Zeichnungen anonymer Frauenpaare fängt Gertrude Sandmann (1893–1981) private Begegnungen ein. Zugleich bezieht die jüdische Künstlerin, die es als Glück ansieht, Lesbierin zu sein, künstlerisch Stellung gegen die Diskriminierung von lesbischem Sex.

The picture study depicts a fleeting, intimate moment between two women in a quiet and familiar atmosphere. Gertrude Sandmann (1893–1981) captures private encounters in her drawings of anonymous female couples. At the same time, the Jewish artist, who considered herself fortunate to be a lesbian, took an artistic stand against the discrimination faced by lesbian sex.

Renée Sintenis (1888, Polen – 1965, Deutschland) gehört zu den bedeutendsten Bildhauer*innen der klassischen Moderne. Der Galerist Alfred Flechtheim vermittelte die bewusst kleinformatig gehaltenen Bronzen der Künstlerin in die großen Metropolen Europas und bis nach New York. In den 1920er Jahren wird sie für ihre ausdrucksstarken, teils fragil erscheinenden Figuren junger Tiere, Porträtbüsten und Sport-Statuetten gefeiert. Aufgrund ihrer eigenen Körperstatur und auffallend schönen, androgynen Erscheinung arbeitet sie parallel als Modell, unter anderem für den Künstler Georg Kolbe oder ihren späteren Ehemann Emil Rudolf Weiß. 1931 wird sie als erste Bildhauerin und zweite weibliche Professorin an die Berliner Akademie der Künste berufen. 1934 erzwingen die Nationalsozialisten ihren Austritt. Zudem werden Arbeiten von ihr 1937 in der Aktion „Entartete Kunst" beschlagnahmt, darunter zwei Skulpturen liegender Rehe und ein Selbstporträt, sowie einzelne Druckgrafiken ihrer für das *Tigerschiff* entstandenen Akte und Tier-Radierungen. Nach dem Tod ihres Mannes 1942 zieht Sintenis 1945 mit ihrer Lebenspartnerin Magdalena Goldmann zusammen, mit der sie bis zu ihrem Tod 1965 zusammenlebt.

Renée Sintenis (1888, Poland – 1965, Germany) is regarded as one of the most important sculptors of Modernism. The gallery owner Alfred Flechtheim brought the artist's bronzes, which were deliberately made in small formats, to the major cities of Europe and as far away as New York. In the 1920s she was celebrated for her expressive, sometimes fragile-looking figures of young animals, portrait busts, and sports statuettes. Thanks to her physical stature and strikingly beautiful, androgynous appearance, she also worked as a model, among others for the artist Georg Kolbe and for her later husband, Emil Rudolf Weiß. In 1931 she was appointed as the first female sculptor and second female professor to the Berlin Academy of Arts. In 1934, the Nazis forced her to resign. Works by her were confiscated in 1937 during the "Degenerate Art" campaign, including two sculptures of lying deer and a self-portrait, as well as individual prints of her nudes and animal etchings created for the *Tigerschiff* (Tiger Ship) series. After the death of her husband in 1942, Sintenis moved in with her partner Magdalena Goldmann in 1945, with whom

Renée Sintenis, 1927

Renée Sintenis, *Zwei stehende Rehe*, Radierung, 1948 | **Renée Sintenis**, *Two Standing Deer*, etching, 1948

1948, im Jahr, in dem auch die hier gezeigte Radierung entsteht, bekommt sie den Kunstpreis der Stadt Berlin. Sie erhält daraufhin zunächst einen Ruf an die Berliner Hochschule für Bildende Künste, 1955 dann an die Akademie der Künste Berlin.

Sowohl der Verzicht auf Monumentalität als auch die in die Skulpturen eingeflossenen Wesensmerkmale, die sie bei Tieren, Sportler*innen und in ihren eigenen androgynen Selbstporträts sah, rücken Renée Sintenis in die Nähe des theoretischen Ansatzes von Franz Marc. In dessen frühen naturalistischen Studien von Pferden und Rehen war er darum bemüht, den Kern und das Wesen der Tiere in seiner Arbeit festzuhalten und nicht die auf reine Materialität reduzierte äußere Hülle.

she lived until her death. In 1948, the year in which the lithograph shown here was created, she received the Art Prize of the City of Berlin. She was then appointed to the Berlin College of Visual Arts, and in 1955 to the Berlin Academy of Arts.

Both the renunciation of monumentality and the essential characteristics that she saw in animals, athletes, and her own androgynous self-portraits, which she incorporated into her sculptures, situate Renée Sintenis close to Franz Marc's theoretical approach. In his early naturalistic studies of horses and deer, he strove to capture the core and essence of the animals in his work, rather than the outer shell reduced to pure materiality.

FEELING BODIES, SEEING IMAGES

246 KÖRPER FÜHLEN, BILDER SEHEN

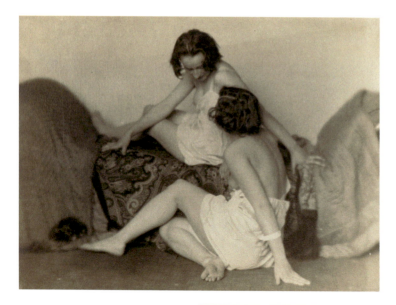

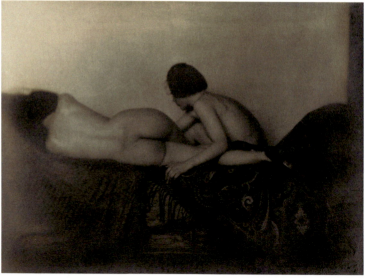

Die Mappe *Akte* der Fotografin und Kriegsberichterstatterin Germaine Krull (1897–1985) versammelt zwölf Fotografien zweier Frauenpaare. Die Frauen wirken jeweils ganz auf sich fokussiert und ungehemmt, trotz der anwesenden Fotografin Krull. Die Lust und das Begehren der Frauen stehen im Mittelpunkt – ganz entgegen der konventionellen Praxis der Aktfotografie, bei der das weibliche Modell für einen männlichen Betrachter in Szene gesetzt wird. Krull, die vermutlich bisexuell war, lebt von 1912 bis 1920 in München und eröffnet dort 1917 ihr erstes Fotoatelier.

The portfolio *Nudes* by the photographer and war correspondent Germaine Krull (1897–1985) consists of twelve photographs of two pairs of women. The women each seem completely focused on themselves and uninhibited, despite Krull's presence as a photographer. The women's desire and lust are the center of the images – quite contrary to the conventional practice of nude photography, in which the female model poses for a male viewer. Krull, who was probably bisexual, lived in Munich from 1912 to 1920 and founded her first photo studio there in 1917.

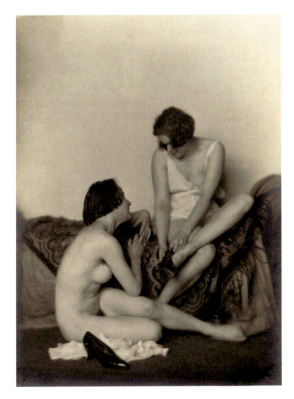
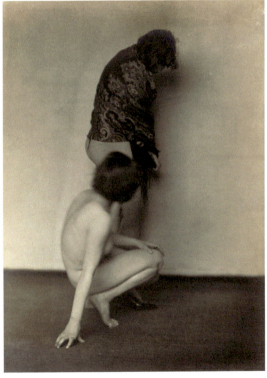

Germaine Krull, *Les Amies* (aus der Mappe *Akte*), Gelatineentwicklungspapier, 1924 | Germaine Krull, *Les Amies* (from the portfolio *Nudes*), gelatin silver print, 1924

FEELING BODIES, SEEING IMAGES

Max Peiffer Watenphul (1896–1976) stößt während seines Jurastudiums in München auf Arbeiten Paul Klees, die in der Buchhandlung Goltz ausgestellt sind. Nach seiner Promotion entscheidet er sich für eine künstlerische Laufbahn und geht 1919 an das Bauhaus in Weimar, wo er wieder mit Klee in Berührung kommt. Watenphul wird Mitglied des Künstlerbunds „Das junge Rheinland", lehrt an der Folkwangschule in Essen und emigriert 1937 nach Italien.

Das hier gezeigte Bild *Stillleben mit Mimosen* entsteht im gleichen Jahr wie *Blumenstillleben*, das die Nationalgalerie Berlin auszeichnet. Letzteres wird 1937 in der Ausstellung „*Entartete Kunst*" in den Hofgartenarkaden Münchens ausgestellt, neben Werken von Freund*innen und Künstlerkolleg*innen Watenphuls wie Lyonel Feininger, Alexej von Jawlensky, Wassily Kandinsky, Paul Klee und Franz Marc. Das Bild gilt seitdem als verschollen. Watenphuls Arbeiten sind geprägt von dem Bemühen, seine Betrachter*innen mit der inneren Schönheit seiner Bildthemen und -gegenstände positiv zu beeinflussen. Diese formale und ästhetische Tendenz ist besonders in den Blumenstillleben sichtbar, die über seine gesamte Schaffensperiode hinweg entstehen.

While studying law in Munich, Max Peiffer Watenphul (1896, Germany – 1976, Italy) came across works by Paul Klee on display at the Goltz gallery and bookstore. After earning his doctorate, he decided to pursue an artistic career and in 1919 went to the Bauhaus in Weimar, where he again came into contact with Klee. Watenphul became a member of the artists' association "Das junge Rheinland," taught at the Folkwangschule in Essen, and emigrated to Italy in 1937.

The painting *Still Life with Mimosas* shown here was created in the same year as *Still Life with Flowers*, honored by the National Gallery in Berlin. The latter was included in 1937 in the *"Degenerate Art"* exhibition in the Hofgartenarkaden in Munich, alongside works by friends and artist colleagues of Watenphul such as Lyonel Feininger, Alexej von Jawlensky, Wassily Kandinsky, Paul Klee, and Franz Marc. Since then the painting has been considered lost. Watenphul's works are characterized by the effort to positively influence his viewers with the inner beauty of his pictorial subjects and objects. This formal and aesthetic tendency is particularly visible in the floral still lifes that he created throughout his creative career.

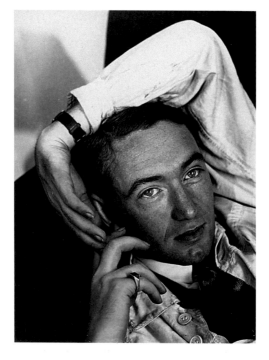

Max Peiffer Watenphul, 1927

Max Peiffer Watenphul, *Stillleben mit Mimosen*, Öl auf Leinwand, 1932 | **Max Peiffer Watenphul,** *Still Life with Mimosas*, oil on canvas, 1932

Max Pfeiffer Watenphuls Homosexualität wurde bisher im Kontext seiner Rolle am Bauhaus wenig thematisiert, ähnlich wie auch die queeren Seiten der Künstler*innen am Bauhaus generell bis vor kurzem kaum aufgearbeitet waren. Watenphul gehört damit in einen Kreis künstlerischer Zeitgenoss*innen, der sich um eine alle Lebensbereiche einschließende und gesellschaftliche Normen sprengende Lebensauffassung bemüht hatte. Mit dem Bild *Stillleben mit Mimosen* ist er nach vielen Jahrzehnten wieder in München zu sehen.

Max Pfeiffer Watenphul's homosexuality has so far been little addressed in the context of his role at the Bauhaus, similar to how the queer sides of the artists at the Bauhaus in general have hardly been dealt with until recently. Watenphul thus belongs to a circle of artistic contemporaries who strived for an attitude to life that transcended social norms and encompassed all areas of life. Now with the painting *Still Life with Mimosas*, he can be seen again in Munich after many decades.

FEELING BODIES, SEEING IMAGES 249

QUEERE LITERATUR

Zwischen 1900 und 1933 erscheinen viele literarische Texte und Zeitschriften, die den medizinischen und juristischen Diskurs über Geschlecht und Homosexualität begleiten. Sie reichen von erotischen Kurzgeschichten und Gedichten über fiktionalisierte Autobiografien bis hin zu Romanen.

Auch wenn vor allem subkulturelle Publikationen beständig von Zensurmaßnahmen bedroht sind und nicht selten als „unzüchtig" oder „jugendgefährdend" verboten werden, bildet sich allmählich ein erster schwul-lesbischer Literaturkanon heraus. In den darin vertretenen Werken werden politische Forderungen artikuliert, Sexualität und Geschlechterrollen diskutiert und konventionelle Lebensformen infrage gestellt.

QUEER LITERATURE

Between 1900 and 1933, many literary texts and journals appeared that accompanied the medical and legal discourse on sex and homosexuality. They ranged from erotic short stories and poems to fictionalized autobiographies and novels.

Even though subcultural publications in particular were constantly threatened by censorship measures and were not infrequently banned as "lewd" or "harmful to minors," a first gay and lesbian literary canon gradually took shape. The works taken up by this canon articulated political demands, discussed sexuality and gender roles, and questioned conventional ways of life.

Aimée Duc, *Sind es Frauen? Roman über das dritte Geschlecht*, 1901 | **Aimée Duc**, *Are They Women? A Novel About the Third Sex*, 1901

Aimée Duc (1867–?), geboren als Hedwig Maria Mina Adelt, ist Journalistin, Schriftstellerin und Verlegerin. Sie schreibt aus feministischer Sicht über das Recht auf Bildung und Berufstätigkeit, die Arbeitsbedingungen von Fabrikarbeiterinnen und die Rechte sexueller Minderheiten. *Sind es Frauen? Roman über das dritte Geschlecht* ist ihr wohl bekanntestes Werk. Es ist einer der ersten lesbischen Romane der Welt. Duc verknüpft darin die glückliche Liebesgeschichte zwischen zwei Frauen mit zeitgenössischen Debatten der Sexualwissenschaft.

Aimée Duc (1867–?), born Hedwig Maria Mina Adelt, was a journalist, writer, and publisher. She wrote from a feminist perspective about the right to education and employment, the working conditions of factory workers, and the rights of sexual minorities. *Are They Women? A Novel about the Third Sex* is probably her best-known work. It ranks as one of the world's first lesbian novels. In it, Duc links a happy love story between two women to contemporary debates in sexology.

FEELING BODIES, SEEING IMAGES

N.O. Body, *Aus eines Mannes Mädchenjahren*, 7. Ausgabe, 1956 |
N.O. Body, *From a Man's Girlhood Years*, seventh edition, 1956

Der deutsch-israelische Autor, Sozialarbeiter und Zionist Karl M. Baer (1885–1956) gewährt mit seiner Autobiografie Einblick in ein Leben zwischen den Geschlechtern. Baer hat bei Geburt weibliche und männliche Geschlechtsmerkmale, wächst als Mädchen auf und lebt später als Mann. Das Selbstzeugnis wird 1907 unter dem Pseudonym N.O. Body mit einem Nachwort von Magnus Hirschfeld veröffentlicht. Baer emigriert gemeinsam mit seiner Frau 1938 nach Palästina.

In his autobiography, the German-Israeli author, social worker, and Zionist Karl M. Baer (1885–1956) provides insights into a life between the sexes. Baer had female and male sexual characteristics at birth, grew up as a girl, and later lived as a man. In 1907 this self-testimony was published under the pseudonym N.O. Body with an epilogue by Magnus Hirschfeld. Baer emigrated to Palestine together with his wife in 1938.

Thomas Mann an Philipp Witkop,
Bad Tölz 18.7.1911 | **Thomas Mann to**
Philipp Witkop, Bad Tölz, July 18, 1911

„Ich bin in der Arbeit: eine recht sonderbare Sache, die
ich aus Venedig mitgebracht habe, Novelle, ernst und rein
im Ton, einen Fall von Knabenliebe bei einem alternden
Künstler behandelnd. Sie sagen 'hum, hum!' aber es ist
sehr anständig."

Im Gegensatz zu seinem Sohn Klaus Mann spricht Thomas
Mann (1875–1955) nie öffentlich darüber, dass er sich zu
Männern hingezogen fühlt. Dennoch finden sich in vielen
seiner Bücher homoerotische Anspielungen; am deutlichs-
ten in *Tod in Venedig* von 1912. Die Novelle wird in über
40 Sprachen übersetzt und ist bis heute Teil des schwulen
Literaturkanons.

"I am working: a rather strange thing I brought back
from Venice, a novella, serious and pure in tone, dealing
with a case of pederasty in an aging artist. You say
'hum, hum!' but it is very decent."

Unlike his son Klaus, Thomas Mann (1875–1955) never
spoke publicly about being attracted to men. Neverthe-
less, homoerotic allusions can be found in many of his
books, most clearly in *Death in Venice* from 1912. The
novella has been translated into over forty languages
and remains part of the gay literary canon today.

FEELING BODIES, SEEING IMAGES 253

Klaus Mann, *Der fromme Tanz. Das Abenteuerbuch einer Jugend*, 1925 | **Klaus Mann**, *The Pious Dance: The Adventure Book of a Youth*, 1925

Klaus Mann (1906–1949) ist der älteste Sohn von Katia und Thomas Mann. Er schreibt den Roman *Der fromme Tanz*, in dem sich der Künstler Andreas Magnus in den heterosexuellen Nils verliebt und fast an dieser unerwiderten Liebe zerbricht.

„Andreas gab sich dieser Liebe ganz hin. […] Ihm kam es nicht in den Sinn, sie vor sich zu leugnen, sie zu bekämpfen als 'Entartung' oder als 'Krankheit'. […] Gut hieß er diese Liebe vielmehr ganz und gar, er lobte sie, wie alles, was Gott gab und verhängte – sei es noch so leicht oder schwierig zu tragen."

Klaus Mann (1906–1949) was the eldest of Katia and Thomas Mann's sons. He wrote the novel *The Pious Dance*, in which the artist Andreas Magnus falls in love with the heterosexual Nils and is nearly destroyed by this unrequited passion.

"Andreas devoted himself completely to this love.… It did not occur to him to deny it to himself, to fight it as a 'degeneracy' or as a 'disease.'… Rather, he welcomed this love completely, he praised it as everything that God gave and imposed – no matter how easy or difficult it was to bear."

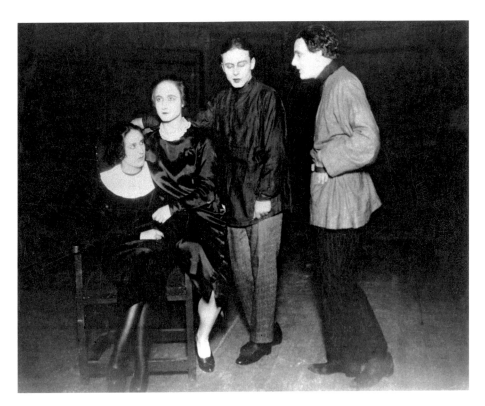

Klaus Mann, *Anja und Esther*, Aufführung mit Erika und Klaus Mann, Pamela Wedekind und Gustav Gründgens, Hamburg 1925 | **Klaus Mann, *Anja and Esther*, performance with Erika and Klaus Mann, Pamela Wedekind, and Gustav Gründgens, Hamburg, 1925**

Klaus Manns Theaterstück *Anja und Esther* handelt von zwei Erzieherinnen in einem Erholungsheim für schwer erziehbare Kinder, die ein lesbisches Verhältnis haben. Bei den Kritiker*innen fällt das Stück auch aufgrund der homosexuellen Thematik durch. Nur die schauspielerischen Leistungen von Erika Mann und Pamela Wedekind werden gelobt. Die beiden sind Klaus Manns Vorbilder für die Figuren im Stück.

Klaus Mann's play *Anja und Esther* is about two governesses working in a convalescent home for troubled and difficult children, who enter into a lesbian relationship. The play was also rejected by critics because of its homosexual theme. Only the performances of Erika Mann and Pamela Wedekind were praised. The two were Klaus Mann's role models for the characters in the play.

FEELING BODIES, SEEING IMAGES 255

Mädchen in Uniform ist der erste deutschsprachige Film, der explizit lesbisches Begehren thematisiert. Er basiert auf Christa Winsloes (1888–1944) autobiografisch geprägtem Theaterstück *Gestern und heute*. Im Mittelpunkt steht Manuela von Meinhardis, die ein Mädcheninternat besucht und sich in ihre Lehrerin verliebt. Die deutsch-ungarische Bildhauerin und Schriftstellerin Christa Winsloe ist in den 1920er Jahren ein Star der Münchner Bohème.

Girls in Uniform is the first German-language film to explicitly address lesbian desire. It is based on Christa Winsloe's (1888–1944) autobiographical play *Yesterday and Today*. The film centers on Manuela von Meinhardis, who attends a boarding school for girls and falls in love with her teacher. The German-Hungarian sculptor and writer Christa Winsloe was a leading figure of Munich's bohemian scene in the 1920s.

Werbeblatt und Einladung zur Vorführung von *Mädchen in Uniform* im Zusammenhang mit einer Wahlkundgebung der SPD, 1933 | Advertising leaflet and invitation to see *Girls in Uniform* in connection with an SPD election rally, 1933.

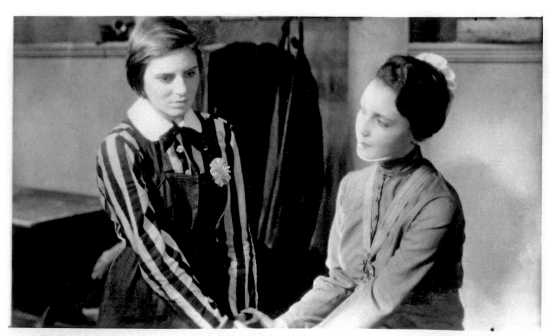

Mädchen in Uniform, Regie Leontine Sagan, Deutschland 1931 | *Girls in Uniform*, directed by Leontine Sagan, Germany, 1931

FEELING BODIES, SEEING IMAGES 257

Bruno Balz (1902–1988) ist Autor von mehr als 1000 Schlager- und Liedtexten. Bis 1933 lebt er offen homosexuell. Bereits mit 17 Jahren ist er in der Homosexuellenbewegung aktiv. Er arbeitet für Adolf Brand als Aktmodell und schreibt Texte für Szene-Zeitschriften. 1936 wird er nach Paragraf 175 verurteilt, verhaftet und vermutlich gefoltert. Sein Talent als Liedtexter wird vom NS-Regime aber auch geschätzt. 1941 wird er vom Kriegsdienst befreit. Er schreibt Liedtexte für große Filmproduktionen des NS-Staats und kann arbeiten, solange er unsichtbar bleibt. In der Bundesrepublik schreibt er später weiter erfolgreich Liedtexte, bis er sich in den 1960er Jahren nach Bad Wiessee zurückzieht.

Bruno Balz (1902–1988) was the author of lyrics for more than a thousand popular songs in the genre known as *Schlager*. He lived openly as a gay man until 1933. By the age of seventeen, he was already active in the homosexual rights movement. Balz worked for Adolf Brand as a nude model and wrote texts for gay magazines. In 1936 he was convicted under Paragraph 175, imprisoned, and presumably tortured. Because his work as a song lyricist remained highly popular, he was exempted from military service by the Nazi regime in 1941. From then on, he wrote song lyrics for major film productions of the Nazi regime and was allowed to work, as long as he remained invisible. In West Germany he continued to write song lyrics until he retired to Bad Wiessee in the 1960s.

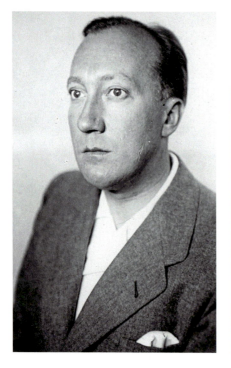

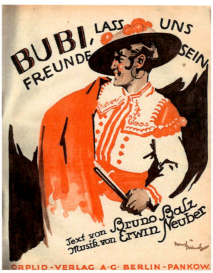

Notenheft zum Lied *Bubi, laß uns Freunde sein*, Text: Bruno Balz, Musik: Erwin Neuber, 1924 | Music booklet for the song "Bubi, laß uns Freunde sein" (Lad, Let's Be Friends), text by Bruno Balz, music by Erwin Neuber, 1924

Bruno Balz, vermutlich um 1935 |
Bruno Balz, probably ca. 1935

In Friedrich Radszuweits Verlag erscheint 1924 mit *Bubi, laß uns Freunde sein* eine der ersten schwulen Schallplatten überhaupt, für die Balz den Text beisteuert. Auch spätere Texte werden homosexuell gelesen, zum Beispiel *Kann denn Liebe Sünde sein?*, ein Lied, mit dem Zarah Leander bekannt wird.

In 1924, Friedrich Radszuweit's publishers brought out "Bubi, lass uns Freunde sein" (Lad, Let's Be Friends), one of the first gay records ever, for which Balz contributed the lyrics. Later texts were also read under a queer-coded perspective, for example "Kann denn Liebe Sünde sein?" (Can Love Be a Sin?), which made Zarah Leander famous.

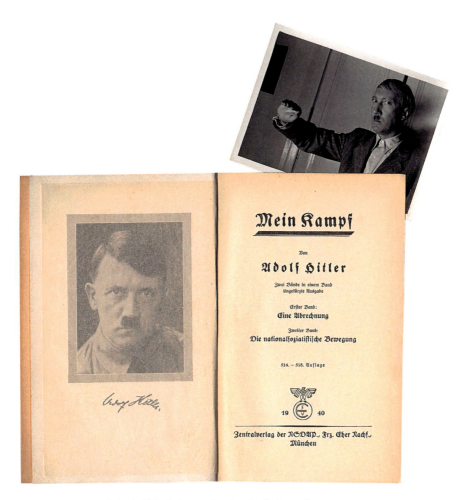

Ein Foto von Bruno Balz als Hitler-Imitator, eingelegt in ein Exemplar von Adolf Hitlers *Mein Kampf*, Anfang der 1940er Jahre | Photo of Bruno Balz imitating Adolf Hitler, inserted in a copy of Hitler's *Mein Kampf*, early 1940s

Nach der Verurteilung wegen Verstoßes gegen Paragraf 175 wird Balz 1937 aus der Haft entlassen. Laut seinem späteren Lebensgefährten Jürgen Dräger parodiert er daraufhin im privaten Rahmen Adolf Hitler und versteckt das Foto in einem Exemplar von Hitlers *Mein Kampf* – auf Seite 175. Nach dem Krieg wird Balz zwei weitere Male wegen Verstoßes gegen Paragraf 175 verurteilt: 1953 und 1965.

After being convicted under Paragraph 175, Balz was released from prison in 1937. According to his later partner Jürgen Dräger, he then parodied Adolf Hitler in private and hid the photo in a copy of Hitler's *Mein Kampf* – at page 175. After the war, Balz was convicted of Paragraph 175 twice more: in 1953 and in 1965.

FEELING BODIES, SEEING IMAGES

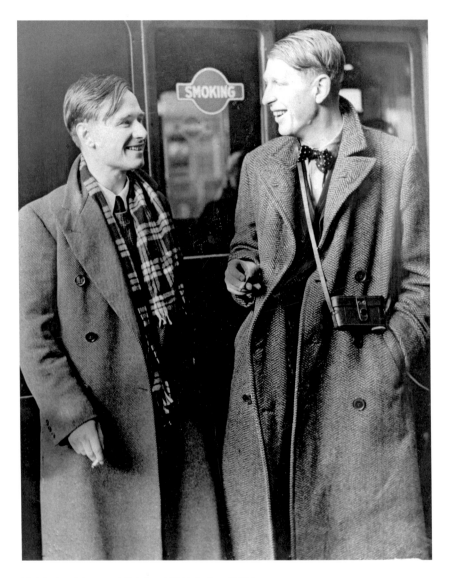

Christopher Isherwood (links) und W. H. Auden, 1938 |
Christopher Isherwood (left) and W. H. Auden, 1938

Der britische Schriftsteller Christopher Isherwood (1904–1986) zieht 1929 nach Berlin, nachdem er dort seinen Freund W. H. Auden besucht hat. Er verewigt das dortige homosexuelle Leben in seinen Romanen *Mr. Norris steigt um* und *Leb wohl, Berlin*, die als Vorlage für das Musical *Cabaret* dienen und teilweise im Szenelokal Eldorado spielen. Bis heute ist Isherwoods Werk damit ein wichtiger Bezugspunkt für Kunst und Literatur.

The British writer Christopher Isherwood (1904–1986) moved to Berlin in 1929, after visiting his friend W. H. Auden. He immortalized the homosexual life in the city in his novels *Mr. Norris Changes Trains* and *Goodbye to Berlin*, which served as a model for the musical Cabaret and was partly set in the gay bar Eldorado. To this day, Isherwood's work has remained an important reference point for art and literature.

Christopher Isherwood, *Mr. Norris Changes Trains*, Erstausgabe der Hogarth Press mit Umschlag-Illustration von John Banting, 1935 | Christopher Isherwood, *Mr. Norris Changes Trains*, first edition published by Hogarth Press with cover illustration by John Banting, 1935

FEELING BODIES, SEEING IMAGES 261

DIE BÜHNE ALS ORT DER UTOPIEN

In der Weimarer Republik entstehen in vielen Großstädten Varietés, Theater und Nachtlokale, auf deren Bühnen ein freier Umgang mit Sexualität und Geschlechteridentitäten möglich ist. Bühnenstars werden zu Identifikationsfiguren alternativer Geschlechterrollen, und der Kleidertausch auf der Bühne entwickelt sich zu einem eigenständigen Genre.

Die oft als „golden" bezeichneten 1920er Jahre sind für die meisten Menschen keineswegs von Wohlstand geprägt, auch wenn immer mehr Menschen Zugang zu Unterhaltungskultur haben. Kriegstraumata und wirtschaftliche Not wecken das Bedürfnis, den Sorgen des Alltags zu entfliehen. Die Bars, Clubs und Varietés dieser Zeit sind für viele Menschen Orte, an denen sie mit alternativen Geschlechterbildern und Homosexualität in Berührung kommen und wo sich gesellschaftliche Debatten entzünden.

THE STAGE AS SITE OF UTOPIAS

In the Weimar Republic, vaudevilles, theaters, and nightclubs emerged in many major cities, on whose stages a freer treatment of sexuality and gender identities was allowed. Stage celebrities became role models for alternative gender roles, with drag performances developing into a genre in its own right.

The 1920s, often referred to as "golden" years, were by no means characterized by prosperity for most citizens, even though more and more people gained access to entertainment culture. War trauma and economic hardship stimulated the need to escape the worries of everyday life. For many people, the bars and clubs of this period were places where they came into contact with alternative gender images and homosexuality, as well as where social debates were sparked.

Ankündigung eines Auftritts von Josephine Baker im Leipziger Krystallpalast, 1929 | Announcement of a performance by Josephine Baker at the Krystallpalast in Leipzig, 1929

Die afroamerikanische Tänzerin, Sängerin und Schauspielerin Josephine Baker (1906–1975) kommt 1926 nach Berlin und tritt am Kurfürstendamm auf. Hier lernt sie die Szene kennen und hat Affären mit Männern und Frauen. Sie ist mit ihrem Kurzhaarschnitt Vorbild und wird als moderne und elegant gekleidete US-Amerikanerin und Vertreterin des Jazz in Europa gefeiert. Baker versteht es, in ihrem Tanz auf rassistische und sexuell aufgeladene Stereotype hinzuweisen, zugleich reproduziert sie dabei die Klischees, die sie mit ihrer Kunst zu unterwandern versucht.

The African American dancer, singer, and actress Josephine Baker (1906–1975) came to Berlin in 1926 and performed on the Kurfürstendamm. Here she got to know the gay scene and had affairs with men and women. With her short hairstyle she became a role model, celebrated as a modern and elegantly dressed American and representative of jazz in Europe. Baker knew how to allude to racist and sexually charged stereotypes in her dancing, while at the same time reproducing clichés she tried to subvert with her art.

FEELING BODIES, SEEING IMAGES

Josephine Baker, um 1930 | **Josephine Baker, ca. 1930**

Während Josephine Baker in Städten wie Leipzig, Berlin oder Hamburg große Erfolge feiert, erhält sie in München 1929 Auftrittsverbot. Auf der Bühne gezeigte Nacktheit und rassistische Vorurteile führen dazu, dass die Stadt wegen einer zu erwartenden „Verletzung des öffentlichen Anstands" Baker nicht gestattet, im Deutschen Theater aufzutreten. Auch beugt sich die Polizei damit dem Druck der NSDAP. 1937 wird Baker französische Staatsbürgerin und unterstützt aktiv den Widerstand gegen die Nationalsozialist*innen.

While Josephine Baker enjoyed great success in cities such as Leipzig, Berlin, and Hamburg, she was banned from performing in Munich in 1929. Nudity shown on stage and racial prejudice led the city to prevent Baker from performing at the Deutsches Theater because of an expected "violation of public decency." In 1937, Baker became a French citizen and actively supported the resistance movement against the Nazis.

Marlene Dietrich, ohne Jahr | **Marlene Dietrich, undated**

Mit ihrer androgynen Ausstrahlung beeindruckt die Ufa- und Hollywood-Schauspielerin Marlene Dietrich (1901–1992) Frauen und Männer gleichermaßen. Im Liebesdrama *Morocco* küsst sie eine Frau. Diese Szene wird erst nach langen Diskussionen im Film belassen. Dietrich als „feminine Frau" mit männlich-codiertem Smoking, Zylinder und Zigarette, die ihre bisexuelle Erotik frei auslebt, löst Faszination und moralische Empörung gleichermaßen aus.

Marlene Dietrich (1901–1992), an actress in German and American films, impressed women and men alike with her androgynous charisma. In the romantic drama *Morocco* she kisses a woman. This scene was left in the film only after long discussions. Dietrich as a "feminine woman" with a male-coded tuxedo, top hat, and cigarette, freely acting out her bisexual eroticism, triggering fascination and moral outrage in equal measure.

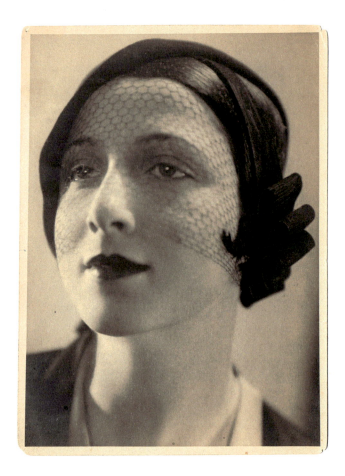

Lil Picard in Berlin, mit handschriftlicher Notiz „In the Roaring Twenties. Photo-Atelier Bruno Winterfeld" | **Lil Picard in Berlin,** with handwritten note "In the Roaring Twenties. Photo-Atelier Bruno Winterfeld"

Lil Picard (1899–1994) ist Malerin, Performancekünstlerin und Journalistin. Geboren in Landau als Lilli Elisabeth Benedick und aufgewachsen in Straßburg, kommt sie nach dem Ersten Weltkrieg nach Berlin, wo sie Literatur und Kunst studiert und in die Kreise der künstlerischen Avantgarde und der Dada-Bewegung eintaucht.

In den 1920er Jahren tritt Lil Picard in den Theatern und Varietés Berlins auf und beginnt ihre Bühnen-Karriere. In dieser Zeit fertigt sie auch Collagen an, in denen sie sich mit dem komplexen Verhältnis von Körper, Sexualität und Freiheit beschäftigt. Die Idee der Dekonstruktion und Konstruktion durchzieht ihre bildkünstlerische Arbeit sowie ihre Performance-Kunst.

Lil Picard (1899–1994) was a painter, performance artist, and journalist. Born Lilli Elisabeth Benedick in Landau and raised in Strasbourg, she came to Berlin after World War I, where she studied literature and art and immersed herself in the circles of the avant-garde and the Dada movement.

In the 1920s, Lil Picard performed in Berlin's theaters and vaudevilles and began her stage career. During this time, she also made collages in which she explored the complex relationship between the body, sexuality, and freedom. The idea of deconstruction and construction permeates her visual artwork as well as her performance art.

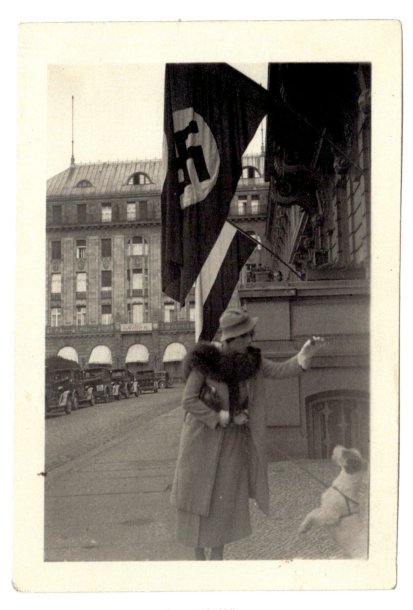

Lil Picard vor dem Hotel Adlon, Berlin um 1934 | Lil Picard in front of the Hotel Adlon, Berlin, ca. 1934

Lil Picard und ihr zweiter Ehemann, Hans Jüdell, sind beide jüdischer Abstammung. Wegen der zunehmenden Verfolgung emigriert das Ehepaar 1936 nach New York. Auch dort bewegt sich Picard in Künstler*innenkreisen, in denen es möglich ist, eine offene Ehe zu leben.

Lil Picard and her second husband, Hans Jüdell, were both of Jewish descent. Due to increasing persecution, the couple emigrated to New York in 1936. There too Picard moved in artistic circles, where it was possible to live in an open marriage.

FEELING BODIES, SEEING IMAGES 267

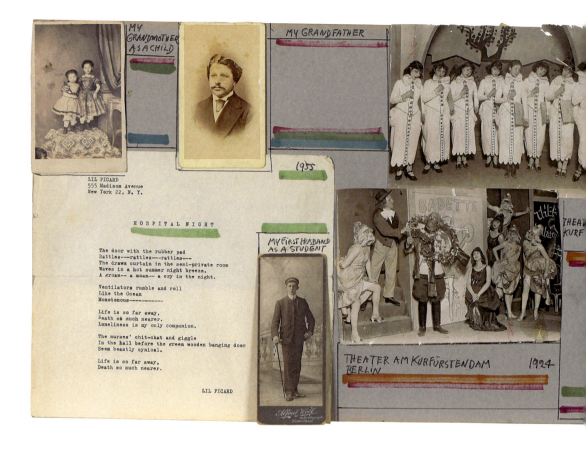

Lil Picard, *Nostalgia*, Foto-Collage, 1973/74 |
Lil Picard, *Nostalgia*, Photo-Collage, 1973/74

In der Collage verarbeitet Lil Picard ihre Kindheit und Jugend sowie ihre Zeit in Berlin. Private Familienfotografien, Bilder von Auftritten im Theater am Kurfürstendamm, ein Artikel im *Berliner Tageblatt* sowie ein Gedicht über die Erfahrung einer lebensbedrohlichen Abtreibung stehen nebeneinander. Unterschiedliche Inanspruchnahmen des weiblichen Körpers werden so über verschiedene Medien dargestellt und neu verbunden.

In this collage, Lil Picard works through her childhood and adolescence as well as her time in Berlin. Private family photographs, images of performances at the Theater am Kurfürstendamm, an article in the *Berliner Tageblatt*, and a poem about the experience of a life-threatening abortion are juxtaposed. Different usages of the female body are thus presented, linking them anew via different media.

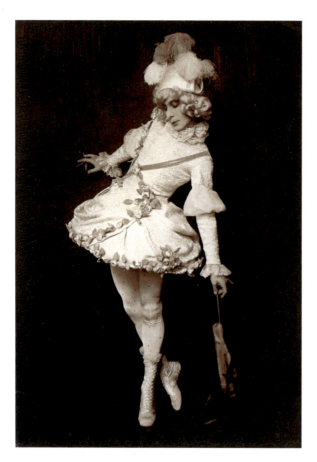

Alexander Sacharoff, fotografiert von Hanns Holdt, um 1914 | **Alexander Sakharoff, photographed by Hanns Holdt, ca. 1914**

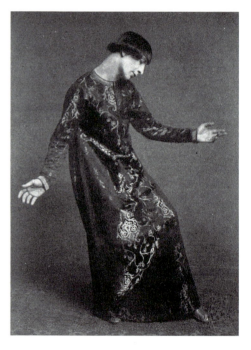

Tanzstudie von Alexander Sacharoff, 1912 | **Dance study by Alexander Sakharoff, 1912**

Der gefeierte jüdische Tänzer Alexander Sacharoff (1886–1963) ist auch Maler, Modell und Kostümgestalter. Als Teil der Münchner Bohème bewegt er sich im Umfeld des Blauen Reiter und wird von der Künstler*innengruppe durchaus queer gelesen. Nicht zuletzt Alexej von Jawlenskys berühmtes Bildnis des Tänzers Alexander Sacharoff betont besonders das Androgyne seiner Erscheinung. Privat lebt Sacharoff wohl homosexuell, die Beziehung zu seiner Tanzpartnerin und ab 1919 auch Ehefrau Clotilde von Derp bleibt platonisch.

The celebrated Jewish dancer Alexander Sakharoff (1886–1963) was also a painter, model, and costume designer. As part of the bohemian scene in Munich, he moved in the milieu of Der Blaue Reiter and was seen by them as queer. Alexei von Jawlensky's famous portrait of Sakharoff emphasizes his androgynous appearance. In his private life, Sakharoff was probably homosexual; his relationship with his dance partner and, from 1919, wife Clotilde von Derp remained platonic.

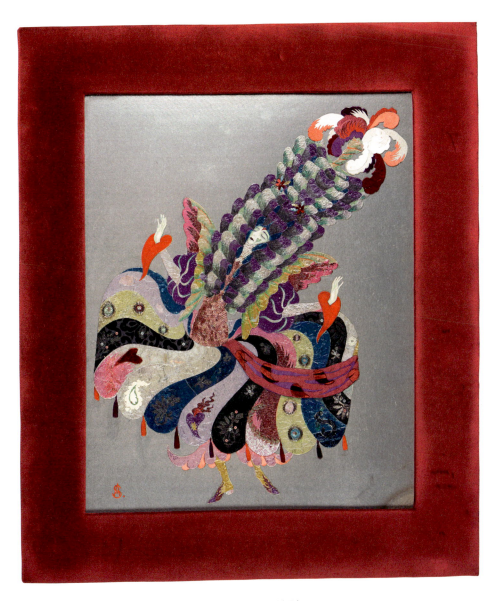

Alexander Sacharoff, *Pavane Fantastique*, Collage, um 1916/17 |
Alexander Sakharoff, *Pavane Fantastique*, collage, ca. 1916/17

Sacharoff verkörpert als Künstler eine fast perfekte Symbiose aus Kunst und Leben. In seinen Tänzen nach griechischen Vasenbildern oder Renaissancemotiven hebt er nicht nur die Grenzen zwischen bildender und darstellender Kunst auf, sondern auch die der eindeutigen Zuordnung der Geschlechter. Die Collage aus Stoff, Papier und Pailletten entwickelt Sacharoff selbst als Kostümentwurf für seine Choreografie *Pavane Royale*.

As an artist, Sakharoff embodied an almost perfect symbiosis of art and life. In his dances based on Greek vase paintings or Renaissance motifs, he not only eliminated the boundaries between the visual and performing arts, but also those of the clear assignment of the sexes and the social roles assigned to them. Sakharoff himself developed this collage of fabric, paper, and sequins as a costume design for his choreographic work *Pavane Royale*.

FEELING BODIES, SEEING IMAGES

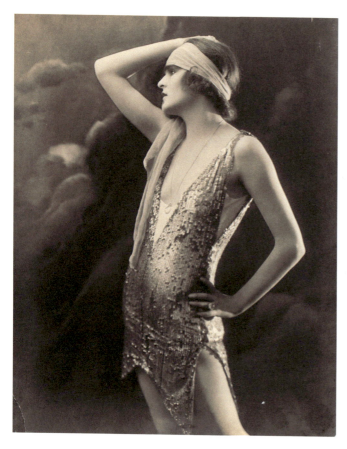

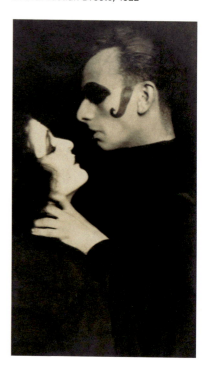

Anita Berber und Sebastian Droste, 1922 | Anita Berber and Sebastian Droste, 1922

Anita Berber, um 1923 | Anita Berber, ca. 1923

Die bisexuelle Tänzerin Anita Berber (1899–1928) sorgt in den 1920er Jahren mit ihren provozierenden Auftritten in den Berliner Clubs für Aufsehen und Skandale. Mit ihrem homosexuellen Tanzpartner Sebastian Droste konfrontiert sie das Publikum mit Homoerotik, Nacktheit und Drogenkonsum und spricht damit Themen an, die in der Öffentlichkeit tabuisiert werden. Im Aufklärungsfilm *Anders als die Andern* übernimmt Berber eine kleine Rolle an der Seite Magnus Hirschfelds, während Droste in dessen *Geschlechtskunde* als Inbegriff des homosexuellen „invertierten Künstlers" abgebildet ist.

The bisexual dancer Anita Berber (1899–1928) caused a sensation and scandal in the 1920s with her provocative performances in Berlin clubs. With her homosexual dance partner Sebastian Droste, she confronted audiences with homoeroticism, nudity, and drug use, addressing issues that were taboo in the public eye. In the homosexual awareness film *Anders als die Andern*, Berber took on a small role alongside Magnus Hirschfeld, while Droste was depicted as the epitome of the homosexual "inverted artist" in Hirschfeld's *Sexology*.

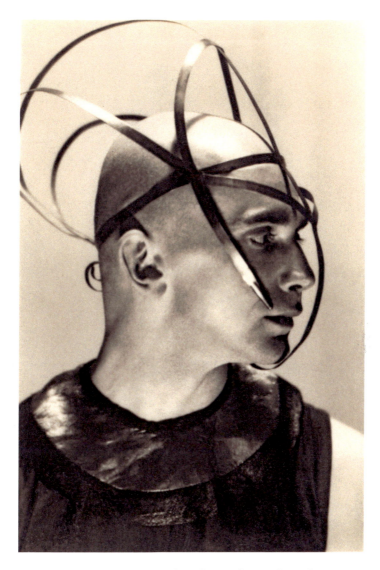

Harald Kreutzberg im *Königstanz* auf dem Titel der Zeitschrift *Das Theater*, 1935 | Harald Kreutzberg in *Königstanz* on the cover of the magazine *Das Theater*, 1935

Harald Kreutzberg (1902–1968) ist einer der bekanntesten deutschen Tänzer und Choreografen des 20. Jahrhunderts. Mit seinen Frauenrollen löst er in der Weimarer Zeit Debatten über Männlichkeit im Tanz aus. Seine eigene Homosexualität thematisiert er in der Öffentlichkeit nicht. Kreutzberg lässt sich von den Nationalsozialist*innen instrumentalisieren und wird einer der erfolgreichsten Künstler des Regimes.

Harald Kreutzberg (1902–1968) was one of the most famous German dancers and choreographers of the twentieth century. During the Weimar period, he triggered debates about masculinity in dance by taking on female roles. Kreutzberg did not address his own homosexuality in public. He allowed himself to be used by the Nazis and became one of the regime's most successful artists.

FEELING BODIES, SEEING IMAGES 273

274 KÖRPER FÜHLEN, BILDER SEHEN

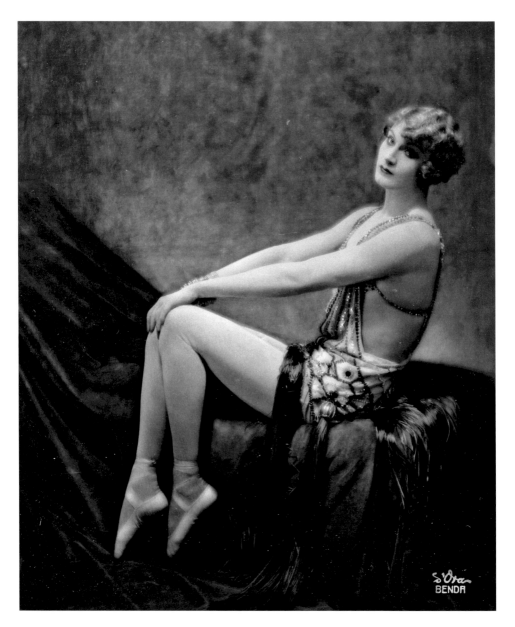

Barbette, fotografiert von Dora Kallmus, ohne Jahr | **Barbette, photographed by Dora Kallmus, undated**

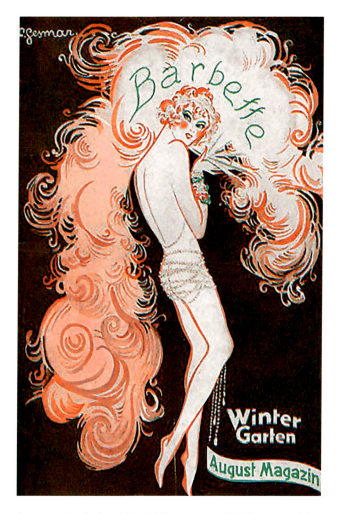

Programm des Berliner Varietés Wintergarten, 1931 | **Program of the Wintergarten Varieté, Berlin, 1931**

Der*die Trapez-Künstler*in Barbette (bürgerlicher Name Vander Clyde, 1899–1973) feiert ab Mitte der 1920er Jahre in Europa große Erfolge. Barbette tritt unter anderem im Berliner Varieté Wintergarten auf. Die aufsehenerregenden Inszenierungen der „female impersonators" werden damit zunehmend auch einem Massenpublikum bekannt – und verhelfen so den Damen- und Herrenimitator*innen der Berliner Szene zu Akzeptanz.

The trapeze artist Barbette (civil name Vander Clyde, 1899–1973) enjoyed great success in Europe beginning in the mid-1920s. Barbette performed at the Wintergarten Varieté in Berlin, among other venues. The sensational productions of the "female impersonators" became increasingly known to a mass audience – and thus helped the female and male impersonators in Berlin to gain acceptance.

FEELING BODIES, SEEING IMAGES 275

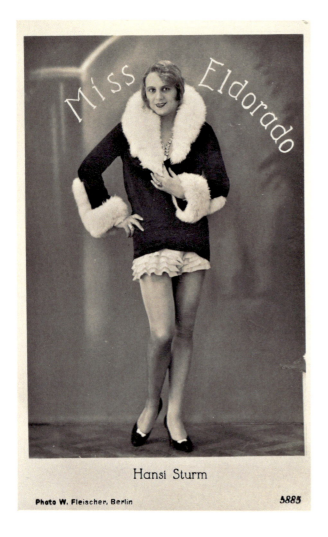
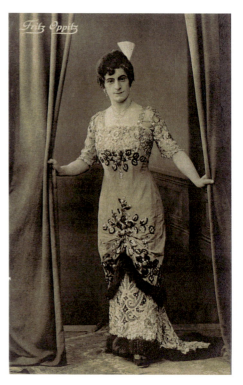

Vier Starpostkarten von Damen- und Herrenimitator*innen | **Postcards of female and male impersonators**

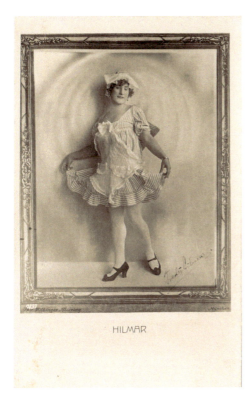

HILMAR

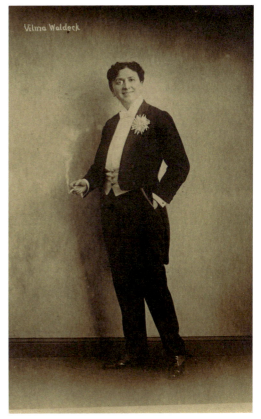

Vilma Waldeck

Die vielen noch erhaltenen Starpostkarten von heute meist unbekannten Herren- und Damenimitator*innen erzählen von ihrer Beliebtheit. Hansi Sturm, Fritz Opitz, Hilmar Damita und Wilma Waldeck sind Berühmtheiten der Szene, die in ihren Shows mit Geschlechterrollen spielen und Konventionen auf den Kopf stellen – und das nicht nur vor queerem Publikum.

The many surviving postcards of male and female impersonator stars – today mostly unknown – testify to their popularity. Hansi Sturm, Hilmar Damita, Fritz Opitz, and Wilma Waldeck were celebrities of the scene who played with gender roles and turned conventions on their head in their shows, and not only in front of queer audiences.

FEELING BODIES, SEEING IMAGES 277

KAROL RADZISZEWSKI

Karol Radziszewski (*1980, Polen) entwickelte für die Ausstellung *TO BE SEEN* eine dem Starfriseur Antoni Cierplikowski (1884–1976), genannt Antoine de Paris, gewidmete Installation. Dieser entwarf unter anderem die ikonische „Garçonne"-Frisur von Josephine Baker, die bewusst konventionelle Geschlechterstereotypen unterlief und das Bild der „Neuen Frau" der 1920er Jahre prägte, das Selbstbestimmtheit, Unabhängigkeit und Freiheit transportierte. Seine androgynen Looks beeinflussten neben Josephine Baker unter anderem den Stil von Marlene Dietrich, Greta Garbo, Renée Sintenis oder Liza Minelli. Neben einem Porträt von Antoine de Paris umfasst die Installation ein Gemälde dieser sechs Frauen, die de Paris' Kreationen weltweit verbreiteten. Die dichte, malerische Maskerade macht die internationalen Netzwerke der künstlerischen Arbeit des Friseurs ebenso sichtbar wie grenzübergreifende Formen des Zusammenhalts in ästhetischen und modischen Codes. Queere und feministische Solidarität kommen darin zum Ausdruck und erinnern an aktuelle Äußerungen der Verbundenheit, wie die öffentlichen Haarschneideaktionen französischer Schauspielerinnen in Solidarität mit der feministischen Revolution im Iran. Mithilfe der zusätzlich ausgestellten historischen Objekte integriert Radziszewski den heute wenig erinnerten schwulen Friseur in seine Reihe von Ahnenporträts als eine Hommage an die prominentesten Vertreter*innen einer queeren Ästhetik.

Karol Radziszewski arbeitet in seiner archivbasierten künstlerischen Praxis interdisziplinär mit Film, Fotografie, Malerei und Installation. Er ist Herausgeber des queerer Kunst gewidmeten *Dike Fagazines* und Gründer der von Künstler*innen geführten Organisation Queer Archives Institute (QAI).

For the exhibition *TO BE SEEN*, Karol Radziszewski (b. 1980, Poland) developed an installation dedicated to the star hairstylist Antoni Cierplikowski (1884–1976), known as Antoine de Paris. He designed, among other creations, Josephine Baker's iconic "garçonne" hairstyle, which deliberately undermined conventional gender stereotypes and shaped the image of the "new woman" of the 1920s, conveying self-determination, independence, and freedom. In addition to Josephine Baker, his androgynous looks influenced the style of Marlene Dietrich, Greta Garbo, Renée Sintenis, and Liza Minelli, among others. Alongside a portrait of Antoine de Paris, the installation includes a painting of these eight women who spread de Paris's creations around the world. The dense, painterly masquerade makes visible the international networks of the hairdresser's artistic work as well as cross-border forms of cohesion in aesthetic and fashion codes. Queer and feminist solidarity are expressed in it, recalling current expressions of support, such as the public haircutting actions of French actresses in solidarity with the 2022 feminist revolution in Iran. With the aid of the additional historical objects on display, Radziszewski incorporates the now almost forgotten gay hairdresser in his series of ancestral portraits as a tribute to the most prominent representatives of a queer aesthetics.

In his archive-based artistic practice, Karol Radziszewski works across the disciplines of film, photography, painting, and installation. He is the editor of *Dike Fagazine*, dedicated to queer art, and founder of the artist-run organization Queer Archives Institute (QAI).

Antoine de Paris, 2022
Mixed Media Installation

The Great Magician
Acryl auf Leinwand, Holzrahmen | Acrylic on canvas, wooden frame

Liza Minnelli, Greta Garbo, Dorothea Wieck, Marlene Dietrich, Renée Sintenis, Josephine Baker, Tamara Łempicka, Lili Elbe
Acryl auf Leinwand, Holzrahmen | Acrylic on canvas, wooden frame
Zwei Glastische, drei Porzellandosen, Glasvase, künstliche Lilien | Two glass tables, three porcelain containers, glass vase, bouquet of artificial lilies
Courtesy the artist and BWA Warszawa

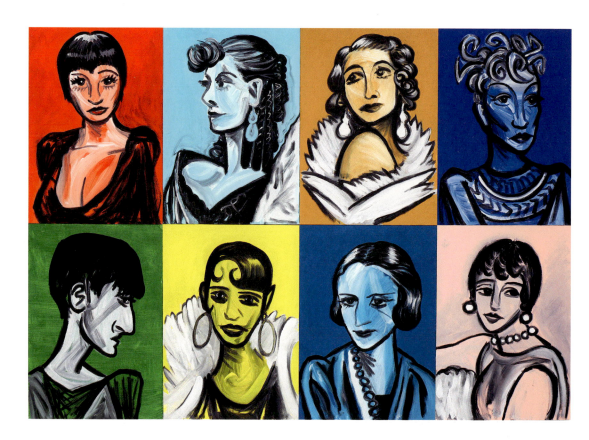

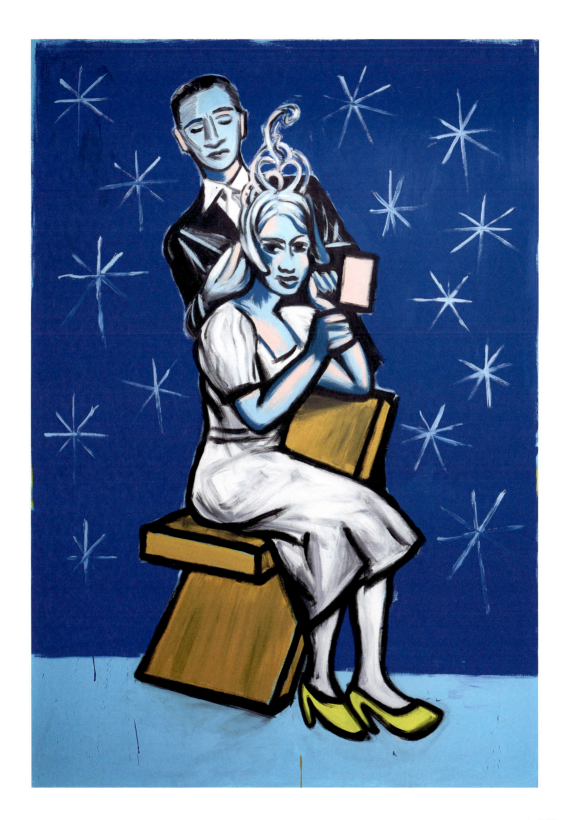

WOLFGANG TILLMANS

Mit seinen frühen Arbeiten aus den 1990er Jahren prägt Wolfgang Tillmans (*1968, Deutschland), einer der bedeutendsten Gegenwartskünstler, das Lebensgefühl der Techno- und Schwulenszene. Ihr Bedürfnis nach Freiheit und Lebenslust transportiert er mit Ausstellungen – wie etwa in New York, London, Taipei oder Hongkong – in die ganze Welt. Empathie und Nähe in Freundschaften und Gemeinschaften sind in seinem Werk ebenso wiederkehrende Themen wie seine kontinuierliche Reflexion über das Medium Fotografie in teilweise abstrakten Arbeiten.

Mit *The Cock (kiss)* trägt Tillmans eine fotografische Arbeit bei, die die Fragilität zwischenmenschlicher Beziehungen widerspiegelt. Das Foto entstand in dem schwulen Nachtclub The Cock im Zentrum von London, in dem Tillmans um die Jahrtausendwende regelmäßig Gast oder auch DJ war. Das längst ikonische Bild stellt genderspezifische Stereotypen infrage, indem es den intimen Moment eines Kusses zwischen zwei Männern abbildet. Lustvolle Sexualität und zwischenmenschliche Zartheit sprechen aus dem Werk, das zugleich humanistische wie politische Elemente enthält. Während einer Ausstellung in Washington DC im Jahr 2011 zerstörte ein Besucher *The Cock (kiss)*. Seit dem Anschlag auf einen schwulen Nachtclub in Orlando im Jahr 2016 ist das Bild eines der meistgeteilten Images auf Social Media und Inbegriff des Protests gegen Homophobie und queerfeindliches Verhalten.

One of best-known artists working today, Wolfgang Tillmans (b. 1968, Germany) defined in his early works from the 1990s the attitude to life of the techno and gay scene. He conveyed their need for freedom and their lust for life in exhibitions around the world, in places such as New York, London, Taipei, or Hong Kong. Empathy and closeness in friendships and communities are recurring themes in his work, as is his ongoing reflection, in occasionally abstract works, on the medium of photography.

With *The Cock (kiss)*, Tillmans contributes a photographic work that reflects the fragility of interpersonal relationships. The photograph was taken at the gay nightclub The Cock in central London, where Tillmans was a regular guest and also DJ around the turn of the millennium. The image, which has gained iconic status, challenges gender stereotypes by depicting the intimate moment of a kiss between two men. Lustful sexuality and interpersonal tenderness are articulated in the work, which contains both humanist and political elements. During an exhibition in Washington, DC, in 2011, a visitor vandalized *The Cock (kiss)*. Since the 2016 attack on a gay nightclub in Orlando, the image has become one of the most shared images on social media and the epitome of protest against homophobia and anti-queer hostility.

The Cock (kiss), 2002
Courtesy Galerie Buchholz

PAULINE BOUDRY/ RENATE LORENZ

Das Künstlerinnen-Duo Pauline Boudry (*1972, Schweiz) und Renate Lorenz (*1963, Deutschland) arbeitet seit 2007 gemeinsam an filmischen Installationen, Texten, Performances, Objekten und Skulpturen. In ihrer künstlerischen Praxis kooperieren sie über Jahre hinweg mit Tänzer*innen, Choreograf*innen und bildenden Künstler*innen. Die entstandenen Arbeiten hinterfragen geschlechtsspezifische Muster und werfen einen prüfenden Blick auf Normen und Kategorien, die unsere Wahrnehmung, Vorstellung und unser soziales Leben bestimmen. Körper, Objekte, Gewalt und Widerstand, Gemeinschaft und Glamour sind dabei wichtige Bezugspunkte, die die Werke von Boudry und Lorenz prägen.

Die *Wall Necklaces Pieces* bestehen aus einer Vielzahl unterschiedlicher Ketten, die zu einer überdimensionalen Halskette verbunden sind: Einige der Ketten sehen aus wie Schmuck, andere erinnern an Absperrungen, die Orte vor unbefugtem Betreten sichern. Auch in Nachtclubs, der S/M-Kultur oder in anderen Subkulturen finden sich ähnliche Elemente. Im Kontext des NS-Dokumentationszentrums und der Ausstellung *TO BE SEEN* entsteht eine Assoziation an die „historischen Ketten" der Verfolgung. In ihrer Gesamtheit verkörpert die Skulptur ein Symbol des Widerstands gegen Unfreiheit, aber auch ein Rückerobern von Zeichenstrukturen: So wurden im queeren Aktivismus Symbole der Unterdrückung, etwa der „Rosa Winkel" oder diskriminierende Begriffe wie *dyke* oder „schwul", neu besetzt und positiv umgedeutet.

The artist duo Pauline Boudry (b. 1972, Switzerland) and Renate Lorenz (b. 1963, Germany) have worked together on film installations, texts, performances, objects, and sculptures since 2007. They have collaborated with dancers, choreographers, and visual artists in their artistic practice for years. The resulting works question gendered patterns and cast a probing gaze on norms and categories that shape our perceptions, imaginations, and social lives. Bodies, objects, violence and resistance, community and glamour are important points of reference that inform Boudry and Lorenz's works.

The *Wall Necklace Pieces* consist of a number of different chains connected to form an oversized necklace: some of the chains look like jewelry, others are reminiscent of barriers that protect places from trespassing. Similar elements can also be found in nightclubs, S/M culture, and in other subcultures. An association with the "historical chains" of persecution emerges within the context of the Munich Documentation Center for the History of National Socialism and the *TO BE SEEN* exhibition. The sculpture embodies in its entirety a symbol of resistance against bondage, but also a reclaiming of sign structures: thus, in queer activism, symbols of oppression, such as the "pink triangle" or discriminatory terms like "dyke" or "gay," have been recast and positively reinterpreted.

Wall Necklace Piece (unpredictable assembly II), 2022
Metallketten | Metal chains
Courtesy the artists, Galerie Marcelle Alix,
Ellen de Bruijne Projects

CARA SCHWEITZER

KÜNSTLER*INNENPORTRÄTS UND GESCHLECHTERIDENTITÄT ZU BEGINN DES 20. JAHRHUNDERTS

Frontal, mit glühenden Augen blickt uns Alexander Sacharoff (1886–1963) an. Sein Gesicht bedeckt dicke weiße Schminke. Zu diesem Weiß bilden die umrandeten dunklen Augen und die dichten schwarzen Locken der Perücke einen ebenso starken Kontrast wie die rot geschminkten Lippen. Den Mund verzieht Sacharoff zu einem Lächeln. Alexej von Jawlenskys (1864–1941) Porträt des 1886 in Mariupol geborenen Tänzers steht am Beginn einer neuen Phase in seiner Malerei. Alle Farben betonen die Fläche. Der zierliche Körper des Tänzers scheint sich im Rot seines Kleides zu verflüchtigen. Jawlensky wird zukünftig Porträts vor allem mit schematisierten Formen malen, ihnen etwas Maskenhaftes verleihen, mit schwarzen Strichen die Nasen, Augenschlitze und Münder formen und mit runden Flecken die Wangen akzentuieren. Jawlenskys Gemälde aus der Sammlung des Münchner Lenbachhauses gilt heute als ikonisch. In einer Publikation der Tate Gallery in London, die sich 2017 dem Thema Queerness und Kunstgeschichte widmet, bildet Jawlenskys Tänzer das Entrée.[1]

Nach Ausbildungsstationen in Sankt Petersburg und Paris war Alexander Sacharoff 1905 nach München gezogen, wo er im Schwabinger Umfeld vielen, ebenfalls aus dem zaristischen Russland stammenden Künstler*innen begegnete. Einige von ihnen waren wie er in der heutigen Ukraine geboren oder dort aufgewachsen, sprachen Russisch und trugen bis zum Ersten Weltkrieg maßgeblich zur Entwicklung der bayerischen Landeshauptstadt zu einem Zentrum der Moderne bei. Die Münchner Avantgarde, aus der 1911 die Künstler*innengruppe Der Blaue Reiter hervorging, war bereit, sich auf neue Vorstellungen von Geschlecht und Körperbildern einzulassen. Zu

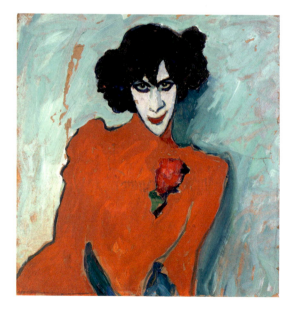

Alexej von Jawlensky, *Bildnis des Tänzers Alexander Sacharoff,* 1909 | **Alexej von Jawlensky,** *Portrait of the Dancer Alexander Sakharoff,* 1909

CARA SCHWEITZER

PORTRAITS OF ARTISTS AND GENDER IDENTITY AT THE BEGINNING OF THE TWENTIETH CENTURY

Facing forward, Alexander Sakharoff gazes out at us with radiant eyes. His face is covered by white makeup, standing in vivid contrast to the darkly outlined eyes and thick black curls of his wig, as well as his red lipstick. Alexej von Jawlensky's (1864–1941) portrait of Sakharoff, who was born in Mariupol in 1886, stands at the beginning of a new phase in his painting. The colors all emphasize the surface, and the dancer's slender body seems to dissolve into the red of his dress. In subsequent work, Jawlensky would principally create portraits with schematic forms, lending his subjects a mask-like appearance, with black lines that delineate noses, eye slits, and mouths, and with round spots accentuating the cheeks. Jawlensky's painting, part of the collection of the Lenbachhaus in Munich, has since gained iconic status. It was featured in a publication by the Tate Gallery in London dedicated to the topic of queerness and art history.[1]

After studying in St. Petersburg and Paris, Alexander Sakharoff moved to Munich in 1905, where in the Schwabing district he met many artists from tsarist Russia. Like him, some were born or grew up in what is now Ukraine, spoke Russian, and contributed significantly to the development of the Bavarian capital into a center of Modernism before the First World War. The Munich avant-garde, which produced the artist group Der Blaue Reiter in 1911, was eager to embrace new ideas of gender and body image. This circle included Jawlensky, his partner Marianne von Werefkin, Wassily Kandinsky, and Sakharoff, whose body and body language impressed them all.

The artists in Sakharoff's circle were connected by the experience of exile. Sakharoff, Kandinsky, Werefkin, and Jawlensky had to leave Germany with the outbreak of the First World War, and only some of them returned after 1918. For those who, like Sakharoff, dealt with themes that today are subsumed under the term "queer" – for example, by changing gender roles in their works – the year 1933 marked a turning point. After Adolf Hitler rose to power, they were confronted with the life-threatening consequences of reprisals by the Nazi regime, were forced to flee Germany forever, and were publicly defamed in 1937 in the "Degenerate Art" exhibitions, while their works fell victim to the Nazi regime's campaign of confiscating artworks from museums.

FEELING BODIES, SEEING IMAGES 289

diesem Kreis zählen auch Jawlensky, seine Lebenspartnerin Marianne von Werefkin, Wassily Kandinsky und Sacharoff, dessen Körper und Körpersprache sie alle beeindruckte.

Die Biografien der Künstler*innen aus Sacharoffs Umfeld verbindet die Erfahrung von Exil. Sacharoff, Kandinsky, Werefkin und Jawlensky mussten Deutschland mit Ausbruch des Ersten Weltkriegs verlassen. Nach 1918 kehrten einige von ihnen zurück. Für all diejenigen, die sich wie Sacharoff zu Beginn des 20. Jahrhunderts auf unterschiedliche Weise mit heute unter dem Begriff queer gefassten Themen auseinandersetzten, indem sie etwa in ihren Arbeiten Geschlechterrollen wechselten, bedeutete das Jahr 1933 eine Zäsur. Nach der Machtübernahme von Adolf Hitler hatten sie im Zuge von Repressalien des NS-Regimes lebensbedrohliche Folgen zu erwarten, mussten für immer aus Deutschland fliehen, wurden 1937 im Kontext der Ausstellungen zur „Entarteten Kunst" öffentlich diffamiert, und ihre Werke fielen den Beschlagnahmungsaktionen des NS-Regimes in Museen zum Opfer.

Alexander Sacharoff vereinte in seiner Erscheinung und seinen Tanzchoreografien Männliches und Weibliches. In Jawlenskys Gemälde ist kaum zu entscheiden, ob es sich bei der stark geschminkten Figur mit dunkler Lockenpracht im knallroten Kleid mit Rose an der Brust um einen Mann oder eine Frau handelt. Schminke und Kostüm deuten eher auf eine weibliche Person hin, auch wenn unter der roten Fläche des Gewandes der Körper geradezu verschwindet. In Sacharoffs Androgynität sahen die Maler*innen in Schwabing ihre bisweilen auch spirituell begründeten Unternehmungen bestätigt, die gegenständliche Formensprache in der Malerei zugunsten der Abstraktion aufzulösen. Kandinsky schuf um 1908 Bühnenproduktionen, an denen Sacharoff beteiligt

war. In den Werken sollten bildende Kunst, Sprache, Tanz, Musik und Theater in synästhetischer Wahrnehmung in einem Gesamtkunstwerk aufgehen. Thomas de Hartmann komponierte zu Kandinskys Bildern und Texten Musik, die Sacharoff in Tanz umsetzte.[2]

Jawlenskys Bildnis sowie Sacharoffs Tanzchoreografien, Kostüm- und Bühnenentwürfe bezeugen, wie vielfältig queere Themen in der Kunst zu Beginn des 20. Jahrhunderts sichtbar werden, auch wenn es den Begriff in seiner aktuellen Bedeutung noch nicht gab. Der Tänzer in seiner androgynen Erscheinung hat offenbar auch Einfluss genommen auf die Entstehung abstrakter Kunst. Künstler*innen experimentierten in unterschiedlichen Gattungen. Seit den 1920er Jahren zählten dazu vor allem die Fotografie, Fotomontage und Collage. Indem Künstler*innen in ihren Werken gängige Vorstellungen von Geschlecht und Rollenbildern infrage stellten, entstand eine vielschichtige und umfangreiche visuelle Kultur von Queerness. Nur eine kleine Auswahl unterschiedlicher Positionen wird im Folgenden beschrieben. Methodisch ist das in der Kunstgeschichte junge Forschungsfeld zu Queerness verknüpft mit feministischen Forschungsperspektiven und den Gender Studies.

Auffällige Kostüme wie das rote Kleid in Jawlenskys Gemälde avancierten zu Sacharoffs Markenzeichen. Ein Beispiel für die Vorliebe des Tänzers für aufwendige Kostümierungen bietet die während seines Aufenthalts in der Schweiz während des Ersten Weltkriegs inszenierte Tanzchoreografie *Pavane Royale*. Das Thema war einem von Sacharoffs liebsten Gemälden aus der Sammlung des Louvre, dem *Porträt Ludwigs XIV.* von Hyacinthe Rigaud (1701) entlehnt. Sacharoffs Entwürfe weisen zahlreiche Bezüge zur Kunstgeschichte auf. Er nannte den Louvre seinen

Alexander Sakharoff fused the masculine and feminine in his appearance and in his choreographic work. In Jawlensky's painting, it is hard to decide whether the heavily made-up figure with dark curls, in a bright red dress with a rose on his chest, depicts a man or a woman. The makeup and costume suggest a female, even though the body virtually disappears beneath the red expanse of the gown. The artists in Schwabing saw in Sakharoff's androgyny the confirmation of their efforts – which they sometimes gave a spiritual justification – to dissolve painting's representational formal language in favor of abstraction. Kandinsky created stage productions around 1908 in which Sakharoff was involved. In these works, visual art, language, dance, music, and theater were meant to unite through a synesthetic perception into a *Gesamtkunstwerk*. Thomas de Hartmann composed music for Kandinsky's paintings and texts, and Sakharoff rendered them in dance.[2]

Jawlensky's portrait as well as Sakharoff's choreography, costume designs, and set designs testify to the many ways in which queer themes became visible in art at the beginning of the twentieth century, even if the term "queer" in its current meaning did not then exist. Through his androgynous appearance, Sakharoff also seems to have influenced the emergence of abstract art. By the 1920s, artists were experimenting in different genres, including photography, photomontage, and collage. In challenging existing notions of gender and role models, artists created a multilayered and extensive visual culture of queerness. The following will explore only a small assortment of different positions. Methodologically, the new field of research on queer art history is linked to feminist research perspectives and with gender studies.

Striking costumes such as the red dress in Jawlensky's painting soon became Sakharoff's trademark. An example of the dancer's penchant for elaborate costuming is provided by his choreographic work *Pavane Royale*, staged during his stay in Switzerland during the First World War. The subject was drawn from one of Sakharoff's favorite paintings in the Louvre, the 1701 portrait of Louis XIV by Hyacinthe Rigaud. Sakharoff's designs reveal numerous references to art history. He claimed that the Louvre was his master.[3] In Rigaud's portrait, the Sun King wears – in addition to the regal insignia of sword, scepter, and ermine cloak – frills of the finest lace, long white silk stockings, and high shoes with colored heels, breeches (so-called rhinegraves) worn by the French nobility in the seventeenth century, and a long curly dark wig. Sakharoff's collage-based costume designs for *Pavane Royale* exaggerate the Baroque model with a huge frilly skirt and an oversized wig. In this playful reinterpretation of Baroque pomp, Sakharoff created a costume that would, by the end of the twentieth century, have been perfectly suited to a drag show (cf. p. 271).

Dance occupies a central role in the artistic strategies challenging conventional notions of gender and body image at the beginning of the twentieth century, and many dancers were shaped by their own queer life experiences. Almost simultaneously with Sakharoff, the ballet dancer Vaslav Nijinsky, born in Kiev in 1885, began to shatter conventional role models in ballet by abandoning traditional costuming.[4] He became a member of the Ballets Russes ensemble, with guest appearances in Paris, London, and Berlin, and he

FEELING BODIES, SEEING IMAGES 291

Lehrmeister.[3] In Rigauds Bild trägt der Sonnenkönig neben den Herrschaftsinsignien Schwert, Zepter und Hermelinmantel Rüschen von feinster Spitze, lange weiße Seidenstrümpfe und hohe Schuhe mit farbigen Absätzen, eine Pumphose, die sogenannte Rheingrafenhose, wie sie im 17. Jahrhundert zur typischen Mode des französischen Adels wurde, sowie eine lange gelockte, dunkle Perücke. Von Sacharoff sind im Kontext der *Pavane Royale* Kostümentwürfe in Collagetechnik erhalten, in denen er das barocke Vorbild durch einen riesigen Rüschenreifrock sowie eine überdimensionierte Perücke übersteigert. In seiner verspielten Rezeption barocken Pomps entwarf Sacharoff ein Kostüm, das sich sechs Jahrzehnte später für die Inszenierungen einer Dragqueen eignen würde (vgl. S. 271).

In Hinblick auf künstlerische Strategien, die zu Beginn des 20. Jahrhunderts gängige Vorstellungen von Geschlecht und Körperbildern infrage stellten, nimmt der Tanz eine zentrale Bedeutung ein. Zudem waren viele Biografien von Tänzer*innen durch queere Lebenserfahrungen geprägt. Der 1885 in Kiew geborene Tänzer Vaslav Nijinsky begann nahezu zeitgleich wie Sacharoff durch den Verzicht auf traditionelle Kostümierung herkömmliche Rollenbilder im Ballett zu durchbrechen.[4] Er wurde Mitglied im Ensemble der Ballets Russes, die auch in Paris, London und Berlin gastierten. Mit dem Begründer des Ensembles, Sergei Diaghilev, verband ihn um 1909 eine homosexuelle Beziehung.

Sacharoff gilt als Erfinder der männlichen Solorolle im Kammer- und Podiumstanz.[5] Ende des 18. Jahrhunderts hatten männliche Rollen im Tanz an Bedeutung verloren, wie sie noch im höfisch geprägten Rokoko selbstverständlich waren. Vor allem in seinen frühen Auftritten schuf sich Sacharoff in seinen Schreittänzen und

sogenannten bewegten Bildern eine neue Rolle.[6] 1910 gelang ihm mit einem Soloauftritt in München der Durchbruch vor großem Publikum.[7] Neben einer Begeisterungswelle erntete seine feminine Körpersprache jedoch auch Ablehnung. Der Tanzkritiker Hans Brandenburg[8] beschrieb in *Der moderne Tanz* 1913 Sacharoffs Auftritte.[9] In seinem Text ringt er zunächst mit den Zuschreibungen von männlichen und weiblichen Aspekten im Tanz Sacharoffs und kommt dann zu dem Fazit: „Und wenn wir Sacharoff schon auf sein Gebiet folgen, so verlieren die Begriffe ‚männlich' und ‚weiblich' ihre Bedeutung; sie können ja in der Kunst überhaupt sehr leicht zu zweifelhaften und irreführenden Begriffen werden, da die männlichen Naturen sehr oft ‚weibliche', die ‚weiblichen' aber ‚männliche' Kunst schaffen und das Größte nur dem übergeschlechtlichen Reinmenschlichen und Reingöttlichen dient."[10] Brandenburg spielt hier möglicherweise auch auf das antike mythologische Motiv des Hermaphroditen an,[11] ein androgynes Mischwesen zwischen Nymphe und Jüngling, mit den göttlichen Eltern Hermes und Aphrodite. Sacharoff verkörperte in seinen ersten Auftritten das „Sinnbild des symbolistischen Androgynen".[12] Die Auseinandersetzung mit antiken Vorbildern erweist sich im Kontext von queerer Kunst als ein umfangreicher visueller Fundus. Zu den bekanntesten Motiven des Altertums, die mit Homosexualität in Verbindung gebracht werden, zählt weiterhin der Ganymed-Mythos. Einer Überlieferungsform zufolge wurde der schöne Jüngling Ganymed vom Göttervater Zeus begehrt, der ihn in Gestalt eines Adlers auf den Berg Olymp entführte.[13] Die Sage taucht ebenso in Bildern mittelalterlicher Buchmalerei auf, wie in der Kunst des 16. Jahrhunderts und galt bis ins 19. Jahrhundert als ein verschlüsselter Hinweis auf gleichgeschlechtliche Liebe.[14] Auch

entered a homosexual relationship with the founder of the ensemble, Sergei Diaghilev, around 1909.

Sakharoff is considered the inventor of the male solo role in chamber and podium dance (performances on podiums instead of stages).[5] By the end of the eighteenth century, male dance roles had lost the importance they had enjoyed in the courtly Rococo period. Especially in his early performances, Sakharoff created a new role for himself in his "step dances" and so-called "moving pictures."[6] In 1910 he achieved a breakthrough with a solo performance in Munich in front of a large audience.[7] Alongside the wave of enthusiasm, however, his feminine body language also led to rejection. The dance critic Hans Brandenburg[8] described Sakharoff's performances in *Der moderne Tanz* in 1913.[9] In his text, he initially wrestles with the attributions of masculine and feminine aspects in Sakharoff's dance, before concluding, "And if we continue to follow Sakharoff into his area, the terms 'masculine' and 'feminine' lose their meaning; indeed, in art they can tend very easily to become dubious and misleading terms, since masculine natures very often create 'feminine' art, 'feminine' ones 'masculine' art, and the greatest only serves the purely human and purely divine, which is supra-gender."[10] Brandenburg may also be alluding here to the ancient mythological motif of the hermaphrodite,[11] an androgynous hybrid of nymph and young male whose divine parents were Hermes and Aphrodite. In his first appearances, Sakharoff embodied the "representation of the symbolist androgyne."[12] The engagement with ancient models reveals, in the context of queer art, an extensive fund of images. Among the best-known classical motifs associated with homosexuality is the myth of Ganymede. According to one version of the legend, the beautiful youth Ganymede was desired by Zeus, the father of the gods, who took the form of an eagle to abduct him and bring him to Mount Olympus.[13] The legend appears in the images of medieval book illumination as well as in the art of the sixteenth century and was considered a coded reference to same-sex love until the nineteenth century.[14] Sakharoff, who repeatedly adopted the motif of the young man of antiquity in his early works, was also inspired by figures from ancient mythology.[15]

The importance of dance for the visibility of queer themes in art is also evident after the First World War in the performances of dancers such as Josephine Baker and Anita Berber. In their radical stage practice, they challenged prevalent role models as well as racist stereotypes. Anita Berber (1899–1928) attained great fame in the early years of the Weimar Republic through her lifestyle of excess: alcohol and drug consumption were just as much a part of her reputation as her new interpretation of dance, which at times had her floating naked across the stage. One of Otto Dix's most famous portraits was inspired by Berber, depicting her in a tight red dress just three years before her death. Narrow folds at the shoulders, chest, and around the belly make the garment appear like a second skin. Only the dancer's face with white makeup and her white hands stand out against the red of the background and the gown. Her eyes are traced with a black line, while lipstick shapes the narrow lips into a doll-like mouth in an otherwise relentlessly gaunt, mask-like countenance.

FEELING BODIES, SEEING IMAGES 293

294 KÖRPER FÜHLEN, BILDER SEHEN

Sacharoff, der in seinen frühen Arbeiten wiederholt das Motiv des antiken Jünglings aufgriff, ließ sich von Figuren antiker Mythologie inspirieren.[15]

Die Bedeutung des Tanzes für das Sichtbarwerden queerer Themen in der Kunst zeigt sich auch nach dem Ersten Weltkrieg in den Auftritten von Tänzer*innen wie Josephine Baker und Anita Berber. In ihrer radikalen Bühnenpraxis stellten sie gängige Rollenbilder sowie rassistische Stereotype infrage. Anita Berber (1899–1928) erlangte in den ersten Jahren der Weimarer Republik durch ihren exzessiven Lebenswandel große Berühmtheit: Alkohol und Drogenkonsum gehörten ebenso dazu wie ihre neue Interpretation des Tanzes, bei der sie sich zuweilen nackt über die Bühne bewegte. Otto Dix, den sie zu einem seiner bekanntesten Porträts inspirierte, malte Berber drei Jahre vor ihrem Tod in einem knallengen roten Kleid. Schmale Falten an der Schulterpartie, der Brust und um den Bauch lassen es wie eine zweite Haut erscheinen. Nur das weiß geschminkte Gesicht und die weißen Hände der Tänzerin heben sich vom Rot des Hintergrunds und des Gewandes ab. Ihre Augenpartie ist mit schwarzer Linie nachgezogen, und der Lippenstift vergrößert die schmalen Lippen zu einem puppenhaften Mund im ansonsten schonungslos hageren, maskenhaften Antlitz.

Zwischen mehreren Ehen führte Anita Berber eine lesbische Beziehung mit Susi Wanowsky.[16] Auf der Bühne und im Film erschien sie wiederholt in Männerkleidern, wie 1921 in einer Revueshow am Berliner Nelson-Theater, in der sie mit Melone, Spazierstock, elegantem Smoking und Monokel auftrat.[17] Das Einglas, das zur Kaiserzeit noch das Markenzeichen national gesinnter Offiziere und Adliger war, erfuhr nach dem Krieg eine modische Umdeutung.[18] In diesem Kontext setzte Anita Berber mit ihrem Kleidungsstil wichtige Impulse

für die damalige Mode:[19] Attribute, die noch vor dem Ersten Weltkrieg Männern vorbehalten waren, wie Hosenanzüge, Monokel, Zigaretten und Kurzhaarschnitt, avancierten nach dem Krieg zu Kennzeichen der „Neuen Frau".[20] Das modische Vexierspiel zwischen Weiblichkeit und Männlichkeit symbolisierte ihre Unabhängigkeit. Zu den Wahlen der Nationalversammlung am 19. Januar 1919 hatten Frauen erstmals in Deutschland das Wahlrecht erlangt. Viele von ihnen waren berufstätig, was jedoch nur in seltenen Fällen zu finanzieller Unabhängigkeit führte.[21] Dennoch machte die massenhafte Verbreitung des Typus „Neue Frau" in den Printmedien der 1920er Jahre sichtbar, dass jede modebewusste Frau ein „Hauch" von Queerness umgab. Das Monokel wurde gar als Erkennungszeichen unter Lesben genutzt. Anita Berber wurde zum Symbol für die sich zu Beginn der Weimarer Republik formierende neue Sicht auf Sexualität. Mehrfach wirkte sie in Filmen Richard Oswalds mit, die als Vorläufer des Aufklärungsfilms gelten.[22] In *Anders als die Andern*, dem ersten Film über ein homosexuelles Paar überhaupt, übernahm Berber eine Nebenrolle.[23]

Ein ähnlich lustvolles Spiel mit luxuriösen Stoffen und Kleidern wie in den Kostüm- und Bühnenentwürfen Alexander Sacharoffs findet sich in der Malerei und den Modeentwürfen der in Dänemark geborenen Künstlerin Gerda Wegener (1885[24]–1940), die ab den 1910er Jahren in Paris für Satire- und Modezeitschriften sowie für Werbung zeichnete und damit ihren Lebensunterhalt verdiente. Seit 1904 war sie mit dem Maler Einar Wegener verheiratet,[25] der in Paris begann, unter dem Namen Lili Elbe als Frau zu leben, und zum wichtigsten Modell der Künstlerin wurde.[26] 1930 ließ Lili Elbe in Dresden chirurgische Eingriffe vornehmen, die in der Öffentlich-

Between her several marriages, Berber had a lesbian relationship with Susi Wanowski.[16] On stage and in film she repeatedly dressed in men's clothes, as in a 1921 revue show at Berlin's Nelson Theater in which she appeared with a bowler hat, walking stick, elegant tuxedo, and monocle.[17] The monocle, still the trademark of nationalist officers and aristocrats during the imperial era, underwent a reinterpretation after the war.[18] In this context, Berber's style of dress provided important inspiration for the fashion of the times:[19] attributes that before the First World War had been reserved exclusively for men, such as trouser suits, monocles, cigarettes, and short haircuts, became the hallmarks of the "New Woman" after the war.[20] Berber's sartorial oscillation between femininity and masculinity symbolized her independence. The elections for the National Assembly on January 19, 1919, was the first opportunity for women in Germany to exercise their right to vote. Many of them were employed, but this rarely led to financial independence.[21] Nevertheless, the mass dissemination of the "New Woman" in the print media of the 1920s showed that every fashion-conscious woman was surrounded by a "whiff" of queerness. The monocle was even used as a distinguishing mark among lesbians. Berber became a symbol for the new view of sexuality that emerged at the beginning of the Weimar Republic. She appeared several times in films by Richard Oswald, which are considered precursors of the sex education film.[22] In *Anders als die Andern* (Different from the Others), the first film ever about a homosexual couple, Berber took on a supporting role.[23]

A sensual play with luxurious fabrics and dresses similar to that of Alexander Sakharoff's costume and stage designs can be found in the paintings and fashion designs of the Danish-born artist Gerda Wegener (1885–1940),[24] who from the 1910s onwards earned her living by drawing for satirical and fashion magazines as well as for advertising clients in Paris. Since 1904 she had been married to the painter Einar Wegener,[25] who in Paris began to live as a woman under the name Lili Elbe and became the artist's most important model.[26] In 1930, Elbe underwent surgical procedures in Dresden that have been seen as the first surgical gender reassignment.[27] As early as the 1910s, Wegener portrayed Elbe in luxurious costumes or as a nude with a focus on her curved waist, elegantly made up and gazing erotically as a woman. She created a self-determined space for herself and her partner in her paintings in light, pastel-like hues, defining their view of femininity and sexuality at a time when the terms "gender" and "transgender" were not yet part of the discourse. Wegener designed haute couture fashion figures outlined in black line, typical of the fin de siècle, for Parisian fashion magazines. She transferred this style to her book illustrations, which included erotic lesbian love scenes.

The artist Hannah Höch (1889–1978), who has become renowned through her participation in the Berlin Dada Club, created collages using clippings of photographs from illustrated newspapers and magazines. She assembled new figures from cut-out body parts of men, women, children, dancers, dolls, or models and sometimes combined them with images of other materials, such as pieces of fabric or plants. In the 1920s, and in particular during her partnership with the woman writer Til Brugman from 1926 to 1935, she focused her work on female role models as well as on androgyny.[28]

FEELING BODIES, SEEING IMAGES 295

keit als erste operative Geschlechtsangleichung wahrgenommen wurden.[27] Bereits ab den 1910er Jahren porträtierte Gerda Wegener Lili Elbe in luxuriösen Kostümen oder als Akt mit Fokus auf ihre geschwungenen Taille, elegant geschminkt und erotisch blickend als Frau. Sie schuf in ihrer Malerei in hellen, pastelligen Farbtönen für sich und ihre Partnerin einen selbstbestimmten Raum, in dem sie ihre Sicht auf Weiblichkeit und Sexualität definierten, als die Begriffe Gender und Transgender noch nicht geprägt waren. Für Pariser Modezeitungen entwarf Wegener für das Fin de Siècle typische, mit schwarzer Linie umrissene Modefigurinen der Haute Couture. Diesen Stil übertrug sie auf ihre Buchillustrationen, zu denen auch erotische lesbische Liebesszenen zählten.

Die durch ihre Mitwirkung im Berliner Club Dada bekannt gewordene Künstlerin Hannah Höch (1889–1978) nutzte für ihre Collagearbeiten Bildausschnitte aus illustrierten Zeitungen und Zeitschriften. Aus ausgeschnittenen Körperteilen von Männern, Frauen, Kindern, Tänzer*innen, Puppen oder Modellen setzte sie neue Figuren zusammen und kombinierte diese bisweilen auch mit Bildausschnitten von anderen Materialien wie etwa Stoffteilen oder Pflanzen. In den 1920er Jahren und insbesondere während ihrer Partnerschaft mit der Schriftstellerin Til Brugman (1926–1935) konzentrierte sie sich in ihren Arbeiten auf weibliche Rollenbilder sowie Androgynität.[28] Höch schuf Mischwesen, die sich aufgrund gezielt eingesetzter Disproportionalität eindeutigen Rollenzuschreibungen entziehen. In ihrer Collage *Dompteuse* vereint sie schwarz-weiße und farbige Bildfragmente zu einer harmonischen Einheit. Die Ambivalenz, die dem Motiv des Androgynen immanent ist, ermöglichte es Höch, ihre Figuren aus den Zwängen eindeutiger Gender- und Rollenzuweisungen zu befreien.[29] 1928 entstand ihre Fotomontage *Russische Tänzerin (Mein Double)*. Möglicherweise spielt Hannah Höch mit dem Titel auf die Ballets Russes an. Durch den Untertitel *Mein Double* erweckt sie den Eindruck, es handle sich bei der Tänzerin um ein, wenn auch vorgetäuschtes Selbstbildnis.

Auf zwei unterschiedliche Beine in Balletthose und Spitzenschuhen montierte die Künstlerin hier – ohne Hals noch Rumpf – einen riesigen Frauenkopf. Das Gesicht der russischen Tänzerin ist beschnitten und mehrfach überklebt. Mit leichtem Silberblick schielt sie die Betrachter*innen an.

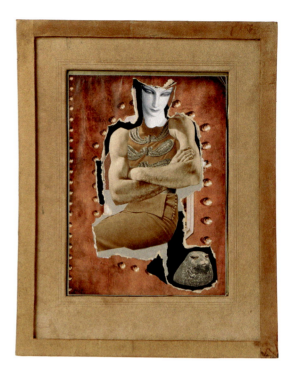

Hannah Höch, *Dompteuse*, um 1930/64, Collage und Fotomontage, Papier auf Karton | **Hannah Höch,** *Female Animal Trainer*, ca. 1930/64, collage and photomontage, paper on board

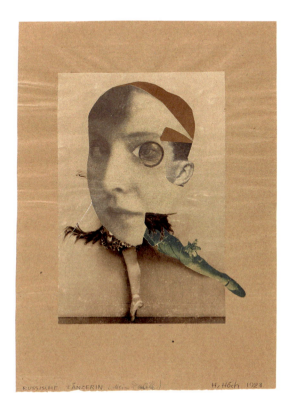

Hannah Höch, *Russische Tänzerin (Mein Double)*, 1928, Collage | Hannah Höch, *Russian Dancer (My Double)*, 1928, collage

Through the deliberate use of disproportionality, Höch created chimeras that elude unequivocal role attributions. In her collage *Dompteuse* (Female Animal Tamer), for example, she combines black-and-white and colored fragments of images into a harmonious unity. The ambivalence inherent in the motif of the androgyne enabled Höch to free her figures from the constraints of definite gender and role assignments.[29] In 1928, she created her photomontage *Russische Tänzerin (Mein Double)* (Russian Dancer (My Double)), a title that may allude to the Ballets Russes. The subtitle *My Double* gives the impression that the dancer represents a self-portrait, albeit a false one.

The artist mounted a huge woman's head – without neck or torso – on two different legs in ballet tights and pointe shoes. The Russian dancer's face is cropped and pasted over several times. She squints at the viewer slightly. A circular cutout over her left eye serves as a monocle, which can be interpreted as a reference to Höch's lesbian relationship with Brugman. In her texts, Brugman dealt with homosexuality; her grotesque text *Warenhaus der Liebe* (Department Store of Love), which appeared in the small volume *Scheingehacktes* (Mock Minced) illustrated by Höch, alludes to the collection in the Institute for Sexology founded by Magnus Hirschfeld.[30]

Artists also experimented with gender and body images in the medium of photography. The photography of Florence Henri (1893–1982) exemplifies the examination of gender roles and queer themes at the Bauhaus. The artist repeatedly used mirrors to construct complex pictorial spaces that make it difficult for viewers to determine the location of the photographed objects and the camera. Henri's self-portraits likewise leave open whether the portrayed person with short dark hair and plain clothing is a man or a woman. The game of deception on the level of pictorial space is also played in relation to the undefined gender identity of the photographed person. As a guest student at the Bauhaus in Dessau in 1927, Henri learned photographic techniques primarily from Lucia Moholy-Nagy, who, although she did not hold a teaching post at the school like her husband László, had a decisive influence

FEELING BODIES, SEEING IMAGES 297

Ein kreisrunder Ausschnitt über dem linken Auge dient als Monokel, das als ein Hinweis auf Höchs lesbische Beziehung zu Til Brugman gedeutet werden kann. Brugman setzte sich in ihren Texten mit Homosexualität auseinander. In ihrer Groteske *Warenhaus der Liebe*, die in dem kleinen von Hannah Höch illustrierten Band *Scheingehacktes* erschien, finden sich Anspielungen auf die Sammlung im von Magnus Hirschfeld gegründeten Institut für Sexualwissenschaft.[30]

Auch im Medium der Fotografie experimentierten Künstler*innen mit Gender und Körperbildern. Als Beispiele für die Auseinandersetzung mit Geschlechterrollen und queeren Themen am Bauhaus dienen die Fotografien von Florence Henri (1893–1982). Wiederholt griff die Künstlerin zu Spiegeln, mit deren Hilfe sie komplexe Bildräume konstruierte, die es Betrachter*innen erschweren, den Standort der fotografierten Objekte sowie der Kamera festzustellen. In Henris Selbstbildnissen bleibt zudem offen, ob es sich bei der Person mit kurzem dunklem Haar und in schlichter Kleidung um einen Mann oder eine Frau handelt. Das Vexierspiel auf der Ebene der Bildräume findet auch in Bezug auf die offene geschlechtliche Identität der aufgenommenen Person statt. Als Gasthörerin am Bauhaus in Dessau lernte Henri 1927 fotografische Techniken vor allem von Lucia Moholy-Nagy, die zwar selbst kein Lehramt an der Schule innehatte wie ihr Mann László, aber maßgeblich die Architektur- und Porträtfotografie am Bauhaus prägte.[31] Am Bauhaus wurden die technischen Möglichkeiten des Mediums Fotografie neu ausgelotet. Fotografie sollte die Entwicklung technischen und gesellschaftlichen Fortschritts sichtbar machen. Neben Mehrfachbelichtung, Montage und harten Hell-Dunkel-Kontrasten zählte auch die Umkehrung der Tonwerte im Negativabzug zu den

Methoden, ein Foto zu konstruieren.[32] In den fotografischen Selbstporträts von Bauhaus-Künstler*innen wurde vielfach mit spiegelnden Objekten oder mit halbtransparenten Glasscheiben experimentiert.[33]

Zu einer der radikalsten Positionen der Fotogeschichte, die sich mit Geschlechteridentität und Gender auseinandersetzen, zählen die Arbeiten von Claude Cahun (1894–1954), die 1894 in Nantes unter dem Namen Lucy Renée Schwob in eine jüdische Literatenfamilie geboren wurde. Bereits während ihrer Schulzeit war Cahun antisemitischen Anfeindungen ausgesetzt, woraufhin ihre Eltern sie für einige Zeit nach England auf eine Schule schickten. Ab 1909 verband Cahun eine Partnerschaft mit Suzanne Malherbe. Cahun verstand sich als Schriftstellerin, hatte aber bereits in den 1910er Jahren begonnen zu fotografieren. Zeitgleich entschied sie sich, einen geschlechtsneutralen Namen anzunehmen.[34] Wie Cahun verwendete auch Malherbe ein Pseudonym, den Namen Marcel Moore. Die beiden verband ein intensiver künstlerischer Austausch und gemeinsame Projekte. Seit den 1920er Jahren lebte das Paar in Paris. Es entstanden eine Vielzahl von Selbstporträts Cahuns, in denen sie sich in verschiedenen Rollen mit Geschlechtsidentität auseinandersetzte, sie zunächst aber nicht veröffentlichte.[35] In ihrer Serie mit dem Titel *Monstrositäten*[36] karikierte sie sowohl medizinische Deutungsmacht als auch eindeutige Geschlechterzuschreibung, indem sie mit ihrem eigenen Körper experimentierte, etwa ihren kahlrasierten Schädel im Profil aufnahm und ihr hageres Gesicht betonte. Auch unterschiedliche Kostüme brachte sie zum Einsatz. So schlüpfte sie in die Rolle des Dandys, eines Harlekins, der Gewichte hebt, oder inszenierte sich mit schwarzem Umhang als Figur der

Florence Henri, *Autoportrait*, 1928, vintage | Florence Henri, *Self-Portrait*, 1928, vintage

on architectural and portrait photography there.[31] New technical possibilities of photography were then being explored at the Bauhaus. Photography was supposed to make visible the development of technical and social progress. In addition to multiple exposures, montage, and stark chiaroscuro contrasts, the inversion of tonal values in the negative print was also among the methods used to construct a photographic image.[32] Bauhaus artists often experimented in their photographic self-portraits with reflective objects or semi-transparent glass panes.[33]

The work of Claude Cahun (1894–1954), who was born in Nantes in 1894 under the name Lucy Renée Schwob into a Jewish literary family, occupies one of the most radical positions dealing with gender identity and gender in the history of photography. During her school years, Cahun was subjected to antisemitism hostility, whereupon her parents sent her to a school in England for some time. From 1909 on, Cahun formed a partnership with Suzanne Malherbe and regarded herself as a writer, though she had already begun to take photographs in the 1910s. Around that time, she decided to adopt a gender-neutral name.[34] Like Cahun, Malherbe also used a pseudonym, Marcel Moore. The two were linked by intense artistic interchange and joint projects. In the 1920s, the couple lived in Paris. Cahun produced a number of self-portraits in which she explored gender identity in various roles, but initially did not publish them.[35] In her series titled *Monstrositäten*[36] (Monstrosities), she caricatured both medical interpretive authority and unequivocal gender ascription by experimenting with her own body, such as by photographing her shaved skull in profile and emphasizing her gaunt face. She also made use of different costumes. For example, she slipped into the role of a dandy, a harlequin lifting weights, or staged herself with a black cape as a figure from commedia dell'arte. She employed multiple exposures, which allow the same figure to appear in different poses on a photographic negative, as well as mirrors to create a multi-perspective view of herself. She eventually published some of the self-portraits questioning her gender attribution in 1930, in the autobiographical text *Aveux non avenus* (Disavowed Confessions).[37] Moore cut out the

FEELING BODIES, SEEING IMAGES 299

300 KÖRPER FÜHLEN, BILDER SEHEN

Commedia dell'arte. Mehrfachbelichtungen, die es ermöglichen, auf einem fotografischen Negativ dieselbe Figur in verschiedenen Positionen erscheinen zu lassen, setzte sie ebenso ein wie Spiegel, um eine mehrperspektivische Ansicht von sich selbst zu gestalten. Einige der ihre geschlechtliche Zuschreibung infrage stellenden Selbstbildnisse veröffentlichte sie schließlich 1930 im autobiografischen Text *Aveux non avenus (Nichtige Bekenntnisse).*[37] Aus dem Fundus der Porträts hatte Moore die Köpfe ausgeschnitten und sie zu neuen Bildkompositionen montiert.[38] „Neutrum ist das einzige Geschlecht, das mir immer entspricht", vermerkte Claude Cahun in dem Text.[39] 1937 zog das Paar auf die Kanalinsel Jersey. Als alte Damen verkleidet, verteilten die beiden auf der Insel zwischen 1940 und 1944 nach der Besetzung Frankreichs und Jerseys eigenhändig hergestellte antideutsche Flugblätter. Im Juli 1944 wurden sie festgenommen und im November desselben Jahres zum Tod verurteilt. Das Todesurteil wurde nicht vollstreckt. Cahun unternahm im Gefängnis einen Selbstmordversuch. Ihr persönlicher Besitz war während der Zeit ihrer Gefangenschaft nahezu vollständig vernichtet worden. Von den schweren gesundheitlichen Folgen der Inhaftierung konnte sich Claude Cahun nicht mehr erholen. Nach dem Krieg nahm sie wieder Kontakt zu befreundeten Künstler*innen auf, die den Zweiten Weltkrieg meist im Exil überlebt hatten, und widmete sich erneut der Fotografie.[40] Im Medium der Fotografie gelang es Cahun, durch das ständige Verkleiden und das kontinuierliche in eine neue Rolle wechseln, sich ein neues eigenes Ich zu konstruieren, dessen Geschlecht undefinierbar ist.[41] Mit ihren Fotos war sie zeitgenössischen Theorien von Geschlechtsidentität weit voraus.

1 Vgl. Alex Pilcher, A Queer Little History of Art, London, 2017, S. 24.

2 Vgl. Rainer Stamm, Alexander Sacharoff – Bildende Kunst und Tanz, in: Frank-Manuel Peter und Rainer Stamm (Hg.), Die Sacharoffs: zwei Tänzer aus dem Umfeld des Blauen Reiters, Köln 2002, S. 19ff.

3 Ebd., S. 11.

4 Vgl. Patrizia Veroli, Der Spiegel und die Hieroglyphe, Alexander Sacharoff und die Moderne im Tanz, in: Frank-Manuel Peter und Rainer Stamm (Hg.), Die Sacharoffs: zwei Tänzer aus dem Umfeld des Blauen Reiters, Köln 2002, S. 167.

5 Vgl. Frank-Manuel Peter, Alexander Sacharoff als Vorbild des „tanzenden Mannes": Joachim von Seewitz und Helge P. Pawlinin, in: Frank-Manuel Peter und Rainer Stamm (Hg.), Die Sacharoffs: zwei Tänzer aus dem Umfeld des Blauen Reiters, Köln 2002, S. 249.

6 Hans Brandenburg beschrieb seine Aufführung als eine „Bilderfolge". Vgl. Hans Brandenburg, Der moderne Tanz, München 1913, S. 126, zit. nach: Veroli 2002 (wie Anm. 4), S. 180.

7 Vgl. o.A., Zeittafel, in: Frank-Manuel Peter und Rainer Stamm (Hg.), Die Sacharoffs: zwei Tänzer aus dem Umfeld des Blauen Reiters, Köln 2002, S. 264.

8 Im Anmerkungsteil zu Carl Zuckmayers Geheimreport findet sich der Hinweis, dass Brandenburg sich 1914 auf den Monte Verità begeben und den Ausdruckstanz in seinen Schriften gefördert habe, aber mit seiner Publikation *Das neue Theater* (1926) auch ein Wegbereiter nationalsozialistischer Thingspiele gewesen sei. Vgl. Gunther Nickel und Johanna Schrön, Carl Zuckmayer: Geheimreport, Göttingen 2002, S. 383f.

9 Hans Brandenburg, Der moderne Tanz, München 1913, S. 121–130, zit. nach: Frank-Manuel Peter und Rainer Stamm (Hg.), Die Sacharoffs: zwei Tänzer aus dem Umfeld des Blauen Reiters, Köln 2002, S. 50–55.

10 Ebd., S. 55.

11 Eine differenzierte Darstellung zum Thema Hermaphrodit und Androgynität bietet Mechtild Fend. Sie verweist zugleich auf die Problematik der „heterosexuellen Normierung eines Systems der Zweigeschlechtlichkeit", gegen das sich vor allem die „gay and lesbian studies" und die „queer theory" wendeten. Vgl. Mechtild Fend, Grenzen der Männlichkeit, Der Androgyn in der französischen Kunst und Kunsttheorie 1750–1830, Berlin 1830, S. 6ff.

12 Veroli 2002 (wie Anm. 4), S. 174.

13 Vgl. Pilcher 2017 (wie Anm. 1), S. 8.

14 Vgl. ebd., S. 8f.

15 Veroli 2002 (wie Anm. 4), S. 173.

16 Vgl. Mel Gordon, The Seven Addictions and Five Professions of Anita Berber, Los Angeles 2006, S. 74f.

heads from the stock of portraits and assembled them into new visual compositions.[38] "Neuter is the only gender that always corresponds to me," states Cahun in *Aveux non avenus*.[39] In 1937, the couple moved to the Channel Island of Jersey. Disguised as old ladies, the two distributed handmade anti-German leaflets on the island from 1940 to 1944, during the German occupation of France and Jersey. They were arrested in July 1944 and sentenced to death in November of the same year. The death sentence was not carried out, but Cahun attempted suicide in prison, and her personal possessions were almost completely lost; due to the severe conditions of her imprisonment, her health never fully recovered. After the Second World War, she re-established contact with artist friends who had survived the war, mostly in exile, and once again devoted herself to photography.[40] In this medium, Cahun succeeded in constructing a new self with an indefinable/indefinite gender by constantly disguising herself and continuously changing roles.[41] In her photography, she advanced far beyond contemporary theories of gender identity.

Author's note: this English version of the essay is a translation from the original German.

1 See Alex Pilcher, *A Queer Little History of Art* (London: 2017), 24.

2 See Rainer Stamm, "Alexander Sacharoff – Bildende Kunst und Tanz," in *Die Sacharoffs: zwei Tänzer aus dem Umfeld des Blauen Reiters*, eds. Frank-Manuel Peter and Rainer Stamm (Cologne: 2002), 19ff.

3 Ibid., 11.

4 See Patrizia Veroli, "Der Spiegel und die Hieroglyphe, Alexander Sacharoff und die Moderne im Tanz," in Peter and Stamm, *Die Sacharoffs*, 167.

5 See Frank-Manuel Peter, "Alexander Sacharoff als Vorbild des 'tanzenden Mannes': Joachim von Seewitz und Helge P. Pawlinin," in Peter and Stamm, *Die Sacharoffs*, 249.

6 Hans Brandenburg described his performance as a "series of images." See Hans Brandenburg, *Der moderne Tanz* (Munich: 1913), 126, quoted in Veroli, "Der Spiegel und die Hieroglyphe," 180.

7 See the anonymous "Zeittafel," in Peter and Stamm, *Die Sacharoffs*, 264.

8 The notes in Carl Zuckmayer's *Geheimreport* mention that Brandenburg visited Monte Verità in 1914 and in his writings espoused expressionist dance; at the same he was also a pioneer supporter of Nazi *Thingspiele* (outdoor theater performances). See Gunther Nickel and Johanna Schrön, *Carl Zuckmayer: Geheimreport* (Göttingen: 2002), 383ff.

9 Brandenburg, *Der moderne Tanz*, 121–30, quoted in Peter and Stamm, *Die Sacharoffs*, 50–55.

10 Peter and Stamm, *Die Sacharoffs*, 55.

11 Mechtild Fend offers a differentiated presentation of the subject of hermaphrodite and androgyny. At the same time, she underlines the complex of problems of the "heterosexual standardization of a system of binary sexes," contested above all by "gay and lesbian studies" and "queer theory." See Mechtild Fend, *Grenzen der Männlichkeit, Der Androgyn in der französischen Kunst und Kunsttheorie 1750–1830* (Berlin: 2003), 6ff.

12 Veroli, "Der Spiegel und die Hieroglyphe," 174.

13 See Pilcher, *A Queer Little History of Art*, 8.

14 See ibid., 8ff.

15 Veroli "Der Spiegel und die Hieroglyphe," 173.

16 See Mel Gordon, *The Seven Addictions and Five Professions of Anita Berber* (Los Angeles: 2006), 74ff.

17 See ibid., 77; Lothar Fischer, *Tanz zwischen Rausch und Tod. Anita Berber 1918–1928 in Berlin* (Berlin: 1984), 45.

18 See Jula Dech, *Hannah Höch. Schnitt mit dem Küchenmesser DADA durch die letzte Weimarer Bierbauch-kulturepoche Deutschlands* (Frankfurt am Main: 1989), 66ff., 80, note 32.

19 See Fischer, *Tanz zwischen Rausch und Tod*, 63.

20 See Herbert Molderings, *Die Moderne der Fotografie* (Hamburg: 2008), 246.

21 See Maud Lavin, *Cut with the Kitchen Knife. The Weimar Photomontages of Hannah Höch* (New Haven: 1993), 2ff.

22 See Fischer, *Tanz zwischen Rausch und Tod*, 34.

23 See ibid., 32ff.

24 Wegener's year of birth is sometimes also given as 1886 in the literature.

FEELING BODIES, SEEING IMAGES 301

302 KÖRPER FÜHLEN, BILDER SEHEN

17 Vgl. ebd., S.77; Lothar Fischer, Tanz zwischen Rausch und Tod. Anita Berber 1918–1928 in Berlin, Berlin 1984, S.45.

18 Vgl. Jula Dech, Hannah Höch. Schnitt mit dem Küchenmesser DADA durch die letzte Weimarer Bierbauchkulturepoche Deutschlands, Frankfurt a.M. 1989, S.66f., 80, Anm. 32.

19 Vgl. Fischer 1984 (wie Anm. 17), S.63.

20 Vgl. Herbert Molderings, Die Moderne der Fotografie, Hamburg 2008, S.246.

21 Vgl. Maud Lavin, Cut with the Kitchen Knife. The Weimar Photomontages of Hannah Höch, New Haven 1993, S.2f.

22 Vgl. Fischer 1984 (wie Anm. 17), S.34.

23 Vgl. ebd., S.32ff.

24 In der Literatur wird das Geburtsjahr Wegeners zum Teil auch mit 1886 angegeben.

25 Die biografischen Angaben stammen aus: Amalie Grubb Martinussen, Biography, in: Christian Gether u.a. (Hg.), Gerda Wegener (Ausst.-Kat. Arken Museum of Modern Art, Ishøj), Ishøj 2015, S.81–85.

26 Vgl. Tobias Raun, The Trans Woman as Model and Co-Creator, Resistance and becoming in the back-turning Lili Elbe, in: Christian Gether u.a. (Hg.), Gerda Wegener (Ausst.-Kat. Arken Museum of Modern Art, Ishøj), Ishøj 2015, S.41– 54, hier S.44.

27 Ausführlich berichtet Reiner Herrn über den medizinischen Kontext der Operationen. Bereits vor Lili Elbes Operationen habe es geschlechtsangleichende Eingriffe gegeben, die aber kaum in der Öffentlichkeit wahrgenommen wurden. Vgl. Reiner Herrn, Der Liebe und dem Leid. Das Institut für Sexualwissenschaft 1919–1933, Berlin 2022, S.433–435.

28 Vgl. Lavin 1993 (wie Anm. 21), S.124.

29 Vgl. ebd., S.193f.

30 Vgl. Herrn 2022 (wie Anm. 27), S.227.

31 Vgl. Susanne Meyer-Büser, Zwei Netzwerkerinnen der Avantgarde in Paris um 1930. Auf den Spuren von Florence Henri und Sophie Taeuber-Arp, in: Die andere Seite des Mondes. Künstlerinnen der Avantgarde (Ausst.-Kat. Kunstsammlung Nordrhein-Westfalen, Düsseldorf), Köln 2011, S.28–41, hier S. 36.

32 Ebd., S.36.

33 Vgl. ebd., S.36.

34 Molderings 2008 (wie Anm. 20), S.264.

35 Vgl. Karoline Hille, Die ungleichen Schwestern. Claude Cahun, Dora Maar und der Surrealismus, in: Die andere Seite des Mondes. Künstlerinnen der Avantgarde (Ausst.-Kat. Kunstsammlung Nordrhein-Westfalen, Düsseldorf), Köln 2011, S. 214–227, hier S.216.

36 Vgl. ebd., S.216.

37 Vgl. ebd., S.217.

38 Vgl. ebd., S.217.

39 Zit. nach ebd., S.217.

40 Vgl. o.A., Biografie Claude Cahun (1894–1954), in: Die andere Seite des Mondes. Künstlerinnen der Avantgarde (Ausst.-Kat. Kunstsammlung Nordrhein-Westfalen, Düsseldorf), Köln 2011, S.262–264, hier S.264.

41 Vgl. Molderings 2008 (wie Anm. 20), S.265.

25 The biographical information is culled from Amalie Grubb Martinussen, "Biography," in *Gerda Wegener,* eds. Christian Gether et al., exh. cat. Arken Museum of Modern Art Ishøj (Ishøj: 2015), 81–85.

26 See Tobias Raun, "The Trans Woman as Model and Co-Creator, Resistance and Becoming in the Back-Turning Lili Elbe," in Gether, *Gerda Wegener*, 41–54, here 44.

27 The medical context of these operations is detailed by Reiner Herrn. Gender reassignment interventions had already been performed before Lili Elbe's operations, but were hardly perceived by the general public. See Reiner Herrn, *Der Liebe und dem Leid. Das Institut für Sexualwissenschaft 1919–1933* (Berlin: 2022), 433–35.

28 See Lavin, *Cut with the Kitchen Knife,* 124.

29 See ibid., 193ff.

30 See Herrn, *Der Liebe und dem Leid,* 227.

31 See Susanne Meyer-Büser, "Zwei Netzwerkerinnen der Avantgarde in Paris um 1930. Auf den Spuren von Florence Henri und Sophie Taeuber-Arp," in *Die andere Seite des Mondes. Künstlerinnen der Avantgarde,* exh. cat. Kunstsammlung Nordrhein-Westfalen, Düsseldorf (Cologne, 2011), 28–41, 36.

32 Ibid., 36.

33 See ibid., 36.

34 Molderings, *Die Moderne der Fotografie,* 264.

35 See Karoline Hille, "Die ungleichen Schwestern. Claude Cahun, Dora Maar und der Surrealismus," in *Die andere Seite des Mondes*, 214–27, here 216.

36 See ibid., 216.

37 See ibid., 217.

38 See ibid., 217.

39 Quoted in ibid., 217.

40 See the anonymous "Biografie Claude Cahun (1894–1954)," in *Die andere Seite des Mondes*, 262–64, here 264.

41 See Molderings, *Die Moderne der Fotografie,* 265.

BEN MILLER

DIE „KLARWELT" VERWERFEN: WIE ELISÀR VON KUPFFER DIE QUEERE GESCHICHTE VERKOMPLIZIERT

„Queer", der Begriff, der ursprünglich als Schimpf-wort verwendet wurde, hat viele Bedeutungen. Zunächst dient er – und so ist er auch den meisten bekannt – als lockerer Sammelbegriff für alles, was sonst umständlich als LGBTQIA2+ oder „Minderheiten in Bezug auf Gender und sexueller Orientierung" bezeichnet werden müsste. Das ist das „queer", das man im beliebten liberalen Nachrichtenportal Queer.de findet. Es umfasst eine Reihe von Identitätskategorien von schwul über lesbisch und bisexuell bis transgender. Die wohlbekannten Minderheiten werden hier als feste Größen verstanden und feinsäuberlich in Begriffsschubladen einsortiert.

Das andere „queer" wird meist von Aktivist*-innen und Wissenschaftler*innen verwendet und ist in seinen Bedeutungen vielfach miteinander verflochten. Dieses „queer" wurde auf den Straßen von schwulen, lesbischen und trans-gender Aktivist*innen geprägt, die sich Ende der 1980er und Anfang der 1990er Jahre in der anglophonen Welt zusammenschlossen, um die mörderische Untätigkeit von staatlicher Seite angesichts der Ausbreitung von AIDS anzupran-gern. Guy Hocquenghem und Michel Foucault beleuchteten Homosexualität auf theoretischer Ebene und begannen, sie als „schräge" Einstel-lung zum Leben und zur Welt zu deuten.[1] Ausge-hend von dieser Auffassung, die „queer" nicht als Identität, sondern als Beziehung zwischen Dingen betrachtete, propagierte eine Generation von Theoretiker*innen wie Judith Butler und Eve Sedgwick den Begriff als Lesart, mit deren Hilfe man das konventionelle, repressive Verständnis von Gender und Sexualität aufbrechen konnte.[2] Die Queer of Color Critique und andere Zweige der Genderforschung empfehlen diese Auslegung und die Fokussierung auf den Beziehungsaspekt als politische Interventionen, die über den sexuel-len Aspekt hinausgehen, und verweisen in vielen Fällen auf die queeren People of Color, die zu den wichtigsten frühen Aktivist*innen der Emanzipa-tionsbewegung gehört hatten.[3] Eine Zeitlang war dieses zweite „queer" vorwiegend positiv besetzt. Immerhin eröffnete es einen Ansatz, der es modernen Menschen ermöglichte, Rückhalt in Texten zu finden, die sie eigentlich ausschlossen.[4] Allerdings ist diese Technik wertneutral: Ob wir jemanden dafür würdigen wollen, dass er oder sie in einer Denkweise auf Umwegen Rückhalt findet oder konventionelle Konstrukte von Gender und Sexualität aufbricht, hängt davon ab, wer diese Person ist und was sie mit diesem wirkmächtigen Instrument erreichen will.

Die Ausstellung *TO BE SEEN. queer lives 1900–1950* beschäftigt sich mit der Geschichte des queeren Lebens in der ersten Hälfte des 20. Jahrhunderts in Deutschland, einer Zeit, in

BEN MILLER

REJECTING THE "KLARWELT": HOW ELISÀR VON KUPFFER COMPLICATES QUEER HISTORY

"Queer," a word reclaimed from its initial use as a slur, has many meanings. The first – and certainly the one most familiar to popular audiences – is a casual collective noun, by which one avoids saying or writing something clunky, like LGBTQIA2+ or "gender and sexuality minorities." This is the "queer" of the popular liberal news website Queer.de, a "queer" that signifies a set of identity categories – gay, lesbian, bisexual, transgender – that are stable and well-understood minorities, signifiers safe in their little boxes.

The other "queer" is a "queer" mostly used in activist and academic circles, and it has many tangled meanings. On the streets, this "queer" was forged by gay, lesbian, and transgender activists who united in the Anglophone world of the late 1980s and early 1990s to confront murderous state inaction vis-à-vis the AIDS epidemic. On the theoretical side, Guy Hocquenghem and Michel Foucault began thinking of homosexuality as a "slant-wise" approach to living in and understanding the world;[1] a generation of theorists, including Judith Butler and Eve Sedgwick, departed from this way of understanding "queer" as a relationship between things rather than an

identity, proposing it as a reading method that could help break down conventional and oppressive understandings of gender and sexuality.[2] Queer of color critique and other interventions into queer thought have proposed this way of reading and relational understanding as interventions into politics beyond the sexual, in many cases returning to the queer people of color who were among the most important early activists in liberation struggles.[3] For a while, this second "queer" was mostly positive in affect. It offered, after all, a way of reading that could help contemporary people find sustenance in texts not designed to include them.[4] But this technique is value-neutral: whether we wish to celebrate someone's finding slantwise sustenance in a way of thinking, or deconstructing conventional constructions of gender and sexuality, depends on who they are and what they wish to do with this powerful tool.

This exhibit, *TO BE SEEN. queer lives 1900–1950,* examines the history of queer lives in the first half of the twentieth century in Germany, with increasing visibility accompanied by resistance and eventual annihilation by the national socialist dictatorship. This important

FEELING BODIES, SEEING IMAGES 305

306 KÖRPER FÜHLEN, BILDER SEHEN

der zunehmende Sichtbarkeit mit Ausgrenzung und schließlich Vernichtung durch die NS-Diktatur einherging. Doch können sich die Erzählstränge auch verwirren, wie das Leben und Wirken des Künstlers und Intellektuellen Elisàr von Kupffer offenbart. Von seinen Publikationen hatte vor allem die 1906 erschienene Anthologie homoerotischer Literatur großen Einfluss auf die homosexuellen Emanzipationsbewegungen im deutschsprachigen Raum. Sein malerisches Hauptwerk bildet das 30 Meter lange Rundbild *Die Klarwelt der Seligen* mit 84 androgynen Aktfiguren, teils mit seinen eigenen Gesichtszügen, zwischen Bäumen in einem fantastischen Zyklus der Jahreszeiten. Zudem schrieb er Liebesbriefe an Adolf Hitler. Dieser Essay basiert auf meinen laufenden Forschungsarbeiten zum Verhältnis zwischen den „Ursprüngen" und der Selbsterfindung des weißen schwulen Mannes im 20. Jahrhundert. Er untersucht eingehend eine zutiefst beunruhigende, problematische, wenn auch unbestreitbar queere Homosexualität politischer Prägung.

Elisàr Franz Emanuel von Kupffer wurde 1872 in Sophiental im heutigen Estland als Spross einer deutschbaltischen Adelsfamilie geboren, nach eigenen Worten „erblickte" er „das trübe Licht der Wirrwelt".[5] Er war der Sohn des Arztes Adolf von Kupffer, empfand sich jedoch zugleich als Nachfahre und Erbe des Gottes Apoll, da sein Geburtsort fast auf demselben Meridian liegt wie die griechische Insel Delos.[6] Die heitere Kindheit, in der er sich bereits, wie er später selbst schrieb, für Kunst begeisterte und „Liebe zur Anmut" besaß, fand durch die politischen Ereignisse in seiner Heimat ein abruptes Ende. Die Familie von Kupffer gehörte zu den adligen deutschen Großgrundbesitzern, deren Vorrangstellung im Baltikum durch den Aufstieg des Panslawismus im späten

19. Jahrhundert und letztlich die Russische Revolution angefochten wurde.

Das Studium „orientalischer Sprachen", das von Kupffer 1893 in St. Petersburg aufnahm, begründete sein lebenslanges Interesse an primitivistischer Esoterik. Während dieser Zeit lernte er den Mann kennen, der sein Lebenspartner oder, wie er selbst es nannte, sein „Mitkämpfer für heldische Selbstverantwortung"[7] werden sollte: Eduard von Mayer. Nach einer kurzzeitigen Trennung, während von Mayer in der Schweiz promovierte, blieben die beiden bis zu von Kupffers Tod 1942 unzertrennlich.

Während eines gemeinsamen Aufenthalts in Pompeji begann von Kupffer, Texte für einen Band zu sammeln, der 1900 im Berliner Verlag des Maskulinisten und Anarchisten Adolf Brand unter dem Titel *Lieblingminne und Freundesliebe in der Weltliteratur* als eine der ersten Anthologien homoerotischer Literatur erschien. In der Einleitung schrieb von Kupffer: „Wir leben leider in einer so unmännlichen Zeit, dass jedes Eintreten für männliche Rechte, um von Vorrechten zu schweigen, als eine unmoderne Blasphemie und Herabsetzung der weiblichen Vorherrschaft empfunden und getadelt wird."[8] Der Begriff der „weiblichen Vorherrschaft" und von Kupffers selektive Vorstellung von der Bedeutung der altgriechischen Kultur bilden den Schlüssel zum Verständnis dieses Werks. Historiker*innen einigten sich für diese Strömung des homosexuellen Denkens auf den Begriff des Maskulinismus. Er deckt mehrere Ausprägungen ab, darunter die „Männerbündler" um den Monarchisten, Frauenfeind und Antisemiten Hans Blüher, die Claudia Bruns in *Die Politik des Eros*[9] eingehend analysiert. Diese Männergemeinschaften entwickelten sich aus dem „Wandervogel", einer antimodernistischen Jugendbewegung, in der gemeinsame Wanderungen mit

narrative becomes somewhat complicated when we examine the life and work of an artist and intellectual named Elisàr von Kupffer whose body of work included a volume of homoerotic literature published in 1906 that was profoundly influential on the homosexual emancipation movements in the German-speaking world; an oeuvre of paintings that culminates in a thirty-meter cyclorama, *The Clear World of the Blessed*, that features eighty-four nude androgynous figures, many depicted with the artist's own face, draped across trees in a fantasia of the seasons; and love letters to Adolf Hitler. This essay, adapted from my ongoing research about the relationship between the "primitive" and the self-invention of the white gay man in the twentieth century, is an in-depth examination of a profoundly disturbing and problematic, if undeniably queer, political homosexuality.

Elisàr Franz Emanuel von Kupffer was born – or, in his words, "first saw the dim light of the tangled world"[5] – in 1872 into an aristocratic, German-Baltic family, in Sophiental, in what is now Estonia. Not only was he the son of the doctor Adolf von Kupffer, but he was also the descendent of a god: his birthplace very nearly shares a meridian with the Greek island of Delos, and so von Kupffer came to understand himself as Apollo's heir.[6] His serene and artistic childhood – with a "love for grace," he would later write – was threatened by political developments in the region. The von Kupffer clan belonged to a class of German aristocrats and landlords in the Baltic states whose dominance was threatened by the rise of pan-Slavic nationalism in the late nineteenth century (and eventually by the Russian Revolution).

His study of "oriental literature" in St. Petersburg, which he began in 1893, inaugurated a lifelong interest in primitivist esotericism. It was also at this time that von Kupffer met the man who would become his life partner (or as he put it, "my fellow fighter for heroic self-responsibility"), Eduard von Mayer.[7] But for a brief period apart, when von Mayer was writing his dissertation in Switzerland, the two would be inseparable until von Kupffer's death in 1942.

It was while staying with von Mayer in Pompei that von Kupffer began to collect texts for a volume that would appear in 1900 in the masculinist-anarchist Adolf Brand's Berlin-based book series under the title *Love of the Beloved and Friendly Love in World Literature*, one of the first collections of homoerotic literature ever published. "Alas," his introductory text begins, "we live in a time that is so unmanly, that any advocacy of male rights, never mind prerogatives, is understood and censured as backwards-looking blasphemy and the denigration of female supremacy."[8] The term "female supremacy" and von Kupffer's selective understanding of the meaning of Ancient Greek culture is particularly important to understanding this work. Historians have settled on the term "masculinism" to describe this strain of homosexual thought, and it had several different flavors: there was the Männerbund described by Claudia Bruns in her masterful history *Die Politik des Eros,* theorized by the monarchist, misogynist, and antisemite Hans Blüher.[9] That evolved from the Wandervogel movement of antimodern German youth groups whose merry homosocial hikes were linked to reform pedagogy and who envisioned pederastic and homosocial male bonding as

FEELING BODIES, SEEING IMAGES 307

Reformpädagogik verknüpft und homosoziale bis päderastische Bindungen zwischen Männern und Knaben als Grundlage für eine reine, kraftvolle „deutsche Rasse" und Nation postuliert wurden. Eine andere Form des Maskulinismus verkörperte das vom homoerotischen Dichterkult des George-Kreises beeinflusste Umfeld von Adolf Brand und seiner anarchistisch-maskulinistischen Zeitschrift *Der Eigene*.[10] Was die verschiedenen Spielarten einte, waren Misogynie und die Ablehnung der Sexualforschung. In dem Bemühen, aus dem komplexen Wirrwarr all der Verführten und Verführer der queeren Geschichte ein paar Helden zu retten, versuchten manche, diesen Kontrast als diametralen Gegensatz hinzustellen, doch traf dies vor allem zu Beginn der Emanzipationsbewegung nur bedingt zu. Die Maskulinisten propagierten hingegen mannhaftes Heldentum und Männerfreundschaften als Fundament einer neuen Gesellschaft. Durch die Veröffentlichung von *Lieblingminne* wurde von Kupffer zu einem der ersten Theoretiker dieser Form des Maskulinismus.

Claudia Bruns zufolge beschwor von Kupffer durch den Rückgriff auf die „Freundesliebe" eine vermeintliche historische Kontinuität dieser Form der Liebe zwischen Männern herauf und schlug damit einen Bogen nationalistisch-maskulinistischer Identifikation von antiken griechischen Helden bis zu Friedrich dem Großen. Seine Ideologie des männlichen Heldentums gründete, so Bruns, auf einer rassifizierten, antisozialistischen Weltsicht.[11] Tatsächlich veröffentlichte von Kupffer 1907 eine Denkschrift mit dem Titel *Klima und Dichtung: Ein Beitrag zur Psychophysik*. Er stützte sich dabei auf Publikationen von Mayers, der mit seiner Behauptung „Kultur ist die Lebensarbeit einer Rasse, die Seele aller Kultur ist die Rasse, des Menschen Werk stammt aus des Menschen Blut"[12] eine deterministische Beziehung zwischen Rasse, Kultur und Sexualität hergestellt hatte. Bruns und andere betonten die Unterschiede zwischen von Kupffer und dem Maskulinismus und Magnus Hirschfelds Modellen sexueller Inversion, doch äußerte sich von Kupffer in *Klima und Dichtung* ausdrücklich lobend über Hirschfelds Arbeiten, allen voran *Vom Wesen der Liebe. Zugleich ein Beitrag zur Lösung der Frage der Bisexualität* von 1906: Hirschfeld habe darin viel Material angeboten, „das der objektiven Erkenntnis [der Liebe] in bester Weise dient".[13] Eine solche Würdigung spricht gegen die These, die homosexuelle Emanzipation Hirschfelds und diejenige der Maskulinisten seien diametral entgegengesetzte Konzepte. Dass sich dieser Satz ausgerechnet in einem explizit rassistischen pseudowissenschaftlichen Werk findet, das Grundzüge des kulturellen Schaffens mit biologisch determinierten Rassentypen korreliert, macht die von einigen Forscher*innen festgestellten Verflechtungen zwischen Hirschfeld, Rassenkunde, Eugenik und der deutschen Kolonialpolitik erst recht plausibel.[14]

Die in vielen orientalistischen und homosexuellen Texten des späten 19. und frühen 20. Jahrhunderts propagierte Vorstellung von einer geografischen Zone sexueller Inversion, in der speziell päderastische Sexualbeziehungen zur kulturellen Norm gehörten (die Richard Burton als „sotadische Zone" bezeichnete), verknüpfte von Kupffer in *Klima und Dichtung* explizit mit einer starren pseudowissenschaftlichen Hierarchie menschlicher Zivilisationen. Laurie Marhoefer zufolge sprachen sich homosexuelle Aktivisten wie Hirschfeld und Kurt Hiller für eine „Entrassifizierung des homosexuellen Subjekts" aus, die jedoch trotz ihres persönlichen Widerstands gegen den deutschen Imperialismus dadurch gehemmt

the foundation of a pure and strong "German race" and nation. Then there was the circle that developed around Adolf Brand and the anarchist-masculinist magazine *Der Eigene*, a circle influenced by the homoerotic poetry cult that surrounded Stefan George.[10] What unified these various formations was misogyny and an opposition to sexology. In an effort to rescue heroes from the complex soup of compromised and compromising figures that populate queer history, some have tried to present this opposition as diametric – but that was not always the case, especially in the beginning of the emancipation struggles. Instead, masculinists proposed manly heroism and friendship as the foundation of a new society. With the release of *Love of the Beloved*, von Kupffer became one of that masculinist movement's first theorists.

As Bruns has argued, von Kupffer's recuperation of "friendly love" – and the creation of a myth of the historical continuity of that love between men – created an axis of nationalist-masculinist identification from ancient Greek heroes through to Frederick the Great; and moreover, it was an ideology of manly heroism that was organized according to a racialized and anti-socialist worldview.[11] Indeed, von Kupffer would publish a 1907 pamphlet entitled *Climate and Poetics: A Contribution to Psychophysics* that – building off of previous publications by von Mayer, who argued that "culture is the life work of a race, the soul of all culture is race, man's work comes from man's blood"[12] – proposed a deterministic relationship between race, culture, and sexuality. Interestingly, while Bruns and others have foregrounded the distinctions between von Kupffer and masculinism and Magnus

Hirschfeld's gender-inversion models, *Climate and Poetics* praises Hirschfeld's work, specifically *Vom Wesen der Liebe* (On the Essence of Love), a 1906 treatise on bisexuality, as having "contributed in the best way to the objective knowledge of love."[13] This kind of praise should at least complicate the idea that the homosexual emancipation of Hirschfeld and that of the masculinists were diametrically opposed projects. Indeed, the fact that such praise was part of an explicitly racist work of pseudoscience that associated essential qualities of cultural production to biologically determined racial types reinforces histories by some scholars that foreground entanglements between Hirschfeld, race science, eugenics, and the German colonial project.[14]

Climate and Poetics explicitly links ideas about the "sotadic zone" – the idea, so named by Richard Burton but shared in many late-nineteenth and early-twentieth century orientalist and homosexual texts, of a geographic zone of sexual inversion in which specifically pederastic sexual relationships were part of the cultural norm – to a rigid and pseudoscientific hierarchy of human civilizations. Laurie Marhoefer has argued that homosexual rights activists like Hirschfeld and Kurt Hiller articulated a "deracialization of the homosexual subject," which, despite their personal opposition to German imperialism, was "hobbled" by their decision to "think sexuality without thinking race."[15] In *Climate and Poetics,* von Kupffer constructed a specifically racialized homosexual subject, a white and heroic one, who was paradoxically conceived as taking influence and inspiration from the savagery and sensuality of "sotadic" peoples. Remembering that scholars of postco-

FEELING BODIES, SEEING IMAGES 309

wurde, dass sie „bei der Betrachtung von Sexualität den Rassenbegriff ausblendeten".[15] Von Kupffer hingegen konstruierte in *Klima und Dichtung* ein eindeutig rassifiziertes homosexuelles Subjekt, das weiß und heroisch, nach seiner Meinung jedoch paradoxerweise von der Wildheit und Sinnlichkeit „sotadischer" Völker beeinflusst und inspiriert sei. Da Forschende, die sich mit postkolonialer Theorie auseinandersetzen (wie Ania Loomba), schon seit langem anprangern, dass „tief verwurzelte [...] Verknüpfungen zwischen fernen Landen und abweichenden Sexualitäten" die Vorherrschaft der Weißen untermauern, ist von Kupffers ausdrücklich von eben dieser Vorherrschaft der „weißen Rasse" geprägter Primitivismus weniger paradox, als es zunächst scheint.[16]

Nach dem Erscheinen von *Klima und Dichtung* stürzten von Kupffer und von Mayer angesichts des drohenden Ersten Weltkriegs in eine Lebenskrise und zogen sich nach und nach aus dem Dunstkreis der organisierten homosexuellen Emanzipation zurück. 1911 stellte von Kupffer seine Bilder erstmals in Zürich aus und erklärte, er habe seine Philosophie zur neuen Religion des „Klarismus" verdichtet. Das darin heraufbeschworene Ideal der „Klarwelt" verkörpere eine alles verändernde Utopie, die nach seiner Vorstellung zunächst auf individueller und später auf gesellschaftlicher Ebene verwirklicht werden sollte. Die komplexe, widersprüchliche, chaotische Realität empfand er als „Wirrwelt". Der Klarismus war eine idiosynkratische Form des Christentums, jedoch durchsetzt mit einer orientalischen homoerotischen Ikonografie sowie Elementen des europäischen Mittelalters und der klassischen Antike. Von Kupffer war zwar vom Monismus beeinflusst (der Betonung der ontologisch-philosophischen

Ganzheit und Einheit aller Dinge, die nach Darstellung von Todd Weir Einfluss auf frühe sozialistische, feministische und faschistische Bewegungen ausübte). Er wies dieses Konzept jedoch als allzu pessimistisch und deterministisch zurück, weil es die Wahrheit in der schon vorhandenen Natur verorte.[17] Stattdessen vertrat er einen transzendenten Optimismus als Seinszustand, den er im ephebengleichen „Araphroditen" perfekt verkörpert fand. In der Kunstgeschichte lassen sich zwei potenzielle Vorlagen für diese Figur ausmachen. Wie Damien Delille belegte, verwies von Kupffer selbst als Quelle auf die Renaissancegemälde von Il Sodoma.[18] In *Klima und Dichtung* schrieb er diese Vision zudem einem Moment exquisiter ästhetischer Klarheit in der Villa Albani zu, dem einstigen Wohnsitz des Kunsthistorikers Johann Joachim Winckelmann, der zu den Wegbereitern des Klassizismus gehörte und die queere Ästhetik beflügelte.[19]

Den künstlerischen Höhepunkt des Klarismus bildete das knapp 30 Meter lange Rundgemälde *Die Klarwelt der Seligen*, das ein utopisches Panorama mit 84 „Araphroditen" zeigt. Einige von ihnen tragen die Gesichtszüge von Kupffers und von Mayers, andere diejenigen eines Jungen aus der Nachbarschaft, der dem Künstler oft Modell saß. Das Bild entstand in den frühen 1920er Jahren. Als der Versuch, Politiker des rechten Spektrums in Eisenach zum Bau eines Tempels für die Klaristengemeinschaft auf der Wartburg zu bewegen, an kritischen Artikeln in der Lokalpresse scheiterte,[20] installierten von Kupffer und von Mayer das Werk 1927 in ihrem Haus im schweizerischen Locarno. 1939 verfügten sie schließlich über die Mittel für einen angemessenen Ausstellungssaal: Besucher gelangten von düsteren, mit türkischen Teppichen und Zimmerpflanzen orientalisch dekorierten Räumen aus durch einen

lonial theory (like Ania Loomba) have long pointed out the ways that "entrenched ... connections between foreign lands and deviant sexualities" serve white supremacy makes von Kupffer's explicitly white-supremacist primitivism less of a paradox than it first appears.[16]

After the book's release – and against the backdrop of the impending First World War – von Kupffer and von Mayer experienced a life crisis and began a retreat from the world of organized homosexual emancipation. In 1911, von Kupffer exhibited his paintings in Zurich for the first time and announced that he had condensed his philosophy into a new religion called Clarism. This system of thought proposed an ideal-state "clear world" (*Klarwelt*), a transformative utopia that von Kupffer thought could be attained first at the individual and then at the social level. The actually existing world, full of complexity and contradiction and chaos, is called the "tangled world" (*Wirrwelt*). An idiosyncratic sort of Christianity, Clarism combined homoerotic iconography from orientalism, the European Middle Ages, and the Classical era. Influenced by monism – the insistence on the ontological-philosophical wholeness and oneness of all things, and a way of thinking that, as Todd Weir has argued, was influential in early socialist, feminist, and fascist movements – von Kupffer nevertheless rejected that theory as overly pessimistic and deterministic in its embrace of already-existing nature as truth.[17] Instead, von Kupffer proposed a transcendent optimism, a state of being that he found most perfectly invoked through an ephebe-like figure called the "araphrodite." There are two possible origin stories in art history for this figure. As Damien Delille has

shown, von Kupffer often credited his realizations about the figure to the paintings of the Renaissance artist Il Sodoma.[18] Additionally, in *Climate and Poetics*, von Kupffer credited this vision to a moment of exquisite aesthetic clarity in the Villa Albani, the former residence of the German art historian J. J. Winckelmann, a pioneer of both classicism and queer aesthetics.[19]

The climactic artistic output of Clarism was a nearly thirty-meter cyclorama painting called *The Clear World of the Blessed*, which depicts a utopia of eighty-four araphrodites – some bearing the artist's face, some bearing the face of von Mayer, and some the face of a favored local boy who served as one of his models. It was painted in the early 1920s and exhibited from 1927 in the artist's home in Locarno, Switzerland, after an attempt to convince right-wing politicians in Eisenach to build a Claristic temple for them on the Wartburg was crushed by a series of unfriendly articles in local newspapers.[20] In 1939, the funds were finally raised to construct a proper environment in which the paintings could be viewed: from the dark, Orientalist spaces of the home, filled with Turkish rugs and potted plants, visitors walked through an even darker tunnel before emerging in a skylit space purpose-built for the cyclorama, with a small viewing pavilion located in the center.

The painting – which, like writings by Adolf Brand and other masculinist theorists in the mid-1920s, paradoxically seeks to unite militarism and utopic peace, promising a harmonic future through a cult of the male youth – was installed in its intended location in the same year that the Second World War broke out. Having separated himself from the homosexual

FEELING BODIES, SEEING IMAGES 311

312 KÖRPER FÜHLEN, BILDER SEHEN

noch dunkleren tunnelartigen Korridor in eine eigens für das Bild geschaffene Rotunde mit Oberlicht und kleinem Aussichtspavillon in der Mitte.

Ähnlich wie Mitte der 1920er Jahre Adolf Brand und andere maskulinistische Theoretiker in ihren Schriften, versuchte auch von Kupffer paradoxerweise in seinem Gemälde Militarismus und Friedensutopie in Einklang zu bringen und durch den Kult männlicher Jugend den Weg in eine harmonische Zukunft zu weisen. In dem Jahr, als das Bild an seinem Bestimmungsort anlangte, brach der Zweite Weltkrieg aus. Nach seiner Abkehr von der homosexuellen Emanzipations-bewegung wies von Kupffer das Etikett „homo-sexuell" für sich selbst und den Klarismus zurück. Von Mayer soll von Kupffers Briefwechsel mit Hirschfeld nach dem Tod seines Partners sogar verbrannt haben. Stattdessen begeisterte sich von Kupffer nun für Adolf Hitler und beschwor ihn 1940 und 1942 in leidenschaftlichen Briefen, in einer Art päderastischer Fleischwerdung des „Dritten Reiches" einen Hohenzollernprinzen zu adoptieren. Hitlers Heilsversprechen hatte in von Kupffers Augen viel mit seiner eigenen Botschaft der Klarheit gemein. Er hielt ihn für „dazu berufen dem Neuen Deutschland ein Fundament zu schaffen".[21]

Der Versuch, die Verbrechen des National-sozialismus der Homosexualität seiner Anhänger zuzurechnen (oder der politischen Linken anzulas-ten), gehört seit langem zu den gängigsten Lügen rechtsextremistischer Gruppierungen. Selbst der angesehene Publizist William Shirer ließ sich auf diesen phobischen Unfug ein, als er Hitler und die komplette NS-Führungsriege fälschlich als homosexuell psychologisierte.[22] Allerdings zeigt die kritische Forschung durchaus Analogien zwischen dem faschistischen und dem homo-

sexuellen Männlichkeitsbild auf, von den bereits angesprochenen Studien zu protofaschistischen Maskulinisten über Eleanor Hancocks kluge Biografien des SA-Führers Ernst Röhm[23] bis hin zu Studien darüber, wie faschistisch-paramilitärische Gruppierungen in den letzten Jahren der Weimarer Republik homoerotische und homosoziale Erfahrungen erlebten und verstanden.[24] Ausge-hend von Theorien zum faschistischen Männ-lichkeitsbild, wie man sie etwa beim brillanten Historiker George Mosse findet, unterstellen solche Schriften Überschneidungen zwischen homosexueller Hypermaskulinität und den homosozialen Codes der faschistischen Hyper-maskulinität.

Ohne je das Bild gesehen zu haben, das von Kupffer nach seinen eigenen Worten bis an sein Lebensende für den ultimativen Ausdruck seiner Utopie hielt, könnte man bei der Lektüre seiner Schriften versucht sein, Parallelen zwischen ihm selbst und seinen Thesen zu ziehen. Ein Blick auf das Gemälde macht jedoch deutlich, dass die Dinge so einfach nicht sind. Als Vorbild für den faschistischen Staatskörper dienten hege-monische Männerkörper (nach Darstellung J. A. Mangans bildet sich in bestimmten Gesell-schafts- und Staatsformen ein typischer Fundus an Körpermetaphern heraus; der Faschismus etwa habe Muskeln als „dominantes politisches Paradigma" seines Staatswesens hervorge-hoben[25]). Von Kupffers gemalte Jünglinge ähneln jedoch in keiner Weise den hypermaskulinen, muskulösen, gestählten Körpern, wie wir sie von Arno Brekers Plastiken kennen. Mit zum Teil verborgenen Genitalien und ausladenden Becken wirken sie vielmehr weich und androgyn. Eines der Selbstporträts von Kupffers im Rundbild hat sogar hüftlanges Haar und zart knospende Brüste.

emancipation movement and having rejected the category of homosexual as it applied to himself and to Clarism – von Mayer even reportedly burned letters between von Kupffer and Hirschfeld after von Kupffer's death – von Kupffer became an enthusiastic supporter of Hitler. He wrote Hitler passionate letters in 1940 and 1942, urging the dictator to adopt a Hohenzollern prince in a kind of pederastic enfleshment of the new German Reich. Furthermore, he compared Hitler's message with his own message of clarity, deeming him "called upon to create a foundation for the New Germany."[21]

Attempting to assign the crimes of National Socialism to homosexuality (as well as to the political left) has long been a favored lie of far-right extremists. Even the respected journalist William Shirer dipped into this phobic nonsense by falsely psychologizing Hitler and the entire leading Nazi command as homosexual.[22] Nonetheless, critical scholarship has proposed resonances between fascist and homosexual masculinities – from studies of protofascistic masculinists discussed earlier in this essay, to Eleanor Hancock's intellectual biographies of the Nazi paramilitary leader Ernst Röhm,[23] to studies of how homoerotic and homosocial experiences were lived and understood by members of fascist paramilitaries in the final years of the Weimar Republic.[24] Drawing on theories of fascist masculinity often associated with the work of the brilliant historian George Mosse, these accounts propose that homosexual hypermasculinities overlap with the homosocial codes of fascist hypermasculinity.

Von Kupffer's writing might lead a reader – someone who had never seen the painting he died claiming was the ultimate expression of his utopia – to understand him as fitting into this pattern. But a look at the painting makes everything more complicated. If hegemonic masculine bodies are understood to be models for the fascist body politic and state – J. A. Mangan describes an evolving tradition of metaphors of the body standing in for versions of society and the state, with fascism ultimately emphasizing muscle as the "dominant political paradigm" of its body politic[25] – then von Kupffer's painted bodies are not the hypermasculine muscular hardened bodies of the statuary of Arno Breker, but instead soft and androgynous, often with hidden genitalia and wide hips. One of von Kupffer's self-representations in the cyclorama has hip-length hair and soft, budding breasts.

Klaus Theweleit helps me understand what is at stake in von Kupffer's art. In his classic study *Male Fantasies*, he proposed a fear of the overflowing, abundant, and unregulated working-class female body as crucial to the development of fascism's sexual and psychological politics. Even men, in fascist rituals, he wrote, were now "split into a (female) interior and a (male) exterior … what we see being portrayed in [fascist] rituals are the armor's separation from and superiority over the interior: the interior was allowed to flow, but only within the masculine boundaries of the mass formations."[26] If Breker's bodies show us clearly defined fascist exterior armor, then von Kupffer's exhibit a different kind of reconciliation: a simultaneously homoerotic and antifeminist imagery, with women excluded from utopia and their features reconciled into new androgynous beings who are still, at the

FEELING BODIES, SEEING IMAGES 313

Mit Klaus Theweleits Hilfe wurde mir die Tragweite des künstlerischen Werks von Kupffers klarer. In seiner klassischen Studie *Männerphantasien* bezeichnete Theweleit die Angst vor dem überbordenden, üppigen, zügellosen Frauenkörper der Arbeiterklasse als entscheidenden Faktor für die Herausbildung der faschistischen Sexualpolitik und Psychologie. Männer, so schrieb er, sind im faschistischen Ritual selbst „gespalten in ein (weibliches) Inneres [...] und ein (männliches) Äußeres, seinen Körperpanzer". Und: „Die Geschiedenheit des Panzers vom Innern und seine Überlegenheit über dieses sehen wir im Ritual inszeniert: Es darf fließen, aber in den männlichen Grenzen der Massenformation."[26] Weisen Brekers Körper einen klar definierten faschistischen „Körperpanzer" auf, so zeigen von Kupffers Figuren eine andere Form der Verschmelzung von innen und außen: eine simultane homoerotische und antifeministische Bildsprache, in der Frauen von der Utopie ausgeschlossen sind. Ihre Merkmale werden auf neue androgyne Wesen übertragen, die aber letztlich immer noch als männlich erkennbar sind. Allerdings beruht dieses Modell auf der Annahme, dass der männliche Körper die Grundlage der Gesellschaft bilden sollte und seine Spaltungen, Teilungen und Ströme strikt reglementiert werden müssen. Von Kupffers faschistische androgyne Figuren verkörpern das, was für ihn einen Ausweg aus Genderproblematik und sexuellem Zwang darstellte: eine queere faschistische Männlichkeit im doppelten Wortsinne.

Kommen wir zum Begriff „queer" und zum Konzept einer „queeren Ausstellung" zurück, die wir am Beginn dieses Essays angesprochen hatten. Wir sollten meiner Meinung nach hinterfragen, warum wir unser queeres Selbst und unser queeres Leben eigentlich in autoethnografischen Ausstellungen dokumentieren und darlegen möchten, wenn diese Art der Präsentation doch nach den provokanten Worten Ashkan Sepahvands an Dioramen in Museen für untergegangene Kulturen erinnert.[27] Der vor aller Augen queere Elisàr von Kupffer, der mit der Zurschaustellung seiner speziellen queeren Vision zur Bildung der Allgemeinheit beitragen wollte und dessen Sehweisen von dem rassistischen Irrglauben inspiriert waren, Kultur sei durch Rasse bestimmt, schrieb begeisterte Liebesbriefe an Adolf Hitler, der zur selben Zeit aus derselben Überzeugung heraus, Kultur sei durch Rasse bestimmt, elf Millionen Jüdinnen*Juden, Sinti und Roma, Homosexuelle, Menschen mit Behinderungen, Kommunist*innen und viele weitere Menschen ermorden ließ. War das europäische Judentum erst einmal „ausgerottet", sollte das Prager Ghetto nach Hitlers Willen zum Museum des „ausgestorbenen" jüdischen Volkes werden.

Die faschistische Maskulinität jedenfalls wurde keineswegs besser durch die eindeutig queere Umdeutung von Kupffers, der sie verfremdete und ihre Einstellungen speziell zu Sexualität und Gender neu konzipierte. Wenn wir erreichen wollen, dass die Einbeziehung queerer Leben in die Geschichtsschreibung uns nach den Worten Jennifer Evans' heute „hilft, sich kritischer damit auseinanderzusetzen, dass sich Konventionen, Ideale, Normen und vor allem Praktiken in unserer Geschichtsschreibung oft als unhinterfragte Wahrheiten durchsetzen und nachhallen", dann müssen wir die klaren, simplen Wahrheiten, die wir so gern über queere Leben verbreiten, aufmischen und durcheinanderwirbeln. Vor allem sollten wir wichtige Geschichten über Sichtbarkeit und Widerstand, und seien sie noch so abgedroschen, wieder und wieder erzählen.[28] Auch unseren Wunsch, queere Leben sichtbar zu machen,

end of the day, considered men. This model is no less predicated on the assumption that the male body should be the basis for society or that its splits, divisions, and flows must be strictly governed. Von Kupffer's fascist androgynes articulated what was, for him, a way out of gender trouble and sexual compulsion: a queer fascist masculinity, in both senses of the word.

To end at the beginning, with the term "queer" and the idea of a "queer exhibition," I think we need to question our desire to understand and present our queer selves and lives in self-ethnographic exhibitions, modes of display that, as Ashkan Sepahavand has provocatively proposed, recall dioramas in museums of extinct cultures.[27] The highly visible queer Elisàr von Kupffer, who aimed to exhibit his particular queer vision for the edification of the public and whose visions were inspired by the racist fiction that race determines culture, wrote Hitler letters of love and praise. Simultaneously, the dictator, similarly confident that race determines culture, was engaged in the mass-murder of 11 million Jews, Sinti/Roma, homosexuals, disabled people, Communists, and various other Others. After exterminating the Jews of Europe, he planned to turn the Prague Ghetto into a museum of the extinct Jewish people.

To queer fascist masculinity, as von Kupffer undoubtedly did – to render it strange, to reconsider its assumptions especially as concerning sexuality and gender – did not, in any way, improve it. If, as Jennifer Evans has written, we want the queering of history in our day to "aid us in thinking more critically about how conventions, ideals, norms and, above all,

practices gain traction and resonance in our history writing, often as unquestioned truths," then we must tangle and disturb the clear and easy truths we like to tell about queer lives, especially as we tell and retell important, if well-trodden, stories of visibility and resistance.[28] And we must trouble our desire to put queer lives on display and embrace the tangled world, the complexity, confusion, and permanent self-reflection, that von Kupffer and his political allies past and present sought, and seek, to annihilate.

1 Michel Foucault, "Friendship as a Way of Life," in *Ethics: Subjectivity and Truth*, ed. Paul Rabinow (New York: The New Press, 1998), 138.

2 See Donald Hall and Annamarie Jagose, eds., *The Routledge Queer Studies Reader* (London: Routledge, 2012).

3 Roderick Ferguson, *One-Dimensional Queer* (Medford, MA: Polity, 2018).

4 Eve Kosofsky Sedgwick, "Paranoid Reading and Reparative Reading, or, You're So Paranoid, You Probably Think This Essay Is About You," in *Touching Feeling: Affect, Pedagogy, Performativity* (Durham: Duke University Press, 2003), 123–51.

5 Elisarion [Elisàr von Kupffer], "Erblickte ich das trübe Licht der Wirrwelt," *Aus einem wahrhaften Leben* (Minusio-Locarno, 1943), 4.

6 Ibid.

7 Elisarion [Elisàr von Kupffer], "Mein Mitkämpfer für heldische Selbstverantwortung," *Heldische Sicht und Froher Glauben* (Minusio-Locarno, 1943).

8 "Wir leben leider in einer so unmännlichen Zeit, dass jedes Eintreten für männliche Rechte, um von Vorrechten zu schweigen, als eine unmoderne Blasphemie und Herabsetzung der weiblichen Vorherrschaft empfunden und getadelt wird." Elisàr von Kupffer, ed., *Lieblingsminne und Freundesliebe in der Weltliteratur* (Berlin, 1900), 5.

9 Claudia Bruns, *Politik des Eros: Der Männerbund in Wissenschaft, Politik und Jugendkultur* (Cologne, 2008).

10 Marita Keilson-Lauritz, "Tanten, Kerle und Skandale. Flügelkämpfe der Emanzipation" in *Politiken in Bewegung. Die Emanzipation Homosexueller im 20. Jahrhundert*, eds. Andreas Pretzel und Volker Weiss (Hamburg, 2017), 65–78.

müssen wir hinterfragen und uns der „Wirrwelt", der Komplexität, Konfusion und endlosen Selbstreflexion stellen, die von Kupffer und seine politischen Gesinnungsgenossen damals wie heute „ausmerzen" wollten und wollen.

Anmerkung des Autors: Diese deutsche Version des Aufsatzes ist eine Übersetzung des englischen Originals.

1 Michel Foucault, Friendship as a Way of Life, in: Ethics. Subjectivity and Truth, hg. von Paul Rabinow, New York 1998, S. 138 [dt. Ausgabe: Von der Freundschaft als Lebensweise, in: Von der Freundschaft. Michel Faucault im Gespräch, übers. von Marianne Karbe und Walter Seitter, Berlin 1984, S. 85–94, hier S. 90].

2 Vgl. Donald Hall und Annamarie Jagose (Hg.), The Routledge Queer Studies Reader, London 2012.

3 Roderick Ferguson, One-Dimensional Queer, Medford 2018.

4 Eve Kosofsky Sedgwick, Paranoid Reading and Reparative Reading, or, You're So Paranoid, You Probably Think This Essay Is About You, in: Touching Feeling: Affect, Pedagogy, Performativity, Durham 2003, S. 123–151.

5 Elisarion [Elisàr von Kupffer], Aus einem wahrhaften Leben, Minusio-Locarno 1943, S. 4.

6 Ebd.

7 Elisarion [Elisàr von Kupffer], Heldische Sicht und froher Glauben, Minusio-Locarno 1943, S. 22.

8 Elisarion [Elisàr von Kupffer] (Hg.), Lieblingminne und Freundesliebe in der Weltliteratur, Berlin 1900, S. 5.

9 Claudia Bruns, Politik des Eros. Der Männerbund in Wissenschaft, Politik und Jugendkultur, Köln 2008.

10 Marita Keilson-Lauritz, Tanten, Kerle und Skandale. Flügelkämpfe der Emanzipation, in: Andreas Pretzel und Volker Weiß (Hg.), Politiken in Bewegung. Die Emanzipation Homosexueller im 20. Jahrhundert, Hamburg 2017, S. 65–78.

11 Claudia Bruns, Ihr Männer, seid Männer, in: Andreas Pretzel und Volker Weiß (Hg.), Politiken in Bewegung. Die Emanzipation Homosexueller im 20. Jahrhundert, Hamburg 2017, S. 37–41.

12 Eduard von Mayer, Lebensgesetze der Kultur: Ein Beitrag zur dynamischen Weltanschauung, Halle 1904, S. 19.

13 „Dr. Magnus Hirschfeld hat in seinem letzten Buche 'Vom Wesen der Liebe' viel lehrreiches und diesmal auch vielseitigeres subjektives Material beschaffen, das der objektiven Erkenntnis in bester Weise dient." Elisàr von Kupffer, Klima und Dichtung. Ein Beitrag zur Psychophysik, München 1907, S. 9.

14 Vgl. Heike Bauer, The Hirschfeld Archives. Violence, Death, and Modern Queer Culture, Philadelphia 2017; Laurie Marhoefer, Racism and the Making of Gay Rights: A Sexologist, His Student, and the Empire of Queer Love, Toronto 2022; Dies., Was the Homosexual Made White? Race, Empire, and Analogy in Gay and Trans Thought in Twentieth-Century Germany, in: Gender and History, 1. Jg., 2019/31, S. 91–114; Jana Funke, Navigating the Past: Sexuality, Race, and the uses of the Primitive in Magnus Hirschfeld's The World Journey of a Sexologist, in: Kate Fischer and Rebecca Langlands (Hg.), Sex, Knowledge, and Receptions of the Past, Oxford 2015.

15 Marhoefer 2019 (wie Anm. 14), S. 93.

16 Ania Loomba, Colonialism/Postcolonialism, London 2011, S. 167.

17 Vgl. Todd H. Weir, The Riddles of Monism. An Introductory Essay, in: Monism, New York 2012, S. 1–44.

18 Damien Delille, Queer Mysticism: Elisàr von Kupffer and the Androgynous Reform of Art, in: Marja Lahelma (Hg.), Between Light and Darkness – New Perspectives in Symbolism Research, Studies in the Long Nineteenth Century, Bd. 1, Helsinki 2014, S. 49.

19 Vgl. Whitney Davis, Queer Beauty. Sexuality and Aesthetics from Winckelmann to Freud and Beyond, New York 2010.

20 Die entsprechenden Unterlagen einschließlich des Briefwechsels befinden sich im Stadtarchiv Eisenach: 5122/30 Elisarion 11/321/5.

21 Zur Idee, Hitler solle einen Hohenzollern-Erben „adoptieren", siehe den Brief Elisarions [Elisàr von Kupffers] an Adolf Hitler vom 21.5.1940, Bundesarchiv Berlin-Lichterfelde 43/4014; zum Zitat am Schluss dieses Satzes siehe den Brief Elisarions an Adolf Hitler vom 1.2.1942, Bundesarchiv Berlin-Lichterfelde 43/4014.

22 Eine seiner bemerkenswertesten homophoben Tiraden findet sich in: William L. Shirer, The Rise and Fall of the Third Reich. A History of Nazi Germany, New York 2011, S. 106 [dt. Ausgabe: Aufstieg und Fall des Dritten Reiches, aus dem Amerikanischen von Wilhelm und Modeste Pferdekamp, Herrsching 1983].

23 Eleanor Hancock, Ernst Röhm. Hitler's SA Chief of Staff, London 2008; dies., „Only the Real, the True, the Masculine Held Its Value". Ernst Röhm, Masculinity, and Male Homosexuality, in: Journal of the History of Sexuality, 8. Jg., 1998/4, S. 616–641.

24 Laurie Marhoefer, Queer Fascism and the End of Gay History, in: Notches, 19.6.2018, URL: https://notchesblog.com/2018/06/19/queer-fascism-and-the-end-of-gay-history [gelesen am 18.7.2022]; Andrew Wackerfuss, Stormtrooper Families. Homosexuality and Community in the Early Nazi Movement, New York 2015.

25 J.A. Mangan, Shaping the Superman. Fascist Body as Political Icon – Aryan Fascism, Abingdon-on-Thames 1999, iBooks.

26 Klaus Theweleit, Männerphantasien, Berlin 2019 [Reprint der Originalausgabe Frankfurt a.M. 1977], S. 533.

27 Ashkan Sepahvand, Showing Without Revealing, in: Odarodle – an imaginary their_story of nature peoples, 1535–2017, Berlin 2018, S. 9–23, URL: https://qalqalah.org/en/essays/showing-without-revealing [gelesen am 18.7.2022].

28 Jennifer V. Evans, Why Queer German History?, German History, 34, 2016/3, S. 316.

11 Claudia Bruns, "Ihr Männer, seid Männer," in *Politiken in Bewegung*, eds. Andreas Pretzel and Volker Weiss, Edition Waldschlösschen 15 (Berlin: Männerschwarm, 2017), 37–41.

12 Eduard von Mayer, "Kultur ist die Lebensarbeit einer Rasse, die Seele aller Kultur ist die Rasse, des Menschen Werk stammt aus des Menschen Blut," *Lebensgesetze der Kultur: Ein Beitrag zur dynamischen Weltanschauung* (Halle, 1904), 19.

13 "Dr Magnus Hirschfeld hat in seinem letzten Buche *Vom Wesen der Liebe* viel lehhreiches und diesmal auch vielseitigeres subjektives Material beschaffen, das der objectiven Erkenntnis in bester Weise dient." Elisàr von Kupffer, *Klima und Dichtung. Ein Beitrag zur Psychophysik* (Munich, 1907), 9.

14 See Heike Bauer, *The Hirschfeld Archives: Violence, Death, and Modern Queer Culture* (Philadelphia: Temple University Press, 2017); Laurie Marhoefer, *Racism and the Making of Gay Rights: A Sexologist, His Student, and the Empire of Queer Love* (Toronto: University of Toronto Press, 2022); Laurie Marhoefer, "Was the Homosexual Made White? Race, Empire, and Analogy in Gay and Trans Thought in Twentieth-Century Germany," *Gender and History* 31, no. 1 (2019): 91–114; Jana Funke, "Navigating the Past: Sexuality, Race, and the uses of the Primitive in Magnus Hirschfeld's *The World Journey of a Sexologist*," in *Sex, Knowledge, and Receptions of the Past*, eds. Kate Fischer and Rebecca Langlands (Oxford: Oxford University Press, 2015).

15 Marhoefer, "Was the Homosexual Made White?," 93.

16 Ania Loomba, *Colonialism/Postcolonialism* (London: Taylor & Francis, 2011), 167.

17 See Todd H. Weir, "The Riddles of Monism: An Introductory Essay," in *Monism* (New York: Palgrave, 2012), 1–44.

18 Damien Delille, "Queer Mysticism: Elisàr von Kupffer and the Androgynous Reform of Art," in *Between Light and Darkness – New Perspectives in Symbolism Research,* ed. Marja Lahelma, Studies in the Long Nineteenth Century 1 (Helsinki: The Birch and the Star, 2014), 49.

19 See Whitney Davis, *Queer Beauty: Sexuality and Aesthetics from Winckelmann to Freud and Beyond* (New York: Columbia University Press, 2010).

20 The related files, including correspondence, are preserved in the Stadtarchiv Eisenach: 5122/30 Elisarion 11/321/5.

21 For the idea that Hitler should "adopt" a Hohenzollern heir, see letter from Elisarion [Elisàr von Kupffer] to Adolf Hitler, May 21, 1940, Bundesarchiv Berlin-Lichterfelde 43/4014; for the final quote in the sentence, see letter from Elisarion [Elisàr von Kupffer] to Adolf Hitler, February 1, 1942, Bundesarchiv Berlin-Lichterfelde 43/4014.

22 For one of his most astonishingly homophobic tirades, see William L. Shirer, *The Rise and Fall of the Third Reich: A History of Nazi Germany* (New York, 2011), 106.

23 Eleanor Hancock, *Ernst Röhm: Hitler's SA Chief of Staff* (London: Palgrave Macmillan, 2008); Eleanor Hancock, "'Only the Real, the True, the Masculine Held Its Value': Ernst Röhm, Masculinity, and Male Homosexuality," *Journal of the History of Sexuality* 8, no. 4 (1998): 616–41.

24 Laurie Marhoefer, "Queer Fascism and the End of Gay History," *NOTCHES* (blog; June 19, 2018), https://notchesblog.com/2018/06/19/queer-fascism-and-the-end-of-gay-history/; Andrew Wackerfuss, *Stormtrooper Families: Homosexuality and Community in the Early Nazi Movement* (New York: Columbia University Press, 2015).

25 J. A. Mangan, *Shaping the Superman: Fascist Body as Political Icon – Aryan Fascism* (Abingdon-on-Thames: Routledge, 1999), iBooks.

26 Klaus Theweleit, *Male Fantasies* (Minneapolis: Polity, 1987), 434.

27 Ashkan Sepahvand, "Showing Without Revealing," in *Odarodle: an imaginary their_story of nature peoples, 1535–2017* (Berlin, 2018), 9–23, https://qalqalah.org/en/essays/showing-without-revealing (accessed July 18, 2022).

28 Jennifer V. Evans, "Why Queer German History?," *German History* 34, no. 3 (2016): 316.

LEBEN IN DER DIKTATUR

LIFE UNDER DICTATOR=SHIP

Nach der nationalsozialistischen Machtübernahme 1933 ist jede Form queeren Lebens bedroht und nur noch in privaten Räumen oder an geheimen Orten möglich. Die Hoffnung auf eine stillschweigende Tolerierung von Homosexualität durch die Nationalsozialisten wird spätestens nach der Ermordung des homosexuellen SA-Stabschefs Ernst Röhm zerschlagen. Die Zeit der offenen Verfolgung beginnt.

Bei den ersten großen NS-Razzien gegen Homosexuelle am 20. Oktober 1934 werden allein in München 145 Männer verhaftet. Paragraf 175 des Strafgesetzbuchs wird im Juni 1935 verschärft: Jede sexuell konnotierte Handlung unter Männern ist nun strafbar.

Etwa 57.000 homosexuelle Männer werden zu Haftstrafen verurteilt, circa 6.000 bis 10.000 von ihnen in Konzentrationslager verschleppt und mindestens die Hälfte davon ermordet.

Weibliche Homosexualität wird im Deutschen Reich nicht strafrechtlich verfolgt, jedoch gesellschaftlich geächtet. Werden lesbische Frauen und Personen, die sich nicht geschlechtskonform verhalten, denunziert, drohen ihnen polizeiliche Ermittlungen, Hausdurchsuchungen und Verhöre. Kommen politische Gegnerschaft, soziale Abweichungen oder rassistische Verfolgung hinzu, müssen sie mit Repressionen oder einer Internierung im Konzentrationslager rechnen.

After the Nazis took power in 1933, every form of queer life was threatend and continued to exist only in private spaces or secret locations. Hopes for a tacit tolerance of homosexuality by the Nazis were finally dashed after the murder of Ernst Röhm, chief of staff of the SA (Storm Troopers). The period of open persecution had begun.

During the first major Nazi raids against homosexuals on October 20, 1934, 145 men were arrested in Munich alone. Paragraph 175 of the penal code was made more severe in June 1935: any act between men bearing sexual suggestion was now punishable.

About 57,000 homosexual men were sentenced to prison, and between 6,000 and 10,000 of them were deported to concentration camps, of whom at least half were murdered.

Female homosexuality was not prosecuted in the dictatorship, but was socially ostracized. If lesbian women and people who did not conform to their gender were denounced, they were threatened with police investigations, house searches, and interrogations. If political opposition, social deviance, or racial persecution additionally occurred, they faced repression or even internment in a concentration camp.

„AUFGRUND MEINER ZUNEIGUNG FÜR EIN ANDERES MENSCHLICHES WESEN VERLOREN WIR NIEMALS UNSERE WÜRDE UND BLIEBEN MENSCHEN."

Margot Heumann, 2020
Holocaustüberlebende

"BECAUSE OF MY CARING FOR ANOTHER HUMAN BEING, WE SOMEHOW NEVER LOST OUR DIGNITY AND REMAINED PEOPLE."

Margot Heumann, 1992
Holocaust Survivor

HOMOSEXUALITÄT IN NS-VERBÄNDEN UND BEIM MILITÄR

Die Ächtung von Homosexualität wird von verschiedenen Seiten im politischen Kampf eingesetzt. 1931/32 instrumentalisieren die Sozialdemokraten Ernst Röhms Homosexualität, um der NSDAP zu schaden. Der Fall Röhm bedient die Vorstellung der sich in Männerbünden sammelnden „schwulen Nazis", ein Phänomen, das durchaus existiert. Ab Mitte der 1930er Jahre geht das NS-Regime verstärkt gegen homosexuelle Aktivitäten in Wehrmacht, Polizei und NS-Verbänden vor. Innerhalb der Parteiorganisationen und der Polizei wird Intimität zwischen Männern jetzt besonders streng bestraft. Die nationalsozialistische Propaganda bezeichnet homosexuelle Männer als „Staatsgefährder", um ihre Verfolgung zu legitimieren. Dennoch gibt es weiterhin versteckte homosexuelle Kontakte.

HOMOSEXUALITY IN NAZI ORGANIZATIONS AND IN THE MILITARY

The proscription of homosexuality was used by various sides in the political struggle. In 1931/32, the Social Democrats utilized Ernst Röhm's homosexuality to harm the Nazi Party. The Röhm case served the notion of "gay Nazis" gathering together in male associations, a phenomenon that did exist. Beginning in the mid-1930s, the Nazi regime increasingly cracked down on homosexual activity in the army, police, and Nazi associations. Intimacy between men was now punished particularly severely in party organizations and the police. Nazi propaganda labeled homosexual men as "enemies of the state" to legitimize this persecution. Nevertheless, clandestine homosexual encounters continued to occur.

Ernst Röhm (1887–1934), SA-Stabschef und Vertrauter Adolf Hitlers, wird trotz seiner Homosexualität toleriert, denn Hitler braucht ihn als Stütze seiner Macht als „Führer". Nachdem er sich etabliert hat, entscheidet sich Hitler im Ringen um die Vormachtstellung gegen die SA und für die Reichswehr. Auf seinen Befehl hin werden Röhm und der SA-Führungsstab am 30. Juni 1934 verhaftet und kurz darauf ermordet.

Ernst Röhm (1887–1934), chief of staff of the SA (Storm Troopers) and confidant of Adolf Hitler, was tolerated despite his homosexuality because Hitler initially needed him to consolidate power. Once firmly established, Hitler, in the fight for preeminence, decided to turn against the SA in favor of the army. It was on Hitler's orders that Röhm and other members of the SA leadership were arrested on June 30, 1934, and murdered shortly thereafter.

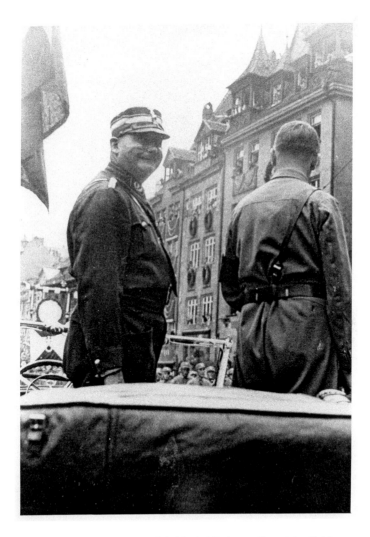

Ernst Röhm und Adolf Hitler im Cabriolet in Nürnberg während des Reichsparteitags, Ende August/Anfang September 1933 | **Ernst Röhm and Adolf Hitler in a convertible in Nuremberg during the Reich Party Congress, late August / early September 1933**

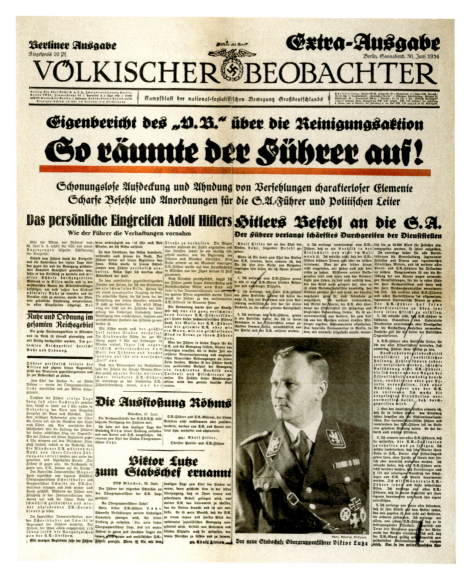

„So räumte der Führer auf!", Titelseite der Extra-Ausgabe des *Völkischen Beobachters*, 30.6.1934, Berliner Ausgabe | "This is how the Führer cleaned up!", front page of the extra issue of the *Völkischer Beobachter*, June 30, 1934, Berlin edition

In einer Extra-Ausgabe des *Völkischen Beobachters* wird die Homosexualität Ernst Röhms als angeblicher Grund für dessen „Ausstoßung" benannt, obwohl es vor allem ein innerparteilicher Machtkampf ist. Die Verschärfung des Paragrafen 175 erfolgt exakt ein Jahr nach der Ermordung Röhms, am 30. Juni 1935.

In an extra issue of the *Völkischer Beobachter*, Ernst Röhm's homosexuality was named as the alleged reason for his "expulsion," although it was primarily an internal party power struggle. The increased severity of Paragraph 175 occurred exactly one year after Röhm's assassination, on June 30, 1935.

Das Ehepaar Franz und Clara Müller (Namen durch Pseudonyme ersetzt) in ihrem Garten, 1931 | The married couple Franz and Clara Müller (names replaced by pseudonyms) in their garden, 1931

Franz Müller (1896–1969) ist Verwaltungsinspektor und Mitglied der NSDAP sowie bis 1934/35 der SA. Er macht bereits als junger Mann homosexuelle Erfahrungen. 1937 wird der verheiratete Familienvater wegen Verstoßes gegen Paragraf 175 zu zehn Monaten Haft verurteilt, die er im Gefängnis Stadelheim verbüßt.

Franz Müller (1896–1969) was an administrative inspector and member of the Nazi Party as well as the SA until 1934/35. He had already had homosexual experiences as a young man. In 1937, the married family man was sentenced to ten months in prison for violating Paragraph 175, which he served in Stadelheim prison.

LIFE UNDER DICTATORSHIP

326 LEBEN IN DER DIKTATUR

Handschriftliche Notizen der Ehefrau Clara Müller über ein Gespräch mit einem Arzt und ihre Fragen bezüglich der Homosexualität ihres Mannes, 1937/38 | Handwritten notes by his wife Clara Müller about a conversation with a doctor and her questions regarding her husband's homosexuality, 1937/38

„1. Sind alle wegen § 175 Verurteilten unheilbar krank und fast alle Ehen geschieden? (500 Fälle allein in Stadelheim) Das weiß er nicht.

2. Besteht irgendwelche Gefahr für die Kinder bei Fortsetzung der Ehe? Charakterliche Einwirkung.

3. Dr. He[y]er hat ihn als bisexuell veranlagt erkannt?!

4. Ist eine Heilung möglich durch besondere Kur oder Behandlung nach dem Gefängnis?

5. Wie kann ich günstig einwirken? Jetzt oder später?

6. Welcher Beruf ist am günstigsten? Gärtner? Verwaltungsberufe? etc. ganz gewöhnlich.

7. Er würde eine Ehe nur weiter führen nach Steril. d. Mannes. Heilung! Da macht der Arzt ein ganz [schmerzliches] Gesicht und sagt [das sei ein furchtbarer Dämon]"

"1. Are all those convicted of Paragraph 175 incurably ill and almost all marriages divorced? (500 cases in Stadelheim alone.) He does not know.

2. Is there any danger to the children if the marriage continues? Character influence.

3. Dr. He[y]er diagnosed him as bisexually predisposed?!

4. Is a cure possible by special therapy or treatment after prison?

5. How can I have a favorable influence? Now or later?

6. Which profession is most favorable? Gardener? Administrative occupation? etc. quite common.

7. He would continue a marriage only after sterilization of the husband. Cure! Then the doctor makes a very [pained] face and says [that is a terrible demon]"

Clara Müller (1899–1997) versucht nach der für sie überraschenden Verhaftung ihres Mannes zu begreifen, was dessen Homosexualität oder Bisexualität bedeutet. Sie sorgt sich um ihn und die gemeinsamen Kinder, konsultiert Ärzte und Juristen. Ihre Eltern drängen sie zur Scheidung, aber sie hält zu ihrem Mann, wie zahlreiche Briefe belegen.

After her husband's arrest, Clara Müller (1899–1997) tried to understand the meaning of his homosexuality or bisexuality, which came as a surprise to her. She worried about him and their children, and she consulted doctors and lawyers. Her parents urged her to divorce him, but she stood by her husband, as evidenced by numerous letters.

Anneliese Kohlmann (rechts) und weitere KZ-Aufseherinnen nach Befreiung des KZ Bergen-Belsen, 2.5.1945 | **Anneliese Kohlmann** (right) and other concentration camp guards after the liberation of the Bergen-Belsen concentration camp, May 2, 1945

Die Geschichte von Anneliese Kohlmann (1921–1977) zeigt, wie NS-Täter*innen Machtverhältnisse sexuell ausnutzen. Die Schaffnerin wird 1944 Aufseherin im KZ Neuengamme. Dort verliebt sie sich in eine inhaftierte tschechische Jüdin und hat mit ihr sexuellen Kontakt. Als diese in das KZ Bergen-Belsen verlegt wird, folgt ihr Kohlmann und versteckt sich bei ihr bis zur Befreiung des Lagers. 1946 wird sie für ihre Tätigkeit als KZ-Aufseherin zu zwei Jahren Haft verurteilt.

The story of Anneliese Kohlmann (1921–1977) shows how Nazi perpetrators sexually exploited power relations. In 1944, Kohlmann, a train conductor, became a guard in the Neuengamme concentration camp. There she fell in love with an imprisoned Czech Jew and had sexual contact with her. When this prisoner was transferred to the Bergen-Belsen concentration camp, Kohlmann followed her and hid with her until the camp was liberated. In 1946, she was sentenced to two years in prison for her work as a concentration camp guard.

LIFE UNDER DICTATORSHIP

ANGEPASST ÜBERLEBEN

Nach der reichsweiten Zerschlagung der schwulen und lesbischen Subkulturen und der Verschärfung des Strafrechts finden homosexuelle Kontakte fast nur noch in Privaträumen statt.

Aus Angst vor Denunziation und Verfolgung versuchen die meisten Homosexuellen, ihre Sexualität zu verbergen und sich anzupassen. Dies gilt auch für lesbische Frauen und trans* Personen, die an sich nicht strafrechtlich verfolgt werden. Sie können unbehelligt bleiben, solange sie nicht auffallen. Scheinehen sind eine von vielen Überlebensstrategien.

Einzelne prominente Künstler*innen werden trotz ihrer allgemein bekannten Homosexualität vom NS-Regime geduldet. Das Regime braucht diese Stars für seine Propaganda, verzichtet auf Verfolgung und verlangt dafür ein angepasstes Leben.

ADAPTING TO SURVIVE

After the dismantling of gay and lesbian subcultures across the entire state and the harshening of criminal law, homosexual contact took place almost exclusively in private spaces.

Fear of denunciation and persecution drove most homosexuals to hide their sexuality and conform. This also applied to lesbian women and trans+ people, who were not prosecuted per se. They could remain unharassed as long as they did not attract attention. Marriages of convenience were one of many survival strategies.

Certain prominent artists were tolerated by the Nazi regime despite their widely known homosexuality. The regime, which needed these stars for its propaganda, held off on persecution, and demanded that they conform in their way of living.

„Natürlich begann die Maskierung auch im privaten Leben. Ich lebte schon seit Jahren mit meiner Freundin zusammen. Manchmal munkelten die Leute: 'Haben die was zusammen?' […] Unsere Zimmervermieterin wurde ausgefragt, ob sie etwas über unser 'Intimleben' wüsste. Eines Tages kam unser Chefredakteur zu mir ins Atelier und sagte ungeduldig, ich müsse endlich heiraten oder er könne mich nicht weiter beschäftigen. […] Also beschlossen wir zwei Frauen, unsere zwei Freunde zu heiraten."

Eine Berliner Modezeichnerin über den gesellschaftlichen Druck nach 1933, zitiert nach: Claudia Schoppmann, *Zeit der Maskierung. Lebensgeschichten lesbischer Frauen im „Dritten Reich",* 1993

"Of course, the concealment began in private life as well. I had been living with my girlfriend for years. Sometimes it was rumored: 'Are they having a fling?' … The landlady who rented us a room was questioned if she knew anything about our 'intimate life.' One day, our editor-in-chief came to me in the studio and said impatiently that I finally had to get married or he could no longer employ me…. So we two women decided to marry our two male friends."

A Berlin fashion illustrator on social pressures after 1933, quoted in Claudia Schoppmann, *Time of Masking: Life Stories of Lesbian Women in the "Third Reich,"* 1993

Der Jurist und Autor Erich Ebermayer (1900–1970) kann trotz seiner Homosexualität weitgehend unbehelligt leben und arbeiten. In einem Ermittlungsverfahren streitet er 1936 die ihm vorgeworfenen homosexuellen Handlungen ab. Damit ist der Fall erledigt. Sein Vater ist der Oberreichsanwalt Ludwig Ebermayer, seine Cousins sind die führenden Nationalsozialisten Philipp Bouhler und Fritz Todt. Er selbst schreibt für prominente Filmemacher wie Emil Jannings oder Heinz Rühmann Drehbücher.

The lawyer and author Erich Ebermayer (1900–1970) was able to live and work largely without harassment despite his homosexuality. In a preliminary investigation in 1936, he denied the homosexual acts he was accused of. This settled the case. His father was the Senior Reich Prosecutor Ludwig Ebermayer, his cousins were the leading Nazis Philipp Bouhler and Fritz Todt. He himself wrote screenplays for prominent filmmakers such as Emil Jannings and Heinz Rühmann.

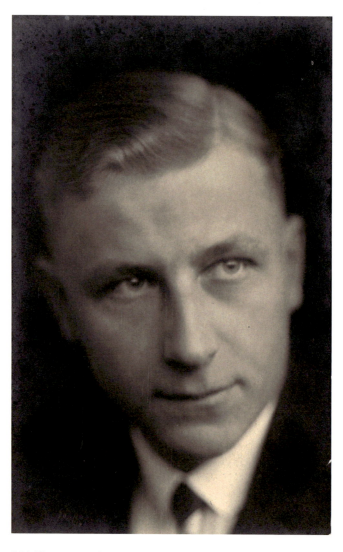

Erich Ebermayer, 1927

Der Chef der Sicherheitspolizei und des SD

III C 4 - b/⌐a.Mei.

Bitte in der Antwort vorstehendes Geschäftszeichen u. Datum anzugeben

AZ. Brf. 814.

Berlin SW 68, den ————— 19
Wilhelmstraße 102——Prinz Albrechtstr. 9

11 16. Nov. 1942

014

An den

Personalbeauftragten des Reichsfilmintendanten

B e r l i n W 8
Wilhelmstr. 80 a.

Betr.: Schriftsteller Dr. Erich E b e r m a y e r.
Vorg.: Dort. Anfrage vom 1.10.42
Anlg.: 1 Schrifttumsgutachten.

Auf die dort. Anfrage wird mitgeteilt, dass der oben Genannte,
der ursprünglich Rechtsanwalt war, durch sein Schrifttum wie-
derholt Anlass zu Beanstandungen gegeben hat. Eine Liste der
auf Liste 1 des schädlichen und unerwünschten Schrifttums stehen-
den Schrifttum wird anliegend mit einer Beurteilung des übrigen
Veröffentlichungen
Schrifttums übersandt. Aus dieser Beurteilung ist zu ersehen,
dass es sich bei E. um eine der dekadenten Erscheinungen der
Systemzeit auf dem Gebiete des Schrifttums handelt. Die auf der
beiliegenden Liste unter Nr. 1-6 genannten Schriften wurden we-
gen ihres pornographischen und homosexuellen Inhaltes verboten.
Namentlich in seinen Jugendschriften ist Ebermayer für die gleich-
geschlechtliche Liebe eingetreten. Er hat auch in der marxisti-
schen Zeitschrift "Junge Menschen Jg. 7, H.3 einen Artikel "Ju-
gend und Eros" mit anklagenden Worten gegen die überlebte Straf-
bestimmung des § 175 erscheinen lassen. Es heisst darin: "Ich
möchte hier nicht Recht und Unrecht dieses § untersuchen. Das
ist oft genug von berufener Seite geschehen. Broschüren und Pro-
teste erscheinen mir heute, wo alle Gründe und Gegengründe end-
los wiederholt sind, aussichtslos. Ich möchte nur ein Wort an
die Jugend richten, die es in der Hand hat, nicht heute und mor-
gen, gewiss aber übermorgen, die hier in Frage stehenden Un-
billigkeiten beseitigen zu helfen. Es ist dies eine Aufgabe und
eine Forderung an die Jugend, die alle angeht, gleichgültig nach
welcher Richtung sie in erotischer Beziehung neigen. Dass der
Kampf um den § 175 StGB heute nicht mehr nur ein "Befreiungskampf

Anschreiben der Sicherheitspolizei und des Sicherheitsdienstes zu einem Gutachten über Erich Ebermayer, 16.11.1942 | Cover letter from the Security Police and the Security Service concerning an expert opinion on Erich Ebermayer, November 16, 1942

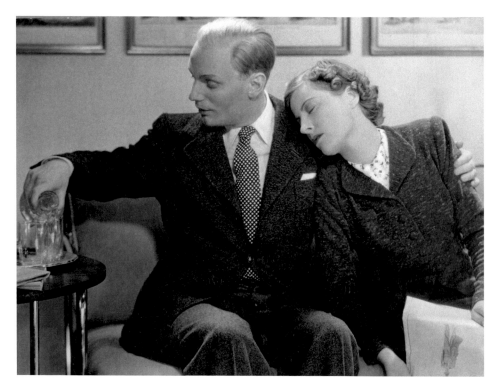

Gustaf Gründgens mit seiner Frau Marianne Hoppe bei den Dreharbeiten zum Film *Capriolen*, 1937 | Gustaf Gründgens with his wife Marianne Hoppe during the shooting of the film *Capriolen*, 1937

Gustaf Gründgens (1899–1963) dient sich für seine Karriere als Schauspieler und Regisseur dem NS-Regime an. Trotz seiner Homosexualität ernennt Hermann Göring ihn zum Generalintendanten des Preußischen Staatstheaters. Gründgens ist zweimal verheiratet: mit Erika Mann von 1926 bis 1929, mit Marianne Hoppe von 1936 bis 1946. 1952 adoptiert er seinen Lebensgefährten Peter Gorski – der einzige Weg für eine juristisch geschützte Bindung.

Gründgens' Anbiederung an das NS-Regime kritisiert Klaus Mann, sein früherer Schwager aus der Verbindung mit Erika Mann, in seinem Roman *Mephisto* scharf. Die Hauptfigur ähnelt Gründgens so stark, dass dieser nach 1945 das Verbot einer Neuauflage durchsetzen kann.

Gustaf Gründgens (1899–1963) served the Nazi regime in order to further his career as an actor and director. Despite Gründgens's homosexuality, Göring appointed him general director of the Prussian State Theater. Gründgens was married twice: to Erika Mann from 1926 to 1929 and to Marianne Hoppe from 1936 to 1946. In 1952 he adopted his partner Peter Gorski as his son – the only way to have a legally protected relationship.

Gründgens's pandering to the Nazi regime was sharply criticized by Klaus Mann, his former brother-in-law during the marriage to Erika Mann, in his novel *Mephisto*. The main character resembles Gründgens so closely that the latter was able to enforce a ban on a new edition after 1945.

Geburtstagsglückwünsche von Gustaf Gründgens an Hermann Göring, 1938 | Birthday greetings from Gustaf Gründgens to Hermann Göring, 1938

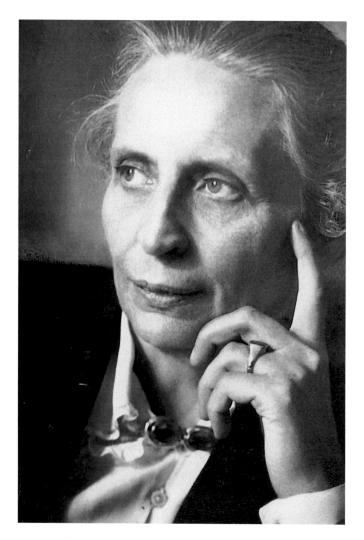

Friederike Wieking, Berlin um 1943 | **Friederike Wieking, Berlin, ca. 1943**

Friederike Wieking (1891–1958) lebt trotz ihrer herausgehobenen Position als preußische Kriminalpolizeirätin während der NS-Zeit in einer versteckten lesbischen Beziehung. Sie hat die Aufsicht über die Jugend-KZ Moringen und Uckermark. Wieking nutzt ihr Amt, um ihrer Lebensgefährtin Hildburg Zeitschel eine Anstellung zu verschaffen, die sie als ihre „Sekretärin" tarnt. Nach der Internierungshaft von 1945 bis 1950 kehrt sie zu ihrer Partnerin zurück.

Friederike Wieking (1891–1958) lived in a secret lesbian relationship during the Nazi era, despite her prominent position as a Prussian criminal police officer. She was in charge of the Moringen and Uckermark youth concentration camps. Wieking used her position to provide employment for her partner Hildburg Zeitschel, disguising her as her "secretary." After being interned from 1945 to 1950, she reunited with her partner.

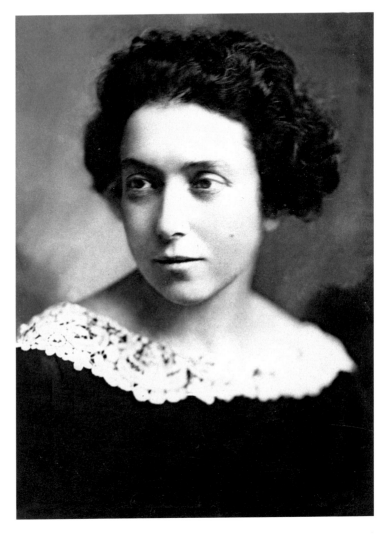

Martha Mosse, um 1927 | **Martha Mosse, ca. 1927**

Die Polizeirätin Martha Mosse (1884–1977) verliert als Jüdin 1933 ihre Anstellung im preußischen Staatsdienst. Sie lebt mit Erna Stock, geborene Sprenger, zusammen, einer Bibliothekarin, die sie während des Studiums kennengelernt hat. 1943 wird Mosse ins Ghetto Theresienstadt deportiert. Nach ihrer Befreiung 1945 kehrt sie zu ihrer nichtjüdischen Lebensgefährtin Erna Stock zurück. Mosses Biografie zeigt, dass Lesben vor allem dann verfolgt werden, wenn weitere NS-Verfolgungskriterien erfüllt sind.

As a Jew, police councilor Martha Mosse (1884–1977) lost her position in the Prussian civil service in 1933. She lived with Erna Stock, née Sprenger, a librarian whom she met during her studies. In 1943, Mosse was deported to the Theresienstadt ghetto. After her liberation in 1945, she returned to her non-Jewish partner Erna Stock. Mosse's biography shows that lesbians were persecuted primarily when other Nazi persecution criteria were met.

LIFE UNDER DICTATORSHIP

VERFOLGUNG UND HAFT

Der Umgang des NS-Regimes mit Homosexuellen und trans* Personen ist nicht einheitlich. Anfangs kommen die meisten der nach Paragraf 175 verurteilten Männer nach verbüßter Gefängnisstrafe wieder frei. Vor allem ab 1940 werden viele in KZ überstellt. Lesbischen Frauen und trans* Personen werden mitunter andere Straftaten zur Last gelegt: etwa Prostitution oder Erregung öffentlichen Ärgernisses. Nicht wenige werden aus politischen, sozialen oder rassistischen Gründen verfolgt.

In Gestapo-Haft und im KZ sind homosexuelle Männer Willkür und Gewalt ausgesetzt, nur wenige überleben. Auch einige lesbische Frauen und trans* Personen werden in KZ ermordet. Es gibt kaum Solidarität unter den Mithäftlingen, vor allem die Männer mit dem „Rosa Winkel" werden geächtet. Mit diesem Symbol werden tausende homosexuelle Männer im KZ gekennzeichnet. Hunderte Männer werden zur Kastration gezwungen. Zugleich kommt es zu sexueller Ausbeutung durch Wachen und Funktionshäftlinge. Die Überlebenden sprechen nach 1945 selten über ihre Verfolgung.

PERSECUTION AND IMPRISONMENT

The Nazi regime's treatment of homosexuals and trans+ people was not uniform. Initially, most of the men convicted under Paragraph 175 were released after serving their prison sentences. It was primarily after 1940 that many were transferred to concentration camps. Lesbian women and trans+ people were sometimes charged with other crimes, such as prostitution or indecent behavior. Others were persecuted for political, social, or racist reasons.

In Gestapo custody and in concentration camps, homosexual men were subjected to arbitrary punishment and violence; few survived. Some lesbian women and trans+ people were also murdered in concentration camps. There was hardly any solidarity among fellow prisoners, and the men forced to wear the "pink triangle" were especially ostracized. With this symbol thousands of homosexual men were marked in the concentration camp. Hundreds of men were forcibly castrated. At the same time, there was sexual exploitation by guards and prisoner functionaries. Survivors rarely spoke about their persecution after 1945.

„Homosexuelle Mithäftlinge, die aufs Krankenrevier mußten, kamen nie wieder lebend zurück. […] Nach und nach erfuhr ich, wer außer mir in unserer Baracke auch noch schwul war. Wir haben es möglichst vermieden, miteinander in Kontakt zu kommen, um bloß nicht aufzufallen. […] Zu homosexuellen Kontakten kam es jedoch nie, obwohl bei einem Transport ein junger Homosexueller aus Düsseldorf ins Lager kam, der mit mir in einem Bett schlief. Wir waren viel zu ausgelaugt und hatten viel zuviel Angst."

Augenzeugenbericht von Johann-Rudolf Brähler, wegen eines Paragraf-175-Vergehens aus der Wehrmacht ausgestoßen und ins Emslandlager III Brual-Rhede verschleppt, in: Hans-Georg Stümke und Rudi Finkler, *Rosa Winkel, Rosa Listen. Homosexuelle und „Gesundes Volksempfinden" von Auschwitz bis heute*, 1981

"Homosexual prisoners who were sent to the infirmary never came back alive…. Little by little I learned who else was gay in our barracks besides me. We avoided coming into contact with each other as much as possible, so as not to attract attention…. However, homosexual contact never occurred, although on one transport a young homosexual from Düsseldorf came to the camp and slept in the same bed with me. We were much too exhausted and much too afraid."

Eyewitness account by Johann-Rudolf Brähler, expelled from the Wehrmacht for a Paragraph 175 offense and deported to Emslandlager III Brual-Rhede, quoted in Hans-Georg Stümke and Rudi Finkler, *Pink Triangles, Red Lists: Homosexuals and "Popular Sentiment" from Auschwitz to the Present*, 1981

338 LEBEN IN DER DIKTATUR

Nᵒ 3895

Tegernsee, den 13.November 1934.

Gendarmerie-Station Tegernsee.

Bezirksamt Miesbach
* 13-NOV-1934 *
Nᵒ.......... Beil..........

Betreff: Registrierung homosexueller Personen.

Name	Geburts= zeit u. = Ort	Beruf	Wohnort	Wie oft beam= standet	wie oft bestraft	mitglied der NSDAP. oder ihrer Neben- organisationen			wenn ver- zogen, wohin?
						wel= cher?	seit wann?	Dienst= grad	
Huth= mann Johann Baptist	13.5.74 Endorf, B.A. Rosenheim	Kauf= mann	München Pinzen= auerstr. 14	4 mal	Jm Jahre 1926 L. Gericht Traun= stein freige= sprochen in den übrigen Fällen Verfahren eingest.	Hier nicht bekannt Soll glaublich in München der Partei beigetreten sein			Besitzt i Bad-Wiess see ein Landhaus mit Miet= autoge= schäft, ständiger Wohnsitz München, Pinzen= auerstr. 14
Schild= hauer Georg	18.12.09 Hochstätt B.A. Rosenheim	K.W. Führer	Jm Som= mer Bad- Wiessee	3 mal	Verfahren eingest.	nein	nein	nein	1.10.34 München, Pinzen= auerstr. 14
Schild= hauer Joseph	17.2.11 Hochstätt B.A. Rosenheim	K.W. Führer	Jm Som= mer Bad- Wiessee	3 mal	Verfahren eingest.	nein	nein	nein	1.10.34 München, Pinzen= auerstr. 14
Guillon Karl	16.8.10 München	K.W. Führer	Bad- Wiessee	1 mal	Verfahren eingest.	nein	nein	nein	

Anmerkung: Nur Huthmann ist als aktiver Teil bekannt, die übrigen Genannten sind nur als paßiver Teil bekannt geworden.

Friedrich

„Rosa Liste" aus Tegern-
see, 1934 | "Rosa Liste"
from Tegernsee, 1934

Nach Einführung des Paragraf 175 im Jahr 1871 beginnen Polizeibehörden, „Rosa Listen" anzulegen, Namens- und Adressverzeichnisse homosexueller Männer. Die hier gezeigte Liste stammt aus dem Ort Tegernsee. Auch bei der Münchner Polizeirazzia im Oktober 1934 wird eine solche Kartei herangezogen. Sie umfasst rund 5.000 Personen.

After the introduction of Paragraph 175 in 1871, police authorities began to compile "Rosa Listen" (pink lists) of the names and addresses of homosexual men. The list shown here is from the town of Tegernsee. Such a card index was also used in the Munich police raid in October 1934. It registered about five thousand people.

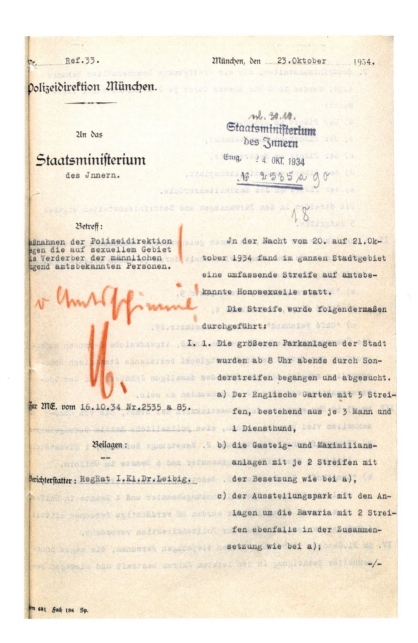

Polizeibericht über die Razzia gegen Homosexuelle in München, 20./21.10.1934 |
Police report on the raid against homosexuals in Munich, October 20/21, 1934

Bei der reichsweit ersten Razzia gegen Homosexuelle werden 1934 in der Nacht vom 20. auf den 21. Oktober 145 Personen festgenommen und 39 davon ins KZ Dachau überstellt. Unter den Festgenommenen sind auch sechs SA-Leute. Die Razzia findet in den Münchner Szenelokalen Schwarzfischer und Arndthof, im Englischen Garten und weiteren Parks, Cafés, an öffentlichen Toiletten (Klappen) sowie in Privatwohnungen statt.

During the first raid against homosexuals in 1934, 145 people were arrested on the night of October 20/21 and thirty-nine of them were transferred to the Dachau concentration camp. Among those arrested were six SA members. The raid took place in the Munich gay bars Schwarzfischer and Arndthof, in the Englischer Garten and other parks, in cafés, public toilets, and in private apartments.

LIFE UNDER DICTATORSHIP 339

2. Bedürfnisanstalten, die als Treffpunkte Homosexueller bekannt sind, wurden ab 8 Uhr abends durch je 2 Kriminalbeamte über- wacht:

a) Der Pißort am Stachus,

b) der Pißort am Hauptbahnhof,

c) der Pißort am Petersplatz,

d) der Pißort am Maximiliansplatz,

e) der Pißort an der Maximiliansbrücke.

Die Streifen in den Parkanlagen und Bedürfnisanstalten ergaben 5 Aufgriffe.

II. 3 Gastlokale der Stadt, in denen gelegentlich Homosexuelle verkehr wurden im Laufe des Abends wiederholt durch je einen Kriminalbeamt unauffällig überwacht.

a) "Bratwurstglöckl", Frauenplatz 9,

b) "Café City", Weinstraße 4,

c) "Café Weichand", Herzog Wilhelmstr.29.

Die Überwachungen ergaben keinen Anlaß, irgendwelche Personen aufz greifen. Der früher im Bratwurstglöckl bestehende Stammtisch Homo- sexueller scheint mit dem Tode des damaligen Jnhabers und der Säu- berungsaktion vom 30.6.34 verschwunden zu sein.

III. Um 23.50 Uhr wurde in den 2 Gastlokalen der Stadt, die von Homo- sexuellen viel besucht werden, eine polizeiliche Razzia durchgeführ

a) "Schwarzfischer", Dultstraße 2. Besetzung: Referent, 1 Dienstst leiter, 1 Spezialfahndungsbeamter und 6 Beamte in Uniform,

b) "Arndthof", Glockenbach 12. Besetzung: Stellvertreter des Dienst stellenleiters, 1 Spezialfahndungsbeamter und 4 Beamte in Unif

Aus diesen 2 Gaststätten wurden 88 verdächtige Personen mittel 4 Gefangenentransportwagen zur Polizeidirektion verbracht.

IV. Am 21.Oktober früh 6 Uhr wurden diejenigen Personen, die wegen homo sexueller Betätigung in den letzten Jahren bestraft und hiewegen be

sonders häufig polizeilich beanstandet werden mußten, soweit sie
bei den Streifen während der Nacht nicht schon aufgegriffen wur-
den, durch die Polizeibezirke aus ihren Wohnungen geholt. Die
betreffenden Personen waren vorher aus der Kartei von ca.5000 Per-
sonen nach genauer Prüfung der Polizeiakten herausgesucht worden
und betrugen insgesamt 75.

Die Festnahme ergab 52 Personen, die ebenfalls bei der
Polizeidirektion eingeliefert wurden. Hiebei wurden übrigens in
2 Fällen je zwei Homosexuelle beisammen nächtigend angetroffen.
14 Personen konnten nicht gefunden werden, sie werden jedoch
sobald als möglich ebenfalls festgenommen werden.

V. Sofort nach Eintreffen bei der Polizeidirektion wurden die Fest-
genommenen einem Verhör unterzogen. Die aus der Streife I einge-
lieferten Personen konnten noch vor Beginn der Streife III ab-
schließend behandelt werden, ebenso konnten sämtliche Festnahmen
aus der Streife III noch vor Beginn der Streife IV endgültig
verbeschieden werden. Am 21.Oktober vormittags 11 Uhr waren
sämtliche Personen behandelt worden.

Das Endergebnis:

Vorläufige Festnahmen insgesamt 145

davon wieder entlassen 99

zur Ausweisung überstellt 1

zwecks Prüfung des Ausschlusses aus der
SA dem SA-Streifendienst überstellt 6

Die in Haft gelassenen 39 Personen werden vorläufig in
Schutzhaft genommen und sollen durch die Bayer.Polit.Polizei dem
Konzentrationslager Dachau überführt werden. Soweit die bei der
Razzia aufgegriffenen Personen Mitglieder der NSDAP. sind, wer-
den sie der Gauleitung München-Oberbayern mitgeteilt werden.
Nach den bisherigen Feststellungen kommen nur wenige Personen in
Frage. J.V.

342 LEBEN IN DER DIKTATUR

StAWü Gestapo Wü 8873 V Bl. 194

[handwritten letter]

Selbstanzeige von Leopold Obermayer an die Staatsanwaltschaft Würzburg, 27.3.1935 | Self-denunciation by Leopold Obermayer to the Würzburg public prosecutor's office, March 27, 1935

Leopold Obermayer (1892–1943), ein jüdischer Rechtsanwalt mit Schweizer Pass, wird 1934 nach einer Beschwerde bei der Polizei in Gestapo-Haft und ins KZ Dachau gebracht. Dort wird er schwer misshandelt. Er zeigt sich selbst an, ein Vergehen nach Paragraf 175 begangen zu haben, um vor ein ordentliches Gericht zu kommen. Obermayer, der sich zu seiner Homosexualität bekennt, führt einen mutigen, aber erfolglosen juristischen Kampf gegen das NS-Regime und wird 1943 im KZ Mauthausen ermordet.

Leopold Obermayer (1892–1943), a Jewish lawyer with a Swiss passport, was taken into Gestapo custody and sent to the Dachau concentration camp in 1934 following a complaint to the police. There he was severely mistreated. He accused himself of having committed an offense under Paragraph 175, in order to be brought before a legal court. Obermayer, who confessed his homosexuality, waged a courageous but unsuccessful legal battle against the Nazi regime and was murdered in the Mauthausen concentration camp in 1943.

Karl-Josef Weigang in bayerischer Tracht, 1930er Jahre | **Karl-Josef Weigang in traditional Bavarian clothing, 1930s**

Karteikarte Karl-Josef Weigangs aus der Häftlingsschreibstube des KZ Dachau mit verzeichneten Strafen („K.A." steht für „Kommandantur-Arrest", Bunkerhaft), 1938 | **Karl-Josef Weigang's file card from the prisoner record office of the Dachau concentration camp with recorded punishments ("K.A." stands for "Kommandantur-Arrest," commander detention, i.e. bunker confinement), 1938**

Karl-Josef Weigang (1895–1938) engagiert sich für Kinder und Jugendliche aus schwierigen Verhältnissen und steht zum demokratischen Staat. Im April 1937 kommt es zu einer Verurteilung nach Paragraf 175. Ob Weigang tatsächlich homosexuell ist oder das NS-Regime in ihm einen politischen Gegner sieht, bleibt unklar. Nach verbüßter Gefängnisstrafe wird er im Oktober 1937 erneut verhaftet und ins KZ Dachau verschleppt, wo er Ende 1938 vermutlich an Misshandlungen stirbt.

Karl-Josef Weigang (1895–1938) supported children and young people from difficult backgrounds and as well as the democratic state. He was sentenced in April 1937 under Paragraph 175. Whether Weigang was actually homosexual or whether the Nazi regime saw him as a political opponent remains unclear. After serving the prison sentence, he was arrested again in October 1937 and deported to the Dachau concentration camp, where he presumably died of mistreatment at the end of 1938.

LIFE UNDER DICTATORSHIP 343

344 LEBEN IN DER DIKTATUR

Zu den wenigen bekannten Schicksalen lesbischer Frauen im Nationalsozialismus zählt die Geschichte von Elisabeth (Lilly) Wust (1913–2006) und Felice Schragenheim (1922–1945). Sie lernen sich im November 1942 in Berlin kennen, kurz nachdem Schragenheim als Jüdin untergetaucht ist. Wenig später ziehen sie zusammen. Im Juni 1944 versprechen sie sich die Ehe und stellen sich gegenseitig Eheverträge aus.

Among the little-known fates of lesbian women under Nazism is the story of Elisabeth (Lilly) Wust (1913–2006) and Felice Schragenheim (1922–1945). They met in Berlin in November 1942, shortly after Schragenheim, a Jew, went into hiding. A short time later they moved in together. In June 1944, they promised to marry and issued each other marriage contracts.

Ehevertrag zwischen Elisabeth (Lilly) Wust und Felice Schragenheim, 26.6.1943 | Marriage contract between Elisabeth (Lilly) Wust and Felice Schragenheim, June 26, 1943

Eheversprechen von Felice Schragenheim und Elisabeth (Lilly) Wust, 29.6.1943 | Marriage vows of Felice Schragenheim and Elisabeth (Lilly) Wust, June 29, 1943

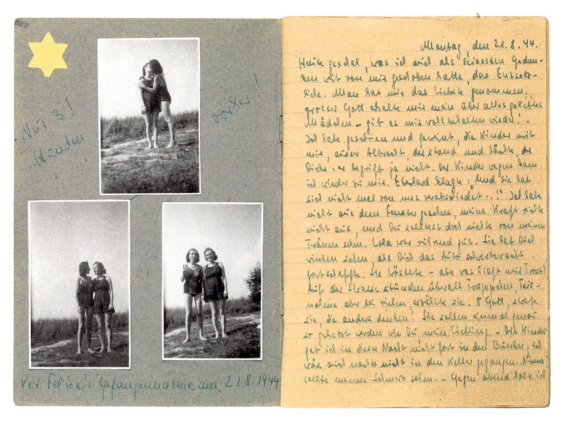

Tagebucheintrag von Elisabeth (Lilly) Wust zur Verschleppung von Felice Schragenheim, 21.8.1944 | **Diary entry by Elisabeth (Lilly) Wust on the deportation of Felice Schragenheim, August 21, 1944.**

Am 21. August 1944 wird Felice Schragenheim entdeckt und zu einer Berliner Sammelstelle für Jüdinnen*Juden gebracht. Lilly Wust besucht sie dort noch einige Male vor der Deportation ins Ghetto Theresienstadt. In der Hoffnung, ihrer Geliebten helfen zu können, reist Lilly Wust im Herbst 1944 selbst nach Theresienstadt. Felice wird wenig später nach Auschwitz deportiert. Sie stirbt Anfang 1945, vermutlich im KZ Bergen-Belsen. Lilly Wust sucht noch Jahre nach ihr. Ihre Briefe und Erinnerungen fließen in das Buch *Aimée & Jaguar* (1994) und den gleichnamigen Spielfilm (1999) ein.

On August 21, 1944, Felice Schragenheim was discovered and taken to a Berlin collection point for Jews. Lilly Wust visited her there several times before the deportation to the Theresienstadt ghetto. In the hope of helping her beloved, Lilly Wust traveled to Theresienstadt herself in the fall of 1944. Felice was deported to Auschwitz a short time later. She died in early 1945, presumably in the Bergen-Belsen concentration camp. Lilly Wust searched for her for years to come. Her letters and memories were incorporated into the book *Aimée & Jaguar* (1994) and the feature film of the same name (1999).

LIFE UNDER DICTATORSHIP 345

Die verheiratete Mary Erna Pünjer (geb. Kümmermann, 1904–1942) aus Hamburg-Wandsbek, beschäftigt im Modegeschäft ihrer Eltern, wird 1940 verhaftet und von der Polizei oder Gestapo trotz bestehender Ehe als „lesbisch" klassifiziert. Vom Polizeigefängnis kommt Pünjer, jüdischer Abstammung, ins KZ Ravensbrück. Im Rahmen des Programms 14f13 wird sie zur Ermordung in der Tötungsanstalt Bernburg ausgewählt.

Mary Erna Pünjer (née Kümmermann, 1904–1942), a married woman from Wandsbek near Hamburg, employed in her parents' fashion store, was arrested in 1940 and classified as "lesbian" by the police or Gestapo, despite being married. From the police prison, Pünjer, of Jewish descent, was sent to the Ravensbrück concentration camp. As part of the 14f13 program, she was selected for murder in the Bernburg execution facility.

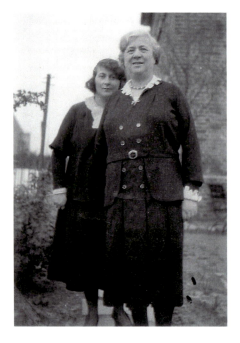

Rückseite der 1940 im KZ Ravensbrück angefertigten Fotos Mary Erna Pünjers, beschriftet 1941/42 | **Reverse side of Mary Erna Pünjer's photographs taken in the Ravensbrück concentration camp in 1940, inscribed in 1941/42**

Mary Erna Pünjer, mit ihrer Mutter Lina Kümmermann, 1930er Jahre | **Mary Erna Pünjer, with her mother Lina Kümmermann, 1930s**

„Verheiratete Volljüdin. Sehr aktive ('kesse') Lesbierin. Suchte fortgesetzt 'lesbische Lokale' auf u. tauschte im Lokal Zärtlichkeiten aus"; diese handschriftliche Notiz, basierend auf den Angaben der Polizei Hamburg, stammt vom SS-Arzt Friedrich Mennecke, der KZ-Häftlinge und Anstaltspatient*innen zur Ermordung in Tötungsanstalten selektiert.

"Married, fully Jewish woman. Very active ('saucy') lesbian. Continually sought out 'lesbian bars' and exchanged caresses in the bars." This handwritten note, based on information from the Hamburg police, was written by SS doctor Friedrich Mennecke, who selected concentration camp prisoners and institution patients for murder in execution centers.

Zugangsliste des KZ Ravensbrück mit Vermerk „politisch" und „lesbisch" bei Elli Smula |
List of prisoners at Ravensbrück with annotations "political" and "lesbian" for Elli Smula

Elli Smula (1914–1943) wird vorgeworfen, mit Kolleginnen sexuell verkehrt und den Dienst als Straßenbahnschaffnerin vernachlässigt zu haben. Sie wird in das KZ Ravensbrück gebracht und stirbt während der Haft.

Elli Smula (1914–1943) was accused of having had sex with female colleagues and of neglecting her duties as streetcar guard. She was imprisoned in the Ravensbrück concentration camp and died in detention.

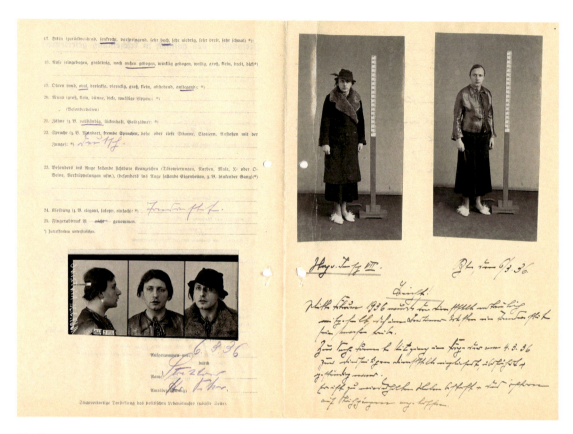

Fritz Kitzing, von der Gestapo gezwungen, bei ihm befindliche Frauenkleidung zu tragen, Haftbogen, 1936 | **Fritz Kitzing, forced by the Gestapo to wear women's clothing found on his person, arrest sheet, 1936**

Der Buchhändler Fritz Kitzing (1905–?) wird 1933 verhaftet, weil er Frauenkleider trägt. 1934 gelingt ihm die Flucht nach Großbritannien, von dort wird er nach Deutschland ausgeliefert. 1936 wird er verdächtigt, erneut als „Transvestit" unterwegs gewesen zu sein. Die Polizei bezeichnet ihn als „Transvestiten schlimmster Art" und empfiehlt KZ-Haft. Aus dieser kommt er 1937 frei. 1938 wird er der Gestapo übergeben, weil er einem Freund in Großbritannien von seinen Erlebnissen berichtet hat. Sein weiteres Schicksal ist nicht bekannt.

The bookseller Fritz Kitzing (1905–?) was arrested in 1933 for wearing women's clothing. In 1934 he managed to escape to Great Britain, from where he was extradited to Germany. In 1936 he was suspected of being a "transvestite" again. The police described him as a "transvestite of the worst kind" and recommended imprisonment in a concentration camp. He was released from this in 1937. In 1938 he was handed over to the Gestapo because he had told a friend in Great Britain about his experiences. His fate is unknown.

Häftlingskarteikarte des KZ Natzweiler für Alexander (Bella) Pree, 1943 | **Prisoner record card of the Natzweiler concentration camp for Alexander (Bella) Pree, 1943**

„Wäre mein Körperzustand schon im damaligen Zeitpunkt geprüft worden, so hätte ich [auch] damals nur wegen Übertretung nach Paragraf 516 STG, niemals aber wegen Verbrechens gemäß Paragraf 129 Ib STG verurteilt werden können. … Nicht genug, daß ich infolge dieses Rechtsirrtums durch 3 Jahre hindurch von KZ. [!] zu KZ getrieben wurde, wird mir auch nunmehr der Genuß der Sonderbestimmungen der Amnestie 1950 wegen desselben Umstandes verweigert."

Alexander (Bella) Pree, WLGI_1817_48, S. 180, zitiert nach: Sara M. Ablinger, *Intersexualität im Kontext der Strafverfolgung nach Paragraf 129 Ib anhand des Falles Alexander P. von 1935 bis 1952*

"If my physical condition had been examined at that time, I could [also] have been convicted then only of transgression under Paragraph 516 STG [Austrian criminal code], but never of a crime under Paragraph 129Ib STG…. It is not enough that as a result of this legal error I was driven for three years from concentration camp to concentration camp, I am now also denied the benefit of the special provisions of the 1950 amnesty because of the same circumstance."

Alexander (Bella) Pree, WLGI_1817_48, p. 180, quoted in Sara M. Ablinger, "Intersexuality in the Context of Criminal Prosecution According to Paragraph 129Ib, Based on the Case of Alexander P. from 1935 to 1952"

Alexander (Bella) Pree (1917–?) würde heute vermutlich als inter* gelten, sie selbst fühlt sich als Frau. Ihr Pass weist sie als männlich aus. Sie wird in Österreich 1936 und 1942 wegen Verstoßes gegen Paragraf 129Ib, den österreichischen Homosexuellen-Paragrafen, verurteilt, in mehreren KZ interniert und 1942/43 im KZ Natzweiler kastriert. 1950 erfolgt eine erneute Anklage nach Paragraf 129Ib. Doch diesmal bleibt ihr die Verurteilung erspart, weil ein Gutachten sie als inter* Person anerkennt.

Alexander (Bella) Pree (1917–?) would probably be considered intersex today. She herself felt like a woman; her passport identified her as male. She was convicted in Austria in 1936 and 1942 for violating Paragraph 129Ib, the Austrian homosexuality statute, was interned in several concentration camps, and was castrated in the Natzweiler concentration camp in 1942/43. In 1950, she was again charged under Paragraph 129Ib. But this time she was spared a conviction because an expert opinion recognized her as an intersex person.

LIFE UNDER DICTATORSHIP 349

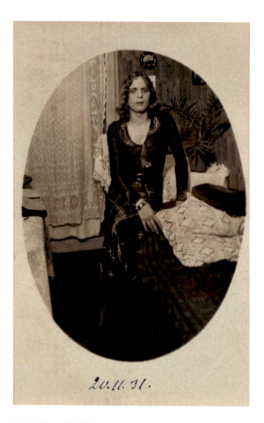

Liddy Bacroff, 1931

Liddy Bacroff, amtliches Foto der kriminalbiologischen Sammelstelle, Hamburg 1933 | Liddy Bacroff, official photo of the Criminal Biology Collection Center, Hamburg, 1933

Liddy Bacroff (1908–1943), bezeichnet sich selbst als „homosexuellen Transvestiten", lebt von Sexarbeit und wird mehrfach wegen „Unzucht" verurteilt. 1930/31 entstehen zahlreiche Texte in der Haft. 1938 erfolgt eine Verurteilung zu drei Jahren Zuchthaus und Sicherungsverwahrung. 1943 wird Bacroff im KZ Mauthausen ermordet. Liddy Bacroff steht für das selbstbestimmte Leben als trans* Person, das die Nationalsozialist*innen nicht akzeptieren.

Liddy Bacroff (1908–1943), described by themself as a "homosexual transvestite," lived from sex work and was convicted several times for "fornication." In 1930/31 they wrote numerous texts while in prison. In 1938 they were sentenced to three years in prison and preventive detention. In 1943, Bacroff was murdered in the Mauthausen concentration camp. Liddy Bacroff represents a self-determined life as a trans+ person, which the Nazis did not accept.

Liddy Bacroff, *Die Nacht des Wiedersehen's*, handschriftlicher lyrischer Text, 1931 | Liddy Bacroff, "The Night of the Reunion," handwritten poetic text, 1931

352 LEBEN IN DER DIKTATUR

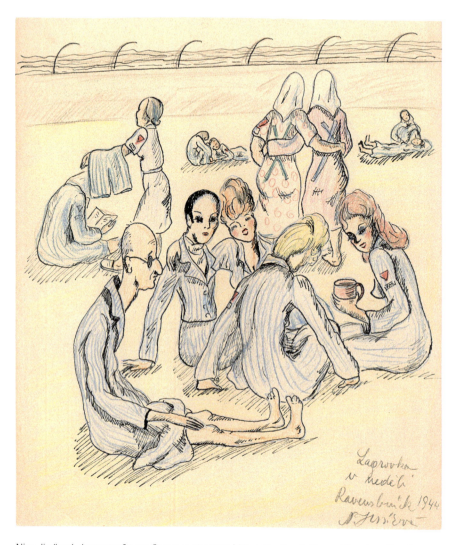

Nina Jirsíková, *Lagerstraße am Sonntag*, um 1944 | **Nina Jirsíková**, *Camp Street on Sunday*, ca. 1944

Nina Jirsíková (1910–1978) arbeitet als Tänzerin, Choreografin und Kostümbildnerin an einem avantgardistischen Theater in Prag. Ein regimekritisches Stück führt 1941 zu ihrer Verhaftung und Deportation ins KZ Ravensbrück. Im Lager zeichnet sie, trotz schwerer Zwangsarbeit. Nach ihrer Befreiung kehrt sie zum Theater zurück.

Nina Jirsíková (1910–1978) worked as a dancer, choreographer, and costume designer at an avant-garde theater in Prague. In 1941, a play critical of the regime led to her arrest and deportation to the Ravensbrück concentration camp. In the camp she made drawings, despite the strenuous forced labor. After her liberation she returned to the theater.

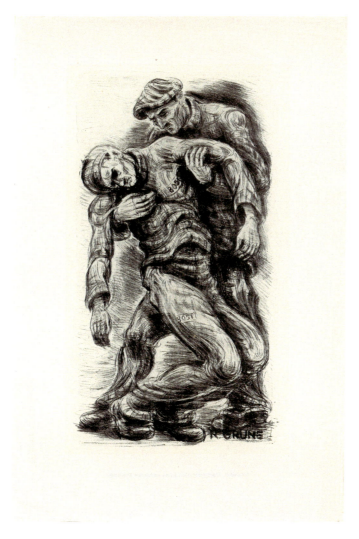

Richard Grune, *Solidarität*, Lithografie, 1945/46 | Richard Grune, *Solidarity*, lithograph, 1945/46

Der Grafiker Richard Grune (1903–1983) ist wegen seiner Homosexualität von 1934 bis 1945 fast durchgängig inhaftiert. Unmittelbar nach seiner Befreiung aus dem KZ verarbeitet er das Erlebte künstlerisch. 1948 wird er erneut zu einer achtmonatigen Gefängnisstrafe wegen homosexueller Handlungen verurteilt. Teile seines Werks werden 1946 bei einer Ausstellung in Kiel zerstört.

The graphic artist Richard Grune (1903–1983) was imprisoned almost continuously from 1934 to 1945 because of his homosexuality. Immediately after his liberation from the concentration camp, he processed what he had experienced through art. In 1948 he was again sentenced to eight months in prison for homosexual acts. Part of his work was destroyed during an exhibition in Kiel in 1946.

LIFE UNDER DICTATORSHIP

EXIL UND WIDERSTAND

Nur wenigen homosexuellen und trans* Menschen gelingt es, sich der NS-Verfolgung durch Emigration zu entziehen. Diese Möglichkeit steht meist nur Wohlhabenden offen oder jenen, die über internationale Kontakte verfügen und aufgrund ihrer Ausbildung und Sprachkenntnisse im Ausland Arbeit finden können. Die Ausreise aus Nazi-Deutschland wird durch die 1934 verschärften Maßnahmen gegen den Vermögenstransfer erschwert. Die „Reichsfluchtsteuer" reduziert das Vermögen bei Ausreise um 25 Prozent, die Ausfuhr von Devisen wird verboten, die Übertragung von Bank- oder Wertpapierguthaben ist beinahe unmöglich.

Einzelne homosexuelle oder transidente Menschen entscheiden sich zu aktivem Widerstand gegen das NS-Regime, auch in den von Deutschland besetzten Gebieten. Sie klären über die Verbrechen des NS-Regimes auf, rufen zum Widerstand auf, leisten Sabotage, begehen Anschläge oder kämpfen als Partisan*innen oder Angehörige fremder Truppen gegen Hitler-Deutschland.

EXILE AND RESISTANCE

Only a few homosexual and trans+ people succeeded in escaping Nazi persecution through emigration. This option was usually only open to the wealthy or those who had international contacts and could find work abroad thanks to their education and language skills. Leaving Nazi Germany was made more difficult by the measures against capital transfer, which were tightened in 1934. The "Reich Flight Tax" reduced assets by 25 percent upon departure, the export of foreign currency was prohibited, and the transfer of bank or securities assets was made almost impossible.

Individual homosexual or transgender people decided to actively resist the Nazi regime, also in the territories occupied by Germany. They documented the crimes of the Nazi regime, called for resistance, carried out sabotage, committed attacks, or fought as partisans or members of foreign troops against Hitler's Germany.

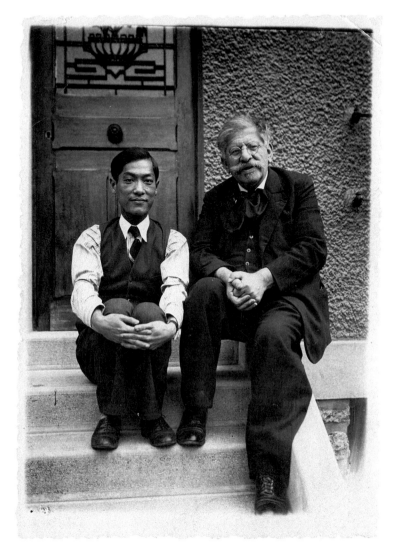

Magnus Hirschfeld mit seinem Freund Li Shiu Tong im Exil in Nizza, 1934 |
Magnus Hirschfeld with his partner Li Shiu Tong in exile in Nice, 1934

Li Shiu Tong (1907–1993) und Magnus Hirschfeld lernen sich 1931/32 während Hirschfelds Vortragsreise in Shanghai kennen. Der 23-jährige Medizinstudent, Sohn eines Geschäftsmannes aus Hongkong, wird Hirschfelds letzter Lebensgefährte und unterstützt seinen Partner ideell und finanziell. Zum Dank vermacht Hirschfeld ihm seinen Nachlass. Li Shiu Tong lebt zuletzt in Kanada.

Li Shiu Tong (1907–1993) and Magnus Hirschfeld met in 1931/32 during Hirschfeld's lecture tour in Shanghai. The twenty-three-year-old medical student, son of a Hong Kong businessman, became Hirschfeld's last partner and supported him both non-materially and financially. In gratitude, Hirschfeld bequeathed his estate to him. Li Shiu Tong later lived in Canada.

LIFE UNDER DICTATORSHIP 355

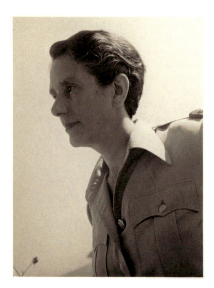

Erika Mann als Mitarbeiterin des britischen Informations-Ministeriums, 22.8.1940 | **Erika Mann as an employee of the British Ministry of Information, August 22, 1940**

Programmflyer des NS-kritischen Kabaretts Die Pfeffermühle, New York 1937 | **Flyer for** *The Pepper Mill*, **a cabaret ensemble critical of the Nazis, New York, 1937**

Erika Mann (1905–1969) bekämpft das NS-Regime mit dem Mittel der Satire, mit dem politischen Kabarett-Ensemble Die Pfeffermühle. 1935 wird Erika Mann die deutsche Staatsbürgerschaft aberkannt. Indem sie den homosexuellen englischen Dichter W. H. Auden heiratet, erlangt sie die britische Staatsangehörigkeit und kann 1937 in die USA emigrieren. Erika Mann wie auch ihr Bruder Klaus Mann klären dort auf Vortragsreisen über das NS-Regime auf.

Erika Mann (1905–1969) fought the Nazi regime by means of satire, with the political-satirical cabaret ensemble *Die Pfeffermühle* (The Pepper Mill). In 1935, Erika Mann's German citizenship was revoked. By marrying the homosexual English poet W. H. Auden, she obtained British citizenship and was able to emigrate to the United States in 1937. Erika Mann, as well as her brother Klaus Mann, subsequently inform the public about the Nazi regime via lecture tours.

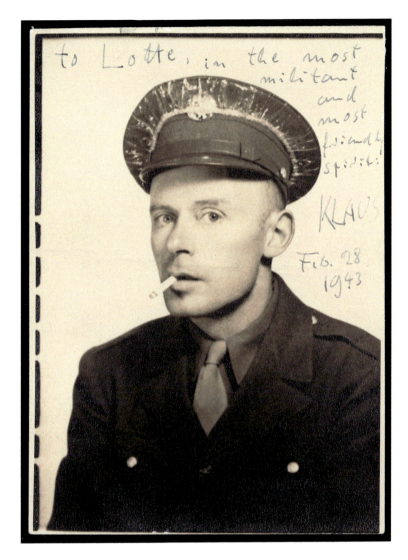

Klaus Mann als amerikanischer Soldat, Foto mit Widmung, 1943 | **Klaus Mann as an American soldier, photo with dedication, 1943**

Klaus Mann (1906–1949) bekennt sich bereits als Teenager zu seiner Homosexualität und thematisiert diese literarisch. Er wirkt bei der Pfeffermühle mit und gibt zwischen 1933 und 1935 in Amsterdam die Exil-Zeitschrift *Die Sammlung* heraus. 1938 flüchtet er weiter in die USA. Dort tritt er in die US-Army ein, um gegen das NS-Regime zu kämpfen. Nach erfolgreicher Einbürgerung interviewt er Kriegsgefangene. 1949 nimmt er sich das Leben.

Klaus Mann (1906–1949) acknowledged his homosexuality as a teenager and made it a literary theme. He participated in *The Peppermill* and, between 1933 and 1935, he publishes the émigré journal *Die Sammlung* (The Gathering) in Amsterdam. In 1938 he flees to America where he joins the US Army to fight against the Nazi regime. After his naturalization as a US citizen, he interviewed prisoners of war. In 1949 he took his own life.

LIFE UNDER DICTATORSHIP

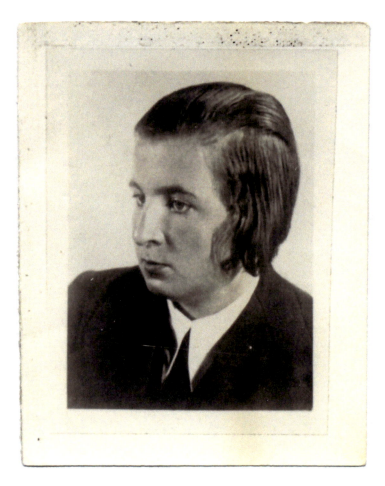

Ilse Sonja Totzke, lesbische Würzburger Musikstudentin und Kunstgewerbetreibende, seit 1995 als „Gerechte unter den Völkern" in Yad Vashem geehrt, ohne Jahr | Ilse Sonja Totzke, the lesbian Würzburg music student and craftswoman, honored by Yad Vashem as "Righteous among the Nations" since 1995, undated

Ilse Sonja Totzke (1913–1987) will mit ihrer jüdischen Freundin Ruth Basinski (1916–1989) in die Schweiz fliehen. Beide werden Ende Februar 1943 unmittelbar hinter der Schweizer Grenze verhaftet und den deutschen Grenzbeamten ausgeliefert. Totzke wird der illegale Grenzübertritt und Fluchthilfe zur Last gelegt, sie kommt in das KZ Ravensbrück. Basinski überlebt die NS-Zeit im sogenannten Mädchenorchester von Auschwitz.

Ilse Sonja Totzke (1913–1987) wanted to escape to Switzerland with her Jewish friend Ruth Basinski (1916–1989). Both were arrested just over the Swiss border at the end of February 1943 and handed over to German border guards. Totzke was charged with illegal border crossing and aiding escape, and was sent to the Ravensbrück concentration camp. Basinski survived the Nazi period in the so-called Women's Orchestra of Auschwitz.

und auch in Dürmenach war. Ich gebe zu, dass ich schon damals den
Fluchtweg ausgekundschaftet und festgelegt habe. Weitere Personen
waren mir nicht behilflich.
In der Nacht vom 26.2. zum 27.2.43 haben wir die deutsch - schwei-
zer Grenze illegal überschritten, indem wir den Drahtverhau über-
kletterten. Der Grenze-übertritt erfolgte bei Neumühle. Auf schwei-
zer Seite wurden wir von Zollbeamten aufgegriffen . Nachdem unse-
re Personalien festgestellt waren und wir erklärt hatten, dass es
uns in Deutschland nicht mehr gefalle, mussten wir bis zum Abend
in der Zollstelle verbleiben. In der Dämmerung wurden wir an der
grünen Grenze zurückgeschoben. In der gleichen Nacht, sind wir
an der selben Stelle wieder illegal nach der Schweiz gegangen. An
dieser Stelle war kein Drahtzaun. Nachdem wir zwei bis drei Stunden
auf schweizer Gebiet gelaufen waren, wurden wir erneut von Zoll-
beamten aufgegriffen. In den Morgenstunden des 28.2.43 wurden wir
von schweizer Zollbeamten an den deutschen Zoll überstellt.

Auf Vorhalt: Ich wurde von keiner Seite beauftragt, die Jüdin
Ruth Sara Basinsky nach der Schweiz zu verbringen. Ich hatte nur
Mitleid mit der genannten Jüdin und wollte sie vor der Evakuierung
schützen. Ich gebe auch zu, dass ich die Jüdin erst zur Flucht über-
redet habe. Für meine Bemühungen habe ich weder von der Basinsky
oder von andern Personen Zuwendungen erhalten.
Ebenso bestreite ich, dass ich schon vordem Juden Beihilfe zur
illegalen Abwanderung geleistet habe. Der Fluchtplan war mein eige-
ner Entschluss, ich wurde von keiner Seite unterstützt. Den Weg
zur Grenze habe ich im September/Oktober 1942 ausgekundschaftet.
Ich bin auch aus diesem Grunde in Dürmenach ausgestiegen, weil ich
wusste, dass in Werenzhausen eine Personenkontrolle durchgeführt
wird. Ich möchte nochmals erwähnen, dass ich aus Deutschland
flüchten wollte, weil ich den Nationalsozialismus ablehne. Vor
allem kann ich die Nürnbergergesetze nicht gutheissen.
Ich hatte die Absicht, mich in der Schweiz internieren zu lassen.
In Deutschland möchte ich unter keinen Umständen weiterleben.

 Ich habe die volle Wahrheit gesagt und nichts wesentliches ver-
schwiegen oder hinzugesetzt.

 selbst gelesen, genehmigt und unterschrieben

 geschlossen:

 apl.Krim.Assistent

Schlussbericht: Ilse Totzke wurde am 28.2.43 , zusammen mit der
Jüdin Eva Ruth Sara Basinski, geb. 10.4.16 in Rawitsch/Posen,
vom Schweizer Grenzposten einem Beamten der GASt. Kiffis über-
stellt. Zur weiteren Behandlung wurden die Genannten der hiesigen
Dienststelle zugeführt. mit der Jüdin B.
Die Totzke ist Deutsche Staatsangehörige und hat in der Nacht vom
26.2. - 27.2.1943 illegal die Grenze nach der Schweiz überschritten.
Beide wurden vom schweizer Zoll an der grünen Grenze zurückgestellt
und versuchten in der gleichen Nacht, nach der Schweiz zu gelangen.
Die Grenze wurde 200 m. östlich von St.Peter überschritten. Die
Zollnachgegriffen angeblich rmeinichen Zoll43wiederbeamten überstellt.
 .//.

Vernehmungsakte der Gestapo zu Ilse Totzke, 1943 |
Interrogation file by the Gestapo on Ilse Totzke, 1943

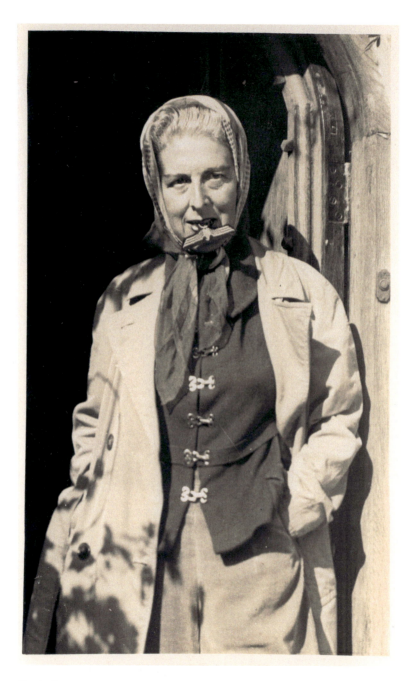

Claude Cahun mit Reichsadler zwischen den Zähnen, Mai 1945 | Claude Cahun with German imperial eagle between her teeth, May 1945

Claude Cahun (rechts) mit Lebensgefährt*in Marcel Moore, 1920 | **Claude Cahun (right) with partner Marcel Moore, 1920**

Flugblatt von Claude Cahun und Marcel Moore, 1940–1944 | **Leaflet by Claude Cahun and Marcel Moore, 1940–44**

HITLER führt uns...
GOEBBELS spricht für uns...
GOERING frisst für uns...
LEY trinkt für uns...
HIMMLER?..Himmler ermordet für uns...
Aber niemand stirbt für uns!

Claude Cahun (1894–1954), jüdisch-französische*r Autor*in und Fotograf*in, zieht 1937 mit seiner*ihrer Lebensgefährt*in Marcel Moore (1892–1972) von Paris auf die Kanalinsel Jersey. Als die deutschen Truppen dort 1940 einmarschieren, die Insel besetzen und mit Zwangsarbeiter*innen zur Festung ausbauen, leisten beide Widerstand. Sie werden verhaftet und zum Tode verurteilt. Kurz vor Kriegsende werden sie begnadigt.

Claude Cahun (1894–1954), Jewish French author and photographer, move from Paris to the Channel Island of Jersey in 1937 with her partner Marcel Moore (1892–1972). When the German troops arrived there in 1940, they occupied the island and used forced labor to modify it into a fortress. Both Cahun and Moore were arrested and sentenced to death for activities in the resistance, but were pardoned shortly before the end of the war.

LIFE UNDER DICTATORSHIP

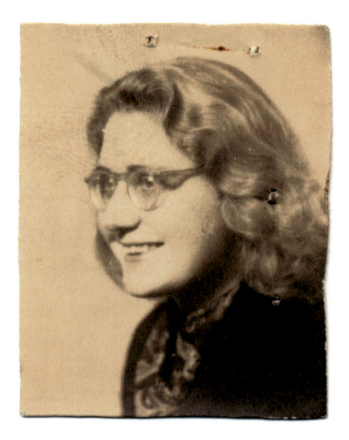

Maria Johanna (Mary) Vaders, lesbische niederländische Widerstandsaktivistin, Ende 1945 | **Maria Johanna (Mary) Vaders, lesbian Dutch resistance activist, late 1945**

Mary Vaders (1922–1996) beschafft als Verwaltungsangestellte in Den Haag Ausweise für den Widerstand. Sie wird 1944 verhaftet, ins KZ Ravensbrück deportiert und wenig später zur Zwangsarbeit ins Agfa-Kamerawerk verschleppt, einem Außenlager des KZ Dachau. Ihre lesbische Identität ist den Verfolgungsbehörden nicht bekannt. Sie wird auf einem Todesmarsch bei Wolfratshausen befreit.

Mary Vaders (1922–1996) procured identity cards for the resistance as an administrative employee in The Hague. She was arrested in 1944, deported to the Ravensbrück concentration camp, and shortly thereafter taken to the Agfa camera factory, a subcamp of Dachau, for forced labor. Her lesbian identity was unknown to the Nazi authorities. She was freed during a death march near Wolfratshausen.

Die 193 aus dem KZ Ravensbrück zu den Agfa-Kamerawerken nach München-Giesing verschleppten Niederländerinnen wie Mary Vaders müssen dort Rüstungsgüter produzieren. Sie montieren Zeitzünder, die in Luftabwehrgranaten eingesetzt werden. Den hier gezeigten Zünder hat eine der Agfa-Frauen nach der Befreiung mitgenommen und behalten.

The 193 Dutch women like Mary Vaders who were deported from the Ravensbrück concentration camp to the Agfa camera factory in Munich-Giesing were forced to produce armaments there. They assembled time fuses that were used in anti-aircraft grenades. The fuse shown here was brought home by one of the Agfa women after liberation.

Zeitzünder aus dem Münchner Agfa-Werk, 1945 | **Time fuse from the Agfa factory in Munich, 1945**

Adressbüchlein mit der Handschrift und Adresse von Mary Vaders, 1945 | **Address booklet with the handwriting and address of Mary Vaders, 1945**

Die Verbundenheit der niederländischen Agfa-Frauen untereinander ist stark. Noch vor ihrer Befreiung fertigen sie kleine Adressbüchlein an, um in Kontakt bleiben zu können. Die dafür verwendeten Pappblättchen stammen aus dem Verpackungsmaterial der Bauteile für Zeitzünder.

The bond between the Dutch Agfa women was strong. Even before they were liberated, they made little address books to keep in touch. The cardboard sheets used for this purpose came from the packaging material of the components for time fuses.

LIFE UNDER DICTATORSHIP

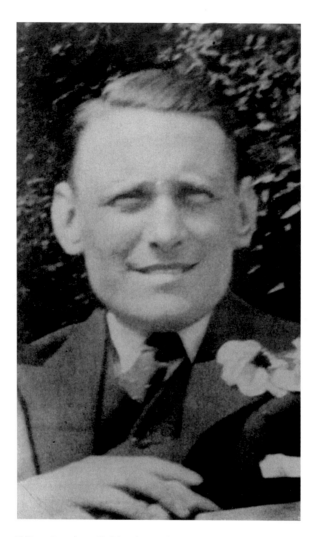

Willem Arondeus, Aktivist des niederländischen Widerstands, ohne Jahr | **Willem Arondeus, activist of the Dutch resistance, undated**

Willem Arondeus (1894–1943), homosexueller Künstler und Schriftsteller aus den Niederlanden, beteiligt sich 1943 an dem Anschlag auf das Einwohnermeldeamt Amsterdams. Dadurch kann bei Verfolgten mit gefälschtem Pass die wahre Identität nicht mehr herausgefunden werden. Er wird gefasst und hingerichtet. Als letzten Satz erklärte er, es müsse bekannt werden, dass Homosexuelle keine Feiglinge seien.

Willem Arondeus (1894–1943), homosexual artist and writer from the Netherlands, took part in the attack on Amsterdam's registration office in 1943. This made it impossible to find out the true identity of persecuted individuals with forged passports. He was caught and executed. As his last sentence, he declared that it must be known that homosexuals were not cowards.

Zerstörte Einwohnermeldekartei der Stadt Amsterdam, einen Tag nach dem Brandanschlag, polizeiliche Aufnahme vom 28.3.1943 | **Destroyed population register of the city of Amsterdam, one day after the arson attack, police photograph from March 28, 1943**

KATHARINA AIGNER

Was können uns Objekte der Vergangenheit erzählen, deren Träger*innen nicht mehr über sie sprechen können? Ausgangspunkt für Katharina Aigners (*1983, Österreich) Videoarbeit sind vier Gegenstände, die sich in der Gedenkstätte Ravensbrück befinden: ein Taschentuch, ein Ring aus Draht, ein abgebrochener Kamm und ein kleines Stoffherz. Vermutlich wurden sie im Frauen-Konzentrationslager hergestellt. Über ihren Ursprung und die Bedeutung für ihre Besitzer*innen gibt es kaum mehr Kenntnisse. Aigner imaginiert ein Archiv der Emotionen, Verflechtungen und des queeren Begehrens. Als digitale Artefakte übersetzt sie die Objekte in einen undefinierten, weder örtlich noch zeitlich begrenzten Raum. Relationen von Nähe und Distanz werden angedeutet, Suchbewegungen suggeriert. Gefertigt unter ständiger Bedrohung des eigenen Lebens und angesichts existenziellen Mangels, sind sie Zeichen von Widerstandsfähigkeit. Sie zeugen einerseits von Verlust und Abwesenheit und sind andererseits Ausdruck der Gegenwehr und Selbstbestimmung ihrer Träger*innen. Indem Aigner die Objekte in neue Konstellationen bringt, schafft sie Anknüpfungspunkte, um ihr Potenzial in verschiedene Richtungen weiterzutragen und einen Platz in der Erinnerung zu behaupten.

Katharina Aigner spürt queere, lesbische Geschichte(n) und Erzählungen auf und beschäftigt sich mit Politiken von Sichtbarkeit und einer feministisch-kritischen Revision von Archivarbeit und Biografieforschung.

What can objects of the past tell us when their owners can no longer talk about them? The starting point for Katharina Aigner's (b. 1983, Austria) video work are four objects found at the Ravensbrück memorial site: a handkerchief, a ring made of wire, a broken comb, and a small cloth heart. They were presumably made in the Nazi concentration camp for women that had been there. We know hardly anything about their origin and what they meant to their owners. Aigner imagines an archive of emotions, entanglements, and queer desire. She translates the objects as digital artifacts to an undefined space that is neither spatially nor temporally limited. Relationships of proximity and distance are implied, movements of searching suggested. Made under the constant threat to one's own life and in conditions of existential scarcity, they are signs of resilience. They testify to loss and absence and at the same time are an expression of the resistance and self-determination of their bearers. By situating the objects in new constellations, Aigner establishes points of contact in order to propel their potential forward in different directions and to claim a place within memory.

Katharina Aigner traces queer, lesbian history(s), and narratives, as well as engages with politics of visibility and a feminist-critical revision of archival work and biographical research.

Something Traced and Diverging, 2022
HD Video, Farbe, Ton, 7 min | HD video, color, sound, 7 min.
Courtesy the artist

MIKOŁAJ SOBCZAK

Mikołaj Sobczak (*1989, Polen) arbeitet zu LGBTIQ*-Aktivismus und politischen Bewegungen des 20. Jahrhunderts. In Performances, Keramikarbeiten und Malereien schafft er durch die Verschränkung mythologischer Erzählungen und historischer Akteure queere Utopien.

Die Vase *Pink Triangles Against Capitalism* zeigt die Teilnehmer*innen der ersten Demonstration für die Rechte von Schwulen und Lesben in Deutschland 1972. Neben Elementen aus dem Triptychon *Der Krieg* von Otto Dix und Symbolen aus den Ursprüngen der LGBTIQ*-Bewegung findet sich auch eine Darstellung homosexueller Häftlinge aus dem Konzentrationslager Mauthausen. Die Kontinuität der Verfolgung und der Widerstand dagegen spiegeln sich in der Form der Vase, dem „Rosa Winkel" oder „pink triangle". Dieses Motiv der Verfolgungsgeschichte wird im Lauf des 20. Jahrhunderts vor allem in ein Symbol des Kampfes für queere Rechte umgedeutet.

Mikołaj Sobczak (b. 1989, Poland) works on LGBTIQ+ activism and political movements of the twentieth century. He creates queer utopias in performances, ceramic works, and paintings, intertwining mythological narratives and historical actors.

The *Pink Triangles Against Capitalism* vase depicts participants in the first demonstration for gay and lesbian rights in Germany in 1972. In addition to motifs from Otto Dix's triptych *The War* and symbols from the origins of the LGBTIQ+ movement, there is also a depiction of homosexual prisoners from the Mauthausen concentration camp. The continuity of persecution and resistance against it is reflected in the shape of the vase, the "pink triangle." This motif of the history of persecution has been reinterpreted during the course of the twentieth century, especially into a symbol of the struggle for queer rights.

Pink Triangles Against Capitalism, 2020
Keramik | Ceramic
Private collection, Milano

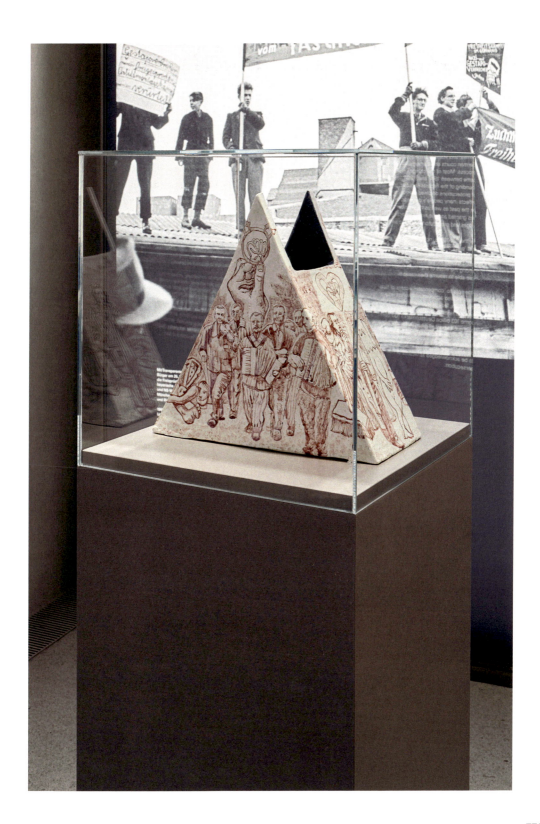

SÉBASTIEN TREMBLAY

DER ROSA WINKEL: VIELSCHICHTIGE SYMBOLIK UND ERINNERUNG IN DER SCHWULENBEWEGUNG BEIDERSEITS DES ATLANTIKS

An einem Regentag im April 1993 versammelten sich auf der National Mall in Washington zahlreiche Besucher*innen anlässlich der Einweihungsfeier des United States Holocaust Memorial Museum (USHMM). Sie kamen, um die Reden von internationalen Würdenträgern zu hören. In ihren Ansprachen betonten diese, wie wichtig das Gedenken an die Ermordung europäischer Jüdinnen*Juden und weitere Gräueltaten des NS-Regimes sei. Im Publikum fanden sich viele schwule und lesbische Paare, die aufmerksam lauschten, Arm in Arm.[1] Als eines von wenigen Museen befasste sich das USHMM schon damals aktiv mit dem Leid nicht-heteronormativer Männer in Europa, die in Konzentrationslager verschleppt und mit dem Rosa Winkel stigmatisiert wurden.[2]

Einige der queeren Männer und Frauen, die dem Regen trotzten, besuchten vielleicht am folgenden Wochenende eine weitere Veranstaltung: den March on Washington for Lesbian, Gay and Bi Equal Rights and Liberation – eine Demonstration, die ein Ende der Diskriminierung von Lesben, Schwulen und Bisexuellen forderte und zu einem der größten politischen Proteste in der Geschichte der Vereinigten Staaten wurde. Doch was diente bei diesem Marsch als Erkennungszeichen? Ein Rosa Winkel mit einer Abbildung des US-Kapitols.

Klaus Müller, Historiker und Berater des USHMM, verurteilte damals die Verwendung des rosa Dreiecks für diesen Zweck. Er bezeichnete es als eine Form „undifferenzierter Viktimologie" und argumentierte damit, der Rosa Winkel habe „als Erfindung der Nationalsozialisten keine andere historische Bedeutung. Die meisten Lesben und Schwulen in Europa, vor allem in Deutschland, weigern sich, ihn zu tragen. Es ist verstörend zu sehen, dass er als modisches Accessoire dient. Wir können frei wählen, ob wir ihn tragen wollen oder nicht. Die Homosexuellen in den Konzentrationslagern hatten keine Wahl."[3]

In diesem Beitrag konzentriere ich mich auf die komplexe Geschichte des Rosa Winkels seit 1945 und ergründe, wie es dazu kam, dass er in der zweiten Hälfte des 20. Jahrhunderts jenseits des Atlantiks von der Queer Liberation adaptiert wurde. Dabei weise ich die Behauptung zurück, das rosa Dreieck in den Sälen des USHMM sei mit jenem rosa Dreieck gleichzusetzen, das in den Lagern verwendet wurde, oder jenem, das die Demonstrant*innen beim Marsch auf Washington zur Schau trugen. Und dennoch werde ich zugleich aufzeigen, dass es derselbe Rosa Winkel war. Einen Schwerpunkt werde ich auf die Opferrolle setzen, denn sie ist es, die dann an Bedeutsam-

SÉBASTIEN TREMBLAY

THE PINK TRIANGLE: MULTILAYERED SYMBOLISM AND MEMORY IN THE QUEER ATLANTIC

On a rainy day in April 1993, a large audience gathered on the capital's National Mall for the dedication ceremonies of the US Holocaust Memorial Museum (USHMM). They came to hear a range of international dignitaries speak about the importance of remembering the murder of European Jews and other atrocities committed by the National Socialist regime. Among those gathered were many gay and lesbian couples, embracing each other, listening with attention.[1] At the time, the USHMM was one of the few museums actively dealing with the suffering of non-hetero-normative men in Europe who were sent to concentration camps and branded with a pink triangle.[2]

Some of the queer men and women braving the rain might have been present for another event happening in Washington, DC, during the same weekend: the March on Washington for Lesbian, Gay and Bi Equal Rights and Liberation, a demonstration calling for the end of discrimination and an event that would become one of the largest political protests in the country's history. The logo of the march? A pink triangle superposed on an image of the US Capitol building.

During that time, the historian Klaus Müller, who works as a consultant for the USHMM, denounced the use of the triangle for this purpose, calling it "undifferentiated victimology" and stating that, as a National Socialist invention, "[i]t has no other historical significance. Most lesbians and gay men in Europe, especially in Germany, won't wear them. To see them worn as fashion statements is very disturbing. We can choose to wear them or not. The homosexuals in the concentration camps had no choice."[3]

In this essay, I focus on the complex story of the pink triangle since 1945 and the constitutive aspect of its transatlantic journey toward queer liberation in the second part of the twentieth century. In so doing, I reject the assessment that the pink triangle in the halls of the USHMM is the same pink triangle as the one used in the camps or the one brandished by protesters on the day of the March on Washington. However, I will also show that it *was* the same triangle. Highlighting the role of victimhood for the creation of identities, I accentuate the recuperation of the triangle, for instance by the West German *Schwulenbewegung* (gay rights movement) in the 1970s.

LIFE UNDER DICTATORSHIP 373

keit gewinnt, wenn Identitäten geschaffen werden. Somit lege ich das Gewicht auf die Wiederaneignung des Rosa Winkels, unter anderem durch die westdeutsche Schwulenbewegung in den 1970er Jahren.

Anders als Müller in den 1990er Jahren sehe ich in der Verwendung des Rosa Winkels keine Relativierung, sondern ein Indiz dafür, dass der Holocaust bei den US-Amerikaner*innen einen hohen Stellenwert besitzt und die nationalsozialistischen Gewalttaten auch insofern bedeutsam sind, dass sie dazu beitragen, ein queeres Selbstverständnis herauszubilden. In diesem Essay plädiere ich weder für noch gegen die vielfältigen Nutzungen des Rosa Winkels zu künstlerischen und/oder politischen Zwecken. Die verschiedenen Erscheinungsformen des Winkels, die manche als ethisch, andere als anstößig empfinden, sollten als Phänomene aufgefasst werden, die dort zum Ausdruck kommen, wo sich (inter)nationale Geschichtsläufe kreuzen und mit einem transatlantischen Netz von Erinnerungen und Identitäten verweben.

In der langen Nachkriegszeit stellten viele westdeutsche schwule Männer ihr politisches Engagement oder ihre eigene Definition ihrer Sexualität in den Kontext des „Dritten Reichs" und schufen mithilfe gemeinsamer Gedenkpraktiken ein umfangreiches kulturelles Netzwerk.[4] Sie betonten zum Beispiel, dass andere queere Männer die Gräuel der Vergangenheit überlebt hatten und somit eine Vorstellung von ihrer eigenen Community entwickeln und deren Geschichte schreiben konnten.[5] Diese gängigen Verweise auf das NS-Regime warfen einen nostalgischen Blick zurück auf die Zeit der Verfolgungen und verstrickten sich zugleich in zeitgenössische Diskriminierungen. Durch die Änderung des Paragrafen 175 im Strafgesetzbuch

hatten die Nationalsozialisten 1935 sexuelle Handlungen zwischen Männern, ob einvernehmlich oder nicht, unter Strafe gestellt und damit im Prinzip jegliche Form des Begehrens zwischen Männern verboten. Tausende nicht heteronormativer Männer wurden in Konzentrationslager verschleppt und mit dem Rosa Winkel gebrandmarkt. Erst die Bundesregierung machte 1969 und 1973 mit einer Gesetzesreform den Weg frei für die Bildung erster politischer Gruppierungen der deutschen Schwulenbewegung. Diese Zeitverzögerung hatte vielschichtige Auswirkungen. Viele der Männer, die in der NS-Zeit in Konzentrationslagern gefangen gehalten worden waren, mussten auch nach Kriegsende noch „in Sicherheitsverwahrung verbleiben".[6]

In den 1970er Jahren setzten sich viele Schwulenaktivisten in Deutschland mit dem Schicksal dieser Männer auseinander und identifizierten sich mit ihnen; in schwulen Publikationen dieser Jahre wurde das Leid der „Männer mit dem Rosa Winkel" oft thematisiert.[7] Die Aktivisten lasen und verbreiteten Zeitzeugenberichte und verankerten ihre eigene Bewegung in den Opfernarrativen.[8] Den Blick in die leidvolle Vergangenheit und das Potenzial, das dieser Zusammenhalt stiftet, nutzte in den 1970er Jahren mehr als nur eine Gruppierung queerer Männer, um eine kollektive Identität zu schaffen. Schon in den vorangehenden Jahrzehnten hatten homophile Publikationen wie die deutsche Zeitschrift *Humanitas* die Geschichte der „Männer mit dem Rosa Winkel" aufgegriffen,[9] ebenso die französische Zeitschrift *Arcadie*.[10]

Historiker*innen, die queere Gedenkpraktiken seit den 1970er Jahren analysieren, vermögen es, auf den Spuren des Rosa Winkels die Geschichte der Queerness in der zweiten Hälfte des 20. Jahrhunderts nachzuzeichnen. Viele schwule Männer

Contrary to Müller's position in the 1990s, I argue that this use of the pink triangle is not a relativization, but rather a sign of the importance of the Holocaust in US life and the significance of National Socialist violence for the constitution of the queer subject. The goal of this intervention is not to advocate for or against the many uses of the pink triangle for artistic and/or political purposes. Ethical for some and offensive for others, the triangle's various manifestations are to be understood as happening at the crossroads of (inter) national histories. These manifestations are indeed entangled within a transatlantic web of memories and identities.

In the long postwar era, many West German gay men related their political engagement or their definition of their own sexuality to the so-called "Third Reich," creating a vast cultural network through shared memorial practices.[4] For instance, they emphasized that other queer men had survived the horrors of the past and were therefore able to imagine and historicize their community.[5] This widespread reference to the National Socialist regime was both nostalgic for that period of persecutions and also entangled in contemporary discrimination. In 1935, the National Socialists had reformed parts of the German penal code (Paragraph 175), which resulted in criminalizing male – male sexuality regardless of its being consensual or not. They essentially outlawed all forms of male – male desire, sending thousands of non-heteronormative men to concentration camps and branding them with pink triangles. The German government eventually passed reforms in 1969 and 1973, allowing the first political groups of the *Schwulenbewegung* to come into being. The implications of this delay were varied. Some of the men who had been sent to concentration camps were forced to remain in detention after liberation.[6]

Discovering the fate of these men, many German gay activists of the 1970s identified with them; indeed gay publications during these years often referred to the suffering of "the men with the pink triangle."[7] Activists read and distributed testimonies, anchoring their own movement in these victimhood narratives.[8] This cohesive potential of looking at a past of injury to create a collective identity was not the endeavor of only one group of queer men in the 1970s. Homophile publications such as the German magazine *Humanitas* had already discussed the story of the "men with the pink triangle" in the decades prior,[9] and the French magazine *Arcadie* had done so as well.[10]

Analyzing queer memorial practices since the 1970s and following the pink triangle, it is subsequently possible for historians to chart queerness in the second part of the twentieth century. Regardless of how they identified themselves, many gay men were aware of the dangers of expressing sexual queerness. By commemorating past injury and understanding that men "like them" had existed and suffered throughout history, they were able to connect queerness to the nation's history. Many organizations – though parts of the *Schwulenbewegung* refused to use the symbol later on – fought for a recognition of the "men with the pink triangle" as official victims of German fascism. Simultaneously, they sought historical justification for their contemporary civil rights struggle for an end to discrimination.

One of these groups is Homosexuelle Aktion Westberlin (HAW), a political group

waren sich – unabhängig von ihrer Selbstidentifikation – der Gefahren bewusst, die mit dem Äußern ihrer nicht-heteronormativen Sexualität einherging. Indem sie sich an einstiges Unrecht und die Erkenntnis, dass „Männer wie sie" in der Menschheitsgeschichte existiert und gelitten hatten, erinnerten, konnten sie Queerness mit der nationalen Geschichte des Landes verbunden sehen. Viele Organisationen setzten sich für die Anerkennung der „Männer mit dem Rosa Winkel" als offizielle Opfer des deutschen Faschismus ein, auch wenn Teile der Schwulenbewegung sich später gegen die Verwendung dieses Symbols aussprachen. Zugleich suchten sie nach einer historischen Rechtfertigung für ihren zeitgenössischen Bürgerrechtskampf um ein Ende der Diskriminierung.

Eine dieser Gruppen war die 1971 gegründete politisch aktive Homosexuelle Aktion Westberlin (HAW). Den Grundlagentexten und Erklärungen der HAW zufolge gingen die Befreiung aus der Isolation und der Kampf gegen Diskriminierung Hand in Hand mit einer geschlossenen sozialen Bewegung, die auf Basis der kollektiven aktuellen Erfahrung des Schwulseins geschaffen wurde. Indem sie ihre Sexualität offen auslebten, ermutigten die HAW-Mitglieder andere schwule Männer, die sichere „Fassade der Heterosexualität" abzustreifen und ihren Platz in einer neuen deutschen Gesellschaft zurückzufordern. Mit dem Rosa Winkel als Emblem verankerten sie ihren Kampf in der deutschen Geschichte und legitimierten ihn dadurch. Diese Wiederaneignung eines von den Nationalsozialisten geschaffenen Stigmas umfasste zwei Komponenten. Einerseits handelte es sich um einen Akt der Selbstmarkierung, der die Sichtbarkeit in der Öffentlichkeit erhöhte. HAW-Aktivisten trugen Rosa Winkel nun als Erkennungszeichen und bekannten sich damit

vor aller Welt zu ihrem Schwulsein und nannten ihre sexuelle Ausrichtung in der Öffentlichkeit beim Namen. Andererseits verwies der Rosa Winkel symbolhaft nicht nur auf ihre Queerness in den 1970er Jahren, sondern insbesondere auf die Verfolgung von Nicht-Heteronormativität durch das NS-Regime in der Vergangenheit. Eine der Kernforderungen der HAW war die Rehabilitierung der nicht-heteronormativen Männer, die in Konzentrationslagern zum Tragen des Rosa Winkels gezwungen wurden. Zudem diente der Rosa Winkel als sichtbarer Verweis auf die auch in der Nachkriegszeit lange unveränderte Gesetzeslage.

Gruppen wie die Gay Liberation Front (GLF) Köln entschieden sich gegen eine erneute Verwendung des Rosa Winkels. Selbst an einer „Rosa Winkel-Aktion" in der Kölner Innenstadt nahm die GLF nicht teil. Die politisch der HAW nahestehende Schwule Aktion Köln (SAK) war hingegen bei der kleinen Kundgebung vertreten,[11] verwendete als Logo aber eine menschliche Silhouette, die sich aus einem umgekehrten Dreieck befreit.[12] Bei anderen Gelegenheiten kämpften SAK und GLF Köln oft gemeinsam um Gleichberechtigung, Nicht-Diskriminierung und das Gedenken an die Verfolgung der Queerness in der NS-Zeit.[13]

In den 1970er Jahren machte der Rosa Winkel den Sprung über den Atlantik. Durch die Schriften von Intellektuellen und Aktivist*innen, die wie James D. Steakley auf beiden Kontinenten zu Hause waren, gelangte das rosa Dreieck in kanadische Publikationen und sogar in die *New York Times*.[14] Bestürzt über das Schicksal der „Männer mit dem Rosa Winkel" begannen nordamerikanische Schwulenrechtsbewegungen, ihre eigenen Unterdrückungserfahrungen durch die Verknüpfung mit einer älteren Leidensge-

created in 1971. According to HAW's main texts and statements, breaking free from isolation and fighting against discrimination went hand in hand with the creation of a cohesive social movement based on a collective experience of the present, a *Schwulsein* (being gay). Through their upfront sexuality, members of the HAW encouraged other gay men to get rid of a certain "façade of heterosexuality" and to reclaim their place in a new German society. Anchoring and legitimizing their fight in German history, they adopted the pink triangle as a symbol. This recuperation of a stigma created by the National Socialists was twofold. On the one hand, it was an act of self-branding, claiming a visual space in the public sphere. HAW members started to wear pink triangles as a badge, declaring to the world that they were indeed gay, naming their sexuality in the public sphere. On another hand, the pink triangle as a symbol not only refered to queerness, but in particular to the persecution of queerness by the National Socialist regime. The rehabilitation of non-heteronormative men, who had been forced to wear the triangle in concentration camps, was one of the core demands of the HAW. The pink triangle also allowed them to draw attention to legal continuities in the long postwar era.

In Cologne, groups such as the Gay Liberation Front Köln chose not recuperate the symbol. The association even recused itself from a so-called "Pink Triangle Action" in the city center. The Schwule Aktion Köln, politically aligned with the HAW, did take part in the small rally.[11] It used a human silhouette breaking free from an inverted triangle as a logo.[12] Yet both the Schwule Aktion and the Gay Liberation Front were often partners in their quest for rights, the end of discrimination, and the commemoration of National Socialist persecutions.[13]

In the 1970s, the pink triangle made its way across the Atlantic. Through the writings of intellectuals and activists with a foot on both continents, such as James D. Steakley, the triangle landed in the pages of Canadian publications and even *The New York Times*.[14] Shocked by the discovery of the fate of the "men with the pink triangle," North American gay rights activists historicized their own experience of oppression by relating it to a longer genealogy of suffering, in which National Socialism played a pivotal role.[15]

At least in the transatlantic world, queerness is therefore connected to a collective memory of National Socialism, and the history of victimhood offered political legitimacy. This collective memory left its imprint on international organizations. In 1989, a draft version of a report for the Economic and Social Forum of the United Nations on the fate of sexual minorities discussed the pink triangle, describing the symbol as a "patent of nobility" for gay and lesbian liberation.[16]

This does not mean that collective memory of National Socialism and an appeal to victimhood were used identically on both sides of the Atlantic. For example, the local chapter of the AIDS Coalition to Unleash Power (ACT UP), an organization that would eventually rebrand the pink triangle for AIDS activism, created a notorious float for the 1987 Gay Pride parade in New York. Connecting the US federal government's inaction on HIV/AIDS with the persecutions of homosexuals under National Socialism, the group built a mock concentration

schichte, in der der Nationalsozialismus eine zentrale Rolle spielte, in einen neuen geschichtlichen Kontext zu stellen.[15]

Zumindest in der transatlantischen Welt ist Queerness deshalb mit einer kollektiven Erinnerung an den Nationalsozialismus verwoben. Die historische Opferrolle untermauerte die eigene politische Legitimation. Dieses kollektive Gedenken prägte auch internationale Organisationen. Der Entwurf eines Berichts über das Schicksal sexueller Minderheiten für das Wirtschafts- und Sozialforum der Vereinten Nationen deklarierte den Rosa Winkel 1989 als „Adelsbrief" der Schwulen- und Lesbenbewegung.[16]

Das heißt allerdings nicht, dass die kollektive Erinnerung an den Nationalsozialismus und der Verweis auf den Opferstatus beiderseits des Atlantiks auf die gleiche Weise eingesetzt wurden. Die New Yorker Sektion des Bündnisses AIDS Coalition to Unleash Power (ACT UP), das später den Rosa Winkel für den AIDS-Aktivismus vereinnahmte, gestaltete beispielsweise einen umstrittenen Wagen für die Gay Pride Parade 1987. Die Gruppe verglich die Untätigkeit der US-Regierung in Bezug auf HIV/AIDS mit der Verfolgung Homosexueller durch die Nationalsozialisten. Auf ihrem Gefährt, das mit einer KZ-Attrappe versehen war, standen Aktivist*innen in T-Shirts mit Rosa Winkel oder nachgemachten SS-Uniformen und verteilten Flugblätter.[17] Die Untätigkeit der US-Regierung zu Beginn der AIDS-Epidemie kam in den Augen der ACT UP-Aktivist*innen einem Völkermord gleich. Unter Verweis auf den Nationalsozialismus bezeichneten sie die HIV/AIDS-Krise als zweiten Genozid an Schwulen, einen zweiten Holocaust, diesmal gegen die queere Bevölkerung gerichtet. In Westdeutschland wäre ein Holocaust-Vergleich in dieser Form undenkbar gewesen. Dafür setzten bayerische Schwulenmagazine die

von Peter Gauweiler in den 1980er Jahren vorgesehenen Maßnahmen wie Zwangstests und Absonderung AIDS-Kranker in Relation zum Schicksal der Männer mit dem Rosa Winkel.[18] ACT UP-Mitglieder in Deutschland stellten jedoch keine direkte Verbindung zur Shoah her.[19] Für viele nordamerikanische Aktivist*innen hingegen stand der Begriff „Holocaust" für sämtliche nationalsozialistischen Gräueltaten und gestattete somit direkte Vergleiche zwischen den Schicksalen der „Männer mit dem Rosa Winkel" und der Jüdinnen*Juden im „Dritten Reich". In Deutschland beschränkten Aktivist*innen solche Bezugnahmen vor allem auf die gegen queere Männer gerichteten Verfolgungen.

Mögen manche Vergleiche mit den Gräueltaten des NS-Regimes aus heutiger Sicht oder für Historiker*innen wie Klaus Müller auch überzogen erscheinen, sollte man sie doch im historischen Kontext sehen. In Westdeutschland beinhaltete das Gedenken an die „Männer mit dem Rosa Winkel" und die Identifikation mit ihnen zugleich die Auseinandersetzung mit hartnäckigen alten „Gespenstern", mit dem Fortdauern eines kulturellen Traumas für die queere Community.[20] Der Austausch von Informationen über die Schicksale dieser Männer, die Schilderungen der von ihnen erlittenen Folterungen und der Kampf für deren Anerkennung als Gräueltaten in den 1970er Jahren bezogen sich auch auf das Fortdauern der Rechtslage in der Nachkriegszeit, insbesondere den Paragrafen 175. Für einen Teil der Community wurde gerade die Verknüpfung des kollektiven Erinnerns mit der aktuellen Gesetzeslage zum Einheit stiftenden Faktor. Solche „Erinnerungspunkte" boten sich gleichermaßen für persönliche und kulturelle Deutungen an, die die Neuerfindung des queeren Selbstverständnisses in den 1970er Jahren positiv beein-

camp flanked by activists wearing pink triangle T-shirts or fake SS uniforms and distributing flyers.[17] For these activists, initial governmental inaction during the epidemic amounted to genocide. Using National Socialism as a reference, they framed the HIV/AIDS crisis as a second queer genocide, a second Holocaust striking the queer population. This kind of Holocaust comparison could not have taken place in West Germany. However, some gay magazines in Bavaria also connected Peter Gauweiler's testing and segregation measures during the 1980s to the fate of the men with the pink triangles.[18] Yet ACT UP members in Germany did not draw direct connections to the murder of European Jews.[19] Indeed, in North America, many activists conflated the Holocaust with all National Socialist atrocities. This made comparisons possible between the fate of the men with the pink triangle and the Holocaust. In Germany, activists chiefly limited the comparison to the regime's persecutions targeting queer men.

If some of these comparisons to the atrocities committed by the National Socialist regime might seem exaggerated to the modern eye or to historians such as Klaus Müller, they need to be contextualized. In the West German case, remembering and identifying with "the men with the pink triangle" meant looking into a haunting past that did not go away, the lingering presence of a cultural trauma for the queer community.[20] The trade of information concerning the fate of these men, the narrative accounts of the tortures they had endured, and the 1970s struggles for the recognition of said atrocities also included continuities in the justice system after the war (Paragraph 175). The pairing of both this collective memory with

these legal realities became a unifying factor for a part of the community. Such "points of memory" offered personal as well as cultural meanings for a recreation of the queer subject in the 1970s.[21] In other words, by shaping their own self according to their sexual orientation, identifying with traumas in the past, gay activists defined and related their own experience through a historicization of queerness; they were creating meanings through social phenomena and acts of memory for their ongoing experience of oppression.[22]

If the West German context exemplifies a transmission of trauma between generations using pictures and self-branding, US activists dived into the same political repertoire of victimhood from another angle, a perspective better understood intersectionally.[23] Many queer activists appealing to the memory of National Socialism were themselves Jewish and the next generation after the Holocaust survivors. In 1970s New York, they wrote extensively in gay magazines, warning their readers of the dangers of homophobia and the possibility of "another Holocaust."[24] In the 1980s, they compared HIV/AIDS to a new form of genocide or hinted directly at the murder of European Jews.[25] Some of the artists recuperating the pink triangle for ACT UP were themselves Jewish.

In both cases, we are confronted with identification processes: in West Germany with the men with the pink triangle, and in the USA with both the fate of these men and with the Holocaust. In other words, queer acts of memory were genealogical, a line traced between two queer generations and uniting them through a painful memory. However, an intersectional analysis also brings to light

LIFE UNDER DICTATORSHIP 379

380 LEBEN IN DER DIKTATUR

flussten.[21] Anders gesagt: Dadurch, dass schwule Aktivisten ihr Selbstbild anhand ihrer sexuellen Orientierung formten und sich mit Traumata der Vergangenheit identifizierten, nutzten sie die Historisierung ihrer Queerness zur Definition und Einbindung ihrer persönlichen Erfahrungen; mithilfe öffentlich wirksamer Aktionen und Gedenkakte schufen sie neue Bedeutungen für ihre eigene laufende Erfahrung von Unterdrückung.[22]

Der westdeutsche Kontext ist insofern beispielhaft für die generationsübergreifende Tradierung von Traumata mithilfe von Bildern und Selbstmarkierung. Anders gingen die US-Aktivist*innen vor, auch wenn sie dasselbe politische Repertoire verwendeten. Sie beleuchteten die Opferrolle unter anderen Aspekten – einer Perspektive, die eher intersektional zu verstehen ist.[23] Viele queere Aktivist*innen, die sich auf die Erinnerung an den Nationalsozialismus beriefen, waren ihrerseits Jüdinnen*Juden und Angehörige der ersten Generation nach den Holocaust-Überlebenden. Im New York der 1970er Jahre äußerten sie sich ausführlich in Schwulenzeitschriften und warnten ihre Leserschaft vor den Gefahren der Homofeindlichkeit und einem drohenden „neuen Holocaust".[24] In den 1980er Jahren bezeichneten sie HIV/AIDS als neue Form des Völkermords oder spielten direkt auf die Ermordung der europäischen Jüdinnen*Juden an.[25] Auch unter den Künstler*innen, die den Rosa Winkel für ACT UP beanspruchten, waren einige Jüdinnen*Juden.

In beiden Fällen geht es um Identifikationsprozesse: in Westdeutschland mit den „Männern mit dem Rosa Winkel" und in den USA sowohl mit dem Schicksal dieser Männer als auch mit der Shoah an sich. Anders gesagt: Queere Erinnerungsakte waren genealogisch. Sie verbanden zwei Generationen queerer Menschen durch eine quälende Erinnerung miteinander. Eine intersektionale Analyse belegt jedoch überdies andere Formen der Erinnerung wie zum Beispiel jüdische Postmemories.

Diese Unschärfe von Erinnerungen und Geschichte hinsichtlich der Verfolgung von Schwulen und Lesben muss ebenfalls kontextualisiert werden. In Westdeutschland konnten Forscher*innen dank der damaligen Verwissenschaftlichung der Schwulengeschichte die Schätzungen nach unten korrigieren und ein präziseres Bild der Verfolgungen zeichnen.[26] Im nordamerikanischen Kontext gedachte man der nationalsozialistischen Gräueltaten wie gesagt nicht nur im Rahmen einer vergleichenden Erinnerung an den Völkermord oder mit Blick auf Kontinuitäten in der Nachkriegszeit. Nach jahrzehntelangem Gedenken durch jüdische Überlebende der ersten und zweiten Generation wandelte sich der Holocaust von einem historischen Ereignis zu einer neuen abstrakten Rolle als Barometer für sämtliche Übel, an dem soziale Bewegungen ihre jeweiligen Anliegen messen konnten.[27]

Im Licht solcher transatlantischer Überlegungen sollten wir die erneute Beanspruchung des Rosa Winkels als vielschichtiges Narrativ verstehen. Zum einen war der Rosa Winkel, wie ihn die Aktivist*innen in den 1970er Jahren verwendeten, ein Akt des Gedenkens und ein Akt der politischen Äußerung. Die Wiederaneignung des Stigmas ging in den 1970er Jahren Hand in Hand mit der Anprangerung der noch immer unveränderten Gesetzeslage durch queere Aktivist*innen. Die Emanzipation der deutschen Schwulen und Lesben war ähnlich wie viele andere soziale Bewegungen dieser Zeit in einer facettenreichen Vergangenheitsbewältigung verankert. Nach dieser ersten Aufarbeitung der nationalsozialistischen

other forms of memory, for example Jewish postmemories.

This murkiness of memory and history regarding the persecutions of gays and lesbian also needs to be contextualized. In the West German case, the professionalization of what was then gay history allowed scholars to revise the estimates downwards and draw a more accurate portrait of the persecutions.[26] In the North American context, as mentioned above, the National Socialist atrocities were not only remembered as part of a comparative memory of genocide or an assessment of continuities in the postwar era. Following decades of memory by Jewish survivors and second-generation survivors, the Holocaust evolved from being a historical event to a new abstract role as the barometer of all evils against which social movements could chart their own struggles.[27]

Under the light of these transatlantic considerations, we must understand the recuperation of the pink triangle as a multilayered story. First, the pink triangle as used by activists in the 1970s was an act of memory and an act of speech. The recuperation of the stigma in the 1970s is linked to an identification of legal continuities by queer activists. Queer liberation in Germany was – similarly to many other social movements at the time – anchored in broader aspects of the need to engage with the country's National Socialist history, a process known as *Vergangenheitsbewältigung* (coming to terms with the past). Following this initial recuperation, the symbol took on a life of its own. It is now even used on mugs and T-shirts. Next to the rainbow flag, it exposes fears and traumatic memories of the queer community. Its cohesive potential is also illustrated by the preponderance of the symbol

in demonstrations supporting queer individuals tortured in camps in the Chechen Republic. Second, pointing upwards, the triangle as reconceptualized by ACT UP became a symbol of hope, of survival. All these uses of the triangle relate to victimhood, queerness, and empowerment through memorial practices, but they do not relativize the fate of the men deported and murdered by the National Socialist regime.

Whether one finds its use ethically abhorrent or not, one possible way to appreciate the pink triangle is to understand it as a political, historical, and visual concept. It links political struggles, queerness, and the constitutive aspects of victimhood. In Germany it underlines the important aspects of *Vergangenheitsbewältigung.* In America it refers to the multidirectional force of the Holocaust, not as the real historical murder of European Jews, but as a sacred evil against which every atrocity is now compared. The antisemitic core of the genocide is seldom at the forefront of that second evocation, allowing the Holocaust to become a rhetorical device for memory politics.

All these triangles – the one from the March on Washington, the one worn in concentration camps, the one brandished by HAW, the one by ACT UP, and the one in demonstrations against the Kadyrov regime – are therefore interconnected, but not necessarily the same. Context and framework are primordial here, as images have a way of influencing discourse. Looking at the pink triangle in the present, we are confronted by its complicated and long history. Depending on our own knowledge of queer history and/or socialization, we might perceive an instrumentalization of a symbol of hate, we

LIFE UNDER DICTATORSHIP 381

382 LEBEN IN DER DIKTATUR

Vergangenheit verselbstständigte sich das Symbol, sodass es uns heute auf Kaffeebechern und T-Shirts begegnet. Ergänzend zur Regenbogenfahne macht es die Ängste und traumatischen Erinnerungen der queeren Community sichtbar. Das Gemeinschaft stiftende Potenzial dieses Emblems zeigte sich auch in seinem häufigen Einsatz bei Demonstrationen für die Befreiung queerer Menschen, die in tschetschenischen Lagern gefoltert wurden. Zum anderen wurde das nach oben zeigende Dreieck, wie es ACT UP neu konzipierte, zum Symbol der Hoffnung und des Überlebens. All diese Verwendungsformen des Rosa Winkels verweisen auf Opferstatus, Queerness und Empowerment durch Gedenkpraktiken, aber sie relativieren nicht das Schicksal der Männer, die vom NS-Regime deportiert und ermordet wurden.

Unabhängig davon, ob man die Verwendung des Rosa Winkels als ethisch empörend empfindet oder nicht, kann man das Dreieck auch als politisches, historisches und visuelles Konzept sehen und würdigen. Der Rosa Winkel bildet ein Bindeglied zwischen politischen Aktionen, Queerness und den konstitutiven Aspekten des Opferseins. In Deutschland unterstreicht er die Hauptthemen der Vergangenheitsbewältigung. In den USA verweist er auf die multidirektionale Anziehungskraft des Holocausts, nicht als reale historische Shoah, sondern als das ultimative Böse, an dem nun jede Gräueltat gemessen wird. Da der antisemitische Kern des Völkermords bei dieser zweiten Deutung nur selten im Vordergrund steht, lässt sie zu, dass der Holocaust zu einem rhetorischen Werkzeug der Erinnerungspolitik wird.

All diese Rosa Winkel sind also miteinander verknüpft, ob sie nun beim Marsch auf Washington, in den Konzentrationslagern, von HAW- oder ACT UP-Aktivist*innen angeheftet oder bei den Demonstrationen gegen das Kadyrow-Regime zur Schau getragen wurden. Verknüpft ja, aber nicht zwangsläufig identisch. Eine elementare Rolle spielen hierbei Kontext und Rahmenbedingungen, denn Bilder beeinflussen den Diskurs auf ihre Weise. Von unserer heutigen Warte aus müssen wir uns der langen, komplexen Geschichte des Rosa Winkels stellen. Je nach persönlichem Wissen über queere Geschichte und/oder Sozialisation können wir darin die Instrumentalisierung eines Hass-Symbols sehen, uns als KZ-Überlebende empören, als nordamerikanische AIDS-Aktivist*innen ermächtigt fühlen oder nostalgisch auf die Schwulenbewegung in den 1970er Jahren zurückblicken. Wir können an das Schicksal von Männern denken, mit denen wir uns identifizieren, und dennoch all diese Dinge gleichzeitig empfinden. In jedem Fall wird der Rosa Winkel zur Brücke zwischen einer schmerzlichen Vergangenheit und einer komplizierten Gegenwart. Und er schlägt auch einen Bogen in die Zukunft, sei es als Wunschvorstellung von einer Welt ohne Homofeindlichkeit oder als Warnung vor einer dystopischen Zukunft der Unterdrückung, die es mit allen Mitteln zu verhindern gilt.

might be triggered as a survivor of the camps, we might be empowered as an AIDS activist from North America, or nostalgic for the *Schwulenbewegung* in the 1970s. We might remember the fate of men we identify *with* while also feeling all these things simultaneously. In all these cases, the triangle becomes a bridge between a past of injury and a complicated present. It also remains a bridge toward the future, either imagining a world devoid of homophobia or a warning for a dystopic future of oppression that needs to be thwarted.

1 David M. Fetterman, "The U.S. Holocaust Memorial Museum Dedication: Standing in the Presence of History," *San Francisco Bay Times* (September 9, 1993): 10.

2 Rick Rose, "Museum of Pain," *The Advocate* (October 19, 1993): 40.

3 Sara Hart, "A Dark Past Brought to Light," *10 Percent* (Winter 1993): 74.

4 Sébastien Tremblay, "'Ich konnte ihren Schmerz körperlich spüren': Die Historisierung der NS-Verfolgung und die Wiederaneignung des Rosa Winkels in der westdeutschen Schwulenbewegung der 1970er Jahre," *INVERTITO* 1 (2019): 179–202.

5 Regarding queer history, Lauren Berlant has written about the political repertoires offered by readings of survival stories: Lauren Berlant, "Introduction: Affect in the Present,"

Anmerkung des Autors: Diese deutsche Version des Aufsatzes ist eine Übersetzung des englischen Originals.

1 David M. Fetterman, The U.S. Holocaust Memorial Museum Dedication: Standing in the Presence of History, in: San Francisco Bay Times, 9.9.1993, S. 10.

2 Rick Rose, Museum of Pain, in: The Advocate, 19.10.1993, S. 40.

3 Sara Hart, A Dark Past Brought to Light, in: 10 Percent, Winter 1993, S. 74.

4 Sébastien Tremblay, „Ich konnte ihren Schmerz körperlich spüren": Die Historisierung der NS-Verfolgung und die Wiederaneignung des Rosa Winkels in der westdeutschen Schwulenbewegung der 1970er Jahre, in: Invertito 2019/1, S. 179–202.

5 Hinsichtlich der Schwulengeschichte schrieb Lauren Berlant über die politischen Repertoires, die verschiedene Lesarten der Schilderungen Überlebender zulassen: Lauren Berlant, Introduction: Affect in the Present, in: Lauren Berlant (Hg.), Cruel Optimism, Durham 2011, S. 1–22.

6 Stefan Micheler, „Und verbleibt weiter in Sicherungsverwahrung" – Kontinuitäten der Verfolgung Männer begehrender Männer in Hamburg 1945–1949, in: Andreas Pretzel u.a. (Hg.), Ohnmacht und Aufbegehren, Hamburg 2010, S. 62–90.

7 Tremblay 2019 (wie Anm. 4), S. 185.

8 Vgl. beispielsweise Alfred Heinlein, Massenmord an Homos bis heute unaufgeklärt, in: Emanzipation: Zeitschrift Homosexueller Gruppen 1975/3, S. 1–3; Helene, Diskussionsbeiträge des Rosa Winkel Kollektivs: Warum tragen wir den Rosa Winkel?, in: Der Rosa Winkel 1975/1, S. 28–39.

9 L. D. Classen von Neudegg, Die Dornenkrone. Ein Bericht aus dem KZ Sachsenhausen, in: Humanitas 1954/2, S. 58–60.

10 B. M., „Die Runde". Les Homophiles dans les camps de concentration de Hitler, in: Arcadie 1960/10, S. 616–618.

11 Zur Rosa-Winkel-Aktion: SMU Berlin, Sammlung Holy, Ordner 027 GLF Köln 1978–1980 und Ordner 028 SAK.

12 Ebd., Ordner 028 SAK.

13 Ebd., Flugblatt Gay Freedom Day.

14 Ira Glasser, The Yellow Star and the Pink Triangle, in: The New York Times, 10.9.1975.

15 Jake Newsome, Pink Triangle Legacies, Ithaca 2022.

16 Paragraf 19 des Berichts der UN Eco/Soc Sub-Commission on Prevention of Discrimination and Protection of Minorities, National Archive of LGBT History, Collection 121, Box 1, Folder 17, UN – Minority Report and Sub-Commission Info.

17 NYPL MS ACT UP, Reihe II. Minutes Box 3. Folder 3 Minutes, ACT UP / NY Minutes, Juni 1987.

18 Siehe beispielsweise eine Karikatur, die Peter Gauweiler bei der Gründung neuer Konzentrationslager für AIDS-Kranke zeigt, in: Rosa Flieder, 1987/52, S. 11.

19 Ulrich Würdemann, Schweigen = Tod, Aktion = Leben: Act Up in Deutschland 1989 bis 1993, Berlin 2017, S. 32.

20 Jeffrey C. Alexander, Toward a Theory of Cultural Trauma, in: Alexander Jeffrey u.a. (Hg.), Cultural Trauma and Collective Identity, Berkeley 2004, S. 1–30.

21 Ernst van Alpen, Symptoms of Discursivity: Experience, Memory, and Trauma, in: Mieke Bal u.a. (Hg.), Acts of Memory: Cultural Recall in the Present, Hannover 1999, S. 24–38.

22 Zu den konstruktivistischen Nutzungen von Traumata siehe Susan Brillon, Trauma Narratives and the Remaking of the Self, in: Bal 1999 (wie Anm. 21), S. 41.

23 Zu einer heteronormativen Analyse der Tradierung von Traumata in Familien anhand von Bildern siehe Marianne Hirsch, The Generation of Postmemory: Writing and Visual Culture After the Holocaust, New York 2012.

24 Vgl. z.B. Seymour Kleinberg, The Homosexual as Jew, in: Christopher Street, 1983/7, S. 35.

25 Larry Kramer, Reports from the Holocaust: The Story of an AIDS Activist, New York 1994, S. 229.

26 James D. Steakley, Selbstkritische Gedanken zur Mythologisierung der Homosexuellenverfolgung im Dritten Reich, in: Burkhard Jellonek u.a. (Hg.), Nationalsozialistischer Terror gegen Homosexuelle. Verdrängt und ungesühnt, Paderborn 2002, S. 55–68.

27 Aleida Assmann, The Holocaust: A Global Memory? Extensions and limits of a new memory community, in: Aleida Assmann u.a. (Hg.), Memory in a Global Age: Discourses Practices and Trajectories, Basingstoke 2010, S. 97–117; Jeffrey C. Alexander, On the Social Construction of Moral Universals. The „Holocaust" from War Crime to Trauma Drama, in: European Journal of Social Theory, 2002/1, S. 5–85.

in *Cruel Optimism*, ed. Lauren Berlant (Durham, NC: Duke University Press, 2011), 1–22.

6 Stefan Micheler, "'…Und Verbleibt Weiter in Sicherungsverwahrung' – Kontinuitäten Der Verfolgung Männer Begehrender Männer in Hamburg 1945–1949," in *Ohnmacht und Aufbegehren*, eds. Andreas Pretzel et al. (Hamburg: Männerschwarm, 2010), 62–90.

7 Tremblay, "Ich konnte ihren Schmerz," 185 (see note 4).

8 As examples: Alfred Heinlein, "30 Jahre später…? Massenmord an Homos bis heute unaufgeklärt," *Emanzipation Zeitschrift Homosexueller Gruppen* 3 (1975): 1–3; Helene, "Diskussionsbeiträge des Rosa Winkel Kollektivs: Warum tragen wir den Rosa Winkel?," *Der Rosa Winkel* 1 (1975): 28–39.

9 L. D. Classen von Neudegg, "Die Dornenkrone: Ein Bericht aus dem KZ Sachsenhausen," *Humanitas* 2 (1954): 58–60.

10 B. M., "Die Runde, Les Homophiles dans les camps de concentration de Hitler," *Arcadie* 10 (1960): 616–18.

11 This campaign was called the "Rosa Winkel-Aktion." SMU Berlin, Sammlung Holy, Folder 027 *GLF Köln 1978-1980* and Folder 028 *SAK*.

12 SMU Berlin, Sammlung Holy, Folder 028 *SAK*.

13 Flyer, Gay Freedom Day, in SMU Berlin, Sammlung Holy, Folder 028 *SAK*.

14 Ira Glasser, "The Yellow Star and the Pink Triangle," *The New York Times* (September 10, 1975).

15 Jake Newsome, *Pink Triangle Legacies* (Ithaca, NY: Cornell University Press, 2022).

16 §19 Report of UN Eco/Soc Sub-Commission on Prevention of Discrimination and Protection of Minorities, National Archive of LGBT History, Collection 121, Box 1, Folder 17, *UN – Minority Report and Sub-Commission Info*.

17 NYPL MS ACT UP, Series II. Minutes Box 3. Folder 3 Minutes, *ACT UP / NY Minutes, June 1987*.

18 See for example a caricature portraying Peter Gauweiler preparing new concentration camps for people living with AIDS in *Rosa Flieder* 52 (1987): 11.

19 Ulrich Würdemann, *Schweigen = Tod, Aktion = Leben: Act Up in Deutschland 1989 Bis 1993* (Berlin, 2017), 32.

20 Jeffrey C. Alexander, "Toward a Theory of Cultural Trauma," in *Cultural Trauma and Collective Identity*, eds. Alexander Jeffrey, Ron Eyerman, and Bernard Giesen (Berkeley, CA, 2004), 1–30.

21 Ernst van Alpen, "Symptoms of Discursivity: Experience, Memory, and Trauma," in *Acts of Memory: Cultural Recall in the Present*, eds. Mieke Bal et al. (Hanover, NH, 1999), 24–38.

22 On the constructivist uses of trauma, see Susan Brillon, "Trauma Narratives and the Remaking of the Self," *Acts of Memory: Cultural Recall in the Present*, eds. Mieke Bal et al. (Hanover, NH, 1999), 41.

23 For a heteronormative analysis of the transmission of trauma in family circles using visuals, see Marianne Hirsch, *The Generation of Postmemory: Writing and Visual Culture After the Holocaust* (New York City 2012).

24 For example: Seymour Kleinberg, "The Homosexual as Jew," *Christopher Street* 7 (1983): 35.

25 Larry Kramer, *Reports from the Holocaust: The Story of an AIDS Activist* (New York: St. Martin's Press, 1994), 229.

26 James D. Steakley, "Selbstkritische Gedanken zur Mythologisierung der Homosexuellenverfolgung im Dritten Reich," in *Verdrängt und Ungesühnt*, eds. Burkhard Jellonek et al. Verdrängt und ungesühnt (Paderborn, 2002), 55–68.

27 Aleida Assmann, "The Holocaust: A Global Memory? Extensions and limits of a new memory community," in *Memory in a Global Age: Discourses Practices and Trajectories*, eds. Aleida Assmann et al. (Basingstoke 2010), 97–117; Jeffrey C. Alexander, "On the Social Construction of Moral Universals. The 'Holocaust' from War Crime to Trauma Drama," *European Journal of Social Theory* 1 (2002): 5–85.

EPILOG

Queere Geschichte wird nach 1945 kaum erinnert oder archiviert. Bis heute kennen wir nur einen Teil der Vorreiter*innen der queeren Emanzipationsbewegung. Noch weniger wissen wir über das Leben derjenigen, die verfolgt, ins Exil getrieben, ermordet wurden – oder einfach unsichtbar geblieben sind.

Nach Kriegsende werden queere Menschen weiter ausgegrenzt. Besonders schwule Männer leiden in großer Zahl weiter unter Paragraf 175. Viele von ihnen kommen nicht frei, sondern werden aus den Konzentrationslagern direkt in Gefängnisse überführt.

Die anhaltende Diskriminierung durch Staat und Gesellschaft ändert sich nur langsam. 1969 wird Paragraf 175 reformiert und das Strafrecht liberalisiert. Ab den 1970er Jahren entstehen neue soziale Bewegungen, darunter auch eine homosexuelle Emanzipationsbewegung. Einzelne Gruppen reklamieren den „Rosa Winkel" als Symbol, um mit ihm für die Rechte queerer Menschen einzutreten.

Auch lesbische und feministische Gruppen gewinnen in den 1970er Jahren an Zuspruch. Obwohl lesbische Sexualität nicht direkt staatlich verfolgt wird, leiden viele unter der frauenfeindlichen Rechtslage. Die gesetzliche Besserstellung von Männern macht das Ausleben lesbischer Beziehungen durch Diskriminierungen im Arbeits- und Eherecht schwer.

Das Aufkommen von HIV in den 1980er Jahren trifft viele schwule Männer und trans* Menschen: Tausende infizieren sich, erkranken an AIDS und sterben. Der Staat hilft nicht, sondern setzt auf stigmatisierende Maßnahmen und eine aggressive Rhetorik der Ausgrenzung, vor allem in Bayern. Das lässt die Betroffenen an die zurückliegende Zeit der offenen Verfolgung denken.

Dank des Einsatzes von Aktivist*innen verbessert sich die gesundheitliche, politische und gesellschaftliche Situation von LGBTIQ* seit den 1990er Jahren. Heute können queere Menschen in Deutschland einige Errungenschaften feiern und sind auch politisch vertreten. Dennoch bleibt für die Gleichberechtigung von LGBTIQ* noch viel zu tun. An vielen Orten der Welt verschlechtert sich die Lage zunehmend wieder. Insbesondere trans* Personen sind nach wie vor großer Diskriminierung ausgesetzt.

Der Einsatz für queere Selbstbestimmung ist damit nicht vorbei, sondern aktueller denn je. Denn am Ende sorgt er nicht nur für die Wahrung von LGBTIQ*-Menschenrechten, sondern schafft eine gerechtere Gesellschaft für alle.

EPILOGUE

Queer history was hardly remembered or archived after 1945. To this day, we know only some of the pioneers of the queer emancipation movement. We know even less about the life of those who were persecuted, driven into exile, murdered – or simply remained invisible.

After the end of the war, queer people continued to be marginalized. Gay men in particular continued to suffer in large numbers under Paragraph 175, many of whom did not go free but were transferred from concentration camps directly to prisons.

The ongoing discrimination by state and society changed only slowly. In 1969, Paragraph 175 was reformed and criminal law liberalized. Beginning in the 1970s, new social movements emerged, including a homosexual emancipation movement. Various groups reclaimed the "pink triangle" as a symbol to stand up for the rights of queer people.

Lesbian and feminist groups also gained popularity during the 1970s. Although lesbian sexuality was not directly persecuted by the state, many suffered from the misogynistic legal situation. The legal preferential treatment of men made it difficult to live out lesbian relationships, due to discrimination in labor and marriage laws.

The emergence of HIV in the 1980s affected many gay men and trans+ people: thousands became infected, developed AIDS, and died. The state did not help, but instead relied on stigmatizing measures and an aggressive rhetoric of exclusion, especially in Bavaria. For those affected, this recalled the previous period of open persecution.

Thanks to the efforts of activists, the health, political, and social situation of LGBTIQ+ people has improved since the 1990s. Today, queer people in Germany can celebrate some achievements and are also represented in politics. However, much remains to be done for LGBTIQ+ equality. In many places around the world the situation is increasingly deteriorating. Trans+ people in particular continue to face great discrimination.

Therefore, the commitment to queer self-determination is not over, but more relevant than ever. Because in the end, it not only ensures the preservation of LGBTIQ+ human rights, but creates a more just society for all.

2008

Das Denkmal für die im Nationalsozialismus verfolgten Homosexuellen wird im Berliner Tiergarten eingeweiht.

The memorial to homosexuals persecuted under Nationalsocialism is inaugurated in Berlin's Tiergarten park.

AUTOR*INNEN

Gürsoy Doğtaş ist Kunsthistoriker und arbeitet para-kuratorisch an den Schnittpunkten zu Institutionskritik, strukturellem Rassismus und Queerstudies. Er promovierte an der LMU München über *Chantal Mouffes Demokratietheorie im Ausstellungsdiskurs der Biennalen* (2020). Neben Ausstellungen kuratierte er u.a. das diskursive Programm Public Art Munich (2018), „The kültür gemma! issue" des *Parabol Art Magazine* (2021) oder ko-kuratierte das Symposium *Das Recht auf Erinnern und die Realität der Städte* in Nürnberg (2021). Er gehört zum Kernkollektiv re:boot und organisierte in diesem Rahmen das Panel *Nach allen Regeln der Ausgrenzung – über die Notwendigkeit eines institutionellen Verhaltenskodex* (2021). Er forscht an der Universität für angewandte Kunst in Wien.

Michaela Dudley, eine trans* Frau und Queerfeministin mit afroamerikanischen Wurzeln, ist Autorin, Kabarettistin und Keynote-Rednerin. Bekannt ist sie für ihre Fernsehauftritte, die Kolumne „Frau ohne Menstruationshintergrund" in der *TAZ* und Beiträge in Medien wie *Der Tagesspiegel, das goethe, Missy Magazine, RosaMag* und dem LGBTI*-Magazin *Siegessäule.* 2022 erschien ihr Buch *Race Relations. Essays über Rassismus.* Die gelernte Juristin (Juris Dr., US) arbeitet außerdem als Diversity-Beraterin.

Sander L. Gilman ist Distinguished Professor emeritus of the Liberal Arts and Sciences, emeritierter Professor für Psychiatrie an der Emory University, Atlanta, Ehrendoktor der Rechtswissenschaften der University of Toronto und Honorarprofessor an der Freien Universität Berlin. Zudem engagiert er sich als Ehrenmitglied der American Psychoanalytic Association sowie Fellow der American Academy of Arts and Sciences. Er verfasste über hundert Bücher, darunter *Gebannt in diesem magischen Judenkreis* (2022), *The Oxford Handbook of Music and the Body* (mit Youn Kim, 2019), *Seeing the Insane* (1982) und *Jüdischer Selbsthass. Antisemitismus und verborgene Sprache der Juden* (1986).

Dagmar Herzog ist als Distinguished Professor of History am Graduate Center der City University of New York tätig. Zu ihren Veröffentlichungen zählen u.a. *Die Politisierung der Lust. Sexualität in der deutschen Geschichte des 20. Jahrhunderts* (2005, 2021), *Sexuality in Europe. A Twentieth-Century History* (2011), *Lust und Verwundbarkeit* (2017), *Unlearning Eugenics* (2018) und *Cold War Freud. Psychoanalyse in einem Zeitalter der Katastrophen* (2017, 2023). Gemeinsam mit Chelsea Schields gab sie das Werk *The Routledge Companion to Sexuality and Colonialism* (2021) heraus. Derzeit forscht sie zur Politik der Behinderung in Deutschland.

AUTHORS

Gürsoy Doğtaş is an art historian and works as a para-curator at the intersections of institutional critique, structural racism, and queer studies. He earned his PhD at the University of Munich with the dissertation *Chantal Mouffe's Theory of Democracy in the Exhibition Discourse of the Biennales* (2020). In addition to various exhibitions, he has curated the public program Public Art Munich (2018), "The kültür gemma! issue" of *Parabol Art Magazine* (2021), and co-curated the symposium "The Right to Remember and the Reality of Cities" in Nuremberg (2021). He is a member of the *reboot:* collective and organized within this framework the panel discussion *By Every Trick of Exclusion – On the Necessity of an Institutional Code of Behavior* (2021). He currently conducts research at the University of Applied Arts Vienna.

Michaela Dudley, a trans+ woman and queer feminist with African American roots, is an author, cabaret performer, and keynote speaker. She is known for her television appearances, the newspaper column "Women without Menstruation Background" in the *TAZ*, and articles in media such as *Der Tagesspiegel, das goethe, Missy Magazine, RosaMag,* and the LGBTIQ+ magazine *Siegessäule.* Her book *Race Relations. Essays über Rassismus* (Essays on Racism) was published in 2022. She holds a doctor of laws degree (Juris Dr., US) and works as a diversity consultant.

Sander L. Gilman is Distinguished Professor emeritus of the Liberal Arts and Sciences as well as emeritus Professor of Psychiatry at Emory University. He has been awarded a doctor of laws degree (*honoris causa*) at the University of Toronto, elected an honorary professor of the Free University in Berlin, and made an honorary member of the American Psychoanalytic Association and a fellow of the American Academy of Arts and Sciences. He is the author or editor of over one hundred books, including: *Gebannt in diesem magischen Judenkreis* (2022), *The Oxford Handbook of Music and the Body* (with Youn Kim, 2019), *Seeing the Insane* (1982), and *Jewish Self-Hatred* (1986).

Dagmar Herzog is Distinguished Professor of History at the Graduate Center, City University of New York. Her books include: *Sex after Fascism: Memory and Morality in Twentieth-Century Germany* (2005, 2021), *Sexuality in Europe: A Twentieth-Century History* (2011), *Cold War Freud: Psychoanalysis in an Age of Catastrophes* (2017, 2023), *Unlearning Eugenics: Sexuality, Reproduction, and Disability in Post-Nazi Europe* (2018), and (coedited with Chelsea Schields) *The Routledge Companion to Sexuality and Colonialism* (2021). She currently researches the politics of disability in twentieth-century Germany.

Ulrike Klöppel, Diplom-Psycholog*in und promoviert im Fach Soziologie, ist wissenschaftliche*r Mitarbeiter*in am Institut für Geschichte und Ethik der Medizin der Ruprecht-Karls-Universität Heidelberg im DFG-Projekt *„Frauen in ver-rückten Lebenswelten" – Diskurse und Praktiken im Umgang mit „Verrücktheit" in der westdeutschen Frauengesundheitsbewegung von den 1970er bis in die 1990er Jahre*. Weitere Arbeitsschwerpunkte sind die Geschichte der AIDS-Bewegung, die Medikalisierung intergeschlechtlicher Menschen in Geschichte und Gegenwart sowie Geschlechtstransitionen in der DDR.

Karolina Kühn ist Literaturwissenschaftlerin und Kuratorin am NS-Dokumentationszentrum München. Von 2013 bis 2020 verantwortete sie den Ausstellungsbereich im Literaturhaus München, zuvor war sie als wissenschaftliche Mitarbeiterin im Buddenbrookhaus Lübeck tätig. Zu ihren inhaltlichen Schwerpunkten zählen u.a. die Themenfelder Exil, Erinnerungskultur und Diversität. Als leitende Kuratorin von *TO BE SEEN. queer lives 1900–1950* forschte sie zur Geschichte von LGBTIQ* in der ersten Hälfte des 20. Jahrhunderts.

Ben Miller ist Autor und Forscher mit Sitz in Berlin. Gemeinsam mit Huw Lemmey verfasste er das Buch *Bad Gays. A Homosexual History* (2022), das auf dem gleichnamigen Podcast basiert und sich vehement für eine komplexere, stärker politisch geprägte queere Public History ausspricht. Derzeit ist Ben Miller Doktorand am Graduiertenkolleg Global Intellectual History an der Freien Universität Berlin. Seine wissenschaftlichen Beiträge erschienen in *Radical History Review* und *Invertito*. Als Journalist und Kritiker schreibt er regelmäßig für die *New York Times* und die Zeitschrift *Literary Hub*. Seit 2018 zählt er zum Vorstand des Schwulen Museums Berlin, einer der weltweit größten unabhängigen Institutionen, die sich der Archivierung und Erhaltung der Geschichte und visuellen Kultur von LGBTIQ*-Menschen widmet.

Cara Schweitzer studierte Kunstgeschichte und Theologie in Berlin und Rom. Seit 2007 ist sie freiberufliche Kunsthistorikerin. Sie schreibt über die Kunst der Avantgarden zu Beginn des 20. Jahrhunderts mit dem Schwerpunkt auf Künstler*innenbiografien. 2011 erschien ihr Buch *Schrankenlose Freiheit für Hannah Höch*.

Sébastien Tremblay, geboren in Montreal, Tiohtià:ke, ist wissenschaftlicher Mitarbeiter an der Europa-Universität Flensburg. Er war assoziierter Forscher für queere Geschichte am Goldsmiths in London und Postdoktorand am Internationalen Forschungskolleg des DFG-Exzellenzclusters SCRIPTS. 2020 promovierte er an der Freien Universität Berlin. Derzeit arbeitet er an seiner ersten Monografie *A Badge of Injury. The Pink Triangle as Global Symbol of Queer Identities in the 20th Century*.

Ulrike Klöppel, degree in psychology and PhD in sociology, is a research assistant at the Institute for Medical History and Ethics at Heidelberg University as part of the research project "'Women in Mad Lifeworlds' – Discourses and Practices in Dealing with 'Madness' in the West German Women's Health Movement from the 1970s to the 1990s." Further research interests include: history of AIDS activism, medicalization of intersex people in history and at present, gender transitions in East Germany.

Karolina Kühn is a literary scholar and curator at the Munich Documentation Center for the History of National Socialism. From 2013 to 2020 she was responsible for the exhibition section at the Literaturhaus in Munich; before that, she worked as a research assistant at the Buddenbrookhaus in Lübeck. Her main areas of expertise include exile, culture of remembrance, and diversity. As lead curator of *TO BE SEEN. queer lives 1900–1950*, she conducted research on the history of LGBTIQ+ in the first half of the twentieth century.

Ben Miller is a writer and researcher in Berlin. With Huw Lemmey, he is the author of *Bad Gays: A Homosexual History* (2022), a book based on the podcast of the same name, which passionately argues for a more complex and political queer public history. He is currently a Doctoral Fellow at the Graduate School of Global Intellectual History at the Free University in Berlin. His academic work has been published in *Radical History Review* and *Invertito*, and as a journalist and critic he is a regular contributor to the *New York Times* and *Literary Hub*. Since 2018 he has been a member of the Board of Directors of the Schwules Museum Berlin, one of the world's largest independent institutions devoted to archiving and preserving LGBTIQ+ histories and visual culture.

Cara Schweitzer studied art history and theology in Berlin and Rome. She has worked as a freelance art historian since 2007, writing on the art of the avant-gardes in the early twentieth century with an emphasis on artist biographies. Her book *Schrankenlose Freiheit für Hannah Höch* (Limitless Freedom for Hannah Höch) appeared in 2011.

Sébastien Tremblay was born in Montreal (Tiohtià:ke) and is associate professor at the Europa-Universität Flensburg. He previously was guest researcher for queer history at Goldsmiths University in London and post-graduate fellow at the International Research College of the DFG Excellency Cluster SCRIPTS. In 2020 he completed his doctorate at the Free University in Berlin. At present he is working on his first study, *A Badge of Injury: The Pink Triangle as Global Symbol of Queer Identities in the 20th Century*.

Mirjam Zadoff ist Direktorin des NS-Dokumentationszentrums in München, zuvor war sie Inhaberin des Alvin H. Rosenfeld Chairs in Jewish Studies und Professorin für Geschichte an der Indiana University Bloomington und hatte zahlreiche Gastprofessuren inne. Zu ihren aktuellen Publikationen zählen *Annette Kelm. Die Bücher*, hg. gemeinsam mit Udo Kittelmann und Nicolaus Schafhausen (2022), *„Aus der Erinnerung für die Gegenwart leben." Geschichte und Wirkung des Shoah-Überlebenden Ernst Grube*, hg. mit Matthias Bahr und Peter Poth (2022) und *Tell me about yesterday tomorrow. Über die Zukunft der Erinnerung*, hg. gemeinsam mit Nicolaus Schafhausen (2020).

Mirjam Zadoff is the director of the Munich Documentation Center for the History of National Socialism, and previously held the Alvin H. Rosenfeld Chair in Jewish Studies and was a professor of history at Indiana University Bloomington and has held numerous visiting professorships. Her recent publications include *Annette Kelm. Die Bücher*, co-edited with Udo Kittelmann and Nicolaus Schafhausen (2022), *"Aus der Erinnerung für die Gegenwart leben." Geschichte und Wirkung des Shoah-Überlebenden Ernst Grube*, co-edited with Matthias Bahr and Peter Poth (2022), and *Tell me about yesterday tomorrow. Über die Zukunft der Erinnerung*, co-edited with Nicolaus Schafhausen (2020).

BILDNACHWEIS / IMAGE CREDITS

Arolsen Archives
S. 343 (rechts) (10777940), S. 347 (129642948_01), S. 349 (3218789)

akg-images
S. 166, S. 230 (Berlinische Galerie, Hannah-Höch-Archiv), S. 244 (© Renee Sintenis/VG Bild-Kunst), S. 260 (Mondadori Portfolio/Archivio GBB), S. 273 (Mondadori Portfolio/Archivio GBB, Foto: Hans Robertson), S. 324

Alamy
S. 257, S. 264, S. 265, S. 288 (Heritage Image Partnership Ltd/Alamy Stock Photo)

Arkivi-Bildagentur
S. 99 (Mitte)

Bauhaus-Archiv Berlin
S. 242 (F5327/1), S. 248 (© Archiv Peiffer Watenphul)

Bayerisches Hauptstaatsarchiv
S. 339–341 (Innenministerium, 30732-1)

Bayerische Staatsbibliothek München
S. 34 (Med.for. 3 wf), S. 37 (Pol.g. 251w-1/2), S. 161 (Path. 8 c-1), S. 252 (P.o.germ. 150b), S. 254 (DD.I 5594 c), S. 323 (Bildarchiv, Heinrich Hoffmann, hoff-8250)

Berlinische Galerie – Landesmuseum für Moderne Kunst, Fotografie und Architektur
S. 229 (Anja Elisabeth Witte), S. 243 (unten) (Anja Elisabeth Witte)

bpk Bildagentur
S. 38 (Stiftung Deutsches Historisches Museum/Sebastian Ahlers) S. 99 (unten) (Stiftung Deutsches Historisches Museum/Sebastian Ahlers), S. 103 (Mitte rechts), S. 170 (Kunstbibliothek, SMB, Photothek Willy Römer/Willy Römer), S. 172 (Kunstbibliothek, SMB, Photothek Willy Römer/Willy Römer), S. 235 (Bayerische Staatsgemäldesammlungen), S. 256 (Stiftung Deutsches Historisches Museum/Indra Desnica)

Bruno Balz Archiv
S. 258 (beide), S. 259

Bundesarchiv
S. 103 (183-1983-0121-500) (Mitte links), S. 331 (Reichsschrifttumskammer Personalakte Ebermayer, R 9361-V/17085)

Comune di Minusio – Centro Elisarion
S. 237

Deutsches Theatermuseum München, Archiv Hanns Holdt
S. 270 (links)

DFF – Deutsches Filminstitut & Filmmuseum e.V.
S. 79

E. J. Pratt Library
S. 261 (© Bridgeman Images)

ETH-Bibliothek Zürich, Thomas-Mann-Archiv
S. 253 (B-I-WITK-26) (Der Abdruck erfolgt mit freundlicher Genehmigung des S. Fischer Verlags, Frankfurt am Main), S. 356 (links) (TMA_0730)

FFBIZ – Das feministische Archiv
S. 334 (B Rep. 500 Acc. 400 – 29.4 Nr. 153 – Friederike Wieking (4836))

Filmarchiv Austria
S. 176

Forum Queeres Archiv München e.V.
S. 32, S. 35, S. 43, S. 83, S. 89, S. 92, S. 98 (rechts), S. 99 (oben), S. 100 (beide), S. 106, S. 107, S. 155, S. 177, S. 234

Frauen-Kultur-Archiv, Düsseldorf
S. 82

FrauenMediaTurm – Feministisches Archiv und Bibliothek
S. 36

Friedrich-Ebert-Stiftung e.V.
S. 93 (rechts)

Georg Kolbe Museum
S. 245

Herbert List/Magnum Photos/Agentur focus
S. 231

Heritage Image Partnership Ltd/ Alamy Stock Photo
S. 288

Herzog Anton Ulrich-Museum Braunschweig
S. 297 (ZL 95/6654)

Hessisches Hauptstaatsarchiv Wiesbaden
S. 346 rechts (HHStAW Best. 631a Nr. 1619)

Jersey Heritage Collection
S. 360 (JHT/1995/00030/u), S. 361 (oben) (JHT/2003/00001/011), S. 361 (unten) (JHT/1995M/00045/53.15)

Jüdisches Museum Berlin
S. 344 (oben) (2006/37/506, Schenkung von Elisabeth Wust), S. 344 (unten) (2006/37/87, Schenkung von Elisabeth Wust), S. 345 (2006/37/486, Schenkung von Elisabeth Wust)

Kunsthaus Zürich
S. 296 (© 2019 ProLitteris, Zürich)

Landesarchiv Berlin
S. 101 (A Rep. 358-02, Nr. 132648), S. 105 (A Pr. Br. Rep. 030, Nr. 16935), S. 179 (oben) (C Rep. 118-01, Nr. A 14093), S. 348 (A Pr. Br. Rep. 030-02-05, Tit. 198a 5, Nr. 169)

Magnus-Hirschfeld-Gesellschaft e.V., Berlin
S. 33, S. 93 (beide), S. 95, S. 165, S. 167, S. 169, S. 170, S. 171, S. 173 (beide), S. 174 (beide), S. 175, S. 183, S. 355

Mahn- und Gedenkstätte Ravensbrück
S. 352 (V783 E1)

Martini & Ronchetti, Courtesy Archives Florence Henri
S. 299

Münchner Stadtbibliothek/Monacensia
S. 330 (P-a 1481), S. 356 (rechts) (EM pepermill 14), S. 357 (KM F 134)

Museen der Stadt Aschaffenburg
S. 241 (MSA Dep. KGKS 1/1986, © Christian Schad Stiftung Aschaffenburg/VG Bild-Kunst)

Museum Utopie und Alltag, Beeskow
S. 179 (unten) (Foto: Thomas Kläber)

Nachlass Madame d'Ora, Museum für Kunst und Gewerbe Hamburg
S. 272 (rechts), S. 274

NIOD Instituut voor Oorlogs-, Holocaust- en Genocidestudies, Amsterdam
S. 362 (Archief 250k invno 603: Maria Johanna Vaders), S. 364 (Beeldbank WO2)

NS-Dokumentationszentrum München
S. 189

Paris Musées, musée d'Art moderne, Dist. RMN-Grand Palais/image ville de Paris
S. 233

Privatbesitz
S. 249, S. 325

Privatbesitz Andreas Hain
S. 243 (oben)

Privatbesitz Rainer Herrn
S. 91, S. 97 (oben) (aus: Das
3. Geschlecht, 1931/4)

Privatbesitz Katja Koblitz, Berlin
S. 42

**Privatbesitz Julis Kumermann
(Neffe von Lina Kümmermann)/Astrid
Louven**
S. 346 (links)

Privatbesitz Sascha Lickes
S. 343 (links)

Privatbesitz Jan van Ommen
S. 363

Privatbesitz F. Pfäfflin, Ulm
S. 81, S. 94

**Queerrörelsens Arkiv och Bibliotek,
Göteborg**
S. 178

Querverlag Berlin
S. 251

Schwules Museum, Berlin
S. 86, S. 87, S. 88, S. 98 (links), S. 103
(unten), S. 276, S. 277

Sigmund Freud Museum, Wien
S. 159

**Spinnboden Lesbenarchiv &
Bibliothek e. V.**
S. 90, S. 102

Staatsarchiv Hamburg
S. 350 (links) (242-4 Kriminalbiologische
Sammelstelle, 339), S. 351 (242-4
Kriminalbiologische Sammelstelle, 339),
S. 350 (rechts) (741-4, Fotoarchiv,
P54705.104)

Staatsarchiv Ludwigsburg
S. 108–109 (alle) (F 263 I, St 50)

Staatsarchiv München
S. 338 (LRA 151016, Meldung der
Gendarmerie-Station Tegernsee vom
13. November 1934)

Staatsarchiv Würzburg
S. 342 (Gestapo Wü 8873 V, Bl. 194),
S. 358 (Gestapo Wü 16015, Bl. 1), S. 359
(Inv.-Nr. Gestapo Wü 16015, bei Bl. 71/72
(ohne Paginierung))

**Staatsbibliothek zu Berlin –
Preußischer Kulturbesitz**
S. 77 (Abteilung Handschriften und
Historische Drucke, Portr. Slg/Med. kl/
Hirschfeld, Magnus, Nr. 1)

Staatsgalerie Stuttgart
S. 246–247 (Graphische Sammlung,
Sammlung Dietmar Siegert)

Stadsarchief Amsterdam
S. 365 (ANWD00676000007)

Stadtarchiv Bamberg
S. 80 (BS (B) + 483 Schedel, Joseph
H021 B003), S. 85 (NL Joseph Schedel
D 1002 + 62)

Stadtarchiv Mühldorf
S. 168

Stadtarchiv München
S. 97 (unten) (DE-1992-FS-PK-
STB-04231), S. 326 (NL_STAD-1, 9)

Stadtgeschichtliches Museum Leipzig
S. 263 (I N 1558/1)

**Städtische Galerie im Lenbachhaus
und Kunstbau München**
S. 271

Stiftung Stadtmuseum Berlin
S. 39 (TA 99/2597 VF), S. 40 (TA 00/29
QA), S. 41 (TA 00/30 QA), S. 238
(Reproduktion: Dorin Alexandru Ionita,
SM 2021-01132), S. 239 (SM 2018-01227,
© VG Bild-Kunst, Bonn; Reproduktion:
Matthias Viertel), S. 272 (links) (Archiv
Deutsche Staatsoper, Reproduktion:
Michael Setzpfandt)

Süddeutsche Zeitung Photo
S. 332, S. 333 (© Scherl)

Theatermuseum Düsseldorf
S. 255

The Chicago Tribune
S. 157

ullstein bild – Becker & Maass
S. 335 (02629497)

**Universitätsklinikum Hamburg-
Eppendorf, Ärztliche Zentralbibliothek**
S. 78

**University of Iowa Libraries, Lil Picard
Papers**
S. 266, S. 267

**University of Iowa, Stanley
Museum of Art**
S. 268–269

Volk Verlag
S. 160

Wellcome Collection
S. 156, S. 180, S. 185, S. 186, S. 188

Wien Museum
S. 353 (309734/12, „Passion des XX.
Jahrhunderts", Blatt 10)

Wikimedia Commons
S. 84, S. 158, S. 181, S. 182 (Centre
Pompidou, MNAM-CCI, JP 445 P),
S. 270 (rechts), S. 327 (Foto: George
Rodger, LIFE Magazin)

Zirkusarchiv Winkler, Berlin
S. 275

ZUMA Press
S. 164

IMPRESSUM / COLOPHON

Diese Publikation erscheint anlässlich der Ausstellung | This catalog has been published to accompany the exhibition

TO BE SEEN. queer lives 1900–1950
7.10.2022–21.05.2023

NS-Dokumentationszentrum München | Munich Documentation Center for the History of National Socialism, Max-Mannheimer-Platz 1, D-80333 München | Munich

Schirmfrau | Patronage
Claudia Roth MdB, Staatsministerin für Kultur und Medien | Minister of State for Culture and the Media

Direktorin | Director
Mirjam Zadoff

Leitung Ausstellungen | Head of Exhibitions
Anke Hoffsten

Kuratorische Leitung | Head Curator
Karolina Kühn

Kurator*innen | Curators
Juliane Bischoff, Angela Hermann, Sebastian Huber, Anna Straetmans, Ulla-Britta Vollhardt

Projektleitung | Project Management
Karolina Kühn, Anna Straetmans, Sebastian Huber

Künstlerische Beratung und Recherche | Artistic Consultant and Research
Philipp Gufler

Wissenschaftliche Beratung | Research Consultants
David Frohnapfel, Rainer Herrn, Carina Klugbauer, Albert Knoll, Claudia Schoppmann, Hannes Sulzenbacher, Niko Wahl

Presse- und Öffentlichkeitsarbeit | Public Relations
Kirstin Frieden, Ilona Holzmeier (Online-Kommunikation | Online Communication)

Veranstaltungsprogramm | Event Planning
Jonas Peter

Vermittlung | Educational Outreach
Nathalie Jacobsen, Dirk Riedel, Martin Zehetmayr

Verwaltung | Administration
Michael Busam, Susanne Lacher, Stefanie Poulios, Angela Völker, Markus Wolf

Technische Einrichtung | In-House Technicians
Joseph Köttl, Ibrahim Özcan, Omar Saleh

Ausstellungsdesign | Exhibition Design
Studio Erika, Kempten: Fabian Karrer, Lisa Bartels, Leon Beu, Lena Gröner, Julian Karrer, Julia Raschke

Restauratorinnen | Restoration
Katharina Geffken, Andrea Snigula, Kaori Nakajima

Gestaltung Werbemittel | Design of Promotional Material
Zeichen & Wunder, München

Katalog / Catalog

Herausgegeben für das NS-Dokumentationszentrum München von Karolina Kühn und Mirjam Zadoff | Edited for the Munich Documentation Center for the History of National Socialism by Karolina Kühn and Mirjam Zadoff

Redaktion | Editorial Team
Angela Hermann, Denis Heuring, Anke Hoffsten, Sebastian Huber, Karolina Kühn, Anna Straetmans, Ulla-Britta Vollhardt, Mirjam Zadoff

Projektleitung | Project Direction
Denis Heuring

Essays von | Essays by
Gürsoy Doğtaş, Michaela Dudley, Sander L. Gilman, Dagmar Herzog, Ulrike Klöppel, Ben Miller, Cara Schweitzer, Sébastien Tremblay

Projektmanagement Hirmer | Project Management Hirmer
Cordula Gielen

Deutsches Lektorat | German Copyediting
Anne Funck

Englisches Lektorat | English Copyediting
James Copeland

Übersetzung ins Deutsche | Translation into German
Birgit Lamerz-Beckschäfer

Übersetzung ins Englische | Translation into English
David Sánchez Cano

Grafik, Satz und Herstellung | Graphic Design, Typesetting, and Production
Lucia Ott

Lithografie | Prepress
Reproline mediateam GmbH & Co. KG, Unterföhring

Papier | Paper
Magno Volume 150 g/m²

Druck und Bindung | Printing and Binding
DZA Druckerei zu Altenburg GmbH

Printed in Germany

Bibliografische Information der Deutschen Nationalbibliothek
Die Deutsche Nationalbibliothek verzeichnet diese Publikation in der Deutschen Nationalbibliografie; detaillierte bibliografische Daten sind im Internet über http://www.dnb.de abrufbar.

Bibliographic information published by the Deutsche Nationalbibliothek
The Deutsche Nationalbibliothek lists this publication in the Deutsche Nationalbibliografie; detailed bibliographic data are available online at http://www.dnb.de.

© 2023 NS-Dokumentationszentrum München | Munich Documentation Center for the History of National Socialism; Hirmer Verlag GmbH, München | Munich; die Autor*innen | the authors

Fotos Ausstellungsansichten | Exhibition photographs
Conolly Weber Photography
© NS-Dokumentationszentrum München | Munich Documentation Center for the History of National Socialism

2023 VG Bild-Kunst (Seiten | Pages: 145, 239, 241, 296, 297, 299, 367–369)

© VG Bild-Kunst, Bonn 2023
Für die Werke von: Katharina Aigner, Florence Henri, Hannah Höch, Jeanne Mammen, Christian Schad, Renée Sintenis

Die Geltendmachung der Ansprüche gemäß § 60h UrhG für die Wiedergabe von Abbildungen der Exponate erfolgt durch die VG Bild-Kunst. | The assertion of all claims according to Article 60h UrhG (Copyright Act) for the reproduction of exhibits is carried out by VG Bild-Kunst.

ISBN 978-3-7774-3992-1

www.hirmerverlag.de
www.hirmerpublishers.com

Wir danken den Leihgeber*innen, Rechteinhaber*innen sowie den zahlreichen Privatpersonen, die uns bei der Ausstellung und der Erstellung des Katalogs unterstützt haben. Sollten trotz sorgfältiger Recherche bestehende Urheberrechte übersehen worden sein, werden diese selbstverständlich im Rahmen der üblichen Vereinbarungen abgegolten. | We wish to thank the lenders, rights holders, and numerous individuals who made the exhibition and catalog possible. We have made every effort to identify copyright holders. Any copyright owner who has been inadvertently overlooked is asked to contact the publisher. Justified claims will be settled in accordance with the customary agreements.

Unser besonderer Dank gilt: | Our special thanks go to:
Muriel Aichberger, Karin Althaus, Sarah Bergh, Lutz Bertram, Birgit Bosold, Kirsten Brandt, Burcu Dogramaci, Ralf Dose, Felicia Ewert, Berti Gammenthaler, Stefan Gruhne, Anna Hájková, Uh-Seok Han, Markus Haselbeck, Lukas Hoffmann, Dierk Höhne, Carolin Jahn, Carla Knoll, Johannes Lechner, Monika Loderová, Astrid Louven, Marion Lüttig, Isabel Miecke-Meyer, Christopher Müller, Alona Pardo, Luan Pertl, Zara Jakob Pfeiffer, Peer-Olaf Richter, Alina Rückerl, Yeshi Rösch, Gaby dos Santos, Johanna Schmied, Vera Seehausen, Michael Semff, Christina Spachtholz, Linda Strehl, Sébastien Tremblay, Irmela von der Lühe, Andreas Unterforsthuber, Anne Wizorek, Raimund Wolfert, Nina Zimmermann

Gefördert durch | Funded by die Kulturstiftung des Bundes

Gefördert von | Funded by der Beauftragten der Bundesregierung für Kultur und Medien

Cover Vorderseite: Liddy Bacroff, amtliches Foto der kriminalbiologischen Sammelstelle, Hamburg 1933 Glasplattennegativ, Staatsarchiv Hamburg 741-4, Fotoarchiv, Nr. P54705.104 | Cover image: Liddy Bacroff, official photo from the criminal biology collection center, Hamburg, 1933, glass-plate negative, Staatsarchiv Hamburg 741-4, photo archive, Nr. P54705.104